The United States Capitol

The United

Perspectives on the Art and
Architectural History of the
United States Capitol

Donald R. Kennon, Series Editor

States Capitol

Designing and Decorating a National Icon

EDITED BY DONALD R. KENNON

published for the United States Capitol Historical Society
by Ohio University Press

Ohio University Press, Athens, Ohio 45701
© 2000 by Ohio University Press
Printed in the United States of America

Ohio University Press books are printed on acid-free paper ⊗ ™

09 08 07 06 05 04 03 02 01 00 5 4 3 2 1

Library of Congress Cataloging-in-Publication Data

The United States Capitol : designing and decorating a national icon / edited by
Donald R. Kennon.
 p. cm. —(Perspectives on the art and architectural history of the
United States Capitol)
 Papers from the U.S. Capitol Historical Society's first two conferences
dedicated to the history and appreciation of the U.S. Capitol.
 Includes bibliographical references and index.
 ISBN 0-8214-1301-5 (cloth : alk. paper). — ISBN 0-8214-1302-3 (pbk. : alk.
paper)
 1. United States Capitol (Washington, D.C.) Congresses. 2. Architecture,
Modern—17th–18th centuries—Washington (D.C.) Congresses. 3. Architecture,
Modern—19th century—Washington (D.C.) Congresses. 4. Decoration and
ornament, Architectural—Washington (D.C.) Congresses. 5. Washington
(D.C.)—Buildings, structures, etc. Congresses. I. Kennon, Donald R., 1948– .
II. United States Capitol Historical Society. III. Series.
 NA4411.U55 1999
 725'.11'09753—dc21 99-32188

Contents

II. Decoration: Mid-Nineteenth-Century Art in the Capitol

Preface

The United States Capitol is a national cultural icon, the most visually recognizable seat of government in the world. From its inception the building was designed to impart the meaning of American representative government. For two centuries the Capitol's architectural design and artistic decoration have made important statements about American values and aspirations.

The past quarter century has witnessed an explosion of scholarly interest in the art and architectural history of the Capitol. The emergence of the historic preservation movement and the maturation of the discipline of art conservation have refocused attention on the Capitol as the American "temple of liberty." Major renovation projects, including the restorations of the historic Old Senate Chamber, the Old Supreme Court Chamber, and Statuary Hall, as well as the conservation of the *Statue of Freedom,* Brumidi's *Apotheosis of George Washington* rotunda fresco, and other nineteenth-century works of art, have made possible a better understanding and appreciation of the building and its decoration. In turn, these projects both benefited from new historical research and stimulated continued scholarship.

A remarkable array of public and private institutions have contributed to the rebirth of scholarly interest in the Capitol through a combination of archival resources, exhibitions, publications, conferences, and fellowships. Principal among these institutions have been the Office of Architect of the Capitol and its curatorial office and architectural historian, the Senate Commission on Arts and Antiquities and its curatorial office, the Senate Historical Office, the old House Historical Office and the current House Legislative Resource Center, the Library of Congress, the American Institute of Architects, the National Building Museum, and the U.S. Capitol Historical Society.

Commemorative events likewise have fueled interest in the Capitol. The restorations of the Old Supreme Court and Old Senate chambers were timed to coincide with the bicentennial of the American Revolution. In 1993 the two hundredth anniversary of the laying of the Capitol's first cornerstone saw, along with several publications and conferences, a major exhibit at the Library of Congress and the dramatic conservation

of the *Statue of Freedom*. Between 1993 and 2001, a number of projects, either completed, under way, or planned, will commemorate the anniversary of Congress's moving into the building on November 22, 1800. These projects include the recently published *Constantino Brumidi: Artist of the Capitol* by the curator of the Office of Architect of the Capitol, whose architectural historian also plans to publish the first comprehensive architectural history of the Capitol to be written since the turn of the century.

The United States Capitol: Designing and Decorating a National Icon also is a product of the revival of scholarly interest in the Capitol and the efforts of the U.S. Capitol Historical Society to cooperate with other institutions, public and private, to foster and disseminate the results of that research to the public. This book combines the papers from the first two conferences the society sponsored in its bicentennial symposia series on the art and architectural history of the Capitol: "Mid-Nineteenth-Century Art in the United States Capitol," held on September 30, 1994, and "Two Centuries of Capitol Architects," held on September 15, 1995. Both conferences drew upon the work of several scholars who had been recipients of the U.S. Capitol Historical Society's Capitol Fellowship, administered in conjunction with the Office of Architect of the Capitol.

The first six papers in this collection focus on the roles of the architects of the Capitol in matters of design and building administration. William C. Allen examines the first difficult decade of Capitol construction, characterized by differences in personality, temperament, and aesthetics among those in charge of the building's design and construction, as well as the obstacles of an insufficient labor force, shortened building season, and lack of funds from a mostly indifferent Congress.

In the second essay, Jeffrey A. Cohen provides an intriguing analysis of the efforts of the second architect of the Capitol, Benjamin Henry Latrobe, to bring to bear his reform ideals of architecture on the building's design, whereas in the next essay Pamela Scott emphasizes the pragmatic political savvy of third architect Charles Bulfinch in accommodating the values and wishes of his congressional patrons.

Thomas U. Walter's turbulent but productive tenure as architect of the Capitol Extension and dome is the subject of James Goode's essay, which highlights Walter's role in the maturation of the architectural profession. William Bushong's essay chronicles the development of the Office of Architect of the Capitol from 1865 to 1954, a period in which its duties expanded to modernize the Capitol as the needs of Congress and the Supreme Court for office space also spawned several new buildings on Capitol Hill.

The final essay in this section, by Richard Guy Wilson, demonstrates the process by which the perception of the Capitol as a malleable building subject to enlargement and remodeling shifted to the image of a venerable architectural landmark that must be preserved. This change in perception has had a corresponding impact upon the architect's role as the Capitol's caretaker.

The six essays in the book's second section examine various topics relating to the

Capitol's artistic decoration. Three authors address the work of Constantino Brumidi, the Italian-American artist whose twenty-five-year career at the Capitol in the mid-nineteenth century did much to embellish the building's artistic symbolism. Barbara Wolanin provides an overview of Brumidi's art, explaining how recent conservation projects, by removing layers of overpaint, discolored varnish, and grime, not only have uncovered much of the artist's techniques but also have contributed to a new appreciation for his talent. Catherine S. Myers reports on her research into Brumidi's paintings in the Senate corridors, detailing how modern research tools make possible an understanding of the artist's mastery of a variety of fresco and mural painting techniques. In the final essay related to Brumidi, David Sellin weaves a fascinating story of the interplay of artistic influences in which a Brumidi design for a Capitol mantelpiece is transformed into a monumental bronze clock for the House chamber.

Daniel Lewis discerns the influence of the Civil War in Emanuel Leutze's massive mural, *Westward the Course of Empire Takes Its Way,* explaining how the artist incorporated pro-Union and pro-emancipation themes in the final version of the 1862 mural. The fifth essay, by Kimberly Jones, examines Albert Bierstadt's efforts to combine landscape and history painting to create a pair of pendant paintings for the House chamber. The book concludes with Teresa B. Lachin's study of the origins and purposes of National Statuary Hall. By carefully researching the records of the commissioning of statues by the states, Lachin is able to chronicle regional and chronological variations in the interpretation of the heroic ideals portrayed in the collection.

The editor wishes to acknowledge the debt of gratitude that this publication and the symposia series it represents owe to several institutions and individuals. The Senate and the House of Representatives, through the offices of Sen. Robert Byrd, Sen. Daniel Moynihan, and Rep. Porter J. Goss, provided rooms in the congressional office buildings for the conferences. The Office of Architect of the Capitol, under the direction of former architect George M. White, has been a driving force behind this symposia series. The 1995 conference was held to commemorate his tenure as architect of the Capitol. Barbara Wolanin, curator for the architect's office, has helped plan and direct each conference. Her assistance and that of her staff have been incalculable. Special thanks are owed to Marco Fabio Apolloni, who gave a talk on Brumidi's artistic background in Italy at the 1994 conference; Vivien Green Fryd and Francis V. O'Connor, who moderated that conference; and to William Seale, who moderated the 1995 conference. The editor especially thanks his colleagues at the U.S. Capitol Historical Society: President Clarence J. Brown, who first suggested this symposia and publication series; Rebecca Rogers, who ably administered the conferences; and Beth Bolling, who helped proofread and prepare the index for this volume.

DONALD R. KENNON

I

Design and Construction

Two Centuries of Capitol Architects

"Seat of Broils, Confusion, and Squandered Thousands"

Building the Capitol, 1790–1802

William C. Allen

THE OFFICE OF ARCHITECT OF THE CAPITOL IS ONE OF THE OLDEST AGENCIES in the federal government. Part of the office traces its origins to the Residence Act of 1790, which authorized the temporary removal of the federal government from New York City to Philadelphia for a ten-year stay while a permanent capital city on the Potomac River was built. The president was authorized to appoint a commission of three men to oversee the development of the new city. Their responsibilities included determining where the Capitol would be built, choosing a design for the building, and beginning its construction. They had other responsibilities, such as finding a plan for the new city, building a house for the president, and operating a surveying department and a stone quarry; but oversight of the Capitol was the part of their job that was a forerunner of the present-day architect's office.

As specified in the Residence Act, the board of commissioners was made up of three men. In 1802, two years after the federal government moved to its permanent seat, that board was replaced by a one-man office called the superintendent of the City of Washington. Following the destruction of the public buildings during the War of 1812, another three-man commission was created to supervise the restoration of the Capitol, the President's House, and the executive office buildings. That board lasted only one year. In 1816 it was blended with the superintendent's office into yet another

one-man post, the commissioner of public buildings. No matter what they were called, these officials represented the government's interests in the public buildings in Washington. They hired and fired workmen, artists, and architects. They negotiated contracts. They oversaw cleaning crews, kept the grass mowed, fixed roofs, painted sash, and kept the windows clean. In short, they did many of the things that the architect of the Capitol does today.

In 1867 the commissioner's office was abolished and its work transferred to the Army Corps of Engineers. But Congress did not want the corps running the Capitol, so in its case the responsibilities of the commissioner were transferred to the architect of the Capitol Extension, Edward Clark, who was finishing the marble wings that were begun in 1851. That merger was the point at which the design, construction, and maintenance of the Capitol were joined into one office that continues uninterrupted to this day.

The initial period of the Capitol's development, 1790 to 1802, during which the first board of commissioners was in charge, was a particularly important and bewildering time. Creating a building for Congress that would be convenient and appropriately embellished was an act of architectural invention without models to copy or precedents to follow. Building far from an established center of the construction trades only aggravated the difficulty of the task. President Washington appointed three men to the board who were more comfortable among politicians or businessmen than with architects, masons, or carpenters; but they shared Washington's vision of developing the commercial possibilities of the Potomac River and were devoted to the idea of a Potomac capital. Thomas Johnson was the first governor of Maryland and the man in the Continental Congress who nominated Washington for commander in chief of the army at the beginning of the Revolution. Another appointee was Daniel Carroll, a scion of the prodigious Carroll family of Maryland, who lost his seat in Congress partly because of his vote for the Residence Act. The third commissioner was David Stuart of Virginia, a member of Washington's family and a close friend. The board was appointed in 1791 and served a little more than three years, until President Washington restocked it with men who agreed to work at the Potomac enterprise full time. To the second board Washington appointed Gustavus Scott, a lawyer with useful connections to the Maryland legislature. Next was William Thornton, a physician and amateur architect who had designed the outside of the Capitol. Alexander White, an ex-congressman from Virginia who had been instrumental in the passage of the Residence Act, filled the last seat. His access to Congress would also prove handy in the future.

When Gustavus Scott died on Christmas Day of 1800, President John Adams named his nephew to the board, but a month later he named the same nephew to the D.C. bench. Then, in one of his famous "midnight appointments," Adams appointed for-

mer Massachusetts Sen. Tristram Dalton to the board. White, Thornton, and Dalton were serving on the board when it was abolished in 1802.[1]

Before the Capitol was begun, the commissioners had managed to buy a quarry, stake out the one-hundred-square-mile federal district, and hire and fire Pierre L'Enfant, the brilliant but difficult engineer who designed the famous city plan. He had also been expected to design the Capitol but never got his ideas down on paper. To obtain a plan, the commissioners advertised in newspapers in the spring of 1792 (fig. 1). Their ad for the Capitol, and a similar one for the President's House, published the first specifications ever written for federal buildings. In the case of the Capitol, at least, they were possibly the worst specifications ever written for a federal building. According to the ad, the Capitol was expected to be a two-story brick building with fifteen rooms and two lobbies. Much happened between the time the newspaper advertisement was run and the day construction was begun. Volumes have been written about the evolution of the Capitol's design during this period, but since the subject of its construction history is not so well known, it is necessary to make a very long story short.[2]

The commissioners' competition for a design for the Capitol was a flop. There were no winners among the eighteen known designs submitted. Etienne Hallet, a French architect who had come to this country around 1790, was encouraged to refine one of his designs. Meanwhile, early in 1793, Washington was shown a design by William Thornton that he loved (fig. 2). It was perfectly suited to his conservative and thoroughly American taste. Its floor plan, however, had some defects, so Washington asked the secretary of state, Thomas Jefferson, to hold a conference to iron out the problems. At that conference, held in July of 1793, Thornton's outside elevation was grafted onto a floor plan that Hallet had drawn. It was not a particularly happy compromise, but at least it was a start. Everyone agreed to the design and plan of the two wings, but the center section was left open for later revisions.

Following the lines staked out by the surveying department, workmen transferred from the President's House began to dig the foundations of the Capitol's two wings during the last days of July 1793. Beginning at the corners, masons started laying stone in the trenches two weeks later. About this time David Stuart wrote the other commissioners to propose a ceremony to mark the beginning of the Capitol. The subject had been overlooked at their last meeting, but it was not too late to assemble the board

[1]William C. diGiacomantonio, "All The President's Men: George Washington's Federal City Commissioners," *Washington History* 3 (1991):53–75.

[2]See Jeanne F. Butler, "Competition 1792: Designing a Nation's Capitol," *Capitol Studies* 4 (1976):15–96; Alexandra Cushing Howard, "Stephen Hallet and William Thornton at the U.S. Capitol, 1791–1797," M.A. thesis, University of Virginia, 1974; and especially Pamela Scott, *Temple of Liberty: Building the Capitol for a New Nation* (New York, 1995).

Fig. 1. Announcement of the competition for a Capitol design, March 15, 1792. Written by Commissioner Thomas Johnson with modifications by Washington and Jefferson, the specifications for the Capitol in 1792 called for a two-story brick building with fifteen rooms and two lobbies. The response was predictably disappointing, with most entries more suited to county courthouses than to the seat of the federal government. Until Dr. Thornton's design was received in January 1793, the president feared that "the exhibition of architecture will be a very dull one indeed." *(Courtesy Office of Architect of the Capitol.)*

Washington, in the Territory of Columbia.
A PREMIUM
OF a lot in this City to be designated by impartial judges and 500 dollars; or a medal of that value, at the option of the party, will be given by the Commissioners of the Federal Buildings, to the person, who, before the fifteenth day of July 1792, shall produce to them the most approved plan, if adopted by them, for a Capitol to be erected in this city, and 250 dollars, or a medal for the plan deemed next in merit to the one they shall adopt. The building to be of brick, and to contain the following apartments, to wit.

A conference room } Sufficient to accommodate
A room for the Re- } 300 persons
presentatives } each.
A lobby or antichamber to the latter.
A Senate room of 1200 square feet area.
An antichamber or lobby to the last.
12 rooms of 600 square feet area, each, for committee rooms and clerks offices, to be of half the elevation of the former. Drawings will be expected of the ground plats, elevations of each front, and sections through the building in such directions as may be necessary to explain the internal structure, and an estimate of the cubic feet of brickwork composing the whole mass of the walls. THE COMMISSIONERS.

and lay a "foundation stone."[3] Later, the commissioners decided to stage a grand ceremony to mark the beginning of the Capitol, the first splendid display of pomp and ceremony ever held in the federal city. And to build confidence in the scheme to relocate the seat of government to the Potomac, George Washington himself laid the cornerstone of the Capitol on September 18, 1793 (fig. 3).

The commissioners first employed two architects to oversee construction of the Capitol. James Hoban, the architect of the President's House, was placed in charge. Below him, the commissioners put Stephen Hallet, who designed the floor plan of the two wings, the so-called Conference Plan. But like L'Enfant before him, Hallet got into trouble with the commissioners because of his refusal to submit to authority. More trouble ensued when he began to lay the foundations of the center part of the

[3]David Stuart to the Commissioners, Aug. 18, 1793, Record Group 42, National Archives and Records Administration, Washington, D.C. (NARA).

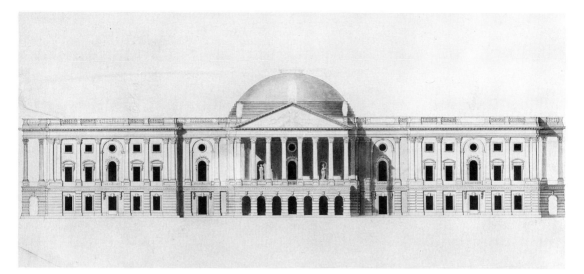

Fɪɢ. 2. Design for the U.S. Capitol by William Thornton, ca. 1796. President Washington praised Thornton's design for its "grandeur, simplicity and convenience," but he was annoyed at the difficulties surrounding its construction. Three architects were employed to build the north wing, the only section that was standing at the time of Washington's death in 1799. *(Courtesy Library of Congress.)*

Capitol before the commissioners or the president had approved the design for that part of the building. He was dismissed in 1794 after being on the job less than a year.

Even though the Capitol was originally intended to be a brick building, President Washington determined that it would be faced with cut stone from the public quarry located at Aquia Creek, Virginia. Finding workmen to quarry, cut, and carve stone was a persistent problem for the commissioners. There were virtually no local craftsmen to hire, and what few there were made a living making such things as tombstones. A Scottish stonemason recently arrived in America, Collen Williamson, took charge of the stone department in 1792 and oversaw laying of the foundations of both the President's House and Capitol. He also ran the quarry at Aquia. George Walker, one of the original landowners in the district, called on stoneworkers during a visit to London but had more success in Scotland, where he was able to recruit seven masons from Lodge No. 8 in Edinburgh.

By August 1794 the foundations of the Capitol had been under way for a year with little to show for it. The contractor for the south wing used a shortcut known as the "continental trench" method of building foundations that was nothing more complicated than dumping stone and mortar into a trench without bothering to lay the stones on their beds or bonding them uniformly with mortar. The masons working on the north wing laid their stone more professionally but neglected to provide air holes for

CAPITOL CORNERSTONE CEREMONY · 1793

FIG. 3. Washington laying the cornerstone of the Capitol, 1793, mural by Allyn Cox, 1971–74. To help restore confidence in the troublesome Capitol project, President Washington came to the federal city to lay its cornerstone on September 18, 1793. Three years later, the foundations were still not finished. *(Courtesy Office of Architect of the Capitol.)*

ventilation. These openings were a necessary precaution against trapped moisture that would destroy the wooden framing and floorboards that would come later.

The commissioners, who were inexperienced in such matters, relied on Collen Williamson to guarantee the work, but he didn't seem to notice or care about the shoddy workmanship. They urged a local builder, Elisha Williams, to keep up the supply of foundation stone for the Capitol and to purchase blankets, bedding, and pots for the public hospital, where sick workmen recuperated. He also was asked to find fresh provisions of rice, sugar, and vinegar for the hospital.[4] To help supply the man-

[4]Commissioners to Elisha Williams, Sept. 19, 1794, RG 42, NARA.

power needs of the city, the commissioners resolved to hire one hundred slaves, paying their owners sixty dollars a year in wages.[5]

John Dobson from Norwich, England, was hired on December 31, 1794, to cut, prepare, and lay freestone at the Capitol. Each type of stonecutting task was priced according to the skill and time involved in its execution. Cutting simple ashlar for plain wall surfaces was valued at three shillings per foot, while more complicated modillions and dentils commanded eight shillings. Molded column bases were most expensive at ten shillings a foot. Dobson was in charge of one of the most visible and important aspects of the construction of the Capitol and was given use of a house on the Capitol grounds as a part of the bargain.[6]

On New Year's Day 1795 the commissioners reported how they had spent £20,000 on the Capitol. Temporary buildings had been constructed, including a carpenters' hall, lime house, stone shed, and a few others for workmen. Five hundred tons of freestone were being worked by twenty of Dobson's men. Timber from Col. Henry "Lighthorse Harry" Lee's Stratford Hall plantation in Westmoreland County, Virginia, accounted for £1,000. About two hundred perches of foundation stone were on Capitol Hill while another twelve hundred and fifty tons were at the wharf. They also had a contract for five thousand bushels of lime. The only major item not on hand or under contract was northern white pine needed for flooring, but the commissioners thought that some could be found near Norfolk.[7]

Two days after their report was issued, the commissioners wrote the president to complain about the "Virginia donation." Both Maryland and Virginia promised cash donations to help build the capital city, but Virginia found it difficult to follow through with its $120,000 pledge. The cash-strapped commissioners began to feel the squeeze. Aggravating the situation was the real estate syndicate of Greenleaf, Morris and Nicholson that in 1793 negotiated a purchase of six thousand city lots payable over seven years. The deal promised a steady infusion of money into the city's coffers; yet, after a year or two, the coffers were still empty. The overextended speculators could not uphold their part of the bargain.

Unsold lots, broken promises, and sour deals left the commissioners without the financial resources to build the public buildings at the brisk pace Washington wanted. On January 29, 1795, before the first block of sandstone was laid on the outside walls, the commissioners asked the president if it would be wise to curtail some of the work on the Capitol. To save money, the commissioners now thought that the Capitol

[5]Commissioners Proceedings, Nov. 3, 1794, RG 42, NARA.

[6]Ibid., Dec. 31, 1794, RG 42, NARA.

[7]"Expenses on the Capitol 1st of January 1795," Miscellaneous Papers in the District of Columbia, Letters and Papers, Manuscript Division, Library of Congress, Washington, D.C.

FIG. 4. East elevation of the north wing by William Thornton, ca. 1796. Although buoyed by a loan guarantee from Congress, the commissioners were forced to curtail the construction of the Capitol in 1796. They decided to continue only the north wing, leaving the domed center building and south wing for a later time. *(Courtesy Library of Congress.)*

should be built in stages, one wing at a time.[8] The north wing could be finished first because it had the most rooms and could better accommodate Congress than the south wing (fig. 4). That section, with its one large room for the House of Representatives, could be built second. The central rotunda area was mainly ceremonial and its construction could be delayed until last.

Shortage of funds left the Capitol for a year without an architect to supervise construction. When Hallet was dismissed in August 1794, the commissioners did not seek a replacement for some months. Learning of the opening, however, John Trumbull, the secretary of the American delegation in London, wrote the commissioners about a promising young architect, George Hadfield, whom he thought perfectly suited for the job of building the Capitol. The commissioners waited several months until their financial condition improved before offering the young architect the job. Sight un-

[8]Commissioners to Washington, Jan. 29, 1795, RG 42, NARA.

seen, Hadfield accepted the offer on March 7, 1795, and Trumbull arranged his passage to America.

By June 1795 the commissioners were awakening to the fact that the construction methods used on the foundations were sloppy at best. A section of the foundation that toppled to the ground finally got their attention. The commissioners found the work so bad that its demolition and reconstruction were the only remedy.

On Monday, July 13, 1795, the first piece of Aquia Creek sandstone was set into place on the outside walls of the north wing. During the following week George Blagden took over the supervision of stone setting that would have been done by Collen Williamson, had he not been dismissed at the beginning of the building season. Williamson was old and cantankerous and was one of the first wave of stonemasons now known to have been incompetent. When he was dismissed, he blamed James Hoban and other powerful Catholics for what he considered unfair treatment.[9]

During the summer of 1795, the height of the Capitol's third building season, dismal weather and more problems with contractors did nothing to cool tempers or promote progress. It was so hot at the end of July that some of the Scottish masons threatened to quit unless they were housed closer to the Capitol. They claimed that the walk from their hotel three times a day was bad for their health. The heat wave was broken when heavy rains came during the first week of August. But John Mitchell complained that he was able to keep only five brick kilns going at Capitol Hill; the wet weather prevented more from being fired up.[10] The shortage of brick was a minor problem compared to the stonecutter John Dobson. He skipped town owing two thousand dollars, forfeited his contract, and deserted his workmen.

When George Hadfield arrived in the federal city in October 1795, his first request to the board was for permission to give a frank opinion respecting the design and construction of the Capitol. He examined the design and went over the work that had been done so far. His first letter to the commissioners contained some of his general observations, none of which were particularly complimentary. Even so, he realized that it was important to get along with the commissioners, especially Dr. Thornton, and he hoped his remarks would be considered professional advice and not be construed as a personal attack. He wrote: "I should be sorry to offend any person by this, my declaration . . . my duty obliges me to speak freely . . . this is a severe situation for me that cannot speak without offending, nor can I offend without being sorry."[11] He was equally polite about the architectural shortcomings of the Capitol: "I find the building begun, but do not find the necessary plans to carry on a work of this importance,

[9]Collen Williamson to the Commissioners [ca. Jan. 1795], RG 42, NARA.
[10]John Mitchell to the Commissioners, Aug. 4, 1795, RG 42, NARA.
[11]Hadfield to the Commissioners [ca. Oct. 15, 1795], RG 42, NARA.

and I think there are defects that are not warrantable, in most of the branches that constitute the profession of an architect, Stability-Oeconomy-Convenience-Beauty."[12]

Hadfield offered several solutions to the problems he found in the Capitol's design, all of which were vigorously opposed by Dr. Thornton. One proposal was to reduce the height of the building by eliminating the basement story. Thus the exterior columns would begin at ground level and the portico would serve as an entrance to the building instead of being a mere balcony. The president refused to become involved and said that he did not care if the plans for the Capitol were changed as long as it would not cause any delay or cost any more money.[13] Ultimately, Hadfield's proposals were not approved.

The winter of 1795–96 set in, bringing that building season to a close. The quarry stockpiled stone for the next year's work, and Hadfield reported that there were enough bricks on hand to keep the masons busy "if only the north wing is to be carried on next season."[14] As workmen drifted away from the city, Alexander White went to Philadelphia for the opening of Congress on December 7. He took with him a memorial on the subject of the public buildings and the prospect of finishing them in time for the move of the federal government to Washington, D.C., in 1800. The memorial explained the commissioners' predicament: unless a steady supply of cash could be found, the public buildings would not be finished on time. They had raised $95,000 from the sale of lots and had an inventory of 4,700 unsold lots worth at least $1.5 million; but when they looked for a loan from European banks, they were turned away because of the 6-percent cap on interest imposed by Maryland law. Now, rather than depend on the sale of property or the collection of debts, the commissioners wanted a loan guarantee from Congress secured by the value of unsold lots. They did not want an appropriation, simply a promise to lenders that the debt would be repaid.[15]

A select committee headed by Jeremiah Smith of New Hampshire was appointed by the House of Representatives to study the commissioners' memorial; its findings were reported on January 25, 1796. The committee determined that $140,000 would be needed annually over the next five years to bring the public buildings to an acceptable state of completion and that the commissioners could raise only $40,000 a year on their own. They recommended that Congress guarantee a loan of $500,000 for the federal buildings. The Capitol had to be made ready for the two houses of Congress, al-

[12]Ibid.

[13]Washington to the Commissioners, Nov. 9, 1795, U.S. House of Representatives, *Documentary History of the Construction and Development of the Capitol Building and Grounds,* 58th Cong., 2d sess., 1904, H. Rep. 646, pp. 36–37.

[14]Hadfield to the Commissioners, Nov. 19, 1795, RG 42, NARA.

[15]*Documentary History of the Capitol,* p. 40.

though a final decision on how much to build still depended on how much money would become available.[16]

Smith's report opened up a rash of debate regarding the city, its management, and its relation to Congress. It was the first time Congress took up the issue of federal buildings, and the opinions expressed were as diverse as the members themselves. According to Jeremiah Crabb of Maryland, a vote against the loan was a vote of no confidence for the federal city. Joseph Varnum of Massachusetts confessed that he did not know anything about the public buildings, how big or how expensive they were. He did not feel inclined to support the measure in any case but could not vote for something unless he knew more about the subject.[17]

Long speeches, sometimes humorous but often tedious, filled the Hall of the House during the debates on the loan guarantee that took place during the last week of February 1796. On the 25th, Henry Dearborn introduced a resolution to inquire whether any alterations ought to be made in the plans of the public buildings. This simple question caught the friends of the city off guard; very few knew anything specific about what was being built there. They did not know such things as what the Capitol was supposed to look like or how big the President's House was going to be. Dearborn confessed that he did not know the size of the President's House, but if it was too big he thought it should be transformed into the Capitol. Congressman Crabb responded with the caustic suggestion that if the President's House was indeed too big perhaps it should be torn down and a smaller residence built in its place. John Swanwick of Pennsylvania, one of the few members who had actually visited the federal city, said that the plans for the Capitol had been changed so many times that it would not hurt to alter them again. According to a member from Connecticut, rumors of extravagance were hurting the prospect for the loan guarantee. In reply, Theodore Sedgwick of Massachusetts made a brief but farsighted statement, saying, "The better the buildings are the more honor it will be to those who erected them, and to those who occupy them."[18] Smith reported that his committee could find nothing to suggest the need for alterations to the Capitol or President's House. On March 31, 1796, the friends of the federal city prevailed and the loan guarantee, reduced to $300,000, was approved by Congress and the president.

With the city's financial future seemingly secure, the building season that began in the spring of 1796 progressed well, bothered only by the usual complaints. The cost of living was making it difficult for carpenters to make ends meet, and the expense of

[16]Ibid., p. 41.
[17]Ibid., p. 59.
[18]Ibid., p. 61.

repairing and sharpening their tools made matters worse. They asked for an increase in wages. Building temporary lodgings for them was suggested as a means to avoid high rents extracted from workmen, who told the commissioners that "some indulgence is necessary to live in this expensive place."[19]

In the summer of 1796, carpenters were cutting and preparing wooden joists, flooring, and rafters that would be installed once the masonry work was sufficiently advanced and dry. They also erected scaffolds used by the masons building the brick and stone walls. Hadfield was asked to report the progress made during the building season, which that year ran from May 17 to November 17. The brick exterior walls and sandstone facing had been carried up twenty-three feet above the ground and reached the bottom of the second-floor windows.

As winter set in, the commissioners ordered supplies for the next season. One million bricks and 6,000 bushels of lime to make mortar were purchased for the walls of the Capitol and the President's House. It was time to order timber for the "Senate room," which the architect was told to buy from the Carroll family. To feed laborers and slaves, 150 barrels of pork, 40 barrels of beef, and 1,500 barrels of meal were ordered.

At the close of Washington's term as president, he urged the commissioners to concentrate all of their resources on the Capitol. That building, more than anything else in the city, would inspire public confidence in the Potomac capital. On January 29, 1797, he wrote: "I persuade myself that great exertions will be used to forward the Capitol in preference to any object. . . . [T]here are many who intermix doubts with anxiety, lest the principal building should not be in a situation to accommodate Congress by the epoch of their removal."[20]

By the end of 1797 the walls of the north wing reached roof level. On the inside, carpenters had laid almost all of the rough flooring and were preparing the trusses for the roof that would be put into place before spring. Once under roof, the interior finishes could be begun. As winter approached, carpenters working on the roof were told not to throw away their "chips," which would be given to the laborers and slaves for firewood. Hadfield was responsible for the structural design of the roof, a complex series of flat and sloping surfaces that was kept as low as possible. He pledged in writing that the roof would not exceed the height of the balustrade. The commissioners had 80,000 wooden shingles on hand but thought slate might be used to cover the roof instead. On June 8 they asked Graham Haskins to sell the shingles at a price that would reflect their high quality. The sale, however, was canceled and the wooden shingles were used. Once in place, the shingles were protected with a coating of paint and sand, a precaution against fire.

[19]Commissioners letters received, Aug. 19, 1796, RG 42, NARA.
[20]Washington to the Commissioners, Jan. 29, 1797, RG 42, NARA.

Smarting from previous experience, Hadfield rarely offered suggestions that would alter the approved plan of the Capitol. But he improved the Senate chamber considerably by introducing a curving wooden wall that transformed the awkward space into an elegant semicircle (figs. 5, 6). The alteration simplified the chamber and allowed for two handsome niches at the gallery level. Dr. Thornton wanted stoves placed in the niches to warm the visitors' gallery, but he was overruled. In another disagreement, Thornton noticed that sections of the exterior cornice were carved incorrectly and blamed the mistake on Hadfield. He asked his fellow board members to order the mistake corrected. When they refused, Thornton admonished his colleagues by saying that the cornice "will remain forever a laughing-Stock to architects."[21] Apparently Scott and White did not believe the mistake serious enough to justify the cost to fix it.

Despite the loan guarantee, the commissioners were still broke. In February 1798, Alexander White returned to Philadelphia with a second memorial from the board, this one asking for a yearly appropriation to finish the public buildings. Two hundred thousand dollars would be needed over the next three years.

When the commissioners sent their memorial to Philadelphia, they were not prepared for the bizarre suggestions made by economy-minded congressmen. On March 8 White wrote his colleagues about proposals that were floating through Congress to house the president on Capitol Hill, to hand over the President's House to the Supreme Court, and to put cabinet offices in the south wing of the Capitol. Others wanted the President's House, which was more nearly completed than the Capitol, refitted for the use of Congress.

While Congress considered the appropriation to assist the federal city, the commissioners hoped that nothing would come of the proposals to change the plans or functions of the public buildings. The House passed the appropriation, but the Senate amended it from an appropriation to a loan and reduced the amount of assistance to $100,000. Fearing it was this or nothing, the House accepted the amended legislation on April 13, and President Adams approved it five days later.

During the time White was in Philadelphia, his colleagues on the board made provisions for making the doors and windows at the Capitol. Once the building was finally closed in, workmen could begin the interior finish. For the exterior doors, the commissioners selected "plain mahogany," while clear pine was specified for interior doors. Later, these could be grained in imitation of a more expensive wood. Hadfield drew the design for the sash, and the board asked several carpenters to make samples. The commissioners decided the sash would be made of mahogany but soon changed their minds when they ordered walnut to be used as well. The strength of mahogany

[21]Thornton to the Commissioners, Jan. 9, 1798, RG 42, NARA.

Fig. 5. North wing of the Capitol, ground plan; reconstruction by the author, drawing by Eric Keune, 1988. The runner-up in the competition of 1792, Steven Hallet, designed the floor plan of the north wing shown here as built. The original configuration of the Senate chamber is indicated by the thick masonry walls, while its alteration into a semicircle is indicated by the thin wooden wall that was suggested by Hallet's successor, George Hadfield. The principal staircase in the oval space (now called the small Senate rotunda) was built by Benjamin Henry Latrobe in 1808. It replaced the original wooden staircase, the design of which is unknown. The second of four committee rooms on the western side of the wing was the first meeting place of the Supreme Court in Washington. *(Courtesy Office of Architect of the Capitol.)*

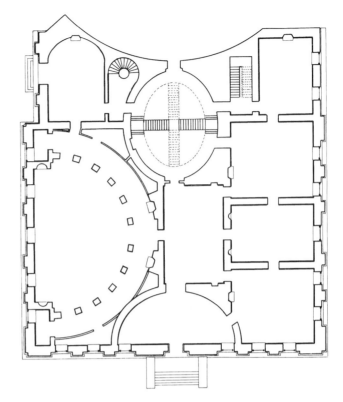

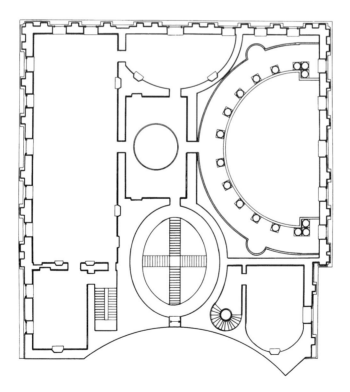

Fig. 6. North wing of the Capitol, plan of the second floor; reconstruction by the author, drawing by Eric Keune, 1988. The House of Representatives first used the large library room on the second floor as its chamber from November 1800 until the "Oven" was finished in December 1801. After the Oven was demolished, the House returned to the library in 1804 for a three-year stay. *(Courtesy Office of Architect of the Capitol.)*

was necessary for the large windows of the first and second floors, but walnut was probably considered adequate for the smaller third-floor windows.

While the windows were being made, the board became concerned about Hadfield's progress on his plans for the executive offices, a pair of buildings that were designed once Congress decided to lend the city financial assistance. Like any architect, Hadfield was anxious to see his design built but wished to oversee the work himself. When the commissioners asked Hadfield to return his drawings, he refused until his relationship with the buildings was explained to his satisfaction. For its part, the board did not believe further explanation was necessary and considered the plans public, not private, property. This dispute, unlike many others, was quickly settled. On May 18, 1798, the commissioners fired Hadfield. While his dismissal was not directly related to the Capitol, Hadfield joined a growing fraternity of architects whose careers were derailed or wrecked by their work in the federal city.

After Hadfield's dismissal, James Hoban alone was in charge of the Capitol. While he was still responsible for the President's House, finishing the north wing of the Capitol became his top priority. By the end of the 1798 building season, Hoban reported that the roof was finished and the gutters were in place and coated with lead. The brickwork was complete, and all the Aquia Creek sandstone was in place on the north, east, and west walls. The only thing still missing was a small section of the balustrade. Bridging, ceiling, and flooring joists were all made and, for the most part, installed. More than fifty thousand feet of northern pine, one to two inches thick, was in stock for floors and interior trim. There were nearly five hundred tons of stone, thirty thousand bricks, and forty thousand shingles on hand that were not now needed.

The most important task that would be undertaken in the next building season was the plastering. In November 1798, the commissioners ordered sixty thousand sections of wooden lath four feet long. To help bind the plaster, one thousand bushels of hair were ordered from a Boston merchant. Archibald Campbell was asked to find enough workmen to trowel ten thousand square yards of plaster, for which the commissioners were prepared to pay three cents a yard. They also needed mechanics to run "Plaster of Paris cornices and ornamental work in the handsomest style."[22]

The contract for plastering the north wing went to John Kearney of Baltimore, who was told to begin work on April 22, 1799. The commissioners ordered twenty tons of plaster of Paris; they did not care if it was foreign or domestic as long as it came in a "good white or blue colour."[23] By the middle of May, Kearney had scaffolding up

[22]Commissioners to Archibald Campbell, Dec. 5, 1798, RG 42, NARA.
[23]Commissioners to Grahame Haskins and Co., May 22, 1799, RG 42, NARA.

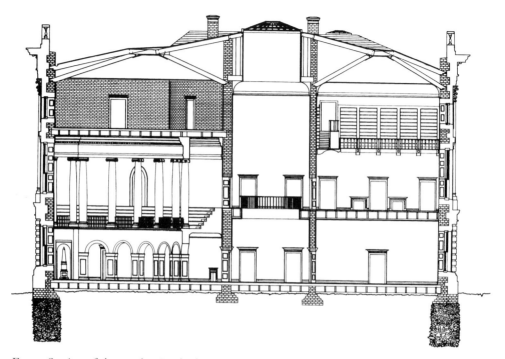

FIG. 7. Section of the north wing looking south, reconstruction by the author, drawing by Eric Keune, 1988. The original Senate chamber occupied the first and second floors on the east side of the wing, with an unfinished room intended for clerks above it. A large space for the Library of Congress, occasionally used by the House of Representatives and the Supreme Court as a temporary chamber, was located above three committee rooms in the western side. In the center was a lobby topped by a skylight. A circular opening in the floor allowed light to penetrate down to the lower level. *(Courtesy Office of Architect of the Capitol.)*

in three committee rooms and had his crew at work boiling vats of plaster. In June the weather aggravated the misery of this hot work, and the commissioners allowed the laborers a half-pint of whiskey a day to help them cope. Hoban probably collaborated with Kearney when he designed the cornices. The two vestibules, four committee rooms, and the Senate chamber on the first floor had cornices with "stucco ornaments," while the large library and its lobby on the second floor had cove cornices. Four rooms to be used by clerks apparently had no cornices at all.

While the plastering went forward, the first shipment of glass arrived in the federal city. On August 1, Robert King from the surveyor's department was asked to examine the glass, and he reported that it appeared to be "Newcastle crown, of the Quality of Seconds."[24] The glass had been poorly packed and was too crooked to be of any use. They placed another order for glass one-eighth-inch thick from London and pleaded

[24]Robert King to the Commissioners, Aug. 1, 1799, RG 42, NARA.

that it be packed in the "securest manner." Until the glass arrived, the window sash could not be installed. Workmen boarded up windows to keep warm during the winter months and then sat idle in the dark. To overcome the problem, Hoban suggested that window sash, with small, cheap panes, be used for the time being. When the permanent sash was installed, the temporary ones could be sold for residential use.

At the close of the 1799 building season, Hoban reported that the north wing of the Capitol was nearly complete.[25] The exterior was finished, lightning rods installed, cistern and cesspools leaded, and the roof painted and sanded. The sixteen Ionic columns in the Senate chamber were in place, standing on a brick arcade covered with wood paneling (fig. 7). The columns were made with wooden shafts coated with plaster and had plaster capitals, which were in the "ancient Ionic order but with Volutes like the modern Ionic." Thus, they probably looked like smaller versions of the Ionic order Hoban used at the President's House. Mantels were made of painted wood, and the hearths were laid with three pieces of sandstone. In the event marble mantles and hearths were installed in the future, the sandstone would be reused to pave the city's sidewalks.

In 1800 the commissioners were hurriedly finishing the public buildings. At the Capitol, hardware was still needed for the doors, and the interior woodwork needed another coat of paint. A violent storm damaged the roof and was particularly rough on the leaded gutters. Walls were damaged and fresh plasterwork fell in some places. John Emory was ordered to make repairs to the gutters, and when his work failed to stop the leaks, the commissioners threatened him with a lawsuit.

On May 15 President Adams asked department heads in Philadelphia to make arrangements for the removal of the government to the new city in a month. When employees began to arrive that summer, last-minute work was still going on at the Capitol (fig. 8). In August, Kearney finally finished plastering, or as much as would be finished; the large room on the third floor above the Senate chamber was never plastered. Mortise locks were still needed, and the commissioners were waiting for seventy boxes of window glass to arrive. William Rush, the Philadelphia sculptor, was asked to carve a wooden eagle for the Capitol, which the commissioners hoped would not cost more than $40. A month before Congress arrived, the commissioners took care of one final detail on Capitol Hill. They had a seventy-foot-long privy built that cost $234.

The second session of the Sixth Congress convened in the north wing of the unfinished Capitol on November 17, 1800. For some, leaving Philadelphia was a bitter pill to swallow, but yellow fever in that city during the past summer made it easier to go. President John Adams addressed Congress in the Senate chamber on Novem-

[25]*Documentary History of the Capitol,* pp. 87–89.

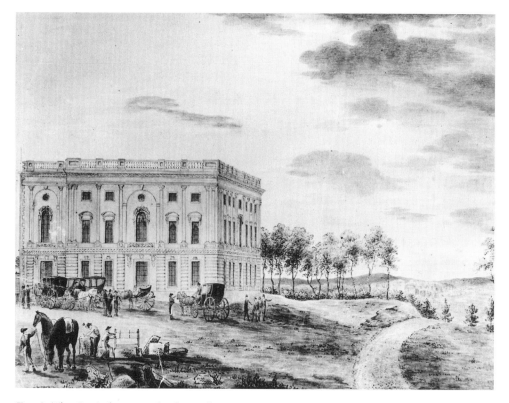

FIG. 8. The Capitol, watercolor by William R. Birch, 1800. The Capitol's appearance when the government moved from Philadelphia to its permanent home on the Potomac is recorded in this charming watercolor. While the artist illustrated stonecutters in the foreground, no such activity was taking place in the summer of 1800, although five hundred tons of surplus sandstone were on hand. Another case of artistic license is the carved oak leaves shown above the arched windows. Birch must have seen Thornton's drawing for the Capitol, which included these ornaments that were, however, never carved in place. *(Courtesy Library of Congress.)*

ber 22, congratulating the members "on the prospect of a residence not to be changed."[26] He acknowledged the cramped conditions of the Capitol, saying the "accommodations are not now so complete as might be wished," but he thought things would quickly improve.

The House of Representatives was crammed into the room designed for the Library of Congress and needed more space (figs. 6, 7). In May 1801, two months after Thomas Jefferson became president, the commissioners asked Hoban to design a temporary building on the existing foundations of the south wing that would better accommodate the House. Hoban devised three schemes for a temporary chamber from which the president could choose. They were sent to Jefferson on June 1, and the com-

[26]Ibid., p. 90.

FIG. 9. Elevation and section of the Oven; reconstruction by the author, drawing by Eric Keune, 1989. According to the part of the conference plan that concerned the south wing, the entire three-story structure was to be occupied by the chamber of the House of Representatives. Within the rectangular wing an elliptical one-story arcade was intended to support columns thirty feet high that would in turn help support the roof. When the Jefferson administration decided to begin construction of a temporary chamber, the president wanted some of it at least to be usable in the permanent structure. He therefore approved a scheme devised by James Hoban to build the arcade, glaze the openings, and cover it with a roof. It was occupied in 1801, but by 1803 the walls began to buckle under the weight of the roof, and they were quickly braced by heavy timbers. The building was entirely demolished in 1804 to make way for Latrobe's revised plan for the wing. *(Courtesy Office of Architect of the Capitol.)*

missioners were informed of the president's selection the following day. Jefferson approved a scheme for building an elliptical arcade that was part of the permanent plan of the wing, glazing the openings, and roofing it over. The temporary chamber was built by William Lovering and William Dyer, local contractors, and cost about $5,000 (fig. 9).

Soon after the temporary House chamber was occupied, it became known as "the Oven." The nickname was bestowed partly because of the structure's shape, which reminded some of a huge Dutch oven, and partly because of its notoriously hot and stuffy interior. Ventilators were installed on the roof to help the chamber's atmosphere, but they never worked satisfactorily.

During much of Jefferson's first term as president, the Capitol was a distinctively odd-looking building. Three sides of the north wing were finished, but the south elevation was a naked brick wall that would eventually be covered by the center building. The elliptical "Oven" and its long, narrow wooden passage to the north wing made the Capitol look even more peculiar (fig. 10). The commissioners had expended more than $370,000 so far on the Capitol and still owed more than $200,000. They had not sold enough city lots to cover even the interest on their loans.

Fig. 10. The Capitol in 1803; reconstruction by the author, drawing by Eric Keune and Juliana Luke, 1989. The north wing and the Oven were connected by a wooden passage that, among other things, contained three privies. It also contained the steep stairs leading to the gallery overlooking the temporary House chamber that was often crowded with spectators. *(Courtesy Office of Architect of the Capitol.)*

President Jefferson sent Congress a message to recommend that the Treasury repay the loans. A special committee of the House of Representatives reported on the president's message as well as on an inquiry from the House on the continuation of the board of commissioners. The committee recommended that the board be abolished and replaced by a single superintendent. In addition, it approved the president's proposal to repay the debt out of public funds. The recommendations were enacted into law on May 1, 1802.

The money problems that had plagued the commissioners from the beginning of their work were only a part of the reason the board was abolished. Now that the government was "fixed" on the Potomac, there was no further need for commissioners to handle the city's affairs for an absentee administration. With Jefferson's love of architecture and building, he would personally direct future development and did not want to contend with any middlemen. When construction resumed in 1803, Jefferson appointed Benjamin Henry Latrobe as surveyor of the public buildings. While Latrobe's first job was to build the south wing, he spent much of his time developing plans for the reconstruction of the north wing, which was already riddled with rot and plagued with falling plaster. In a few years about half of what the commissioners had built inside the wing had been torn out and replaced. The destruction of the Capitol during the War of 1812 left nothing remaining of the north wing built by the commissioners except the walls.

The final entry into the minutes of the board ordered accounts settled and salaries paid. Dr. William Thornton, whose hopes for the future were closely allied with the city's fortunes, concluded the entry with a flourish of swirling lines under the phrase: *"Finis Coronat Opus!"* (the end crowns the work). Thornton's work may have ended; but the Capitol was barely begun, and it was not a particularly good beginning. Yet, despite the shaky start, it was nonetheless the beginning of what miraculously turned out to be one of the world's greatest buildings: the United States Capitol.

Forms into Architecture

Reform Ideals and the Gauntlets of the Real
in Latrobe's Surveyorships at the U.S. Capitol,
1803–1817

Jeffrey A. Cohen

THE STORY OF BENJAMIN HENRY LATROBE'S PARTICIPATION IN THE CREATION of the United States Capitol is a critical one in the building's history. It also reaches into some resounding political and personal dimensions of architectural design that form the principal focus of this paper. Before turning to seven specific themes in that vein, however, it might be useful to provide some orientation by outlining the general sequence of Latrobe's efforts during his two terms as architect at the Capitol.

First, Jefferson appointed Latrobe "surveyor of the public buildings of the U.S." in the spring of 1803, and Latrobe immediately set about building the south wing—to accommodate a new chamber for the House of Representatives—within walls matching those of the north wing, already built (fig. 1).

Second, Latrobe proposed an astylar semicircular House chamber (i.e., lacking columns along its curving wall) with a masonry half-dome and a tempietto-like "lantern" to bring in light from a concentrated source at its apex, but this design was quickly rejected. Latrobe instead carried out a hippodrome-shaped House chamber (with half-domed semicircles appended to the long sides of a barrel-vaulted rectangle). Completed in 1807, it had more than one hundred small dispersed skylights in its wooden dome (fig. 2).

FIG. 1. Latrobe, pencil sketch of the U.S. Capitol from the northeast, 1806, Maryland Historical Society. At right is the north wing, erected to accommodate both houses of Congress upon the arrival of the federal government in 1800. At left, across from the space reserved for the grand portico and rotunda, is the rising south wing, amid building sheds and stone blocks in the foreground. *(Courtesy Maryland Historical Society.)*

Third, structural problems in the north wing permitted Latrobe to replan and rebuild its interior beginning in 1806 (fig. 3). He devised a new Senate and Supreme Court chamber on its east side, conceiving an Egyptian design for the Library of Congress on its west, and explored notions for the great domed center between the two wings (fig. 4); but work ceased about 1811 as funding dissipated and war threatened.

Fourth, after British forces burned the building in 1814 (fig. 5), Latrobe returned from Pittsburgh, designing a temporary Capitol and embarking on a second campaign in the spring of 1815, this time as "surveyor of the Capitol of the U.S." He rebuilt the south wing, with the semicircular colonnaded House chamber that survives as Statuary Hall. In the north wing he constructed an expanded Senate chamber and introduced the tobacco-leaf tempietto that disguises the former elliptical stair hall (fig. 6). He also elaborated his plan for the center building, now to lead to a deeper west wing containing redesigned quarters for the Library of Congress.

Fifth, Latrobe resigned in late 1817, driven principally by bureaucratic interference in his conduct of the work. He was succeeded by Charles Bulfinch, who completed the great domed center nearly a decade later.

This narrative has been told and retold over more than a century of historiography,

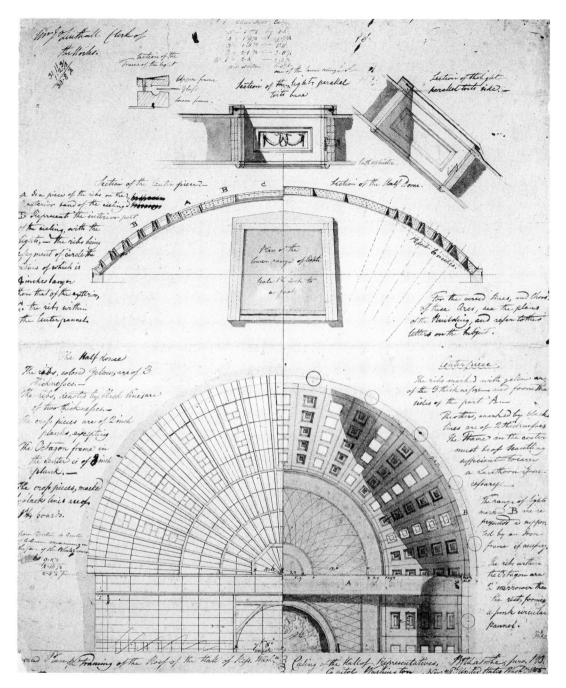

Fig. 2. Latrobe, dome of the Hall of Representatives, U.S. Capitol, plans and details, 1805, Prints and Photographs Division, Library of Congress. This sheet showing the reflected ceiling plan and framing plan of half the House chamber also details the form of the small squarish skylights in the dome—instead of a single tempietto lantern over an oculus—by which Latrobe came to terms with Jefferson's wishes. *(Courtesy Library of Congress.)*

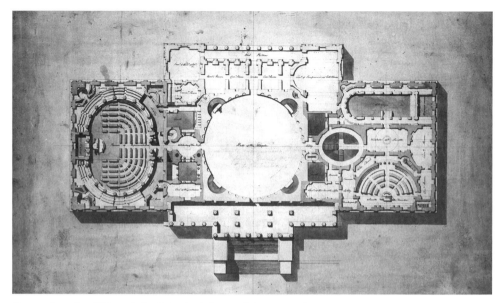

FIG. 3. Latrobe, "Plan of the Principal Story of the Capitol, 1806" (ca. 1808–9), Prints and Photographs Division, Library of Congress. The plan of the south wing, at left, shows the House chamber as Latrobe carried it out in the first campaign, inscribed within the perimeter defined by Thornton's design. Latrobe replanned the north wing, at right, which was largely rebuilt accordingly, except for the bullet-shaped, Egyptian-style Library of Congress. In this first campaign, little work was carried out on the domed center and western projection, distinguished by the lighter tint of their walls. *(Courtesy Library of Congress.)*

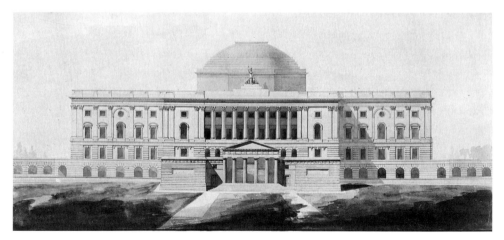

FIG. 4. Latrobe, "West Elevation of the Capitol U.S. Washington," 1811, Prints and Photographs Division, Library of Congress. From the west side facing the Mall, the approach to the Capitol passed through a colonnaded propylaeum between blocky doorkeepers' residences. This sheet also shows the severe dome and drum over the center that Latrobe contemplated rising over a broad western loggia. The west wing carried over elements of Thornton's wing elevation but rendered them in simpler and more solid forms. *(Courtesy Library of Congress.)*

FIG. 5. "A View of the Capitol of the United States after the Conflagration of the 24th. August 1814," engraving, 1814, by William Strickland after George Munger. This view from the southeast shows the surviving exterior walls, but the interiors were more seriously damaged. Note the entrances to the wings in the two "recesses" near the center and the curved brick wall anticipating the central rotunda. *(Courtesy Library of Congress.)*

with varying emphases and degrees of accuracy. The interested reader is referred to the wealth of recent publications represented by the other contributors to this volume, where one will find authoritative scholarship and engaging analysis, accessibly digesting a mountain of documentation. Rather than delve more deeply into the details of this story and further reintegrate its documentary evidence, this paper will focus on an exploration of seven themes:

1. The prior face (and body) of American government
2. Latrobe, the architectural missionary
3. A democratic transparency
4. Communal grandeur as the image of democracy
5. Class and professionalism
6. The best and worst client
7. The thing itself, sent out into "the world"

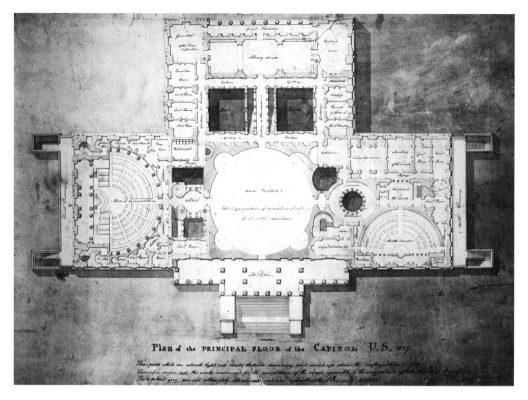

FIG. 6. Latrobe, "Plan of the Principal Floor of the Capitol U.S. 1817," Prints and Photographs Division, Library of Congress. At this point in the second campaign, Latrobe has abandoned his Egyptian Library of Congress design in the north wing for one centered on a domed tripartite suite in the west wing, at top. Committee rooms and offices fill out much of the western perimeter. *(Courtesy Library of Congress.)*

The Prior Face (and Body) of American Government

As William Allen has discussed earlier in this volume, fundamental decisions about the form of the U.S. Capitol were a decade in the making before Latrobe was appointed "surveyor" in the spring of 1803. A first theme relates more to the world of forms Latrobe encountered in the young United States than to those he devised as the symbol of and container for American government. This is illustrated in three of the most highly representational buildings newly erected by the young federal government to constitute its first public face: the Capitol, the White House, and the First Bank of the United States, whose executed designs were all initially conceived between 1792 and 1795.

Major elements of all three, curiously enough, bore the imprint of Dublin. Latrobe, for example, wrote in February 1807 of the initial form of the Senate chamber, con-

ceived as part of William Thornton's design, as "a Copy [of] the house of Commons in Dublin . . . excepting only that *that* room was a compleat circle." The Commons chamber (fig. 7) was part of the Irish Parliament House, built 1728–39 by Sir Edward Lovett Pearce. Before its rebuilding following a 1792 fire, the Commons chamber was actually octagonal in shape and had a colonnade over an arcade and a coffered dome over its center. Latrobe described that chamber as "always a wretched speaking room," but taunted Thornton by claiming that even that Irish room was better than that which Thornton and others had devised for the Senate.[1] With a similar portion of bile, he referred to the President's House in May 1806 as "a mutilated copy of a badly designed building near Dublin," and in March 1817 Latrobe described its plan as "that of the palace of the duke of Leinster," built 1745–51 (fig. 8).[2] The third appearance of Dublin was in Philadelphia, in the facade of the Bank of the United States (fig. 9), built 1795–97 to a design by Samuel Blodget. In May 1811 Latrobe called it "only a copy of a European building of indifferent taste." In the same year James Mease noted its resemblance to what was almost surely the referent Latrobe had in mind. Mease wrote that the bank's front was "said to be nearly a copy of the Dublin Exchange" (fig. 10).[3] The Exchange had been built 1769–79 to designs by Thomas Cooley, a follower of Sir William Chambers.

As Latrobe described the influence of the plan of Leinster House upon the White House, he noted that he had before him "a book containing the principal edifices of Dublin," doubtless Robert Pool and John Cash's *Views of the Most Remarkable Public Buildings, Monuments, and Other Edifices in the City of Dublin,* published in that city in 1780.[4] This book illustrated all three Irish referents, including a section through the House of Commons and front elevations of the other two structures. In fact, one telltale element of the facade design of the White House (fig. 11) seems to tie it specifically to this book: the somewhat unusual sequence of curved and triangular pediments across the front of the principal story—with curved ones nearest the corners—coincides not with Leinster House itself, nor with other engravings of it, but with the mistaken order in the Pool and Cash plate of it (fig. 12).

It is difficult to assess the significance of these Irish connections; there may have been more of coincidence here, in Thornton's, Blodget's, and Hoban's independent choices, than an intentional, programmatic focus on or emulation of Irish experience. Considered more generally, though, all three buildings adhere to an architectural language

[1]Latrobe to George Logan, Feb. 18, 1807, John C. Van Horne et al., eds., *The Correspondence and Miscellaneous Papers of Benjamin Henry Latrobe,* 3 vols. (New Haven, 1984–88), 2:377.

[2]Latrobe to Philip Mazzei, May 29, 1806, ibid., 2:228; Latrobe to William Lee, Mar. 22, 1817, ibid., 3:872.

[3]Latrobe, "Anniversary Oration to the Society of Artists" [May 8, 1811], ibid., 3:81; James Mease, *The Picture of Philadelphia* (Philadelphia, 1811), p. 320.

[4]Latrobe to William Lee, Mar. 22, 1817, Van Horne, *Latrobe Correspondence,* 3:872.

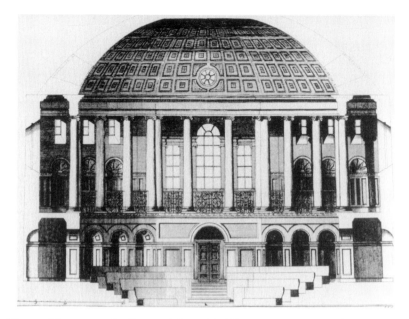

Fig. 7. House of Commons, Parliament House, Dublin, 1728–39, section, from Robert Pool and John Cash, *Views of the Most Remarkable Public Buildings, Monuments and Other Edifices in the City of Dublin* (Dublin, 1780). *(Courtesy the author.)*

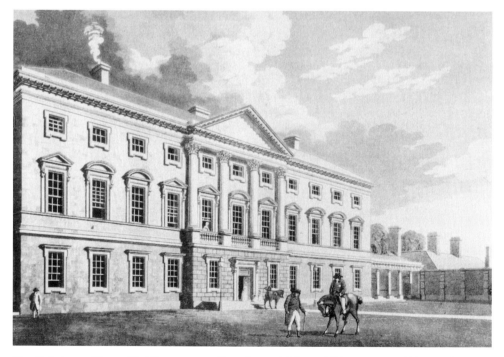

Fig. 8. Leinster House, Dublin, 1745–51, from James Malton, *A Picturesque and Descriptive View of the City of Dublin* (London, 1799). *(Courtesy the author.)*

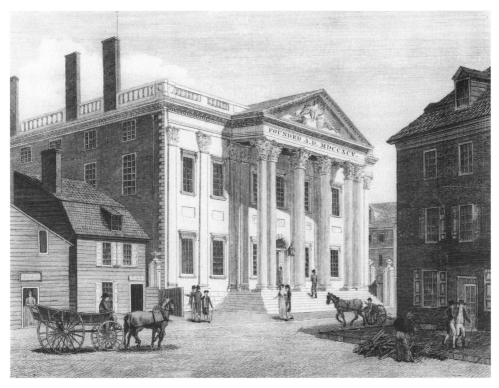

FIG. 9. Bank of the United States, Philadelphia, 1794–97, engraving 1799, from William R. and Thomas Birch, *The City of Philadelphia, in the State of Pennsylvania, North America; as It Appeared in the Year 1800* (Philadelphia, 1800). *(Courtesy Winterthur Museum Libraries.)*

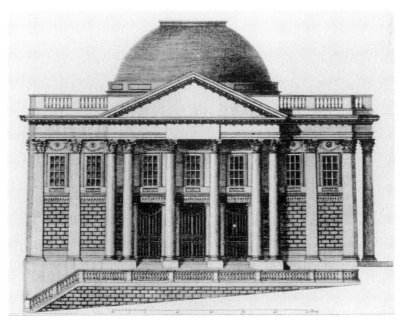

FIG. 10. Royal Exchange, Dublin, 1769–79, front elevation, from Robert Pool and John Cash, *Views of the Most Remarkable Public Buildings, Monuments and Other Edifices in the City of Dublin* (Dublin, 1780). *(Courtesy the author.)*

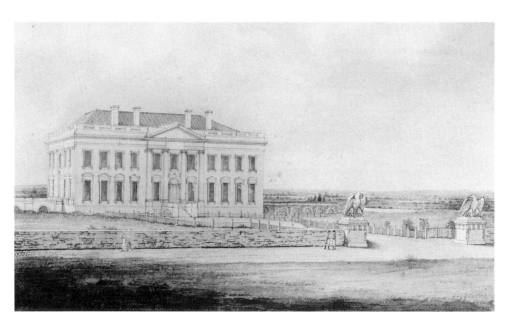

FIG. 11. Latrobe, "The President's House in the City of Washington, Sepr. 1811," view from the northeast. *(Private collection.)*

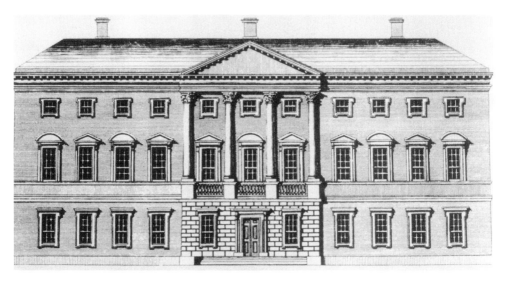

FIG. 12. Leinster House, Dublin, 1745–51, front elevation, from Robert Pool and John Cash, *Views of the Most Remarkable Public Buildings, Monuments and Other Edifices in the City of Dublin* (Dublin, 1780). *(Courtesy the author.)*

of Anglo-American gentility, of the Georgian tradition of gentlemen's houses, neo-Palladian and after, elevated to a more rhetorical intensity for public buildings by virtue of their size, material, ordonnance, and detail. Even where touched by the more wide-ranging classicism of Chambers, they maintain a characteristically British—and subsequently Anglo-American—restraint, a favor for purity in rendering orders and shaping moldings that generally distinguishes British from Continental classicism.

Such buildings demonstrated the educated taste of the gentleman on his country estate, one who joined others in institutions that sustained their mutually shared ideals of social structure and of architecture. The private and public buildings of his class presented an almost ubiquitous image of social leadership distributed across urban and rural landscapes. These buildings intimated that this gentleman's role was predicated not simply on wealth and power—often presented on the Continent in more baroque expressions—but on a restraint born of essential fairness, of knowledge, and of taste exercised in the service of the betterment of the entire polity. This idea of a gentleman in Georgian Britain was the pillar of an aristocratic society, or more accurately in its architectural imagery, of a Whig oligarchy, and the neo-Palladian house was its emblem. Rather than personal innovation reflecting a patron's individuality, the strongest identification in these buildings was to a group, a class, one portrayed as worthy of its social role.

This social and architectural imagery was very clearly emulated in the eighteenth-century American landscape among the houses of successful farmers and merchants adopting a similar social role, and among their institutions. Their position was often less exalted in terms of wealth and descent, with fewer of the strictures of exclusive class membership and more of a breadth of participation in British North America. But in the decades before and after the Revolutionary War, Americans subscribed to this taste more than they challenged it, taking it as a badge of membership in social privilege and civil duty. The early architectural face of the federal government, almost as much as the government itself, embodied this notion of guidance by the educated ideals of such a self-nominated squirearchy rather than some more Jacobinical sense of revolutionary democracy.

These American Georgian buildings found their main foil less often in examples of Continental taste than in the prosaic, the seemingly unconsidered jumble of gabled rectilinear volumes that dominated much of the American landscape, many of them touched by assertive materiality and localisms that these gentlemen would have regarded as unenlightened. Among those engaged in matters of design, the contrast with Continental work was more persistent and meaningful than its relative rarity would suggest. Much of the social character of neo-Palladian building was implicit in that contrast, even when that foil was far removed. Latrobe, championing a new language

of architectural modernity that succeeded the neo-Palladian, accorded that midcentury work a modicum of respect; he reserved a greater derision for high-style expressions reflecting seventeenth- or early-eighteenth-century fashions, baroque, or what he called "Dutch," that he regarded as overly sculptural and free, unguided by the central tenets of classical proportion and correctness.

The Irish models thus exemplified what stood more broadly as the image of advancing civilization in the Anglo-Colonial world, its patrons cast as a class as civilization's agents, and their buildings playing against the momentum of unreflective habit and expediency as well as against other social models. This class erected an image of gentility and refinement that presumed to stand as an ideal for all society; although democratic notions of the rights of man pertained to all, they were truths articulated and self-evident mainly to an intellectual elite. The houses of the Founding Fathers generally invoked this Georgian, neo-Palladian imagery borrowed of a landed gentry, fostered here by gentleman farmer-citizens and merchant-citizens claiming similar roles of political and social leadership amid the more permeable class strata of the American colonies. The American Revolution did not significantly dispossess this class in the way that the French Revolution did its reigning classes. Ours remained a society of Anglo-American gentlemen exercising the prerogatives and imagery of leadership; the first federal buildings adhere to that image of society more than they articulate something more revolutionary. More than the rhetoric surrounding them sometimes suggests, they comfortably inhabit an Anglo-American context that was rather conservative—and that was not an inappropriate societal imagery. In a way possibly innocent, not meant as an overt pointer to Ireland per se, these Irish models may have been found eligible because they were recent, grand buildings of related types and with similar social roles, part of Anglo-American society but not English, not pointing to allegiance to London. The most influential Americans still found an appeal in the "classism" of British classicism.

Then again, Ireland also might have held a more specific attraction. The Irish parliament briefly enjoyed an enhanced degree of legislative independence from Britain from the early 1780s with the repeal of the Declaratory Act, furthered by other advances and rumblings until the formation of the United Kingdom in 1801. (The American Protestant elite may not have been greatly troubled by the largely Protestant character of Irish institutions amid the predominantly Roman Catholic population.) Irish institutional buildings at this moment may thus have provided special models for others in the Anglo-American orbit meant to embody an element of independence from England but not fully overthrowing this genteel British social structure.

Latrobe, the Architectural Missionary

Latrobe arrived in America in March 1796 indoctrinated with a fervor for reform in architectural taste. With an almost missionary zeal, he championed changes already widely recognized in London at the cosmopolitan center of the Anglo-American cultural world. He could expect that the newly coined Americans, still placing their main cultural allegiance in that center and aware in varying degree of these changes decades in the making, would welcome him as an agent of this new dispensation whose triumph at the center surely licensed its succession over other values in the provinces. Latrobe was proud and confident of its superiority and inevitable attraction; he saw resistance as ignorance or irrationality, as the offspring of vested interests and minds closed to the advance of culture.

Latrobe embraced the role of transmitter of these new values to this country, confronting the more benighted architectural inclinations that reigned here—as they did in most places outside a few European centers. In 1806 he explained this to the members of Congress, recalling his reaction to the Capitol design when he first encountered it: "I frankly confess that, excepting in a few of the details, all my ideas of good taste, and even of good sense in architecture were shocked by the style of the building. I am well aware that in what I shall say on this subject I am probably in the minority. All the books for the last three or four hundred years up to 1760, are against me, and many that have been published since stand on the same ground. But as the arts continue to be improved, simplicity gains daily more admirers."[5]

Latrobe identified himself as part of a modern generation in the arts whose works bore the stamp of this new revelation (fig. 13). He identified especially with John Soane, the younger George Dance, and probably his own master, S. P. Cockerell, in architecture; he also admired the distilled outlines of artist John Flaxman and the laconic surfaces of sculpture by Antonio Canova. Simplicity and reason were the credos. To quote again from Latrobe's letter to the congressmen:

> A graceful and refined simplicity is the highest achievement of taste and of art. . . . Nothing is so easy as to *ornament* walls with foliage, with wreaths, festoons and drapery, with pilasters and rustic piers; especially if it be not required that these things should have the remotest relation to the purpose of the building on which they are carved, or that they should contribute to the real or apparent strength or convenience of the structure. And on this account we find ornaments increase in proportion as art declines, or as ignorance abounds.[6]

[5]Latrobe, "A Private Letter to the Individual Members of Congress, on the Subject of the Public Buildings of the United States at Washington," Nov. 28, 1806, ibid., 2:306.

[6]Ibid.

Fig. 13. Latrobe, architect, east pavilion, Hammerwood Lodge, East Grinstead, Sussex, England, 1792, photograph 1990. One of the two porticoed end pavilions that frame the garden front of Hammerwood, among Latrobe's earliest independent works. Note the severity of detail, the simplification of elements in the entablature, and the landmark appearance of early Greek Doric capitals modeled on examples at Paestum. *(Courtesy Michael Fazio and Patrick Snadon.)*

In 1804 he had mocked Thornton's design for the Capitol as overwrought, even in plan, stating that "the Doctor was born under a musical planet, for all his rooms fall naturally into the shape of fiddles, tamborines, and Mandolines, one or two into that of a Harp."[7]

Like those British architects he emulated, Latrobe preferred the solid, elemental stereometry of simple shapes and classical details writ large and clear against plain surfaces. Platonic forms were made manifest, as were each of the constituent decisions that made a whole. In his explanations to colleagues, clients, and the public alike, he predicated his choices of form less on refined tastes reinforced by a colluding genteel empathy than upon a certain rationalism, both as emblem and fact, that justified forms on grounds of use or structure.

It was in this spirit that Latrobe wrote, in the spring of 1805, that he was "very anxious to see a rational house built in Philadelphia." He suspected, though, that it would be "too much out of the common road to please entirely."[8] Pleasing was clearly not the main issue. He believed in progress in the arts. He felt that he brought something better than the locals knew, and that high art was no more a matter of popular enthusiasm than was science; artists led, proffering advances. In the modernity of his day, a basis in reason, visible and explicable, was presented as a validation of such advance.

Among Latrobe's architectural generation there was a taste for reason: reason justifying form in use or structure, even at the expense of familiar expectation and visual calm (fig. 14); reason justifying ornament that communicates and celebrates public ideals; reason manifest in the visibility of pure geometries, of cubes and spheres; and reason in an innocence objectified in simplicity. In Anglo-American buildings, simplicity rarely took the heroically singular shapes of French Revolutionary projects, most of them unexecuted, but was presented in assemblies of intact, elemental components and in regular reiteration—as contrasted to compositions more willfully imposed, melding and manipulating component parts and presenting graded hierarchical intervals in elevation or plan (fig. 15).

Like many of his architectural contemporaries, Latrobe called upon Gothic, Egyptian (fig. 16), and other anachronistic or distant vocabularies as languages of associational communication. Still, he remained fundamentally a classicist. His public and private buildings were the modern vanguard of a long continuity reaching back through the Enlightenment and the Renaissance to antiquity, one that portrayed the civic and civilized in classical forms and discipline. Cornices and orders and moldings remained, a classical ordering present even where simplified and amplified in scale

[7]Latrobe to John Lenthall, Mar. 8, 1804, ibid., 1:450.

[8]Latrobe to Joshua Gilpin, Apr. 7, 1805, Thomas E. Jeffrey, ed., *The Microfiche Edition of the Papers of Benjamin Henry Latrobe* (Clifton, N.J., 1976), 39/B6.

FIG. 14. Latrobe, "(Original) Sketch of a design for the house of John Markoe Esqr.," Philadelphia, 1808, Maryland Historical Society. The octagonal entry vestibule launches the distinctive projection in the facade. *(Courtesy Maryland Historical Society.)*

FIG. 15. Latrobe, "Elevation of the front of the Commandant's quarters to the East," Allegheny Arsenal, Pittsburgh, 1814, detail, Prints and Photographs Division, Library of Congress. *(Courtesy Library of Congress.)*

and set against stark surfaces, even where modernity led the designer to noncanonical and exotic languages of detail.

Latrobe and his peers found a coincident taste in the works of antiquity, particularly from ancient Greece. Most knew Greek models not through personal experience, but through the plates of Stuart and Revett's *Antiquities of Athens* and related publications, and through the emerging example of British work. In 1806 Latrobe wrote of "the chaste and simple buildings of the best days of Athens."[9] Their elemental stereometry betokened Western cultural beginnings in the natural logic of simple shapes, a modern primitivism that conferred a sense of renewal, that sense of the tabula rasa that recurs in discussions of this phase of neoclassicism. He also admired Roman buildings, particularly "the *immense size,* the bold *plans and arrangements* of the buildings of the Romans," but reviled what he found the unmeaning encrustation of late Roman ornamentation.[10] The scale, structural daring, and fit to use in the planning of Roman baths and theaters were widely influential and widely emulated in neoclassical designs of Latrobe and his contemporaries.

His *"principles* of good taste," however, were rigid, Latrobe declared in 1807; he was "a bigotted Greek." In a discussion frequently excerpted, he stated that whenever "the Grecian style can be copied without impropriety, I love to be a *mere,* I would say

[9]Latrobe, "A Private Letter to the Individual Members of Congress, on the Subject of the Public Buildings of the United States at Washington," Nov. 28, 1806, Van Horne, *Latrobe Correspondence,* 2:306.

[10]Latrobe to Thomas Jefferson, May 21, 1807, ibid., 2:428.

F<small>IG</small>. 16. Latrobe, "Details of the Library of Congress U.S. in the N. Wing of the Capitol Washington," ca. 1808–16, Prints and Photographs Division, Library of Congress. *(Courtesy Library of Congress.)*

a *slavish* copyist."[11] There are occasional designs in which he was quite literal in emulating Greek models, as at the Capitol's planned western Propylaea (see fig. 4) and the Second Bank of the United States (modeled on the Athenian Propylaea and the Parthenon). But Latrobe's architectural performance generally reads differently than one might expect from this credo; it does not resemble the episode dawning in the late 1820s, when all sorts of institutions were housed in Greek temples, though it may have helped create the rhetorical momentum for that. He qualified his copyism, he explained, because "the *forms,* and the *distribution* of the Roman and Greek buildings which remain, are in general inapplicable to the objects and uses of our public buildings."[12] The logic of function would determine form, and he loved nothing better than to find in that logic a formal solution that differed recognizably from what had come before.

This proud sense of new beginnings brooked no heterodoxy; it supplanted the earlier taste, as was evident in the works and words of his students Robert Mills and William Strickland. Mills recalled: "The example & influence of Mr. J[efferson] at first operated in favour of the introduction of the Roman style, into this country, and it required all the talents and good taste of such a man as Mr. Latrobe to correct it by introducing a better [one]. . . . His style was purely Greek, and for the first time in this country was it introduced by him in the Bank of Pennsylvania."[13] Strickland echoed this "correcting" of prevailing tastes. At night in Latrobe's office, he had "copied the Engraved plates and read the letterpress of Stuart's Athens, Ionian Antiquities &c; and was soon enabled, by contrasting these works with *Batty Langley, Swan,* & my father's *bench mate,* to discover the graceful forms of Grecian Architecture."[14]

As demonstrated in connection with Hoban's and Thornton's designs, mentioned earlier, Latrobe was often highly critical of other tastes. Jefferson, he explained to his assistant at the Capitol, "fishes everything" out of "the old French books."[15] In the same letter from May 1805 he referred to the colonnaded wings that Jefferson proposed for the White House as "exactly coincident with Hoban's Pile, a litter of pigs worthy of the great Sow it surrounds." A year earlier he had described Mangin and McComb's rising New York City Hall (fig. 17)—preferred to what he thought his own best design to date (fig. 18)—as "a vile heterogeneous composition in the style of Charles IX of France, or Queen Elizabeth of England."[16] His own design showed that large-scale

[11]Ibid.

[12]Ibid.

[13]Robert Mills, "The Architectural Works of Robert Mills," 1827, Tulane University Library, in Pamela Scott, ed., *The Papers of Robert Mills, 1781–1855,* microfilm ed. (Wilmington, Del., 1990), item 4004, p. 135.

[14]Strickland, autobiographical fragment [ca. 1825], J. K. Kane Papers, American Philosophical Society Library, Philadelphia.

[15]Latrobe to John Lenthall, May 3, 1805, Jeffrey, *Latrobe Papers,* 178/F13.

[16]Latrobe to Christian Ignatius Latrobe, Nov. 4, 1804, Van Horne, *Latrobe Correspondence,* 1:563.

Fig. 17. Joseph F. Mangin and John McComb, Jr., architects, New York City Hall, 1802–12, engraving 1828, by V. Balch after A. J. Davis. *(Courtesy Library of Congress.)*

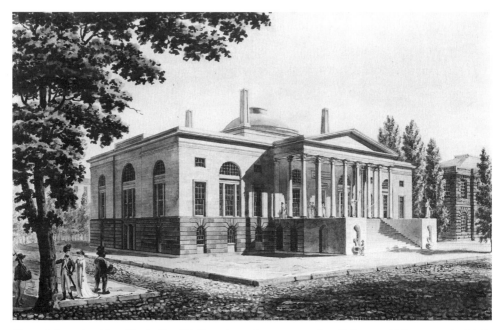

Fig. 18. Latrobe, New York City Hall project, 1802, perspective, Prints and Photographs Division, Library of Congress. *(Courtesy Library of Congress.)*

ordering of simple shapes and volumes that marks much of his best work, here as else-where serving as a foil for passages of sculptural but restrained classical detail.

Thornton responded to Latrobe's stinging criticism in kind, focusing on the sever-ity of his classicism. In 1808 the doctor skewered the laconic classicism of Latrobe's gateway to the White House grounds: "Instead of being adapted to the termination of a grand Avenue, and leading to the Gardens of a Palace, [it] is scarcely fit for a Stable Yard. Though in humble imitation of a triumphal Arch, it looks so naked, and dis-proportioned, that it is more like a monument [i.e., a funerary monument] than a Gateway; but no man now or hereafter will ever mistake it for a *monument of taste.*"[17] Others also mocked such severity, such as the senator who quipped that Latrobe's cenotaphs for the Congressional Cemetery (fig. 19), combining a cube and a shallow cone, added "a new terror to death."[18] But Latrobe was unbowed, and most public ar-chitecture soon followed suit—due to his direct or indirect influence, or to the example of modern European models. Even Thornton would soon come nearer this taste, as in his designs from about 1805 to 1816 for Tudor Place, the Georgetown house of Thomas Peter.

Latrobe was the most ardent and effective champion of this language of form; de-spite the inherited perimeter walls, the Capitol offered the opportunity for its most prominent and appropriate exposition, if mainly internally.

A Democratic Transparency

In a fundamental way, the new architecture that Latrobe brought, exercised, and de-fended was a more democratic expression than the architecture it displaced. This kind of design aimed at the analytical mind of the viewer more than at his genteel taste. Latrobe and many fellow architects strove to make their buildings accessible in intel-lectual terms, revealing their fit to function, the character of their physicality, and even of their overt ordering. Such a building sought to explain itself, and its constituent parts; Latrobe, for example, exploited the segmental geometries of structure in arches and vaults as tools provided by natural law (see fig. 20). The architect presented his discrete decisions as if confessing them, seeking absolution in the comprehension of some part of the public audience and in the enlightenment of another part. The building pre-sented itself less as the result of visual judgment rendering or transforming established

[17]William Thornton to Samuel Harrison Smith, editor of the *National Intelligencer,* Apr. 20, 1808, ibid., 2:600.
[18]A quip attributed to congressman (1869–77) and then senator (1877–1904) George Frisbie Hoar of Massa-chusetts, quoted in Thomas Froncek, ed., *An Illustrated History of the City of Washington* (New York, 1977), p. 175.

FIG. 19. Latrobe, architect, cenotaphs, Congressional Cemetery, designed ca. 1807–12. *(Photograph courtesy of Louise W. Carter.)*

types, of the unexplained exercise of taste and artistic talent, than as a kind of transparent mechanism, one whose form and surface the observer was invited to penetrate, to see through, so that the building revealed its means and purposes. But the designer's motive went beyond revelation and even invitation; the architect devised and manipulated form to celebrate rationality both in fact and in the imagery of elemental parts. Latrobe's buildings exhibited an almost unprecedented geometric idealism, presenting themselves as ordered assemblages of quickly grasped, fundamental shapes.

In the same vein, Latrobe was constantly trying to explain his design choices, to clients, collaborators, and the public—usually to defend his decisions, justify expenditures, or advocate a course of action, but sometimes simply to explore and explain the bases for form. He even wrote in 1812 of publishing "a collection of Essays in a convenient form on the principles on which public as well as private buildings ought to be constructed," but postponed the idea with the thought that it would not "make money either for the bookseller or author."[19] His words, prospective as well as retrospective, seem to reflect his own design processes, and the architectural result, though filtered and reshaped by his talent and taste, visibly reflected those reasoned predicates to form

[19]Latrobe to Joseph Delaplaine, Jan. 1, 1812, Van Horne, *Latrobe Correspondence,* 3:222.

Fɪɢ. 20. Old Supreme Court chamber, U.S. Capitol, 1816–17. *(Courtesy Office of Architect of the Capitol.)*

in ways that presented them to the inquiring observer. This transparency in his architecture, displaying motivating ideas behind solid forms, made his designs accessible to a wider public, not simply those who had refined their taste and honed their eye on proper Georgian models. In this accessibility and rationality there was more of democracy than in a taste based on a cultivated literacy and connoisseurship.

This transparency, of course, did not reign in this country alone, or even first. Was such architectural rationalism of the late eighteenth century also a more accessible language where it emerged—was it more democratic in London or Paris too? A tough question. In part, its appearance here was a coincidence of timing; Latrobe would probably have brought the latest from London no matter what that was, whether it suited the new democratic nation or not. But, somehow, in British country houses, town mansions, and grand London theaters, this kind of design seems to have represented the height of modern fashionability more than an invitation to a wider enfranchisement of architectural judging. The same, it seems, could be said about the Greek Revival in England versus the United States. The forms appeared there, and earlier in many cases. The content here, however, seems to have become different. In this country, this architectural language found its preeminent application in the work of Latrobe and his successors on governmental buildings. The political rhetoric and history associated

with them in the young republic seem to color the American examples distinctly as more transparent, more democratic.

Communal Grandeur as the Image of Democracy

Latrobe's was not the image of the Capitol that reigns today as the backdrop of the evening news, of Thomas U. Walter's commanding dome. That Capitol's richly plastic detailing and its relentlessly colonnaded wings strike notes of baroque centrality, of the potency of the nation's resources and its will. Embellishment pervades all architectural frames there, as if blanker forms would assign the poverty of the prosaic to the country's leading symbol and diminish its majesty.

Latrobe's designs for the Capitol dome and his Capitol building generally relied much less on sculptural elaboration as an index of social importance, but there were other expressions of communal grandeur in his design. Some came in the insistent—if thin and attenuated—embellishment of Thornton's elevations, retained by Latrobe through even the new parts of the perimeter. But in some of the superstructure and in his new interiors Latrobe also created grandeur by other means. He of course employed the fundamental grandeur connoted by rich materials and great size. The building also enlisted the grandeur of symbolism and association, reflecting the glow of great historical landmarks and episodes onto the new republic.

But Latrobe especially sought to invest it with a grandeur of modernity in its geometrically disciplined simplicity. In their large-scale ordering and shaping, in their implication of purpose in form, the restrained elements and surfaces demonstrated that they had been orchestrated by a guiding intelligence. They asserted that these solid features had been invested with intellectual rather than manual embellishment, that the institution was celebrated in the coin of heroic control rather than labored surfaces. Manipulation of light, brought in from unseen sources or concentrated for dramatic contrast, could be an accessory of such control; if that was, ironically, the opposite of intellectually transparent, focused on sublime effect rather than revealed means, it invoked yet another kind of grandeur.

These mechanisms of grandeur in Latrobe's Capitol differed from Walter's, and probably would not have been viable amid the reigning professional or popular architectural values of the 1850s. They were effective nonetheless, in their time, in endowing the building with the special rather than prosaic character essential to a building fulfilling such an important representational role. They served to monumentalize the simple, elevating that architectural transparency to a more symbolic level.

Class and Professionalism

The issue of democratic imagery, of course, inserts the issue of class, which ultimately haunts any discussion of Latrobe. He grew up something of an outsider to the stratified structure of British society. His father was the chief British official of the United Brethren, the Moravian Church; Latrobe was raised and educated in Moravian communities and seminaries in northern England and central Europe until his attraction to civil and military engineering led to his departure from the seminary at age nineteen.

This upbringing was unusual in two important ways: he was separated from his immediate family and society at large for much of his youth, instead residing, worshiping, working, and attending school with others of his age and gender within the Moravian community in a group called a "choir"; and he received an extraordinary education, with subjects like music, ancient and modern languages, drawing, higher mathematics, botany, and physics, that was the equal of a gentleman's private tuition. In adopting his profession as an architect and engineer, Latrobe (fig. 21) imagined setting himself up on an equal footing among gentlemen of taste and intellect, but his attainments and expertise constituted a distinctly limited entrée to fellowship and life on that plane. He had to ask his genteel clients for payment for his services, placing him on the level of a tradesman in a society that was decidedly not a meritocracy. He had been bred to intellectual tastes beyond his means or birth. He looked back on what he called his "erroneous education," something to which he attributed "all my unhappiness."[20]

In 1814 he explained to his son Henry that Henry was fortunate not to have been "educated in the absurdity, as I was, to believe it beneath a Gentleman to earn an honest livelihood."[21] Later that year he elaborated:

> How could a Man, whom his short stay at a Moravian school taught to consider wealth and honor as a vanity, . . . and whose constant association with German Noblemen till his 20th Year gave him the persuasion . . . that to support yourself by your own industry, was disgraceful; how could such a Man, deprived of an independent fortune expect to go thro' the World otherwise than I have done. Had I indeed been engaged in the same business in Europe . . . [rather than pursued] frothy reputation in these woods, I should not have wanted the means to live as I unfortunately was educated to live. My industry has indeed been unremitting, my talents sufficient for their employment, but my habits, and habitual sentiments, and modes of acting as well as [thin]king have been altogether ruinous.[22]

[20]Latrobe to Henry S. B. Latrobe, Dec. 31, 1814, ibid., 3:608.
[21]Latrobe to Henry S. B. Latrobe, Sept. 24, 1814, ibid., 3:573.
[22]Latrobe to Henry S. B. Latrobe, Dec. 31, 1814, ibid., 3:608.

FIG. 21. Charles Willson
Peale, *Benjamin Henry
Latrobe,* ca. 1804, White
House Collection.

Through his family, Latrobe had been introduced early into intellectual and literary circles in England and even found a degree of official patronage from Lord Barham and others; but the Reign of Terror in France and a change of British government soon rendered his democratizing political sympathies a liability that his talents might never have overcome.

In choosing to start over in the United States, where he had inherited extensive Pennsylvania land holdings through his mother's family, Latrobe may have felt he would find the landed basis of a gentlemanly existence. Upon realizing its insufficiency, if not before, however, he probably also had hope of finding the kind of society where expertise and talents would win and afford inclusion into that tier of intellectual and social life that he sought. His economic and professional struggles demonstrated that the new country was not all he might have wished. Thus, he responded to a prospective student in 1808: "I believe I am the first who, in our Country has endeavored and partly succeeded to place the profession of Architect and civil Engineer on that footing of respectability which it occupies in Europe. But I have not so far succeeded as to make it an eligible profession for one who has the education and feelings of a Gentle-

man, and I regret exceedingly that my own Son . . . has determined to make it his own."[23]

Much of the problem lay in Latrobe's own hunger for what he thought a gentlemanly standing. If this country offered lower barriers to social and intellectual participation, remuneration was even more a struggle in a profession not yet widely recognized or consulted by individuals building privately. Latrobe succeeded in establishing professionalism mainly with institutional clients, necessarily as an itinerant expert living in or near a half-dozen different cities in his American journey of two dozen years. The professional and social prerogatives and economic sustenance he sought were nearly always embattled.

As he wrote to his brother in November 1804, "in England the croud of those whose talents are superior to mine is so great, that I should perhaps never have elbowed through them. Here I am the only successful Architect and Engineer. I have had to break the ice for my successors, and what was more difficult[,] to destroy the prejudices which the villanous Quacks in whose hands the public works have hitherto been, had raised against the profession. *There,* in fact lay my greatest difficulty."[24]

To Latrobe, the United States was ultimately not just an opportunity of inherited lands and an escape from economic trouble and personal crisis. It was more of a hope, a response to his awkward position in English society and a sometimes ambivalent pursuit of a better one. At times it seemed to offer a more accessible path toward the association and social privilege enjoyed by an elite, at others the economic promise in the mechanism of meritocracy. When Latrobe put his faith in the latter, he placed emphasis on professionalism as a counter to class prerogatives, and he maintained his pedagogical inclination as the lever of reason over position in society, whether explaining to a client, a student, a friend, or even to himself. It was an almost totemic act of self-assertion and validation.

The Best and Worst Client

Work for the government provided some of the few opportunities to create the kind of architecture of which Latrobe dreamed: large-scale, strongly representational, with the kind of programmatic specificity that exercised an approach to rationalism in function and structure and promised demonstratively novel results. It offered the scale of building and permanence of materials that Latrobe found most noble and exciting

[23]Latrobe to Henry Ormond, Nov. 20, 1808, ibid., 2:680.
[24]Latrobe to Christian Ignatius Latrobe, Nov. 4, 1804, ibid., 1:563.

and the promise of employment in a young country where private commissions were sparse and difficult.

But this came at some cost, with various constraints and complications that Latrobe focused on retrospectively; in the end, he feared that the result at the Capitol still showed too much of "the difficulty overcome."[25] The main sources of difficulty were four, probably familiar in varying degrees to all his successors in office right up to the present. First, he had to work with an existing fabric and plan that was held inviolate in some respects, despite his critical response in matters of taste, logic, and solidity. Second, he was repeatedly frustrated by the political and bureaucratic figures reigning over the work, whether by their holding to contrary views on design and execution or by their insistent assertion of control. Third, his efforts were frequently hobbled by the unpredictability and piecemeal nature of funding, with annual cycles that meant late starts, that constrained the scope of a season's achievement; and that meant inefficient use of what were seriously scarce resources—appropriate materials and knowledgeable, cooperative workmen—in an economy largely unfamiliar with monumental masonry construction. But the fourth and most important and overarching issue was that of building for a democracy. Latrobe could have envied the patronage of a king or prince or other autocrat, whose buildings were often presented as his benefaction, however ultimately funded. In his dreams the architect might envision monies flowing directly, by fiat, as when dealing with a private client. That client might speak with a single voice, without the interference of intermediaries. And, if this is Latrobe's dream, that client might defer to his architect's professional expertise and taste and explanations.

A democracy, on the other hand, means spending what is more overtly the people's money. Charges of extravagance are always possible; popular taste can easily collide with leadership by an artistic elite; expenditures are often impeded by bureaucratic defenses against potential diversion of funds, disapproved preferences, or independent design initiatives. Partisanship can turn an architectural decision into a political football. The many voices of Congress may involve themselves, exercising real power even where ostensibly outside the direct chain of authority. Figures in power change with elections: Latrobe worked for three presidents whose inclinations and levels of involvement differed. (The recently retired architect of the Capitol, George White, worked for six.) Such wide involvement and scrutiny can erode and impinge upon what an architect regards as his proper professional prerogatives in matters of design and execution.

This is what finally led Latrobe to resign in November 1817, after years on the brink. At various points he had submitted to compromises and contravention, surren-

[25]"Memoir of Benjamin Henry La Trobe," *Repository of Arts* (London), 2d ser. 11 (1821):31–32, where it was called "la difficulté vaincue."

dering elements of his aesthetic vision and ultimately the Capitol's crown, the domed center, leaving little of his work visible from outside. But he found other consolations for what he called in May 1812 "the many mortifications which are inseparable from the practice of my profession."[26] One can still find Latrobe's mind in the interiors of the two original wings (fig. 20), amid the works of his predecessors and his successors. In those surviving spaces executed from his designs, he was able to play out his vision with striking boldness and adherence to his guiding architectural ideas in ways that are still aesthetically articulate today.

The Thing Itself, Sent Out into "the World"

Among all the tasks that his professional roles placed upon him, that which Latrobe found most rewarding was conceiving the thing itself, shaping form and rendering that in the material stuff that could inhabit the real world. Designs seem to have come with ease, and his adeptness at drawing provided a fluent language for articulating and refining them. His drawings indulged a lifelong interest in the natural science of the behavior of solids and volumes in light (fig. 22) as Latrobe, still the Moravian student observing the rules of nature, captured stereometry in orthogonal conventions, perspective, and shading (fig. 23). His architectural forms are idealizations, the image of an underlying order, sent out into "the world," the latter in the sense that Quakers and the Amish have made this usage familiar.

This was often no easy process, demanding assertive and defensive exertions, but Latrobe recognized their integral necessity in his chosen profession, and he embraced the gamut of tasks and expertise by which his imaginings would reach social and physical realization, whether matters of craftsmanship or contractual language, costs or appropriate building materials, persuasion or political maneuvering, structural innovation or appropriate symbolism, compelling delineation or personnel management. The extent of this commitment was reflected in the result. More than almost any other architect's, Latrobe's designs transport abstractions into matter without diminishing them; in their physicality they become more evocative of the sustainability of the ideal. He was not trapped by the two dimensions of his paper's surface, nor by lines in place of solid. Matter obeys and gives conviction to the elemental forms invoked by the architect, making it clear that the idea reigns. Tectonics and acoustics obey natural laws as well; Latrobe insistently portrayed them in segments of circles that reinforced the projected image of a pervasive rationality in nature.

[26]Latrobe to Henry Clay, May 15, 1812, Van Horne, *Latrobe Correspondence,* 3:294.

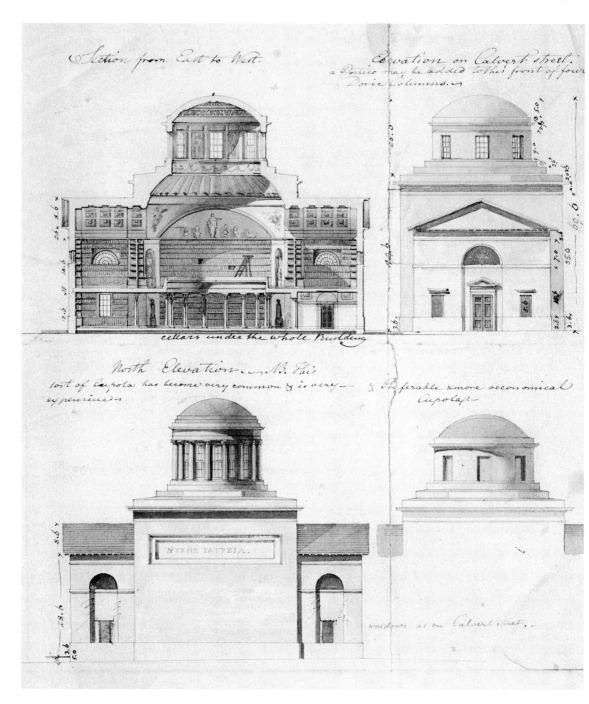

Section from East to West.

Elevation on Calvert Street.
a Portico may be added to this front of four Doric columns.

cellars under the whole Building

North Elevation. NB. This sort of Cupola has become very common & is very — expensive

3 Preferable & more oeconomical Cupolas —

ΨΥΧΗΣ ΙΑΤΡΕΙΑ.

windows as on Calvert Street. —

Fɪɢ. 22. Latrobe, "Sketches of a design for the Library of Baltimore," 1817, detail, Maryland Historical Society. *(Courtesy Maryland Historical Society.)*

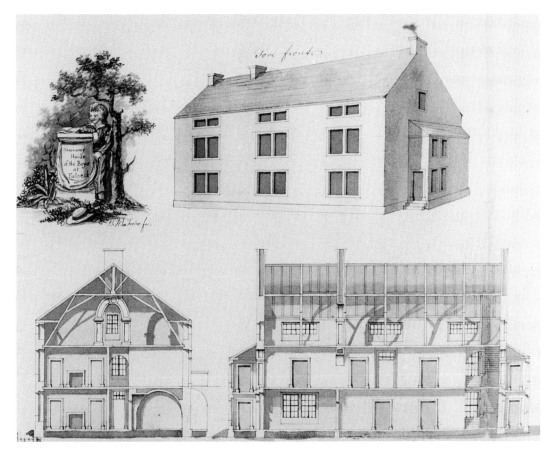

FIG. 23. Latrobe, "Oeconomy House of the Boys at Fulneck," ca. 1784, detail. *(Courtesy Archiv der Brüder-Unität, Oberlausitz, Germany.)*

At its heart, this remained a rather crystalline endeavor. Like many of the best neoclassical designs, his resolved their various desiderata in a proud apartness (fig. 24). The architect resisted external theatricality and ostentation; people were meant to come to the building on its terms, to see into its internal logic, to choose to enter a purer sanctuary.

But Latrobe recognized the reign of "the world." And in his last years—as in his second campaign at the Capitol, when one compares it to his first—there is more of a sense of meeting social and decorative expectation, a greater intensity of architectural and symbolic features, and a stronger role for embellishment in colors and furnishings (fig. 25). His geometry becomes less unitary, his treatment of lighting more intricate and dramatic. If that seems an incremental retreat from some of his ideals, perhaps we admire the purism from afar, the image of democracy in intellectual transparency

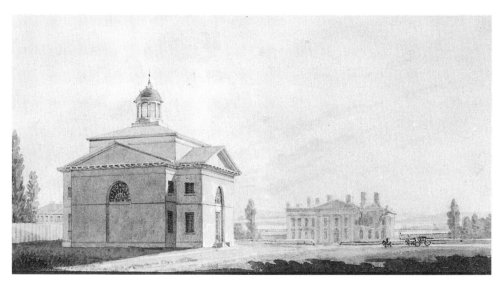

Fig. 24. Latrobe, "St. John's Church in the city of Washington, with the President's house as it appeared in 1816, when the Church was built," ca. 1817, St. John's Church, Washington, D.C. *(Courtesy St. John's Church.)*

Fig. 25. Samuel F. B. Morse, *The Old House of Representatives,* 1821–23, Corcoran Gallery of Art, Washington, D.C. *(Courtesy Corcoran Gallery of Art.)*

more than the dynamics of popular preference, and applaud the artist's elitism. For Latrobe, though, he was simply meeting another challenge to the quiet realm of platonic nature by the hurly-burly of worldly forces, another gauntlet form must pass to become architecture, another step by which the cleric's son and one-time seminarian entered "the world."

Charles Bulfinch

Well-Connected, Refined Gentleman Architect

Pamela Scott

On January 28, 1818, the painter John Trumbull wrote his friend of thirty years, Charles Bulfinch: "Your letter of the 19th points to me precisely the Situation in which I imagined you would find yourself, on your arrival in Washington, surrounded by every possible diversity of opinion, interest, and prejudice." Between mid-September 1817 and early January 1818, Bulfinch had negotiated for the position of architect of the Capitol. He must have realized that the job he contemplated undertaking had a contentious history. The incumbent, Benjamin Henry Latrobe, the fifth architect since 1793, was being driven away by political maneuvers, partially occasioned by his own behavior, rather than because of incompetence. On January 7, 1818, Bulfinch had an audience with President James Monroe. He reported to Mrs. Bulfinch: "He entered fully on the subject of the public buildings, and without mentioning the particular causes of offense with the late architect, clearly evinced that he was not satisfied with his conduct or plans, while he gave him credit for professional skill."[1]

Bulfinch chose to leave New England because completing the Capitol offered him greater sustained financial security than the increasingly competitive Boston architectural scene. What honors finishing the Capitol would add to his already considerable

[1]John Trumbull to Charles Bulfinch, Jan. 28, 1818, John Trumbull Papers, Manuscript Division, Library of Congress, Washington, D.C. (DLC); Ellen Susan Bulfinch, ed., *The Life and Letters of Charles Bulfinch, Architect* (Boston, 1896), p. 212.

reputation must have seemed problematical in January 1818, when he walked among the throng of workmen busily finishing architectural spaces that he had not designed and of which he did not wholly approve. Bulfinch's architectural principles, as well as his methods of dealing with people, differed considerably from those of his predecessor. During the next twelve years he was answerable to three presidents and their cabinets, two commissioners of public buildings, and at least twenty-eight congressional committees composed of dozens of legislators. All of these officials had opinions about how the Capitol should be completed; there certainly was no consensus among them. Rather, they fell loosely into two groups: those who conceived of the Capitol as integral to the federal government's national and international prestige and those for whom architectural elegance was costly ostentation and, therefore, offensive in a republic.

Bulfinch's background prepared him for the difficult task of responding to both factions. He differed considerably from his near contemporary Latrobe, a brilliant but volatile genius with an excellent pan-European education who pushed forward radically new architectural ideas in America. Bulfinch, born into a cultured and conservative New England Federalist family, was not educated to be a professional architect and engineer but a gentleman whose avocation was architecture. From the 1780s on, he had had considerable success designing elegant public and private buildings in wood, brick, and stone with a delicate sensitivity that satisfied contemporary upper-class canons of good taste. Bulfinch's professional dealings seem to have been characterized by equally acute social sensibilities. When he first received news in September 1817 that Latrobe might resign his position, he wrote his correspondent William Lee, an auditor at the Treasury Department originally from Massachusetts: "I have always endeavoured to avoid unpleasant competition with others, that my opposing their interest would excite enmity and ill will. I should much regret to be an instrument of depriving a man of undoubted talents of an employment which places him at the head of his profession and which is necessary to his family's support."[2]

Upon learning that Latrobe had actually resigned, he wrote President Monroe on November 26, 1817, stating his qualifications: "Having resided from my youth in my native town of Boston & received an education at our University [Harvard], I had an early opportunity to gratify a strong partiality for the study of architecture by an extensive tour in England, France & Italy. By the partiality of my townsmen, I have been employed in most of their important public works for nearly thirty years past, during which time I have been annually elected to superintend the municipal affairs of the town."[3]

[2]Bulfinch, *Life and Letters,* pp. 200–201.
[3]Charles Bulfinch to James Monroe, Nov. 26, 1817, Record Group 42, National Archives and Records Administration (NARA).

Bulfinch's modest précis of his dual capabilities as distinguished American architect and seasoned politician, combined with his innate understanding of American tastes and traditions, was calculated to appeal to Monroe. Whether justified or not, Monroe and other Washington political figures blamed the Capitol's halting progress on Latrobe, famous for his contentious behavior toward his colleagues and friends as well as his enemies. Bulfinch's conciliatory attitude toward Congress and the presidents under whom he served accounted for much of his success in Washington. It also directly affected his architectural decisions, frequently with unhappy results.

Bulfinch did not fight for his preferred design solutions; rather, he presented possibilities and recommended one course of action. He then left the ultimate decisions to elected officials and carried out their orders. Yet Bulfinch's long experience of dealing with groups making decisions, combined with his anomalous position—responsive to the legislative branch but answerable to the executive—schooled him in a subtle persuasive technique.

In January 1821, when he had to report on the vexing question of poor acoustics in Latrobe's House of Representatives, Bulfinch wrote his kinsman John Coolidge: "Some members complain that they can neither hear nor be heard. This, in most instances, arises from their own defects of voice or hearing, for no room of its vast size and height would accommodate them better. . . . The committee called on me, and I was obliged to appear ready with my advice, and to act as they should direct, but you will discern that the report discourages the alteration, and this will be the decision."[4]

In fact, on January 10, 1821, Bulfinch sent Rep. Silas Wood, a New York Democrat, three solutions to the House's acoustical fault; he recommended a flat glass ceiling suspended from the top of the entablature at a cost of five thousand dollars. As Bulfinch predicted, no action was taken, but there were later repercussions.[5]

Reconstructing many aspects of Bulfinch's decade-long tenure as architect of the Capitol is difficult because his reports most often stated where the money went, rather than explaining his architectural decisions. Latrobe's correspondence is a valuable record of his architectural attitudes, as well as a window on the political processes of how public works in this country were accomplished. Would that there existed a similar sustained exchange of ideas between Bulfinch and one of his contemporaries. Bulfinch may never have written fully about his architectural principles because they were predicated on current ideas of convenience and good taste readily understood by and acceptable to his contemporaries. Latrobe, on the other hand, was actively lobbying for a radical change in taste among his educated public clients.

[4]Bulfinch, *Life and Letters,* pp. 238–39.

[5]U.S. House of Representatives, *Documentary History of the Construction and Development of the United States Capitol Building and Grounds,* 58th Cong., 2d sess., 1904, H. report 646, pp. 236–37.

A handful of letters to and from Trumbull, matter-of-fact reports to Congress routed via the commissioner of public buildings, a few stray letters sent directly to congressional committees or written by their members, and excerpts from John Quincy Adams's diaries provide us with a sketchy idea of Bulfinch's modus operandi but little knowledge about his architectural decisions at the Capitol. His precise, linear drawings recording the facts of their alterations and additions require careful study to understand, a decided contrast to Latrobe's three-dimensionally instructive watercolors.

Completing the "center building"—the domed rotunda and a projecting west wing that overlooked the Mall—was Bulfinch's mandate. His tour through the Capitol's two wings on January 8, 1818, calmed his initial anxiety after viewing Latrobe's "beautifully executed" drawings for completing the Capitol in the "boldest stile." After actual examination, Bulfinch judged that the subsidiary spaces were "intricate and dark," giving an overall "sombre appearance." If the work of rebuilding the wings had not been so far advanced, he would have designed them anew. Bulfinch never understood that Latrobe's intricate web of vestibules, corridors, and anterooms was calculated to make a small building seem large. "As to the centre building, a general conformity to the other parts must be maintained. I shall not have credit for invention, but must be content to follow in a prescribed path: as my employers have experienced so much uneasiness of late, they are disposed to view me and my efforts with complacency."

Bulfinch eventually followed Latrobe's general organization of the center building, erecting the east and west porticos as Latrobe had designed them with only minor modifications to the west portico. Latrobe chose the position of the Library of Congress along the front of the west wing, but its architectural character was decidedly Bulfinchian. Certainly Bulfinch left his own distinctive stamp in the rotunda and dome.[6]

The difference between his and Latrobe's superintendence of the Capitol is reflected in Bulfinch's first report written on February 5, 1818, less than a month after his thorough inspection of the existing work. Nineteen years of administrative experience as chairman of Boston's selectmen, as well as his many commissions for public buildings in New England, undoubtedly prepared Bulfinch for the concise marshaling of salient facts designed to appeal to busy legislators. In a short introduction he noted the state of affairs at the Capitol as he had found them and promised several alternate designs for the center building, from which Monroe could choose the final plan. In response to congressional complaints that there were not enough offices and committee rooms, Bulfinch designed a temporary one-story building, "on the east of the Capitol square," that contained twelve committee rooms. Its cost of $3,634 indicates what its character must have been; the appropriation passed on April 20, 1818.[7]

[6]Bulfinch, *Life and Letters,* pp. 213–14.
[7]*Documentary History of the Capitol,* pp. 201–2.

Some minor correspondence concerns Bulfinch's alternate designs for completing the center building. His initial response to the daunting task of constructing the Capitol's proposed ninety-foot rotunda and covering it with a masonry dome was to suggest eliminating it altogether. He broached replacing the circular room with a vestibule and a rectangular picture gallery in a lost letter written to John Trumbull on January 19, 1818. The artist had recently been working with Latrobe on how best to display within the rotunda his commissioned cycle of history paintings that recounted the Revolutionary era's great civic and military events. Trumbull's response to Bulfinch was immediate; he favored the rotunda because he wanted his most important works to be prominently displayed in the Capitol's actual and symbolic centerpiece, the "Hall of the People," as Latrobe had labeled it on a drawing made in 1806.[8]

The kind of congressional attitudes that Bulfinch encountered, and his response to them, is revealed in a letter he sent Trumbull on April 17, 1818, in which he recounted his "state of uncertainty, respecting the temper of Congress, and the plans that would be adopted":

> I prepared drawings of the entire building with the rotunda, one with the floor entire, another with a circular opening in the floor of 40 ft. dia'r, forming a spacious gallery 25 ft wide all round, supported by a circular colonnade, & another plan according to your idea. These drawings were exhibited to the president, who could devote but a few minutes to their consideration, but referred them to the Committee of Congress. This Committee commenced with a declaration, that enough of the building had been devoted to show and parade, to passages & vestibules, and that unless they could be convinced that all the conveniences of Committee rooms & offices could be obtained, they would not sanction an appropriation for the centre; & moreover that if these rooms will not be had in any other way, the rotunda should be cut up for this purpose.[9]

The chairman of the Committee on Public Buildings in 1818 was Henry St. George Tucker of Williamsburg, Virginia, whose claim to fame during his four-year term in the House was to vote in 1816 against an increase in the salaries of members and to refuse to accept his when the law was enacted. Presumably this economy-minded man was the head of the congressional committee to whom Monroe deferred and with whom Bulfinch dealt. Almost invariably Bulfinch closed his reports by noting, "and the expense has been kept within the estimates." When expenditures did exceed his expectations, it was never due to design changes, as it had been with Latrobe.

The surviving visual record of Bulfinch's several proposals for the center building consists of contemporary engravings, some Bulfinch drawings, and a few sketches by

[8]John Trumbull to Charles Bulfinch, Jan. 28, 1818, Trumbull Papers, DLC.
[9]Charles Bulfinch to John Trumbull, Apr. 17, 1818, ibid.

Trumbull. An engraved elevation of the east front (fig. 1) done by the English archi-tect Charles A. Busby in 1822 is the only view of one of Bulfinch's 1818 proposals for finishing the center building's exteriors. Busby apparently copied a Bulfinch drawing he saw while on an American tour in 1819. Busby's engraving demonstrates Bulfinch's stylistic retrenchment, as the Capitol's architect was proposing a self-contained variant on William Thornton's arcaded east portico of 1793 (fig. 2), in preference to the wel-coming, monumental staircase and expansive portico designed by Latrobe and Jefferson in 1806 (fig. 3). Yet, as we know, the Latrobe-Jefferson portico was built in 1823–24 under Bulfinch's superintendence.

In a second engraving, a plan of the main floor (fig. 4), Busby oriented the Capitol incorrectly, confusing north and south for east and west. In other respects, Busby's plan was accurate. Its rotunda, labeled "Grand Vestibule for Great Public Occasions," corresponds with Bulfinch's description of one of his three proposals made in the spring of 1818. It depicts a forty-foot-wide hole in the center of the rotunda, seemingly a daring spatial interpenetration of the crypt, rotunda, and dome. In actuality it would have allowed Bulfinch to build substantial walls in the crypt underneath the hole's edges to support the rotunda floor. Both the engineering and construction of the crypt's light and airy forest of columns as executed (fig. 5), so reminiscent of Sir Christopher Wren's crypt (fig. 6) beneath the crossing of St. Paul's Cathedral in Lon-don, were more difficult, time-consuming, and expensive.

The spatial intricacy of the present crypt and the complex engineering of the three rings of slender columns carrying elliptical groin vaults to support the rotunda floor reflects Latrobe's spatial sensibilities more than Bulfinch's decorative ones. No Latrobe drawing survives showing this or a similar arrangement for the crypt. On January 18, 1820, Bulfinch estimated the cost of "preparing and setting stone work now on hand for the east wall and walls of western projection, and colonnade of lower rotunda [crypt]" to be $15,600. Again, shortly after Busby copied a drawing showing Bulfinch's economical scheme, a probable design by Latrobe, more expensive and architecturally more impressive, was begun under Bulfinch's superintendence.[10]

Particularly noticeable on Busby's plan is the disparity between the complex geo-metric puzzle of Latrobe's main block with the simplicity of Bulfinch's blocky rooms, not yet fully articulated. The qualitative difference between Bulfinch's low-cost pro-posals for finishing the building and Latrobe's much-admired legislative chambers was recognized by Henry Meigs of New York, a Democrat who was trained as a lawyer at Yale. As chairman of the House Committee on Expenditures on the Public Buildings in 1819–20, Meigs reported to Congress March 21, 1820, the results of his

[10]*Documentary History of the Capitol,* p. 228.

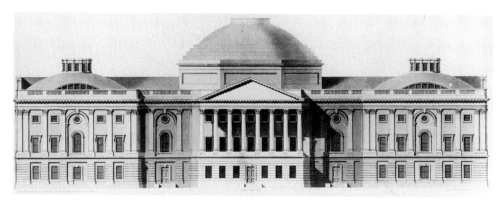

Fig. 1. Charles A. Busby, "The Capitol at Washington," 1823. *(Courtesy Library of Congress.)*

Fig. 2. William Thornton's winning design of the U.S. Capitol's east front, published on Robert King's "A Map of the City of Washington in the District of Columbia," 1818. *(Courtesy Library of Congress.)*

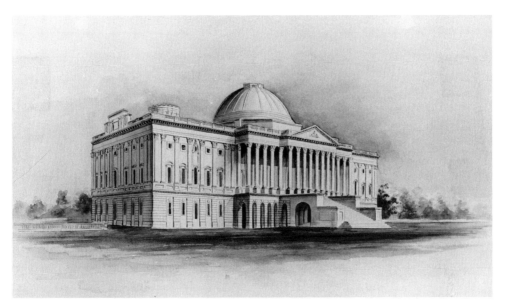

FIG. 3. Charles Bulfinch, perspective of the U.S. Capitol from the southeast, 1828. *(Courtesy Library of Congress.)*

committee's investigation of the Capitol's costs from 1815 to 1820. One million dollars had been spent to repair damages caused by the fire of August 1814. While charged with keeping the expenses for completing the Capitol low, Meigs realized that there could not be too great a disparity of architectural character between the wings and the center building. He noted:

> The committee have endeavored to make themselves acquainted with the general character of the work which is designed to be bestowed upon the centre building of the Capitol; and it appears to them that it cannot properly be conducted with less attention to ornament than is designed, without injury to that fitness of parts which becomes a whole; and they are pleased to find that the principal ornament of the centre work will not consist of expensive sculpture, but of its simple form—the rotundo.[11]

Busby's plan does show Bulfinch's indisputable signature column arrangement for his proposed freestanding west portico—two sets of double columns flanking single central ones. Latrobe had suggested a recessed portico to provide a balcony off the Library of Congress; it was built by Bulfinch instead of the projecting portico illustrated by Busby. If Busby's engravings are what they seem to be, prints copied from Bulfinch drawings acquired through authoritative channels, they indicate that a very economical plan for completing the Capitol was either approved or the favorite in 1818–19,

[11]Ibid., p. 231.

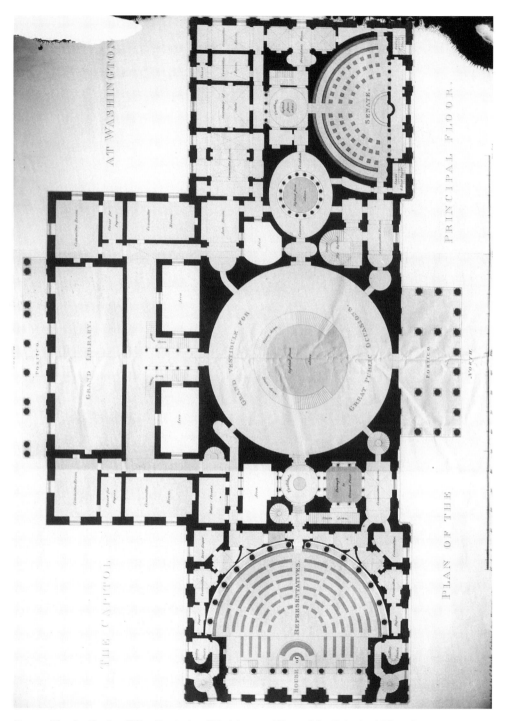

F<small>IG</small>. 4. Charles Busby, "The Capitol at Washington. Plan of the Principal Floor," 1823. *(Courtesy Office of Architect of the Capitol.)*

Fig. 5. Benjamin Henry Latrobe and Charles Bulfinch, "Crypt of the Capitol," ca. 1815–23. *(Courtesy Library of Congress.)*

Fig. 6. Sir Christopher Wren, crypt of St. Paul's Cathedral, London, 1675–1711. *(Courtesy the author.)*

but rescinded very shortly thereafter. It should be noted that only one copy of the Busby elevation survives, and his plan is known only from a photograph of it that was published by Glenn Brown in the first volume of his *History of the United States Capitol* in 1900. Possibly Busby sent Bulfinch an early printing of the engravings, and, when informed that they were incorrect, suppressed other copies.

The central unanswered question about Bulfinch's surveyorship of the Capitol revolves around the contradictory evidence of the Busby engravings, congressional reports, and the building's actual fabric. When was Latrobe's basic scheme for the exterior reinstated and by whom? Minor variants on Latrobe's design may have been among Bulfinch's alternates shown to Monroe that were then referred to the congressional committee. During congressional debates, the recommendation of frugality by the Committee of Public Buildings may have been challenged. Monroe and his cabinet may at a later date have had more time to review Bulfinch's designs. Bulfinch may have sought Monroe's support against Congress. There are several possible scenarios with no written evidence from which to draw informed conclusions. Monroe's scanty papers do not address the issue; the published *Debates of Congress* do not record the decision, nor do Bulfinch's and the committee reports. None of Secretary of State John Quincy Adams's diary entries in 1818 or 1819 mention discussion of the Capitol's design and construction during cabinet meetings.

Bulfinch's report to the House Committee on Public Buildings of February 9, 1820, does establish a *terminus ante quem.* He noted that the "external appearance [of the west wing] is substantially preserved" according to Latrobe's design. The importance of maintaining the Capitol's outward appearance may have been because prints had already been published showing Latrobe's east portico. To deviate again from the Capitol's known design would have caused comment at least, and may even have led the public to question the federal government's efficiency.[12]

The major thrust of Bulfinch's first report, written on February 5, 1818, set the pattern for his future ones: a long, detailed estimate of how $177,803.46 would be spent to complete the north and south wings. Bulfinch had no interest in emulating Latrobe's numerous attempts in his reports to educate congressmen in the proper taste in contemporary architecture. Explication of the Capitol's physical progress, and its cost, took precedence over intellectual and aesthetic theorizing. On January 28, 1818, the Senate had voted to require an annual statement of expenditures on public buildings. The House Committee on Expenditures on Public Buildings had been formed in 1816; in 1819 it was chaired by Democratic Rep. George Tucker of Virginia (cousin of

[12]Ibid., pp. 226–27.

Henry St. George Tucker), the published author on finance and economics whom Thomas Jefferson later appointed the first professor of moral philosophy at the University of Virginia. This select committee was joined in 1819 by the newly formed House Committee on Public Buildings. In 1826, a third House committee was established, its name indicative of increasing impatience: the Committee on Finishing and Furnishing the Public Buildings. The Joint Committee on the Library, in existence since 1806, was interested in the design for the Library of Congress, as well as artworks for the Capitol. The House Committee on Appropriations, of course, controlled the purse strings.

How much influence these committees, or their key members, actually exerted is difficult to assess. Those created specifically to oversee the public buildings were primarily composed of first-term congressmen, an indication of their low priority, perhaps because their function was primarily advisory. The president made the final decisions concerning the Capitol's design; Congress funded the work. Bulfinch assiduously responded to the concerns of these committees; repeatedly economy was their credo. Time after time Bulfinch gave them inexpensive alternatives, yet either medium-priced or expensive solutions were actually built, probably to maintain the Capitol's overall character established by Latrobe and to avoid public criticism.

Satisfying congressional space needs was one of Bulfinch's first priorities. He explained his solution and its genesis in his April 17, 1818, letter to Trumbull. Bulfinch included in the letter a now-famous pencil sketch (fig. 7) showing his idea of a sub-basement for the Capitol's west wing, subsequently exaggerated in several prints.

> These threats [of cutting up the rotunda for committee rooms] put me upon my exertion, and I have contrived to make 30 Committee rooms, besides a Court room & offices connected, & a library & reading rooms above. I obtain these rooms in part by sinking the Centre one story—it projects 70 feet from the wings, and as the ground falls rapidly, this advantage may be easily gained, as Glacii of turf on each side will fall to this level in face of the wings. I think that the effect will not be bad, that it will give greater boldness to the west front, which is seen at a great distance on the avenue, & the projection falling lower than the wings, will give an artificial perspective to the receding parts. I intend that this basement story, which will be 18 ft high, should be plain, of square blocks of Granite prepared in Boston, with bold rusticated windows. The color of this stone, white, rather with a bluish tinge, will keep the line of the yellow freestone above unbroken.[13]

Bulfinch went on to describe one of the Capitol's greatest lost treasures:

[13]Charles Bulfinch to John Trumbull, Apr. 17, 1818, Trumbull Papers, DLC.

I found it so difficult to convey correct ideas of such a complicated building by plans, that I availed myself of the services of an ingenious young man from Boston who I found was at Baltimore, to have a model of the building in wood. His employees allowed him to be with me 3 weeks, in which time he built a model about 4 feet in length, and in correct proportions. It exhibits the different facades that have been proposed by Dr. Thornton & Mr. Latrobe, gives a section of the rotunda and dome, & exhibits the different stories of the west projection. I find that it has been of material service—it has been seen by the President, & I believe nearly all the members of Congress; it conveys a correct notion of the design at a glance, & I believe has been satisfactory, in convincing them that I understand what I am engaged in.[14]

Apparently the young man from Boston was Solomon Willard, although he was thirty-five years of age at the time, twenty years younger than Bulfinch. There is a record of payment to Willard for a model. However, shortly thereafter, a "Mr. Russel" toured models in the southern states during the winter of 1822–23. The *Charleston Courier* reported on January 9, 1823: "Mr. Russel still continues his Exhibition of MODELS of the Capitol, and Public Buildings of Baltimore, at 123 Church-street."[15]

Bulfinch's model was not the first to be made to explicate the Capitol's complex internal-external relationships. In November 1794 Stephen Hallet reported that during the previous three months he had privately hired one of the Capitol's French stonecutters and the plasterer Giuseppi Provini to make models to show how "to procure Light and air into the Cellars."[16] Hallet's models seem to have been made for his own study. Bulfinch, on the other hand, quickly understood that a model was worth ten thousand words when it came to explaining the three-dimensional problems of connecting the rectilinear wings via a circular element and, at the same time, creating thirty-six committee and office rooms, courtrooms, and a library for Congress on sloping ground.

The two points where the three wings came together on the west required additional strengthening because of the declivity of the hill. In 1820 Congressman Meigs explained why Bulfinch put double pilasters on the inside corners of the west wing walls. They changed the rhythm of the adjacent north and south walls by pushing the window bays westward and terminating the west wing's outside corners with single pilasters. This was an error according to the classical language of architecture that Latrobe would never have countenanced.

The committee think proper to suggest to the House, however, that, as it is contemplated to form the dome of the centre of brick work, in imitation of the Pantheon at

[14]Ibid.
[15]*Charleston Courier,* Jan. 9, 1823.
[16]Stephen Hallet to Thomas Johnson, Nov. 24, 1794, RG 42, NARA.

FIG. 7. Charles Bulfinch, sketch of the west front of the Capitol in a letter addressed to John Trumbull, April 17, 1818. (*Courtesy Library of Congress.*)

Rome, and as such work will, when added to the great weight of the edifice, require the most serious attention to the foundations of the whole edifice to secure its safety, and as, from the examination which the committee have had occasion to make, they feel convinced that these foundations require attention, it is worthy the consideration of the House whether effectual means should not be taken to give perfect security, especially on the westerly side of the edifice, by means of walls of sufficient weight and compactness to counteract the apparent tendency of damage to the Capitol in that direction.[17]

In April 1818 Bulfinch expressed to Trumbull his uncertainty of how the subbasement would be received and sought some historical justification for it. He wrote: "I am almost afraid to ask your opinion of this basement, because it was a recourse of necessity, and cannot be disposed with, but if you can recollect any precedent that will warrent it, I will thank you to inform me, even if I lose by it all claim to originality." Trumbull's reply was reassuring, congratulating Bulfinch for extricating himself from the "multitude of contradictory projects with which you was [sic] surrounded." The painter could offer no precedent for the basement but felt that the "necessity of the case justifies the novelty; and nothing can be easier than to disguise it by what the English call *planting it out,* that is, screening it from distant view by shrubs." Eight years later Bulfinch's terrace design that masked the subbasement was approved.[18]

The end of the short correspondence between Bulfinch and Trumbull in 1818 closes the best unofficial window on the architect's motivations and interactions with official Washington. With few exceptions we must depend on Bulfinch's and committee reports to piece together the important history of the rotunda and dome's design and construction. By November 19, 1820, Bulfinch was able to write: "The walls of the rotunda have accordingly been commenced, and give an opportunity of viewing the style and manner in which it will be finished." His description on December 6, 1823, of the rotunda after it was finished provides one of the few clues to his architectural intentions at the Capitol.[19]

In the rotundo, a bold simplicity has been studied, suitable to a great central entrance and passage to more richly finished apartments. This room is ninety-six feet in diameter, and of the same height; its walls are divided into twelve compartments, by stone pilasters, or Grecian Antae; four of these compartments are occupied by doors, and the others by pannels to receive paintings. The Antae support a Grecian entablature, decorated with Isthemean wreaths in the frieze, apparently in honor of the subjects of national history to be exhibited below.[20]

[17]*Documentary History of the Capitol,* p. 231.
[18]Charles Bulfinch to John Trumbull, Apr. 17, 1818, and John Trumbull to Charles Bulfinch, July 25, 1818, Trumbull Papers, DLC.
[19]*Documentary History of the Capitol,* p. 234.
[20]Ibid., p. 257.

Wreaths in the entablature based on those of the Choragic Monument to Thrasyllus, published in Stuart and Revett's *Antiquities of Athens,* were the Greek source of this motif; why would Bulfinch note what they "apparently" signified if he had chosen them? Certainly from what we know of Bulfinch's amenable nature, he might have readily accepted suggestions from a wide variety of people.

Bulfinch's original design for the rotunda was closer to his ideal of "bold simplicity" than the executed version, as decorative and allegorical sculptural panels were gradually added. On July 8, 1822, Bulfinch expressed some of his ideas about the rotunda's decoration: "I have long considered that it would be suitable to the purposes of the building, to have 2 tablets in the interior of the Rotundo, in the panel over the east & west doors, one to represent, either the discovery of America by Columbus, or which I should prefer, the landing of Capt. Smith in Virginia; & the other, the Declaration of Independence, or the adoption of the Federal Constitution."[21] Additional sculptural works were suggested by congressional committees who responded to a variety of stimuli.

At the beginning of the 1822 building season, Bulfinch was ready to raise the dome above the rotunda. Official accounts are mainly concerned with a discussion of the materials. On March 25, 1822, Samuel Lane, the commissioner of public buildings, sent William S. Blackledge, a Democrat from North Carolina and the chairman of the House Committee on Public Buildings, Bulfinch's estimate of the difference in cost between erecting a brick dome or a stone one, nearly $36,000. Lane's response made clear his and Bulfinch's position: "It will be for Congress to determine, whether the greater security, durability, and elegance afforded by a stone dome, will not more than countervail the difference in first cost." Bulfinch had written Lane on February 4: "I also hand an estimate of the dome built of brick (on which the general estimate is founded) and one built wholly of stone, which would be preferable in some respects, for solidity, and not requiring future repairs; but am apprehensive the expense would prevent so large an appropriation as it would require."[22]

Sometime in the next two months, Blackledge, or one of his committee members, apparently asked Bulfinch for an estimate for a third contingency, a wood dome. Bulfinch's final estimates were about $61,000 for a stone dome, $25,000 for a brick one, and less than $20,000 for one constructed of wood. Blackledge's committee reported nearly two months later on March 25, 1822: "From the deliberation which the committee have given the subject, they recommend the dome to be built of wood; and the appropriation they propose is founded on the estimate for a dome of that description." Bulfinch's only surviving section drawing of the rotunda and dome, labeled "No. 2" (fig. 8), shows a single-shell masonry dome based on that of the Roman Pantheon. The

[21]Charles Bulfinch to Henry [Enrico] Causici, July 8, 1822, RG 42, NARA.
[22]*Documentary History of the Capitol,* p. 244–45.

F<small>IG</small>. 8. Charles Bulfinch, section of the Capitol dome, design "No. 2," ca. 1822. *(Courtesy Library of Congress.)*

shape and articulation of the lower half of the double-shelled dome actually built was modeled on the Pantheon.[23]

On December 9, 1822, Bulfinch tersely described the Herculean effort of building the dome in his annual report:

> The principal labor of the season has been devoted to raising the dome of the centre. For this purpose, the interior walls of the rotunda were continued: as soon as appropriations were made in the spring, they were raised to the full height, and covered with the entablature and blocking course. The exterior walls were carried up with stone, formed into large pannels, and crowned with a cornice and four receding gradins [the octagonal drum]; about two thirds of the interior dome is built of stone and brick, and the summit of wood. The whole is covered with a wooden dome of more lofty elevation, serving as a roof. . . . It will be finally crowned with a balustrade, to surround a sky-light of twenty-four feet diameter, intended to admit light into the great rotunda.[24]

Apparently Bulfinch and Lane turned to Monroe and his cabinet to make the final decision about the dome's shape. Among the letters published by Bulfinch's granddaughter, Ellen Susan Bulfinch, in *The Life and Letters of Charles Bulfinch, Architect* (1896) is one the architect wrote his son Stephen Greenleaf Bulfinch in 1842. He explained the difficult situation in which he found himself vis-à-vis the dome's height and the model he had had made in 1818.

> But there was one universal remark, that the dome was too low, perhaps from a vague idea that there was something bold and picturesque in a lofty dome. As the work proceeded, I prepared drawings for domes of different elevations, and, by way of comparison, one of a greater height than the one I should have preferred: they were laid before the Cabinet, and the loftiest one selected, and even a wish expressed that it might be raised higher in a Gothic form, but this was too inconsistent with the style of the building to be at all thought of by me.[25]

Bulfinch continued: "[I]f I attempted to throw the ponderosity of the dome upon the Cabinet of Mr. Monroe, what could I expect but a retort from J. Q. A.—from which may all good powers defend me." John Quincy Adams served as secretary of state from 1817 to 1825 in Monroe's cabinet before being elected for one term as president in 1825. His voluminous and chatty diaries contain the best record of Washington's political and social life of the period. His entries during the critical periods when

[23]Ibid., pp. 249–50.
[24]Ibid., p. 251.
[25]Bulfinch, *Life and Letters,* p. 299.

Fig. 9. Charles Bulfinch, alternate designs for the Capitol dome, ca. 1822. *(Courtesy Library of Congress.)*

decisions about the Capitol were being made are confined to mundane matters. The actual profile of the dome did not coincide with either of the two Bulfinch drawings believed to be alternates submitted to Monroe and his cabinet (fig. 9).

In 1842 Bulfinch recalled:

> Upon the ribs of the dome being boarded, I was so far dissatisfied as to propose to reduce it, stating that the saving in copper would meet all the expense; but our Commissioner was not a very compliant gentleman and rested upon the Cabinet decision, and, to avoid the altercation which had been so common formerly, I yielded the point. But I should be well pleased if, when the dome requires a thorough repair, which it may in ten or fifteen years, it should be reduced in height—not to Mr. Latrobe's design, but about halfway between that and the present elevation.[26]

In a situation where Latrobe would have either stormed or resigned his post, claiming that his professional reputation would be ruined, Bulfinch took the politic view, hoping the dome's odd profile would soon be lowered. Instead, it became an instant American icon, reviled by some—the architect William Strickland called it a "kettle bottom *renversé*"—but emulated by the architects of many new county courthouses and state capitols who apparently regarded it as an example of American inventiveness—"bold and picturesque"—akin to Latrobe's corn and tobacco orders.

Neither committee reports nor correspondence relate how the deal was struck that the Capitol's dome as built was stone, brick, *and* wood. Bulfinch's estimates for 1820 also stipulated "two iron bands bedded in the stone, to surround the walls, 5000lbs each." It is not certain whether Bulfinch's iron rings were in the octagonal drum or in the dome itself. The use of chains or rings to secure domes dates from antiquity and was well known in the early nineteenth century. Thomas U. Walter wrote in 1869 that he had weighed the materials from Bulfinch's dome when it was dismantled in 1855. He took down 5,926 tons of stone, brick, and "heavy timbers sheathed with boards and covered with copper." Walter's new cast-iron dome, weighing 6,786 tons, was erected on top of Bulfinch's octagonal stone drum.[27]

Bulfinch's dome was the fourth documented masonry dome in America. All of the earlier ones were designed by Latrobe and all depended on iron bands for their solidity. The single-shell dome of Latrobe's Bank of Pennsylvania (1798) in Philadelphia was forty-five feet in diameter. His double-brick dome with a fifty-foot span covered Exchange Hall in Baltimore's Merchant's Exchange (1817–18); it was spatially inter-

[26]Ibid.
[27]*Documentary History of the Capitol,* p. 228; Thomas U. Walter, "The Dome of the United States Capitol," *Architectural Review and American Builders' Journal* 3 (1869):344.

connected by an immense oculus in the lower dome of about forty feet. Baltimore Cathedral's (1817) sixty-eight-foot-wide dome was a double dome, the inner of brick and the outer shell of wood pierced by multiple skylights. Latrobe had also designed and superintended construction of the Senate chamber's brick half dome in 1808–9 that was destroyed in the fire of 1814. He wrote James Madison upon its completion on September 8, 1809: "This vault is one of the most extraordinary ever attempted, as to *span* and *altitude,* being a segment of a Dome 110 feet diameter supported by less strength of walling than any other arch, in modern or ancient times with which I am acquainted." When rebuilt between 1815 and 1819, the Senate was covered with a wood half-dome.[28]

Bulfinch may well have been competing with the now-deceased Latrobe, enlarging the diameter of the Capitol's dome six feet beyond what Latrobe had planned (ninety feet) and building the widest and tallest dome yet erected in America. Bulfinch's preference, a dome entirely of stone, would have been the first erected in America, as all of Latrobe's were built with brick. In December 1818, Latrobe had read two of Bulfinch's early reports, interpreting parts of them as critical of vaults in the north wing that were left for Bulfinch to oversee when Latrobe resigned in November 1817. After vigorously defending himself in a dazzling display of technical knowledge about vault construction in a memorial to Congress, Latrobe concluded with a thinly veiled attack on Bulfinch's professional competence:

> No blame may however attach to my successor who erroneously believing that I had directed the work did not think it necessary to give his own instructions respecting it. For had he calculated the amount and direction of lateral pressure under the circumstances of the Case; it cannot be doubted but that he would have given success to the Original plan. And this is the more probable because it appears from the foundations of the Center that Mr. Bullfinch [*sic*] is a much bolder Architect than myself as he has ventured to omit all those precautions in securing so heavy a building on so bad a foundation which I should have thought indispensible.[29]

On December 9, 1822, Bulfinch modestly reported on his achievement, crediting his colleagues for their contributions but not explaining how the dome was constructed in a single building season: "This work has required a great effort to complete it, and raised and secured at so great a height. I cannot omit this occasion to mention the ingenuity and persevering diligence of the superintendents of each branch of the

[28]Jeffrey A. Cohen and Charles E. Brownell, eds., *The Architectural Drawings of Benjamin Henry Latrobe* (New Haven, Conn., 1994), pp. 446–47, 646; and John C. Van Horne et al., eds., *The Correspondence and Miscellaneous Papers of Benjamin Henry Latrobe,* 3 vols. (New Haven, Conn., 1986), 2:764.

[29]Van Horne, *Latrobe Papers,* 3:1015–16.

work, and the cheerful and unremitted exertions of the workmen, in their endeavors to execute their orders, and to bring this part of their labors to a close."[30]

A year later Bulfinch described his dome's interior. "The concave of the drum is divided into five ranges of large and deep caissons, finished plainly; and a border of Grecian honeysuckle surrounds the opening of the sky-light twenty-four feet in diameter, which give light to the whole rotondo." Pringle Slight, a carpenter at the Capitol, made a sketch showing the relative profiles of Bulfinch's inner and outer domes (fig. 10). Robert Mills's sketch of 1842 shows the depth and angle of the cylinder connecting the two domes (fig. 11). A. J. Davis's rotunda sketch, done in the early 1830s, shows how its decoration appeared from the rotunda floor ninety-six feet below (fig. 12). Although its size was impressive, Bulfinch's dome did not adequately light the paintings and sculptural panels in the rotunda, nor was it an exciting architectural space, as Latrobe's nearly contemporary domes in Baltimore were with their multiple light sources.[31]

The pressures under which Bulfinch worked did not allow him the time to work out elaborate means of constructing a better solution to the Capitol's double dome. On July 8, 1822, in response to Enrico Causici's suggestion that the proposed pedimental sculpture for the east front be executed in marble (a ten-year project), Bulfinch expressed the political realities which he faced. "I should be much pleased if Congress would determine to finish the Capitol in any manner, which would render it complete as a work of art and a national monument; but they are tired of the expense, & would be dissatisfied with any further delay."[32]

Adams had just been elected president when a public competition was held in 1825 to choose the sculpture for the east pediment. He personally and forcefully controlled the direction of the sculpture's symbolic content at several stages during its design and execution. Thirty artists submitted thirty-six designs that Bulfinch submitted to Adams's judgment. The president suggested that a jury be appointed composed of the architect William Thornton, Col. George Bomford of the Army's Ordnance Department, and the Washington painter Charles Bird King; they selected elements from several entries to make a composite design and chose the sculptor Luigi Persico to execute it. Adams's diary entries reveal that during meetings with Bulfinch and Persico, he instigated both major and minor changes in the jury's design in order that the "duties of the Nation or its Legislators should be expressed in an obvious and intelligible manner." The east pediment's final sculpture, entitled the *Genius of America,* consists of a

[30]*Documentary History of the Capitol,* p. 251.
[31]Ibid., p. 257.
[32]Charles Bulfinch to Henry [Enrico] Causici, July 8, 1822, RG 42, NARA.

Fig. 10. Pringle Slight, "Detail of a Section of Capitol Dome Showing Its Construction," ca. 1822–23. *(Courtesy Office of Architect of the Capitol.)*

Fig. 11. Robert Mills, "Section of the Rotunda of the Capitol," 1840. *(Courtesy National Archives and Records Administration.)*

FIG. 12. Alexander Jackson Davis, perspective view of Capitol rotunda, ca. 1832–34. *(Courtesy Division of Drawings and Archives, Avery Architectural and Fine Arts Library, Columbia University.)*

central figure of America, flanked by figures of Hope (Adams's choice over Hercules) and Justice. The opinions of legislators do not seem to have been solicited at all.[33]

By the close of the 1825 building season the major work and expense of the Capitol was complete. In addition to the long rectangular, two-story Library of Congress and a similarly shaped room beneath it, Bulfinch had managed to eke out thirty-seven committee rooms in the west wing. But they were not enough; the Capitol was too small. The budget prepared by the commissioner of public buildings to present to Congress for the monies needed in 1826 included a request for $80,000 "for erecting offices at each end of the Capitol." During House proceedings on February 6, 1826, Charles Anderson Wickliffe, a newly arrived Kentucky Democrat, "was opposed to

[33]Vivien Green Fryd, *Art and Empire: The Politics of Ethnicity in the U.S. Capitol, 1815–1860* (New Haven, Conn., 1992), pp. 180–82.

commencing any addition to the Capitol, at least until the building was finished on its present plan." True, the east portico was not yet completed, requiring an additional expenditure of $19,000 during the year, and the Capitol grounds had not yet been entirely cleared of rubble and landscaped. Bulfinch immediately responded to Wickliffe, suggesting the "propriety of striking the whole appropriation out of this bill, leaving the subject for future consideration, that the project for ranges of offices, &c. might be deliberately examined and passed upon by the House." Bulfinch was invariably accommodating to his clients![34]

A month earlier, on January 3, 1826, the new Select Committee of the House of Representatives for "Finishing and Furnishing the Public Buildings" had been appointed with Stephen Van Rensselaer of New York as its chair. Bulfinch responded by February 24 to Van Rensselaer's request for ideas on how to finish the Capitol with four alternate designs that would provide for both immediate necessities and future office needs. Storage space for four hundred cords of wood that heated the Capitol each winter, a firehouse in which to park the Capitol's own fire engine, privies, guard's quarters, and covered carriage houses and stables were needed right away. Lost plans that Bulfinch identified as numbers one and three called for lateral wing additions, the first being for rectangular buildings 140 feet long attached directly to the Capitol on the north and south walls. These wings, presumably one story tall, would have increased the Capitol's length to 632 feet. In 1807 low service wings had been added to the White House by Latrobe and Jefferson and did not detract from its stately appearance. Bulfinch's design number three called for "two buildings, of a crescent form for storage etc." that cost half as much as the rectangular-shaped wings. Presumably, curved arms facing eastward would have increased the sense of arrival at the Capitol. The loss of these latter drawings is particularly lamentable because Bulfinch had been the country's premier designer of crescents, the most famous being Boston's Tontine Crescent (1793–94).[35]

Both of these solutions verify Bulfinch's perception of the Capitol as a continuation in America of the late Renaissance Anglo-Palladian tradition he played such a prominent role in furthering in New England. Low service wings connecting the main block to dependencies were a common feature of both public and private buildings erected during the eighteenth century in both England and America. William Thornton's first design for the Capitol, his famous Tortola plan of 1792 that was never submitted in competition, was a five-part plan with the wings separated from the main block by low connecting corridors (fig. 13).

[34]*Documentary History of the Capitol,* p. 269.
[35]Ibid., pp. 272–76.

Fɪɢ. 13. William Thornton, "Tortola Plan" for U.S. Capitol, ca. 1792. *(Courtesy Prints and Drawings Collection, The Octagon, Museum of the American Architectural Foundation.)*

Bulfinch's other two solutions prepared at Van Rensselaer's behest in February 1826 called for the dispersal of several buildings around the Capitol's grounds. Bulfinch's famous gatehouses, now located on the Ellipse, guarded the west entrance at the foot of Capitol Hill (fig. 14). Their articulation—channeled rustication and quoins in imitation of the Capitol's basement story—probably indicate how Bulfinch would have treated wing additions, had they been chosen. Also integral to Bulfinch's two landscape-oriented solutions were terraces supported by arches, with their outer walls masked by an earthen berm and their inner storage walls facing the Capitol's basement and sub-basement. Van Rensselaer, in reporting on his committee's decisions on March 17, 1826, noted that:

> As considerable objections exist to the erections of wings, the Committee have, after great deliberation, determined to recommend, to the adoption of the House, plan No. 2. . . . This plan will have the great advantage of masking the basement story of the western front, which was rendered necessary by the declivity of the ground, and was required for committee rooms, but which is at present a serious blemish on a building, otherwise among the first in the world. The construction of this wall will restore it to the rules of taste, at the same time that the main objects of convenience will be obtained.[36]

Bulfinch's terrace continued the ground level from the park on the east around the north and south ends to create an overlook, or belvedere, on the Capitol's west front.

[36]Ibid., p. 271.

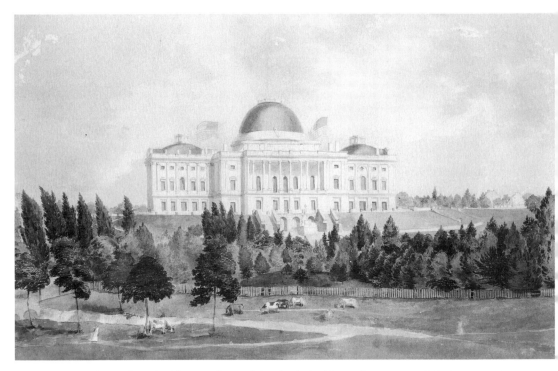

FIG. 14. John Rubens Smith, west front of the Capitol with gatehouses, ca. 1828. *(Courtesy Library of Congress.)*

Van Rensselaer also noted in his report that "the Committee have directed numerous plans to be submitted to them, and the same are now respectfully submitted to the House." Drawings for the west terrace staircase by two other architects survive among the original House committee report of February 24, 1826, one unsigned and the second (fig. 15) signed by Duprieur Delorme (spelling of last name uncertain), the latter dated "19 fevrier 1828," probably an error in the year. What is significant is that Bulfinch's authority, and that of the executive officer under whom he labored, the commissioner of public buildings and grounds, was challenged by a congressional committee that believed neither in the dispatch with which the final stages of the Capitol's construction and decoration was being carried out, nor apparently in Bulfinch's attention to practical considerations. When Democratic Sen. John Randolph of Virginia noted that they had had at the Capitol "splendor without comfort, without neatness, without accommodation," he was speaking for members of both houses who contended with serious acoustical faults, damp and cold chambers, and overcrowded conditions.[37]

[37]Ibid., pp. 271, 276; Charles Bulfinch to Stephen Van Rensselaer, Feb. 24, 1826, RG 233, HR19A-D7.1, NARA.

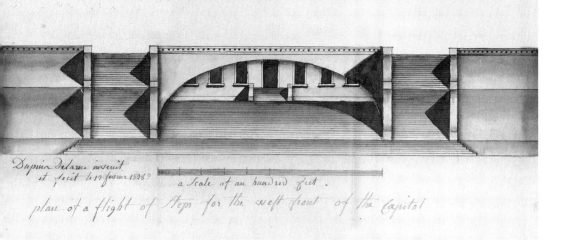

Fɪɢ. 15. Duprieur (Delorme?), design for terrace staircases, west front of the Capitol (1826 or 1828). *(Courtesy National Archives and Records Administration.)*

The protracted saga of trying to fix the acoustical fault in the House chamber, when Bulfinch's solutions did not work, led the clerk of the House in 1826 to hire William Strickland and the Committee on Public Buildings and Grounds to engage Robert Mills. This further eroded confidence in Bulfinch's abilities and must have embarrassed him, but he worked amicably with both architects trying to solve the problem.[38]

This study of Bulfinch's surveyorship as the Capitol's architect indicates that the government's official records kept during the 1820s do not provide the answers to many important questions. Private correspondence that might have illuminated decisions by Bulfinch and the commissioner of public buildings, the president and his cabinet, and the members of Congress serving on the appropriate committees is also scarce; no meeting notes of Monroe's cabinet have survived. Latrobe frequently wrote about his ideas and the events of his professional and personal life, records saved by his family. The only comparable written record of Bulfinch's career is Ellen Susan Bulfinch's compilation of documents, many originals of which are now lost.

To promote his designs, Latrobe instructed, pushed, cajoled, charmed, and offended congressmen and presidents. The end result was a series of great architectural spaces, but many aggrieved and mistrustful Washington officials. Bulfinch, conscious of the unrest caused by years of overspent appropriations and slow progress, was perhaps too conciliatory, as his contemporaries and posterity have judged his subbasement and bulbous dome mistakes. In fact, during Bulfinch's first four years as architect,

[38]George C. Hazelton, Jr., *The National Capitol: Its Architecture and History* (New York, 1897), pp. 261–72.

his estimates were no more reliable than Latrobe's, and for many of the same reasons —dependable supplies of materials and workmen simply were not available. Yet there was no sound and fury with Bulfinch pushed to the wall as Latrobe had been. Bulfinch was a gentleman, treated others as gentlemen, and received gentlemanly treatment in return. When his work in Washington was finished in 1829, Congress voted to pay Bulfinch's return passage to Boston, an unprecedented move!

Thomas U. Walter and
the Search for Propriety

James M. Goode

ONE OF THE MOST SIGNIFICANT OF THE NINE ARCHITECTS OF THE UNITED States Capitol was Thomas Ustick Walter, who served as the fourth architect, from 1851 to 1865 (fig. 1). Today we take for granted the idea of the architect as a professional, but in the mid-nineteenth century, professional standards of architectural practice did not exist in the United States. Walter himself would help develop these. At the same time, his firm adherence to his own idea of professional propriety throughout his fifty-five-year career as an architect, especially during his tenure at the Capitol, was a remarkable feat. As the architect of the major public building project of the time he was a target of political maneuvering. In addition, in Capt. Montgomery C. Meigs, he came up against a competing professional viewpoint, underhanded tactics, and a powerful ego.

Walter was Philadelphia's leading architect when he was selected by President Millard Fillmore in the competition of 1851 to design the enormous new House and Senate wings and, later, the new iron dome for the Capitol. There is no question that Walter was among the most qualified neoclassical architects in the United States. When he was selected as architect of the Capitol Extension, he was at the height of his career; he had designed more than three hundred and fifty buildings, from Maine to

Note on abbreviations: The following frequently cited names are abbreviated after the first full citation: Benjamin B. French (BBF), Montgomery C. Meigs (MCM), and Thomas U. Walter (TUW).

FIG. 1. Thomas Ustick
Walter as he appeared
when he was selected by
President Millard Fillmore
as the architect of the
Capitol Extension in 1850.
*(Courtesy The Athenaeum
of Philadelphia.)*

Georgia and as far west as Indiana. He was most famous for his many public build-
ings, including over forty churches, numerous courthouses and jails, and the monu-
mental Girard College complex in Philadelphia, the largest neoclassical building
project in the country.

Of all the American architects at midcentury, Walter was the best trained. He was
the only one of the leading American architects in 1850 who was educated in four
complementary ways: practical work as a craftsman in the trades—that is, as a brick-
layer on the Second Bank of the United States; academic training at the Franklin In-
stitute; apprenticeship to William Strickland, an established architect; and the
accomplishment of a grand architectural tour of Europe. Walter was fortunate in hav-
ing Nicholas Biddle, president of the Second Bank of the United States, as his patron
in Philadelphia. He further distinguished himself as the author of two architectural
pattern books and as a founder and later as president of the American Institute of Ar-

chitects. Perhaps Walter's most important role, however, was his leadership in the United States in establishing a code of ethics for his profession.

Relatively little has been written on Walter's career because his papers, until recently, had been lost. The discovery in 1975 on a descendant's horse-breeding farm near Larkspur, Colorado, of Walter's voluminous letterpress books, containing over eight thousand outgoing letters, forty diaries, and over five hundred drawings, and their subsequent purchase by The Athenaeum of Philadelphia, have for the first time revealed his role in establishing a code of ethics. This paper focuses on Walter's quest for propriety in the practice of architecture and the enormous problems he encountered during his fourteen years at the Capitol.

Even though both the House and Senate voted in late 1850 to enlarge the Capitol, they could not agree on the architect of the design. The Senate favored Robert Mills (fig. 2) and his north-south expansion (fig. 3), while the House wanted Walter as architect and an eastern expansion (fig. 4). The Senate, at the urging of Sen. Jefferson Davis (fig. 5), voted to hold its own competition in 1850 to get the ball rolling. In order to break the deadlock between the two bodies, Congress voted to authorize President Fillmore to make the final selection of both the architect for the enlargement and to decide between a new Capitol building or an expansion of the old building by the addition of wings. Five months after the Senate competition began, Fillmore (fig. 6) and his cabinet, led by Secretary of State Daniel Webster, began to interview those architects who had entered the earlier Senate competition as well as new competitors. After carefully reviewing all plans, they selected Walter in June 1851. They also chose north and south wings rather than an eastern extension in order to better preserve the original Capitol—that is, the building as completed in 1826 from designs by William Thornton, Benjamin Henry Latrobe, and Charles Bulfinch. The public was quickly made aware of Walter's winning design when printers in New York and Philadelphia produced bird's-eye (fig. 7) and eastern perspective views of the projected enlarged Capitol.

The intrigues Walter endured during the competition of 1851 gave him a preview of what he would experience over the next fourteen years as architect of the Capitol: attempts by jealous architects, builders, and contractors to remove him from office with charges of fraudulent contracts, plagiarism of their designs for the Capitol Extension, and faulty construction. Three of the losing architects—Charles F. Anderson of New York and two Washington architects, Robert Mills and Charles Cluskey— eventually claimed that Walter had stolen their ideas. In attempting to tear down Walter's reputation by accusations and lies, his competitors hoped to gain his prestigious and well-paid position for themselves. Anderson circulated so many rumors that

Fig. 2. Robert Mills, seen here with his wife, was a principal competitor in the competitions of 1850 and 1851 for the Capitol Extension. *(Courtesy National Portrait Gallery, Smithsonian Institution, gift of Richard Evans.)*

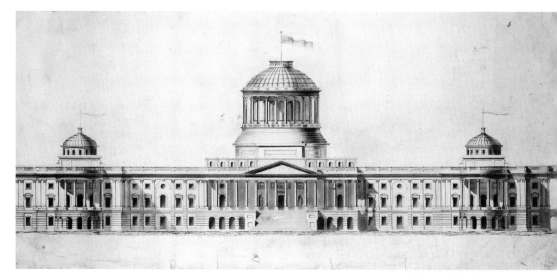

Fig. 3. Robert Mills's 1850 design for a north-south expansion of the Capitol, favored by the Senate. *(Courtesy Office of Architect of the Capitol.)*

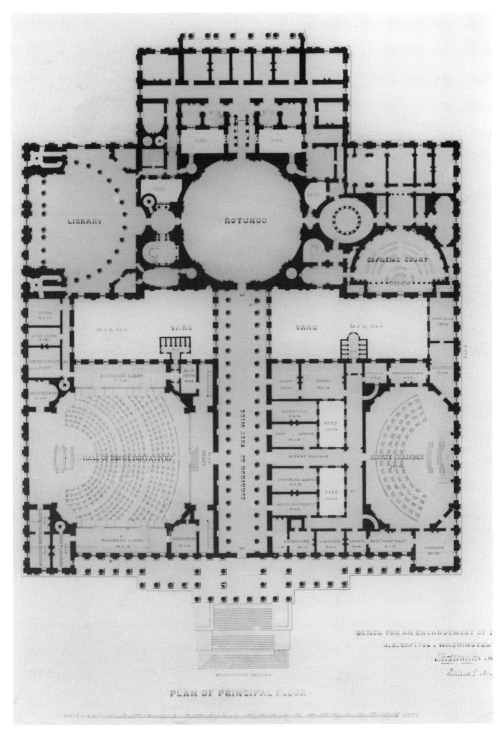

FIG. 4. Thomas U. Walter's 1850 plan for an eastern expansion of the Capitol, favored by the House. *(Courtesy Office of Architect of the Capitol.)*

FIG. 5. Sen. Jefferson Davis was a leading advocate of the Capitol Extension. *(Courtesy Library of Congress.)*

Walter had built faulty foundations for the wings that the Senate Committee on Public Buildings included Walter in its investigation into the issue in March 1852 (fig. 8).[1] The House joined the fray by investigating Walter as well. To make matters worse, several members of Congress, notably Congressman John McNair of Pennsylvania and Sen. Solon Borland of Arkansas, reinforced the accusations because they hoped to replace Walter with their own preferred architects, who would favor contracts with construction firms from their districts or states. In addition, a number of disappointed

[1]Petitions by Robert Mills and his friends calling for Walter's removal are found in Linn Boyd et al. to President Millard Fillmore, Mar. 1, 1853, Curator's Office, Architect of the Capitol, Washington, D.C., hereafter cited as AOC; Josiah J. Evans et al. to President Fillmore, Mar. 1, 1853, AOC; Robert Mills to Jefferson Davis, Sept. 12, 1853, AOC. Charles B. Cluskey's claim that Walter stole his plans is found in Donald Lehman, "Charles B. Cluskey," unpublished manuscript, ca. 1975, AOC, while his 1856 claim is mentioned in the *Congressional Globe* for Aug. 14, 1856. Charles F. Anderson petitioned for years to have the government compensate him for his designs for the Capitol's wings, which he claimed both Walter and Meigs stole from him. Charles F. Anderson to Capt. William Franklin, Nov. 3, 1859, AOC; Montgomery C. Meigs to Jefferson Davis, Feb. 9, 1860, Lynda L. Crist and Mary Dix, eds., *The Papers of Jefferson Davis,* 8 vols. (Baton Rouge, 1989), 3:635; U.S. Senate, *Report of the Senate Committee on Public Buildings and Grounds Regarding Memorial of Charles F. Anderson,* 38th Cong., 1st sess., Mar. 29, 1864, S. Com. Rep. 39, pp. 1–8; Montgomery C. Meigs Journal, July 6, 1858, AOC.

FIG. 8. This 1852 woodcut shows the controversial foundations for the Capitol's wings under construction. *(Courtesy Kiplinger Washington Collection.)*

contractors who had failed to win contracts for the Capitol Extension charged Walter with paying inflated prices for building materials, taking favors from contractors, using bad stone, and tolerating bad workmanship. The most vicious attacks came from William Easby, a Washington granite contractor. Even though the two congressional committees did not prove Walter guilty of any wrongdoing, his reputation was damaged by the long and adverse hearings in 1852 and early 1853.[2]

The day after the last investigation ended, the new Democratic president, Franklin Pierce, shifted control of construction of the Capitol Extension from the secretary of the interior to the new secretary of war, Jefferson Davis, at Davis's request. Davis was the most powerful member of Pierce's cabinet. The two congressional investigations dictated such a change, Davis theorized, and he turned over supervision of construc-

[2] William Easby to Alexander H. H. Stuart, Jan. 28, 1852, Record Group 42, National Archives and Records Administration (NARA); William Easby to Fletch R. Veitch, Nov. 1, 1852, RG 42, NARA; Thomas U. Walter, "Testimony before the Senate Committee on Public Buildings," Feb. 17, 1852, AOC; U.S. Senate, *Report of the Committee on Public Buildings on Their Investigation of the Soundness of the Foundation of the Capitol Extension,* 32d Cong., 1st sess., Apr. 2, 1852, S. Com. Rep. 163, pp. 1–4; U.S. House of Representatives, *Documentary History of the Construction and Development of the United States Capitol and Grounds,* 58th Cong., 2d sess., 1904, H. Rep. 646, pp. 460–61.

FIG. 9. Capt. Montgomery C. Meigs was selected by Secretary of War Jefferson Davis to supervise the construction of the Capitol Extension in 1853. *(Courtesy The Athenaeum of Philadelphia.)*

tion to an army engineer as well. He selected a fellow West Point graduate, thirty-seven-year-old Capt. Montgomery C. Meigs to replace Walter as superintendent of construction and to serve as his superior (fig. 9).[3]

During his first twenty months as architect of the Capitol, while he was still superintendent of construction, Walter brought order to the complicated logistics of building and weathered the first round of political attacks. He executed the brick and marble contracts, laid the foundations, tested dozens of materials for strength, hired a capable workforce often exceeding eight hundred men, and—no small accomplishment—rebuilt and fireproofed the Library of Congress, which had been gutted by fire in late December 1851 (fig. 10). Walter's fireproof design was copied throughout the country for the following thirty years. Simultaneously, Walter defended himself against false charges leveled during his two congressional investigations. The problems and conflicts Walter endured over the following six years, however, would make the early difficulties seem weak by comparison.

After the Capitol Extension project was turned over to the Department of War, Walter reported to Captain Meigs, who in turn reported to the secretary of war. Walter welcomed the change, as he reported in an 1854 letter to his father-in-law in Philadelphia: "The Captain—is better fitted for his post than any one they could find

[3]Russell F. Weigley, *Quartermaster General of the Union Army: A Biography of M. C. Meigs* (New York, 1959), pp. 65–66.

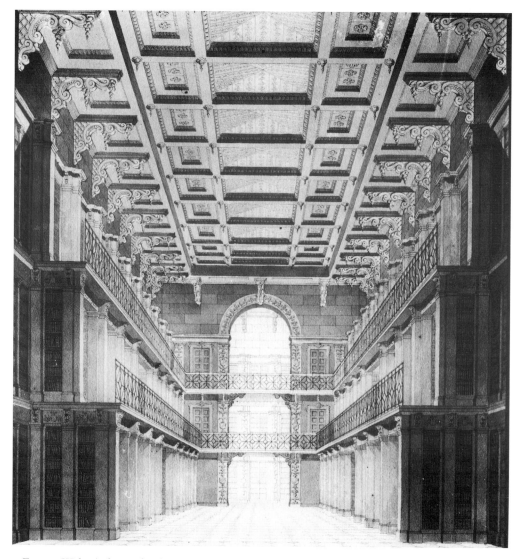

Fig. 10. Walter's design for the new fireproofed Library of Congress chamber on the second floor of the west front of the Capitol. *(Courtesy Library of Congress.)*

whether soldier or civilian.—you have no idea what a luxury it has been to me, during the past year to be able to devote myself to my legitimate professional duties, and be freed from the annoyances of contractors, appointments, disbursements and the like, all of which take time, unhinge the mind, and create an army of enemies—I have enough to do without such troubles, and my ardent desire is that they may allow things to remain as they are."[4] Meigs and Walter enjoyed good relations during the

[4]TUW to Dr. R. Gardiner, Feb. 22, 1854, AOC (quote).

first four and one-half years they worked together on the Capitol. Walter even readily
agreed to Meigs's design changes.

During the six and a half years Meigs was in charge at the Capitol, he focused on
decorating the extensions as well as experimenting with improving ventilation, heat-
ing, and acoustics in the House and Senate chambers. Perhaps his greatest contribu-
tion was employing the distinguished Italian artist, Constantino Brumidi, to execute
the frescoes in the Capitol Extension and dome (fig. 11). Although Meigs handled the
administrative tasks and made occasional rounds to check on the physical building of
the extensions, most of the work was directly supervised by Walter and by the many
foremen employed for the purpose. While working on the Capitol, Meigs retained his
supervision of other projects, including the extension of the Post Office Department

FIG. 12. Brumidi's elaborate neo-baroque frescoes in one of the Senate corridors were originally referred to as "Pompeiian style." *(Courtesy Office of Architect of the Capitol.)*

Building, the Patent Office Building, and most importantly, the Washington Aqueduct. Although Walter's job was officially to design and build the Capitol's new wings, he also was called upon by the government to design a dozen other buildings during his fourteen years in office.[5]

During this early period Meigs contributed to the design process by five decisions— moving the legislative chambers to the centers of the two wings, figuring out how to support the iron columns of the dome's peristyle, adding pediments to the eastern porticoes, thickening the marble skin of the extension walls, and insisting on monoliths for the one hundred columns used on the Capitol Extension (that is, that each column be carved whole from a single block of marble). All of these changes pushed costs far above the original estimate Walter had submitted in 1851. Meigs's mission to enrich the Capitol with sculpture and paintings further escalated expenses. Indeed Meigs's

[5]MCM to Jefferson Davis, Feb. 22, 1855, ibid.; MCM Journal, Mar. 16, Apr. 19, Apr. 21, Apr. 26, 1855, and Sept. 6, 1854, Library of Congress, Washington, D.C. (DLC).

great passion, in addition to the Washington Aqueduct, was the decoration of the Capitol.

Meigs and Walter worked together on the decorations up to a point, but their collaboration was rent by diametrically opposed philosophies. For reasons of economy and a desire to match the simplicity of the old Capitol, President Fillmore had directed Walter to design plain interiors and to use spartan decorations. Walter readily agreed, for he adhered to the philosophy of those trained in the Greek Revival movement of the 1820s, which called for a chaste classicism in architectural interiors as well as exteriors. The policy completely changed when Fillmore left office and Franklin Pierce moved into the White House in 1853. President Pierce followed the views of his secretary of war, Jefferson Davis, who endorsed Meigs's idea of enriching the Capitol with sculpture, paintings, and elaborate interior decoration. In order to implement these embellishments, Meigs trained himself in art history. He painted in watercolors and attended exhibitions at public and commercial art galleries, which he frequently noted in his journal. In New York he spent hours studying library books on art that included works in the Vatican as well as examples of frescoes in Italian palaces. He often attended exhibitions at the National Academy of Design in New York. Meigs even visited the Pennsylvania Academy of the Fine Arts in Philadelphia to study the plaster cast of the famous bronze Renaissance doors by Lorenzo Ghiberti. The engineer's goal, to make the Capitol into the major example of American public art of the time, was realized. His introduction of the European neo-Baroque, or "Pompeiian style," as it then was termed, shocked many Americans (fig. 12). This ornate mode was characterized by bold colors, rich patterns that covered most of the walls and ceilings, and motifs and configuration based on those of ancient Rome. The Capitol's fresco decoration, considered gaudy by most Americans in the 1850s, became fashionable in American public buildings by the early 1870s.[6]

Good relations between Walter and Meigs came to an abrupt end in December 1857 when Walter learned that Meigs was attempting to steal credit for his design of the Capitol wings. During most of the following twenty-three months, Meigs and Walter communicated only through their superior, the secretary of war. Meigs became increasingly harsh toward Walter and tried over a dozen ways to force him to resign. By this time President James Buchanan had taken office, and his secretary of war, John B. Floyd, had assumed charge of the Capitol enlargement (fig. 13). Much of the trouble could have been averted had Secretary Floyd ordered Meigs to stop harassing Walter. Because Meigs had important friends in Congress, however, Floyd did nothing

[6]Lillian B. Miller, *Patrons and Patriotism: The Encouragement of the Fine Arts in the United States, 1790–1860* (Chicago, 1966), p. 71; Kent Ahrens, "Nineteenth-Century History Paintings and the United States Capitol," *Records of the Columbia Historical Society* (1980):202.

FIG. 13. Secretary of War John B. Floyd ultimately fired Capt. Montgomery C. Meigs for insubordination. *(Courtesy Library of Congress.)*

until November 1859 when Meigs wrote an insulting letter to the War Department. Floyd removed Meigs from the Capitol at that time and curtailed his activities to the work on the Washington Aqueduct.

Walter's steadfastness in resisting the attacks of the engineer is a milepost in the history of the rise of professionalism in American architecture. Even when, during the first four years, Walter at times privately criticized excess in Meigs's decorative schemes and his abrupt militaristic manner in dealing with the construction staff, he tried in every way to assist the superintendent with all aspects of design and construction. He humored Meigs's egotistical bent by changing the specifications for the iron vendor when Meigs wanted his name cast into all of the iron roof trusses of the House and Senate wings. Walter initially overlooked other instances of Meigs's desire for fame, such as naming the Washington Aqueduct packet boat used on the C and O Canal the *M. C. Meigs* and designing each riser on the aqueduct's receiving-station

Fɪɢ. 14. Captain Meigs had his name cast in high relief on the iron valves for the Washington Aqueduct. *(Courtesy Library of Congress.)*

stairs with the pierced letters "M. C. MEIGS." Even the iron valves for the Washington Aqueduct had his name cast in high relief on them (fig. 14). Meigs also ordered the following inscription to be engraved on the gauges of the four new boilers ordered for the basement of the Post Office Extension: "Made for Captain M. C. Meigs, U. S. Corps of Engineers, for General Post Office Heating and Ventilating Apparatus, 31st October 1859."[7]

Over time Meigs became increasingly eager to take the credit due to the architect for designing the Capitol's wings and dome. After only two years on the job in 1855, he privately claimed equal credit with Walter for all design work on the Capitol. That year Meigs confided to his journal that he must remain on guard so that Walter would not get too much credit for the Capitol. By 1856 he boasted—still privately in his journal—

[7]MCM Journal, Apr. 11, 1856, DLC; MCM to American Gauge Company, Boston, Oct. 31, 1859, AOC (quote).

FIG. 15. The stone-carving firm of Provost and Winter had marble carving sheds adjacent to the new wings. *(Courtesy Library of Congress.)*

of designing the wings and the dome himself. From the start, in his direction of interior decorations, he mostly ignored Walter. In 1856, after Walter finished drawings for fourteen marble mantels of varying designs, Meigs rejected them and ordered ready-made marble mantels from New York. He also was unhappy with Walter's design for the rostrum in the Senate chamber, saying it was too restrained.[8]

Meigs began reprimanding Walter and overruling his decisions in order to force him from his job. The first overt attack came in late 1857. It involved hauling finished marble from the contractor's shops near the Capitol to the site where the stone was to be installed. The original marble contract allowed the stone carving firm, Provost and Winter, to have its carving sheds within feet of the new wings (fig. 15). When members of Congress objected to the noise from the sheds, they were forced to relocate so far away that the transport of tons of finished marble blocks became a burdensome expense. In response to the firm's request, Walter agreed that the government would pay half the moving costs. But Meigs abruptly reversed Walter's decision and refused to pay for transporting marble. After the firm appealed to the House Committee on Public Buildings, Floyd directed Meigs to pay retroactively and immediately half their hauling costs, or ten thousand dollars.[9]

[8]MCM Journal, Feb. 22, 24, 1856, DLC; TUW to Amanda Walter, May 20, 1857, AOC; TUW to MCM, Sept. 7, 1857, AOC.

[9]MCM to Jefferson Davis, Aug. 6, Dec. 24, 1857, Jan. 21, 1858, in Crist and Dix, *The Papers of Jefferson Davis,* 6:546–47; MCM to President James Buchanan, Aug. 14, 1858, AOC; MCM to Jefferson Davis, Mar. 5, 1856, AOC.

CORRIDOR

DUPLICATE OF ORIGINAL REVISED PLAN FOR EXTENSION OF CAPITOL

BY CAPT. M. C. MEIGS. U.S. ENGINEERS

ADOPTED BY THE PRESIDENT OF THE U.S. 5 JULY 1853

FIG. 16. Meigs had his draftsmen add additional lettering to Walter's architectural drawings of the Capitol asserting that Meigs was the creator. *(Courtesy Office of Architect of the Capitol.)*

The breaking point between Meigs and Walter came in late 1857 when Floyd, alarmed by escalating costs, asked the two why the original cost estimate had almost doubled in six years. Walter insisted on the accuracy of his original $2,675,000 estimate, derived from President Fillmore's directions that the new wings be designed in a simple fashion consistent with the interior design of the old Capitol. He placed the blame for the enormous cost overruns on Meigs's many design changes and elaborate decorations. Walter itemized them: in addition to those already mentioned—moving the legislative chambers, doubling the thickness of the outer marble walls, monolithic columns, sculptured pediments, and changes to the dome design—they included adding the Senate Marble Room, four grand staircases, the first-floor Hall of Columns, bronze doors, and expensive imported Minton tile floors.[10]

Meigs answered Secretary Floyd's inquiry in two letters. He attacked Walter's original cost estimate as faulty and claimed all credit for the design of both the two wings and the iron dome. His next step was to direct Walter to deliver all of his architectural drawings to the engineer's office. Meigs then had his draftsmen add additional lettering to Walter's major architectural drawings of the Capitol asserting that Meigs was the creator (fig. 16). He then had the drawings photographed and copies sent to the members of the House and Senate committees on public buildings as well as such prominent libraries as those at West Point, the Astor Library in New York, and Harvard College. Soon after Walter learned of this development, he and his draftsmen entered Meigs's

[10]TUW to John B. Floyd, Oct. 20, Dec. 21, 1857, Thomas U. Walter Collection, Athenaeum of Philadelphia, hereafter cited as AP.

office while the engineer was away on business at the Washington Aqueduct office in Georgetown and retrieved all of the original drawings, leaving only a set of duplicates in Meigs's office. When Meigs ordered Walter to return the original drawings, the architect did not even bother to reply.[11]

When, soon afterward, Meigs moved out of the Capitol to new offices in a nearby building on A Street, N.E., Walter ignored an order to move his offices into part of the building. To protect his drawings, Walter moved from the House wing, which was under Meigs's jurisdiction, to the third floor of the old Capitol, which was under the control of the Speaker of the House and the commissioner of public buildings.[12]

A few more notes passed between Meigs and Walter, but they never spoke to one another during the following two years. It was impossible for Meigs to claim that he designed the dome because the authorizing legislation stated that the dome would be built on Walter's design. Meigs did, however, try to gain recognition from President Buchanan that he was the real designer of the Capitol wings by sending him plans for the new House and Senate chambers and claiming they were his own. He worried increasingly that Walter, because of his influence with members of Congress, would replace him as superintendent. To prevent this, Meigs appealed to his three principal friends in the Senate, Jefferson Davis of Mississippi, Robert M. T. Hunter of Virginia, and James A. Pearce of Maryland, all of whom agreed to support him.[13]

Walter and his staff of ten draftsmen continued to complete new drawings for the dome's construction. Work slowed considerably in 1858 and 1859, for Meigs would not allow Walter's new drawings to be distributed to the foremen without his own name on them. Walter would not send the new drawings to Meigs for fear of having them altered. The battle escalated when Meigs directed Walter not to give any orders to foremen, contractors, or workmen. Walter refused to honor this directive because it violated his professional rights. He continued to direct the iron foreman working on the dome and even smuggled drawings to him, which Meigs occasionally found.[14]

Meigs devised a new form of harassment to inflict on Walter. When Walter sent his customary monthly pay vouchers to Meigs, they were returned. Meigs refused to pay Walter or his staff as long as Walter "misrepresented his title" of "Architect of the New Dome." After four months, Secretary of War John B. Floyd intervened and ordered Meigs to pay the vouchers.[15]

Meigs's cunning made Walter very apprehensive about leaving his office for even a

[11]MCM to John B. Floyd, Dec. 9, 1857, AOC; TUW to John C. Frankwine, Apr. 29, 1858, AP; TUW to John B. Floyd, Dec. 21, 1857, AP; MCM to TUW, Dec. 24, 1857, AOC; TUW to MCM, Jan. 19, 1858, AOC.

[12]MCM to TUW, Jan. 21, 1858, AOC; MCM to Maj. Richard Delafield, Feb. 27, 1858, AOC; MCM to Dr. Joseph G. Cogswell, Feb. 27, 1858, AOC.

[13]TUW to Clement L. West, Aug. 23, 1858, AOC; TUW to John Rice, Oct. 13, 1858, AOC.

[14]TUW to Charles Fowler, Oct. 27, 1858, AOC.

[15]MCM to TUW, Aug. 23, 1858, AOC; TUW to MCM, Aug. 24, 1858, AOC; TUW to Robert Briggs, Jr., Aug. 21, 1858, AOC; Robert Briggs, Jr., to TUW, Aug. 24, 1858, AOC.

day. Unfortunately, Walter had to visit New York a number of times to inspect the construction of the Marine Barracks in Brooklyn. While Walter was out of town on one inspection trip, Meigs sent a note to Walter's chief draftsman, August Schoenborn, demanding that he bring all of Walter's original drawings to the superintendent's office. Walter's faithful staff refused. Walter wrote to the commandant of the Brooklyn Marine Barracks in 1858 describing why his visit would be so brief: "I am afraid to leave here for a day. . . . I have to stick to my works like a master sticks to his quarter deck in a storm, so that when business compels me to leave the city I have to fly back as fast as steam can bring me, or run the risk of having my plans upset."[16]

Walter nearly resigned several times in 1858, but friends dissuaded him. He stayed on partly because of his interest in advancing and codifying the professional rights of architects. He had been elected the first vice president of the newly organized American Institute of Architects in 1857 and led the effort to elevate the prestige of American architects by the formulation of a code of ethics pertaining to the conduct of both architects and their clients. His difficulties with a military engineer who saw architects as mere draftsmen and architecture as an inconsequential profession compared to engineering were especially galling. He expressed his frustration to J. B. Swain, a Baptist minister, in a letter of November 1858. Walter objected to the Pierce administration's placement of public works under military officers, writing: "I was so unfortunate as to have a man placed on my works of the most imperious, self-conceited, vain, arrogant and unscrupulous character of any human being I ever met. I endured his insults and permitted him to appropriate the fruits of my mind to his own glory for 4 years without complaining, rather than run the risk of being considered quarrelsome."[17]

Finally, Secretary of War Floyd relieved Meigs of his work at the Capitol in November 1859 when Meigs refused to honor a government contract given to a Baltimore firm for heating the Post Office Department Building because there had not been the required sixty-day period of public advertisement for bids. Meigs had in fact acted honestly, seeing the impropriety of awarding the contract to a firm that had Democratic party connections. Meigs's insulting letter to the War Department concluded with the following sentence: "Official respect for the department alone prevents my speaking of it as its imprudence deserves." Floyd replaced Meigs the same day with Capt. William B. Franklin of the Army Corps of Topographical Engineers (fig. 17). Franklin and Walter worked well together for the following sixteen months until construction of the extension was suspended by the outbreak of the Civil War.[18]

[16]TUW to Rev. M. E. Farmstead, Oct. 5, 1858, AOC; TUW to John Boulton, Oct. 4, 1858, AOC (quote).
[17]TUW to Rev. J. B. Swain, Nov. 16, 1858, AOC (quote).
[18]U.S. Senate, *Message of the President of the United States Communicating Information Relative to the Heating and Ventilation of the Capitol Extension, Post Office Department, etc.,* 36th Cong., 1st sess., 1860, S. Doc. 20, pp. 111–14; Dumas Malone, ed., *Dictionary of American Biography* (New York, 1961), 6:507–8, 5:181–82; MCM to War Department, Oct. 16, 1859, AOC (quote).

FIG. 17. Capt. William B. Franklin of the Army Corps of Topographical Engineers replaced Meigs as superintendent of construction at the Capitol in 1859. *(Courtesy National Archives and Records Administration.)*

For Walter the four years of the Civil War also were difficult times (fig. 18). In 1861 and 1862 construction on the extension halted for eleven months. The building also was damaged during this period while it was in use as an army barracks, bakery, and hospital. Construction was delayed throughout the war because of the slowness in the shipment of marble from Lee, Massachusetts, the strikes of the workmen for higher pay, the escalation in the cost of building material because of wartime inflation, and the difficulty in securing adequate ironworkers for the dome.[19]

With the work on the wings and the dome almost completed in early 1865, Walter turned his attention to his last project—the expansion of the Library of Congress. The

[19]Stanley Kimmel, *Mr. Lincoln's Washington* (New York, 1957), pp. 44–53; Elden Billings, "Military Activities in Washington in 1861," *Records of the Columbia Historical Society* (1960–62):123–33.

FIG. 18. Thomas U. Walter as he appeared in the midst of the Civil War. *(Courtesy Library of Congress.)*

library had grown so fast that half the books were in storage because the iron room Walter had built on the west front a decade earlier no longer provided adequate space. He planned to gut the committee rooms on the north and south sides of the existing library, located on the second floor of the central west front, and install a series of three iron balconies in each. Of the four bids Walter received in early 1865, Charles Fowler came in lowest with a proposal of $169,500. He and his former partners in the firm of Janes, Fowler, and Kirtland had kept the original patterns for the castings they had used in building the Library of Congress in 1852. With the patterns on hand, Walter was confident that the two additions could be completed within the six months before Congress was to meet in December. Lincoln's secretary of the interior, John Usher, approved the plans and the contract with Charles Fowler.[20]

The assassination of President Lincoln on April 15, 1865, would result indirectly in Walter's resignation from the Capitol six weeks later. Having endured the difficulties

[20]TUW to Charles Fowler, Nov. 14, 1862, AOC; John G. Stephenson to Benjamin B. French, Nov. 20, 1862, AOC; TUW to BBF, Jan. 15, 1863, AOC; TUW to John P. Usher, Apr. 27, 1865, AOC.

FIG. 19. President Andrew Johnson appointed James Harlan as the new Secretary of the Interior in 1865. (*Courtesy Library of Congress.*)

and intrigues of Jefferson Davis and Montgomery Meigs, Walter could not tolerate another case of interference, which he quickly found in President Andrew Johnson's new secretary of the interior, James Harlan (fig. 19), and his confidant, the commissioner of public buildings, Benjamin B. French (fig. 20).

Harlan, a former Republican senator from Iowa, assumed office on May 15. His first action was to make sweeping changes in the staff of the Interior Department. He fired the heads of three of the principal bureaus: Indian affairs, census, and patents, and appointed inexperienced friends to fill the positions. In addition Harlan removed almost all clerks over sixty years of age because he thought they were not as efficient as younger ones. He even fired Walt Whitman, an Interior Department clerk, because he felt *Leaves of Grass* was immoral.[21]

By the time Harlan took office, Fowler, the iron contractor, was tearing out the end walls of the main reading room to connect the north and south additions. As had happened in 1852, the losing architects and contractors began to question the soundness of the construction and Walter's honesty in awarding the contract to Fowler. The losing

[21]R. E. Davis, "James Harlan: A Case Study of Early Republicanism," *Central States Speech Journal* 34 (1983):104; Johnson Brigham, *James Harlan* (Iowa City, 1913), pp. 206–7; TUW to Alexander Provost, July 14, 1865, AOC.

Fig. 20. Commissioner of Public Buildings Benjamin B. French. *(Courtesy Library of Congress.)*

architect, Charles F. Anderson, and two jealous contractors, Severson and Heutis, wrote Secretary Harlan, attacking Walter. In addition, Severson wrote to President Johnson complaining that the contract for the enlargement of the library was illegal because Walter had not advertised it publicly for bids for a sixty-day period. To make matters worse, French went behind Walter's back and asked Harlan to remove Walter as superintendent of construction at the Capitol.[22]

Without consulting Walter, Harlan placed French, a fellow Mason, in charge of all government buildings in Washington, including the Capitol, and voided Walter's

[22]B. Severson to President Andrew Johnson, May 16, 1865, AP; TUW to Amanda Gardiner Walter, May 22, 1865, AP.

FIG. 21. Because of bad investments and speculation in the stock market, Thomas U. Walter lost his imposing house in Germantown, Pennsylvania, in the Depression of 1873. *(Courtesy The Athenaeum of Philadelphia.)*

FIG. 22. Thomas U. Walter as he appeared shortly before his death in 1887. *(Courtesy Office of Architect of the Capitol.)*

contract with Charles Fowler for the library enlargement. The following day Walter submitted his resignation effective June 1, 1865. Walter was appalled at Harlan's order to stop work in the midst of construction. He wrote to his wife in Germantown: "The arches are torn down, the Capitol is filled with thousands of bricks and rubbish, the stairway opposite the library door is torn down, and columns, architraves, bricks, etc. are lying in supreme confusion." Walter could not tolerate the unprofessional behavior he received from Harlan. With his resignation Walter wrote: "The breaking of a contract which I alone had the power to annul without saying a word to me about it, and the putting of the Commissioner of Public Buildings over me without giving me notice of the intended change, was too much for a sensitive mind to endure, and too much ever to be forgotten."[23]

Walter's life after he left the Capitol was not an easy one. His long-awaited retirement ended eight years later when he lost his house and stocks, which today would be equivalent to $3 million, in the Depression of 1873 (fig. 21). He was forced to return to work as an architect at the age of sixty-nine. As assistant architect of the Philadelphia City Hall, Walter worked until his death at age eighty-three in 1887 (fig. 22).

During his later years as president of the American Institute of Architects, Walter fought to establish architectural schools, a standard schedule for fees, and rules for competitions, as well as to protect the ownership of architectural drawings and to ensure the architect's right to superintend the construction of his own works. Although rarely remembered today, Walter also left his mark in the field of architectural history as the first professor in the United States to teach architectural history at an American university—Columbian College (now George Washington University)—in 1860.

Strangely enough, in 1875, twelve years before Walter's death, Montgomery C. Meigs, now a retired Civil War general, initiated a reconciliation for reasons that remain unknown. Perhaps it was because Walter attended the funeral of Meigs's father, prominent Philadelphia physician Charles D. Meigs. It may have occurred because Meigs felt sorry about Walter's financial situation in his old age. They visited a number of times and exchanged letters. In 1890, three years after Walter's death, Meigs wrote a strong letter of support for Amanda Gardiner Walter's petition to Congress for back pay in the amount of $113,000 owed to her husband at the time of his death. He concluded his letter by writing: "Your husband was the first of American architects and to this day no one has excelled him in taste and knowledge of his profession."[24]

[23]TUW to Amanda Gardiner Walter, May 25, 1865, AP (short quote); BBF to James Harlan, June 1, 1865, RG 42, NARA; TUW to George C. Whiting, June 19, 1865, AP (long quote).

[24]MCM to Sen. Justin S. Morrill, Jan. 20, 1875, AP; TUW to MCM, Mar. 29, 1882, AP; MCM to TUW, Apr. 27, 1882, AP; TUW Diary, Oct. 9, 1883, AP; TUW to Congressman A. C. Harmer, Oct. 29, 1883, AP; MCM to Amanda Gardiner Walter, July 18, 1890, AP (quote).

Right-Hand Men

The Development of the Office of Architect of the Capitol, 1865–1954

William B. Bushong

The appointment of the former architect of the Capitol's key assistant or, as the press phrased it, the "right-hand man," initiated a tradition that shaped the development of the office as an agency for almost one hundred years between 1865 and 1954. Edward Clark, who had extensive professional training as Thomas U. Walter's apprentice and assistant, would be the first architect promoted from this role as understudy. Elliott Woods entered the employment of the office at age twenty. Although he was not trained as an architect, he was described by reporters, when he was appointed the head of the office in 1902, as a man who had "grown up" in the job as Clark's trusted assistant. David Lynn, who succeeded Woods, spent more than twenty years in the office, starting as a laborer in 1901 and rising to a position as Woods's right-hand man.[1]

Congress has traditionally authorized the president to appoint the architect of the Capitol, but underpinning the decisions after 1865 was the tacit recognition that having a permanently employed and experienced specialist in superintendence of the Capitol was essential for the efficient operation of an increasingly complex office. By

[1]For newspaper reports discussing the appointments of Clark, Woods, and Lynn, see Scrapbooks, 1856–1980, Record Group 40, Art and Reference Series, Curator's Office, Architect of the Capitol, Washington, D.C. (AOC). For an overview of the office's history, see William B. Bushong, *Uncle Sam's Architects: Builders of the Capitol* (Washington, D.C., 1994).

FIG. 1. Edward Clark
portrait by Constantino
Brumidi, ca. 1870.
*(Courtesy Office of Architect
of the Capitol.)*

the early twentieth century, the term *right-hand man* could be applied as a metaphor for the importance of the architect of the Capitol's role as an agent of Congress.

Born in Philadelphia on August 22, 1822, Edward Clark was the son of builder James Clark and Mary Cottman, the daughter of Capt. John Cottman, a Revolutionary War veteran (fig. 1). He was educated in Philadelphia's public schools and then given extensive instruction in mechanical drawing by his father. His uncle, Capt. Thomas Clark, a retired army engineer who had published numerous translations of Greek and Latin classics and a series on mathematics, tutored his nephew in these subjects and probably inspired his lifelong love of books.[2]

To further his son's advancement in the architectural profession, James Clark placed Edward as an apprentice with Thomas U. Walter, then Philadelphia's leading architect. Clark began his apprenticeship in 1849 and later advanced to become Walter's superintendent for his extensions for the Patent Office (1851) and the General Post Office (1857) in Washington. Clark continued to work under Walter's guidance

[2]Edward Clark, Art and Reference Subject Files, RG 40, Curator's Office, AOC.

until federal construction stalled during the Civil War, at which time he gained employment as director of construction for all military hospitals and barracks in the District of Columbia under Quartermaster General Montgomery C. Meigs.[3]

After his appointment as architect of the Capitol Extension, Clark was engaged to complete the new wings and dome, although Commissioner Benjamin B. French continued to exercise oversight over the Capitol's older center section. In 1867 Congress abolished the office of commissioner and assigned its duties for repairs and alterations at the Capitol to the architect of the Capitol Extension, in effect providing for the establishment of the Office of Architect of the Capitol as a permanent agency. In 1876, Congress expanded the architect of the Capitol's position by officially adding responsibility for the care of the Capitol's grounds, dropping "extension" from the office's title, and stipulating that the incumbent occupy an office in the building.[4]

Clark was an average designer, but he was respected for his contributions to the profession by his peers, who elected him a fellow of the American Institute of Architects in 1888.[5] However, he developed into an outstanding administrator who recognized his limitations and routinely persuaded Congress to employ outside experts to provide design services for improvements or modifications to the Capitol and its grounds. Clark's ability as a design administrator was indicated early in his tenure by his strong recommendation to Congress in 1874 that it commission Frederick Law Olmsted, then the nation's preeminent landscape architect, to create a plan for the Capitol grounds. His efforts resulted in the development of the Olmsted landscape plan, a major undertaking that today defines the broad eastern plaza, west terraces, and the romantic naturalistic landscape treatment of the Capitol grounds (fig. 2).

The work on the grounds, including the grading, planting, and construction of the boundary walls, was completed between 1875 and 1881. In 1883 Congress approved Olmsted's plans for erection of two marble stairways and terraces on the west that had not been a provision of the original legislation. The execution of the design for this imposing construction project was left to Olmsted's assistant Thomas Wisedell under

[3]Scrapbooks, 1856–1980, RG 40, Curator's Office, AOC. Numerous news clipppings and obituaries in the collection chronicled the early career of Edward Clark. Particularly useful were "Edward Clark, Dead," *Washington Post,* Jan. 6, 1902; "Architect of the Capitol Dead," [?], Jan. 2, 1902; see also biographical information files on Edward Clark, Art and Reference Subject Files, RG 40, Curator's Office, AOC. These folders contain a typescript biography of Clark compiled by "G.H.W." of the AOC staff about 1902.

[4]For information on this transitional period in the administration of the Capitol, see Bushong, *Uncle Sam's Architects,* p. 26; William C. Allen, *The Dome of the United States Capitol: An Architectural History* (Washington, D.C., 1992), p. 70; and James M. Goode, "Architecture and Politics: Thomas U. Walter and the Enlargement of the United States Capitol, 1858–1865," Ph.D. diss., George Washington University, 1994, pp. 298–301.

[5]Clark accepted an invitation to become a charter member of the Washington Chapter of the American Institute of Architects, established in 1887, and was notified of his election as a Fellow of the Institute on June 15, 1888. See Glenn Brown to Edward Clark, Aug. 22, 1887, and AIA Secretary A. J. Bloor to Edward Clark, June 15, 1888, both in Architect's Letterbooks, 1867–1920, RG 40, Curator's Office, AOC.

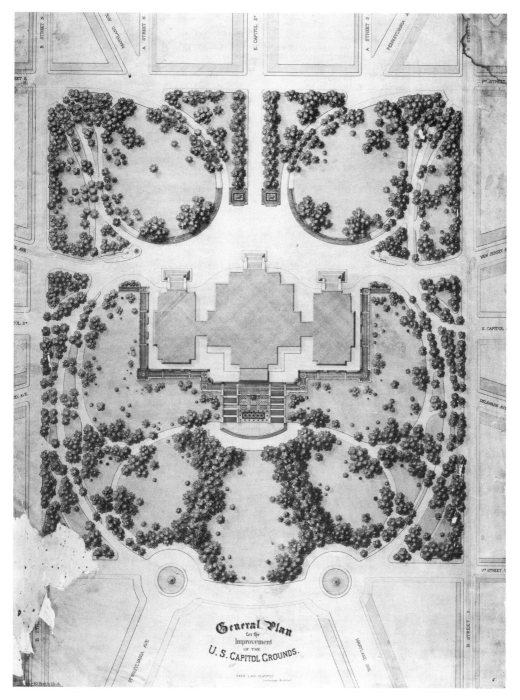

FIG. 2. Frederick Law Olmsted's 1874 plan for the U.S. Capitol Grounds. *(Courtesy Office of Architect of the Capitol.)*

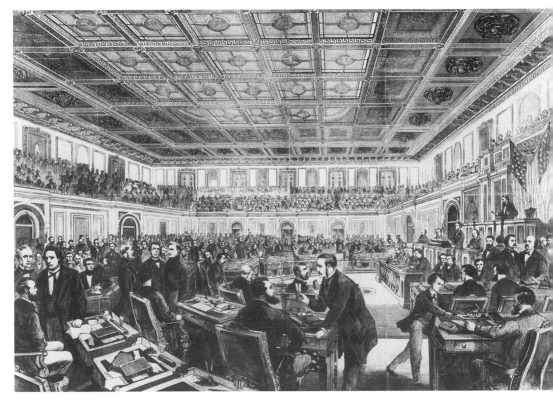

FIG. 3. The House of Representatives in 1868. The crowded gallery was often cited as one of the reasons for the hall's ventilation problem. *(Courtesy Office of Architect of the Capitol.)*

Clark's supervision, and by 1892 the grand marble staircases and terraces had been completed. The overall result of the landscape design was an open naturalistic setting subordinate to the Capitol, with an accessible ground plan presenting the building as a national monument to be admired from various points in the city.[6]

As for Clark's role as caretaker, there were numerous technological innovations introduced in the Capitol for the comfort and convenience of Congress. These included numerous upgrades of the heating and ventilation systems; introduction of elevators, first installed in the Senate wing of the Capitol in 1874; modern plumbing, added in 1893; and electricity, wired throughout the building by 1897. Clark also placed electric bells with buttons at the member's desks to enable them to summon pages.[7]

Approval of appropriations for these repairs and improvements at the Capitol soon became an onerous annual ritual that often yielded opportunities for disgruntled

[6]For information concerning Olmsted's plans for the Capitol grounds and west terraces, see Capitol Grounds, Art and Reference Subject Files, RG 40, Curator's Office, AOC.

[7]*Annual Reports of the Architect of the Capitol, 1867–1947 and 1976–*, RG 40, Curator's Office, AOC.

members of Congress to criticize Clark. Nothing stirred debate or occupied Clark's energy during his tenure more than supervision of the heating and ventilation systems of the House and Senate chambers. By an act of Congress in 1869, Clark was given authority for all repairs, improvements, and extensions to the heating system. The larger House chamber proved most difficult to cool in summer, heat in winter, and ventilate to the legislators' satisfaction. For several decades members continually complained that the House and Senate chambers were uncomfortable and that the air was detrimental to their health (fig. 3).[8]

In 1892 the Senate in frustration considered a resolution to change the jurisdiction for managing sanitation and ventilation of the Senate wing from the Committee on Public Buildings and Grounds to the Committee on Rules as a means of modernizing the wing's plumbing and solving the ventilation problems. This proposal elicited a history of the Senate Committee on Public Buildings and Grounds and its careful review of past ventilation plans and an eloquent defense of Thomas U. Walter's design of the Capitol's wings by Sen. Daniel Voorhees, Democrat of Indiana. In remarks to the Senate, Voorhees stated that the ventilation system might not provide the "sweet air of the prairies to be wafted over beds of flowers," but it was at least fresh air. According to Voorhees, there were other reasons for the senators' frequent griping about the chamber's air quality: "Overwork, tired, late hours, resulting in headache and disordered stomach, dizzy and weary, we look around for some object to vent our spleen upon, and commence abusing this beautiful Hall in which we stand. I have had my periods of ill health as well as others. . . . But at the worst and lowest ebb I never thought that I was killed because I breathed the air of the Senate of the United States."[9]

When the heating system was first installed in 1857, the apparatus was described as "one of the most extensive and complete in the world."[10] A register under each desk was installed so that each member of the House or Senate could regulate the heat according to personal need. The system, developed by Capt. Montgomery C. Meigs and his consultant Robert Briggs, drew fresh air into the chamber with large fans, forcing it over steam coils and carrying the warmed air through ducts into the Capitol's major rooms and passageways. The air intakes were located on the west terraces in the corridors connecting the old and new sections of the Capitol building.[11]

[8]For reports and congressional debate related to the history of heating and ventilation of the wing extensions of the Capitol, see U.S. House of Representatives, *Documentary History of the Construction and Development of the United States Capitol and Grounds,* 58th Cong., 2d sess., 1904, H. Rep. 646, pp. 413, 614–15, 666, 698, 702–4, 738, 795, 834–38, 840, 850, 855, 858–59, 869–72.

[9]Ibid., p. 963.

[10]Ibid., p. 666.

[11]Ibid., p. 703; see also Eugene S. Ferguson, "An Historical Sketch of Central Heating: 1800–1860," in *Building Early America,* ed. Charles E. Peterson (Radnor, Pa., 1976), pp. 176–79.

FIG. 4. Sen. Roscoe Conkling described the Senate chamber as an "iron box covered with glass." This photograph, taken ca. 1900, depicts the appearance of the chamber with its old cast-iron roof and skylight before replacement with steel and the renovation of the Senate in a modern neoclassical style in 1950. *(Courtesy Office of Architect of the Capitol.)*

Clark directed the installation of a new floor in the House chamber with adjustable registers in 1871. In addition, the ventilation shaft was enlarged, and two steam engines were placed in the cellar of the south wing to power exhaust fans moving fifty thousand cubic feet of air per minute.[12] The Senate, which had similar ventilation apparatus installed in 1870, still unsatisfied, revisited the ventilation issue in 1872 by discussing the extension of the chamber to the exterior walls to obtain fresh air and sunlight (fig. 4). New York Sen. Roscoe Conkling, an influential Republican party leader, represented the views of many of his colleagues in favor of the renovation when he described the Senate chamber as an "iron box covered with glass" and further stated: "I say it is monstrous to contemplate the idea that this is to go on when we have

[12]*Annual Reports of the Architect of the Capitol, 1867–1947 and 1976–,* RG 40, Curator's Office, AOC.

only to take out that partition and yonder partition, and move this Chamber out to the corner where, like all other civilized people, we can have permission to breathe the air that God made, in place of breathing the air pumped up through these apertures, which have been used in the two Houses by a great many gentlemen for years under the apprehension that they were spittoons."[13]

In 1873 the House approved an appropriation bill authorizing an additional $40,000 to complete a remodeling of the House chamber to improve the lighting, ventilation, and rearrangement of desks to accommodate forty new members expected for the next session of Congress. In these deliberations the subject of extending the House chamber to the exterior walls also surfaced as a means of obtaining fresh air and obviating the ventilation problem. After a lengthy debate, Rep. Joseph Hawley (R-CT) had the last word summarizing much of the preceding discussion:

> I do believe that this is the foulest Hall in which any deliberative body ever undertook to sit day after day. And I wish here as a new member—for the old members may not feel it, having become so much accustomed to it—I wish, as a new member, to say that it is not creditable to an intelligent body of men to sit here month after month in this foul air.... The proposition is to appropriate $40,000 for the alterations of the Hall. I do not care what the particular alteration may be; but I insist that this shall be attended to in any plan which may be adopted, that there be better ventilation.[14]

The ventilation issue remained a major concern throughout Clark's tenure as further major renovations were made, including the construction of fresh-air inlet towers on the west grounds in 1885 and 1890. Discontent with the heating and ventilation system spurred several serious investigations of the office and culminated in a bitter confrontation over charges of corruption against Clark in 1893.[15] After careful review of pertinent financial records, the House Committee on Public Buildings and Grounds fully vindicated Clark and refused to have the material alleging his corruption published.[16] The last six years of Clark's tenure as architect were spent in a supervisory role as his health steadily deteriorated. Reports and correspondence concerning the activities of the office were sent to him for his approval at his home, but Elliott Woods was actually administering the daily affairs of the office and communicating with the

[13]*Documentary History of the Capitol,* p. 874.

[14]Ibid., pp. 880–81.

[15]Edward Clark, Art and Reference Subject Files, RG 40, Curator's Office, AOC. Several folders labeled "Investigations of Edward Clark" contain material concerning major investigations of Clark and the Office of Architect in 1877, 1885, and 1893.

[16]House Committee on Public Buildings and Grounds, "Investigation of the Office of the Architect of the Capitol," in *Report of the Architect of the United States Capitol to the Secretary of the Interior* (Washington, D.C., 1895).

FIG. 5. Elliott Woods, ca. 1910. *(Courtesy Office of Architect of the Capitol.)*

House and Senate leadership. Clark died in 1902 and was buried at Rock Creek Cemetery in the District of Columbia.[17]

In his first report as the new superintendent of the Capitol in 1902, Elliott Woods noted that the "Capitol building is like a city which for its government requires the repetition of repairs to its various branches of sanitation and private and public spaces. Features will age, floors will wear out, and heating and ventilating appliances will become defective by use."[18] During Elliott Woods's twenty-one-year tenure as superintendent and architect of the Capitol (1902–23), the Capitol complex would be expanded to include two massive office buildings and a power plant. Woods often likened his duties to those of a small city "mayor" responsible for the life and comfort of the more than twenty-five hundred citizens (legislators and their staffs) who worked on Capitol Hill.[19]

[17]For newspaper reports that discuss this transition from Clark to Woods, see "Architects Oppose Change" [1902]; "New Superintendent of Capitol Grounds," Jan. 16, 1902; and "Architect of Capitol Long in the Service," May 4, 1907. Scrapbooks, 1856–1980, RG 40, Curator's Office, AOC.

[18]*Annual Report of the Superintendent of the United States Capitol Building and Grounds* (Washington, D.C., 1902), p. 3.

[19]Woods made this analogy in his annual reports and a typescript history he probably prepared of the Office of Architect of the Capitol about 1902 located in the AOC history files, Art and Reference Subject Files, RG 40, AOC; and for a contemporary article describing the citylike character of Capitol Hill in the early twentieth century, see "A City within a Building," Sept. 24, 1905, Scrapbooks, 1856–1980, RG 40, Curator's Office, AOC.

Born in 1864, Woods had come to Washington from Indiana at the age of twenty. He had a high school education and apprenticed as a woodcarver in a building supply factory before briefly working as a state government clerk in Indianapolis. Woods was largely a self-educated man who was considered an amateur expert in several scientific fields, including x-ray, wireless radio, astronomy, and electronics. He gained his architectural training from Clark and was influenced by his mentor's love of books and music (fig. 5). Woods possessed administrative skill, a congenial personality, and the political awareness to direct a major building program for Congress during his term in office.[20]

Woods knew how to get things done on Capitol Hill and made himself a valued friend to many congressmen. Joseph Cannon (R-IL) so respected Woods's thrift and administrative ability that he gave him virtual carte blanche over the building and maintenance of the Capitol and its grounds when he became Speaker of the House of Representatives in 1903. Woods appealed to "Uncle Joe" because he had risen to his position through hard work and a long apprenticeship under Clark. Cannon had little patience for the pronouncements of professional architects, who, in his opinion, had foisted on Congress the 1901 Senate Park Commission and its grandiose plan for Washington. He wanted Capitol Hill under the control of a trusted administrator and sensible builder, and Woods fit those qualifications.[21]

Woods's official promotion to architect after Clark's death in 1902 touched off a heated controversy involving Congress and the American Institute of Architects (AIA). His appointment was opposed by the AIA because he was not a qualified professional architect. In the institute's view, the appropriate candidate for the vacancy was Glenn Brown, a national AIA officer and the author of the monumental two-volume *History of the United States Capitol* (1900–1902), the first book to chronicle the Capitol's architectural evolution in a comprehensive fashion. Architects throughout the country sent letters to their congressmen to impress on them the importance of appointing a recognized architect. This lobbying effort and the AIA's encouragement of newspaper stories slighting Woods infuriated Cannon.[22]

[20]Elliott Woods, Biographical Information, Art and Reference Subject Files, RG 40; and for articles describing Woods's work ethic and diverse talents, see "Elliott Woods, Hardest Worker of Summer in Washington," July 29, 1910; "Capitol 'Boss' Hoosier Genius," Sept. 30, 1912; and "Like Mother over His Child: Elliott Woods Finds Joy in His Work and Plenty of Work to Keep Him Joyful," Dec. 25, 1921, Scrapbooks, 1856–1980, RG 40, Curator's Office, AOC.

[21]For sample articles relating Cannon's advocacy of Woods for the position of architect of the Capitol and animosity toward professional architects, see "Fight on Elliott Woods," 1902; "The Capitol Architect," 1902; "Architects Oppose Change," 1902; "Cannon Fought the Architects," 1910, Scrapbooks, 1856–1980, RG 40, Curator's Office, AOC.

[22]For a discussion of the controversy over the appointment of the architect of the Capitol in 1902, and for Brown's career and the influence of his Capitol history on the planners and government officials of his generation, see William Bushong, ed., *Glenn Brown's History of the United States Capitol* (Washington, D.C., forthcoming).

Fig. 6. The 1901–2 McMillan Plan for Washington, D.C. *(Courtesy Office of Architect of the Capitol.)*

To end the dispute, Cannon, then the powerful Republican chairman of the House Committee on Appropriations, presented President Theodore Roosevelt with a petition signed by more than forty prominent House and Senate members calling for Woods's appointment. In the eyes of Uncle Joe and many other members of Congress, Woods would be an ideal custodian, but the highly publicized debate over qualifications did effect a change in the office's title and led to the appointment of Woods as the "Superintendent of the Capitol Building and Grounds." The salary and responsibilities of the position remained unaltered, but by changing the office's name, President Roosevelt mollified the architectural profession and its allies by deleting *architect* from its title.[23]

The AIA's campaign to block Woods's appointment may have been motivated by a desire to install Washington architect Glenn Brown in a position of influence as a design adviser to Congress at a time when a new "City Beautiful" plan for Washington was being developed. The institute's lobbying under Brown's leadership had largely been responsible for the formation of a Senate Park Commission sponsored by Sen. James McMillan (R-MI), whose 1902 plan, now usually referred to as the McMillan plan, became a template for the development of the city's core (fig. 6). The Capitol and its grounds were the centerpieces of a plan that envisioned the future construction of a government enclave on Capitol Hill, including new office buildings for the House and Senate and a separate structure for the Supreme Court. The AIA believed that only an experienced professional architect could manage the development of this Capitol complex and ensure the success of the McMillan plan.[24]

With the controversy over his appointment settled in early 1902, Woods set to work with confidence and his trademark meticulous attention to detail. Woods was renowned for his hard work and personal oversight of even minor details at the Capitol. Contemporary accounts of his administration popularly referred to him as a "veritable engine of industry." Woods became well known in Washington for the cleanliness of the Capitol and jovially took his place "among the strenuous" in the Washington *Evening Star*'s "Big Stick Hall of Fame" in 1913 for his work as the custodian of the "biggest political pot in the world."[25] Woods's industry and method on the job can be illustrated by his approach to resolution of longstanding complaints with food service at the Capitol.

In the early twentieth century, restaurants in operation on the House and Senate

[23]For a copy of the petition and a collection of news clippings related to Woods's appointment in 1902, see Scrapbooks, 1856–1980, RG 40, Curator's Office, AOC.

[24]For a discussion of the AIA's attempts to influence the planning of the nation's capital, see William B. Bushong, "Glenn Brown, the American Institute of Architects and the Development of the Civic Core of Washington, D.C.," Ph.D. diss., George Washington University, 1988.

[25]"Keeping Life and the Capitol New," July 12, 1913, Scrapbooks, 1856–1980, RG 40, Curator's Office, AOC.

sides of the Capitol served notoriously poor food and were largely unprofitable enterprises. Woods set out to solve the problem of procuring satisfactory food at reasonable prices by consulting the managers and proprietors of hotels and restaurants in Washington and New York. He was determined to find out how a successful modern restaurant was maintained and operated. The result was the total renovation of the House restaurant. The new facility featured a large buffet table where legislators could be served "quick lunches," avoiding the long delays occasioned by dumbwaiter food delivery from the antiquated basement kitchens.[26]

In 1906 Woods completely overhauled the House and Senate restaurant kitchens, which markedly improved food quality (fig. 7). A standing joke at the Capitol in this period involved the remark of a senator to a constituent, who in a "somewhat obscure utterance asked the Senator for a copy of the 'poor food bill,' meaning pure food bill." The senator "replied facetiously, Oh, that is easy to get. I will send for the Senate restaurant menu."[27] Woods bolstered his request for appropriations to renovate the Senate restaurant by revealing information about the "true conditions" of the present restaurant kitchen before the Senate Rules Committee. Naturally, the press reveled in Woods's description of the kitchen as a "paradise for rats" and wrote approvingly of his plans to renovate the House and Senate facilities.[28] Woods would supervise installation of new plumbing and sewer connections, modern refrigerators with the first ice-making plant installed in the Capitol, steel tables for meat cutting, and a new bakery. It was stated that the new equipment and cold storage facilities had remedied conditions "rivaling those of the meat packing establishments of Chicago."[29] With the renovations of the two cafes in the Capitol and the opening of new restaurants in the House and Senate office buildings occupied by 1909, the food service problems dissipated for the time being.

Elliott Woods was at heart an inventor always looking ahead and searching for technological innovations to improve the Capitol and its grounds. He brought the "automobile lawn mower" to the Capitol in 1902, added "electric fountains" to the east front plaza; but most significantly, he planned and directed construction of state-of-the-art office buildings for the House and Senate.[30] The modernity of the new office buildings and the fact that all building materials and furniture were American made or manufactured was emphasized by Woods in building descriptions circulated to the press (fig. 8). His description of the House annex underscored the efficiency and con-

[26]"Topics of the Capital," Oct. 5, 1903, Scrapbooks, 1856–1980, RG 40, Curator's Office, AOC.
[27]"Capitol Cafes Dirty," Aug. 23, 1906, Scrapbooks, 1856–1980, RG 40, Curator's Office, AOC.
[28]Ibid.
[29]Ibid.
[30]*Annual Reports of the Architect of the Capitol, 1867–1947 and 1976–*, RG 40, Curator's Office, AOC.

Fig. 7. Senate lunchroom in the 1920s. *(Courtesy Office of Architect of the Capitol.)*

venience of a building that was equipped with a "modern heating system, electric lights, telephones in all the offices, conduits adapted to carry wires for buzzers, call bells and desk fans; conduits for the electric clock system; mail chutes and gravity conveyors, the latter adapted to handle bulky mail matter; each office is supplied with hot and cold water and ice water, and, in general, it may be said that the equipment is on a par with that of any of the most modern office buildings in New York, Chicago, or other large cities."[31]

In the early twentieth century, members of Congress still rented office space at their own expense or were compelled to use committee rooms and offices in the Capitol, which created problems for committee work and contributed to the general overcrowding of the building. Legislation authorizing the design and construction of the first House and Senate office annexes established three-member building commissions for each body. Subject to the approval of these commissions, the superintendent of the Capitol directed construction and letting of contracts for "all necessary skilled

[31]"The Office Building for the House of Representatives, Washington, D.C.," General File, Cannon House Office Building, Art and Reference Files, RG 40, Curator's Office, AOC.

Fig. 8. A view of the Russell Senate Office Building taken from the Capitol's dome in 1962. *(Courtesy Office of Architect of the Capitol.)*

and other services" for these public buildings.[32] This clause was significant since Woods had already presented well-developed design alternatives for these structures in his 1902 annual report. However, early in 1903 a committee of prominent architects from the AIA led by Charles McKim met with members of Congress and Woods to ensure that "competent professional advice" would be employed in the design of these new public buildings.[33]

The pending conflict was avoided with an amicable meeting between McKim and Woods concerning the design of the new office buildings. On April 1904, on Woods's recommendation, Congress retained the design services of the New York architectural firm Carrere and Hastings for the House and Senate annexes. Thomas Hastings took charge of the design of the House Office Building project while John Carrere took the lead on the preparation of drawings for a similar office building for the Senate (fig. 8). The Beaux Arts exteriors of both buildings, now called the Cannon House

[32]For legislation authorizing the Cannon House Office Building, see Sundry Civil Act, Mar. 3, 1903, *Statutes at Large,* 32:1114; for the Russell Senate Office Building, see Sundry Civil Act, Apr. 28, 1904, *Statutes at Large,* 33:481.

[33]For a record of the AIA leadership's discussion of this 1903 Sundry Civil Act, see Feb. 20, 1903, American Institute of Architects Minutes, RG 609; and for Charles McKim's description of his meeting and agreement with Woods, see Charles McKim to Glenn Brown, Feb. 27, 1903, AIA Office Files, Incoming, Folder 1903-M, American Institute of Architects Archives, Washington, D.C.

Office Building and the Russell Senate Office Building, were inspired by French architectural prototypes but were designed to complement the Capitol without pediments, domes, or other "strongly accented features."[34]

Although the office buildings' exteriors appear to be nearly identical, the interior finish of the Senate Office Building definitely presented a grander impression than that of the larger House of Representatives annex. The Senate Office Building's caucus room and rotunda are marble, while those of the House Office Building are mostly decorative plaster (figs. 9, 10). Other more subtle differences were that the wood finishes in the office suites throughout the Senate building are mahogany rather than pine, and all of its hardware, electric lighting fixtures, handrails, elevator cars, and enclosures were specially designed and made of bronze instead of iron.[35]

The introduction of interior marble and bronze in the Senate Office Building was justified as a measure to "produce permanently substantial results," with the attending minimum charges for upkeep.[36] However, the building's fine overall appearance inevitably was criticized as expensive and wasteful. In 1909, as the building neared completion, the *New York Times* proclaimed that it "looks about as much like a prosaic business office building as a lady's boudoir."[37] Even before the Senate and House buildings were complete, critics labeled the annexes as "palaces" to be maintained at the taxpayer's expense and the underground electric railcars in tunnels connecting the building to the Capitol as evidence that legislators now perceived the walk as unthinkable (fig. 11).[38]

As large and significant as the construction of the House and Senate office buildings were, they were by no means the only major public works project on Capitol Hill that would affect the development of Washington during Woods's tenure. The aggrandizement of the land between the Capitol and the new Union Station, construction of which in 1903 would eventually shape the future growth of Capitol Hill, helped determine the core of modern Washington as we know it today. The elimination of the Mall grade crossings and the construction of Union Station north of the Capitol, as outlined by the McMillan plan, precipitated the need to enlarge and develop the Capitol grounds. One famous aborted attempt to improve these grounds was a 1909 House proposal supported by Speaker Cannon to locate a Lincoln Memorial on Capitol Hill, which was defeated by the AIA lobby. For the next forty years,

[34]"The Office Building for the United States Senate, Washington, D.C.," and for a detailed architectural comparison to the House Office Building, see "Report on the Senate Office Building, Apr. 15, 1908," General File, Russell Senate Office Building, Art and Reference Files, RG 40, Curator's Office, AOC.

[35]"The Senate Office Building," *Through the Ages* 2 (1924):26–32.

[36]"The Office Building for the Senate, Washington, D.C.," General File, Russell Senate Office Building, Art and Reference Files, RG 40, Curator's Office, AOC.

[37]*New York Times,* Mar. 14, 1909.

[38]Rene Bache, "Congress as a Landlord," *Harper's Weekly,* Aug. 31, 1907, pp. 1272–73.

FIG. 9. The Caucus Room,
Russell Senate Office
Building. *(Courtesy Office
of Architect of the Capitol.)*

FIG. 10. The Caucus Room, Cannon House Office Building. *(Courtesy Office of Architect of the Capitol.)*

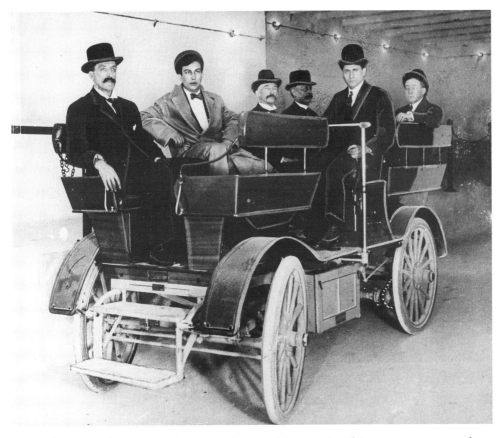

FIG. 11. Beginning in 1909, electric automobile cars with a capacity of sixteen passengers ran from the Capitol to the Senate office building every three minutes. *(Courtesy Office of Architect of the Capitol.)*

Congress worked to complete this "dignified and adequate" approach to the Capitol from Union Station.[39]

Woods's durability as architect of the Capitol can largely be attributed to his reputation for hard work, his cultivation of members of Congress as close personal friends, and the development of collaborative ties with leading members of the architectural profession. During his tenure he established the office as a respected adviser to official Washington on matters related to public architecture and often was consulted without compensation as an associate architect for such large-scale buildings in Washington as the Scottish Rite Temple and the Arlington Amphitheater.[40] This advisory role

[39]For background information on the politics surrounding the Lincoln Memorial proposal on Capitol Hill, see Bushong, "Glenn Brown, the AIA and the Development of the Core of Washington, D.C."; and Christopher Thomas, "The Lincoln Memorial and Its Architect, Henry Bacon," Ph.D. diss., Yale University, 1990.

[40]Elliott Woods, Biographical Information, Art and Reference Subject Files, RG 40, Curator's Office, AOC.

expanded and enhanced the architect's prestige in the city, which was shared and passed on to his chief assistant, David Lynn. Thomas Hastings and Lincoln Memorial architect Henry Bacon would eventually sponsor Woods's election as an honorary member of the AIA in 1921, and soon thereafter Congress reinstated the office's title as architect of the Capitol.[41] At Woods's death in 1923, his personal attention to Congress and importance to the development of the Capitol complex was captured by the *Washington Post*, whose obituary of Woods opened succinctly with the statement that "Washington's irreplaceable man has gone."[42]

With the appointment of David Lynn to head the office of the architect of the Capitol, there was a subtle but clear change in the agency's direction (fig. 12). The ambitious plans and grand expansion schemes presented to Congress on an almost yearly basis by Elliott Woods were no longer a priority. Lynn was content to manage the existing plant and fulfill plans either initiated by his former boss or inspired by the 1902 Senate Park Commission. Lynn was first and foremost a business executive who valued efficiency. His first report to Congress in 1924 was filled with information concerning the detailed duties of the office related to the Capitol's maintenance. Before itemizing repairs and other work by carpenters, plumbers, metalworkers, and electricians, Lynn emphasized, "It should be remembered that the duties of this office are largely those of a caretaker intrusted with what may be termed the 'domestic care' of a large legislative building."[43]

David Lynn was born in Wheeling, West Virginia, on November 10, 1873, and educated in the public schools of Cumberland, Maryland, where his family had settled. Through industry and loyalty to Woods, he rose through the ranks to become a foreman and gained appointment as an engineer in 1910. Numerous stories relating his appointment by President Calvin Coolidge in 1923 noted that he was the "right-hand man" and a natural successor to the office. The tone of these articles paralleled earlier stories of Woods's relationship with Clark and the rationale for his appointment in 1902.[44]

A striking characteristic of the architect's office under Lynn, as revealed in a 1925 Washington *Sunday Star* article, was the importance placed on the teamwork of these professionals, "unaffected by the tides and shifting winds of politics." It was clear the office prided itself for its efficiency, nonpartisanship, and the smooth functioning of the "workshop of Congress." The journalist's report also conveyed the importance of conti-

[41]For correspondence related to Woods's membership in the AIA, see Elliott Woods to Thomas Hastings, Mar. 14, 1921; Electus D. Litchfield to Elliott Woods, Apr. 4, 1921; and Edward C. Kemper to Elliott Woods, May 7, 1921; Elliott Woods Correspondence, Art and Reference Subject Files, RG 40, Curator's Office, AOC.

[42]"Most Useful Man Dead," *Washington Post,* May 22, 1923, Scrapbooks, 1856–1980, RG 40, Curator's Office, AOC.

[43]*Annual Report of the Architect of the Capitol* (Washington, D.C., 1924), p. 1.

[44]"David Lynn New Capitol Architect," Aug. 22, 1923; "Coolidge Appoints Cumberland Man Capitol Architect," Aug. 23, 1923, Scrapbooks, 1856–1980, RG 40, Curator's Office, AOC.

Fig. 12. David Lynn's official portrait, ca. 1923. *(Courtesy Office of Architect of the Capitol.)*

nuity and loyalty to the office.[45] Several professionals remained in service at the Capitol for long periods, most notably August Schoenborn, who worked at the Capitol for more than a half century. Schoenborn came to work at the Capitol in 1851 as Thomas U. Walter's draftsman and remained in the drafting rooms until his death in 1902.[46]

Although Lynn's administration emphasized frugality and efficiency, he did direct more than $45 million worth of public building projects at the Capitol between 1923 and 1939. This construction program included alterations to existing buildings and the construction of new facilities for the Library of Congress, the House and Senate, and the Supreme Court. Lynn also supervised the design and construction of a conservative Art Deco annex to the Library of Congress (now the John Adams Building), designed by Pierson and Wilson and completed in 1939 (fig. 13).[47]

The Capitol complex was also significantly expanded with the construction of a new House Office Building (Longworth Building), completed in 1929 to the designs

[45]*Sunday Star* (Washington, D.C.), Feb. 15, 1925, Scrapbooks, 1856–1980, RG 40, Curator's Office, AOC.
[46]For a sketch of Schoenborn, see Allen, *The Dome of the United States Capitol,* p. 76.
[47]David Lynn, Biographical, Art and Reference Subject Files, RG 40, Curator's Office, AOC.

Fig. 13. Aerial view of the Capitol grounds, ca. 1964. *(Courtesy Office of Architect of the Capitol.)*

of Allied Architects, and Cass Gilbert's Supreme Court building completed in 1935. The heating and ventilation of the Capitol and the Senate and House office buildings were all modernized by Lynn. A refrigeration plant was built to provide central air conditioning, an improvement that was most welcomed by Congress and immediately led to longer legislative sessions.[48]

The most impressive change to Capitol Hill during Lynn's tenure was the addition of 61.8 acres to the Capitol grounds. Lynn directed the massive landscape project that created an imposing park space between Union Station and the Capitol. This plan included major objects and structures, such as a reflecting pool and fountain, gatehouses, and an underground garage. Congress bought and condemned blocks of houses and temporary government buildings to accomplish this goal of a grand entry from Union Station to the Capitol.[49]

[48]Ibid. See also "Cooler Air and Longer Sessions: Air Conditioning Keeps Congress on Job," *Heating, Piping and Air Conditioning* 18 (1946):76–77.
[49]*Enlarging the Capitol: The Final Report of the Commission for Enlarging the Capitol* (Washington, D.C., 1943).

Lynn would also usher in the age of telecommunications at the Capitol with the installation of wiring and lighting for radio, motion picture, and television productions (fig. 14). Since 1946 the architect's office has been responsible for these communication systems that are now vital to the modern Congress. On February 12, 1946, as part of the Lincoln Day ceremonies, the first telecast was made from the Capitol. The program marked the inauguration of television service between Washington and New York and included interviews with members of the House and Senate. In 1947 the first broadcasts were made of the House proceedings, including the Joint Session of the House and Senate opening the Eightieth Congress on January 3, 1947; President Truman's State of the Union Address on January 6, 1947, and his speech on relief for Turkey, Greece, and the Middle East on March 12, 1947; and the Joint Meeting to hear the address of Mexican President Miguel Aleman on May 1, 1947.[50]

By 1948 the Capitol complex consisted of more than 131 acres, including the Capitol, large Senate and House office buildings, a power plant, a garage, two buildings for the Library of Congress, and a Supreme Court building. The architect was responsible for the structural and mechanical care of these buildings as well as the U.S. Court of Claims Building, U.S. Court House, the U.S. Court of Appeals Building, and the Columbia Hospital for Women in downtown Washington. The office also operated the U.S. Botanic Garden and the House and Senate restaurants.[51] The magnitude of this work required a large workforce, specialization, and new management methods that would probably have seemed foreign to Edward Clark, who never had more than a dozen core staff members.

During Clark's tenure, the architect of the Capitol had been first and foremost a building superintendent. Other important roles as a design and construction administrator, engineer, and property manager would be added as time passed. From 1865 to 1954, only three men directed the evolution and maintenance of the U.S. Capitol Complex. Each had been trained by a mentor who preceded him in the office, and each attained his position as architect largely based on the logic that he had been the right-hand man of his predecessor.

In a 1921 interview, Woods related that Clark had treated him as a son and had given him free run of his home and library as he was given his technical education. Woods's comments in this interview typified the work culture and personal bonds that underpinned the office's operations in this near century of service. The reporter noted: "In the old days Mr. Clark's boys would work all day and all night long to get a hard job done—and similarly Mr. Woods works with his helpers today. They have often warmed their dinners in the boiler room and indulged in a kazoo band, awakening

[50]*Annual Report of the Architect of the Capitol* (Washington, D.C., 1947).
[51]David Lynn, Biographical, Art and Reference Subject Files, RG 40, Curator's Office, AOC.

Fig. 14. Senate Television Studios in 1962. *(Courtesy U.S. Capitol Historical Society and the National Geographic Society.)*

the Capitol police; then back to the work through the still hours of the night until the job is done right."[52]

The principal stated qualifications of the architect of the Capitol in this period were administrative and executive ability and an expert's knowledge of the Capitol building's construction. Yet, it also was clear that the architect was expected to be the agent of Congress—its right-hand man. Since 1865, the success or failure of the architect's stewardship can be judged by his ability to balance the needs and conveniences of Congress with the integrity of the most important and symbolic complex in the United States.

[52]"Like Mother over His Child," Dec. 25, 1921, Scrapbooks, 1856–1980, RG 40, Curator's Office, AOC.

The Historicization of the U.S. Capitol
and the Office of Architect,
1954–1996

RICHARD GUY WILSON

REEDOM TRIUMPHANT IN WAR AND PEACE LORDS MAJESTICALLY OVER HER domain. Thomas Crawford's magnificently tall statue stands at the apex of the United States Capitol, planted firmly on top of the great rising dome, or *tholos,* that rises from the glistening white horizontal mass of the building below. Both the forms and the classical language of the Capitol make reference to the venerable monuments of the ancient world. But here on Jenkins Hill they receive new meanings and allow the building to project authority in all directions. The dome, initially a pagan image of the cosmos and then transformed into the heaven of the Christian cathedral, now in Washington, D.C., becomes a representation of the unity of democracy and the union of the states. Certainly the best-known American building, the Capitol serves as a functional structure housing the legislative branch of government, but it also serves a ceremonial function and acts as a symbol. As a symbol it resonates with many different voices and pitches.

Who owns or controls the Capitol and how it should be treated and interpreted have a long and contentious history. One significant shift in the meaning of the Capitol

For assistance in research I want to acknowledge and thank Barbara Wolanin, curator of the Capitol; William Allen, architectural historian of the Capitol; William Bushong, historian, White House Historical Association; and Charles Rosenblum and Claudine Hof of the University of Virginia.

came in the period between the 1950s and the 1990s. Although physically the building received what might be considered minor and even cosmetic changes, such as the moving of the east front forward about thirty feet, the rebuilding of the west front, the creation of new interior spaces, and the restoration of others, these changes indicated a profound reorientation in perceptions of the building. In a sense the Capitol disappeared and then reemerged, or metaphorically shed one skin for a new one. From being a structure capable of extension and remodeling, it took on a new character as a venerable historical landmark that must be preserved. This shift of meaning involved a tremendous variety of individuals, including historians, architects, patriotic groups, and politicians; but where the change came to be felt most profoundly is in the Office of Architect of the Capitol and its two principals, J. George Stewart (fig. 1) and George M. White (fig. 2), who served 1954–70 and 1971–96, respectively.

What the Capitol meant changed, or one might say the *consensus gentium*—the agreement of all enlightened men—or "general assent of the ages," broke down to be replaced by a new consensus. William Bushong in his essay in this volume has shown that although the two previous architects of the Capitol—Elliott Woods and David Lynn—were not architects, they went along with the suggestions of Charles McKim, Glenn Brown, and other professional architects. The exchanges for the most part were gentlemanly, and an accord existed between the architect of the Capitol and the leaders of the architectural community. This civility broke down under Stewart and a vituperative hostility emerged between the architectural community and the Office of Architect of the Capitol. Nobody agreed on how the building should be treated, and a state of siege warfare existed. But with White, a new agreement, or *consensus gentium,* was reached and the Capitol became a historical object. Although the shift was most profound in the period after 1954, the process had been under way for some time.

Although the U.S. Capitol up to the 1950s contained a venerable past and, of course, historic elements, it was not primarily viewed as a historic landmark, but as a functional building that could be altered as circumstances dictated. Some of the last work of David Lynn, architect of the Capitol from 1923 to 1954, involved remodeling and modernization of the decor of the House and Senate chambers, which caused no outcry.[1] Retrospectively, however, one can sense a change in the historical perception of the Capitol with Allyn Cox's completion of the rotunda frieze in October 1953. Begun in 1877, the frieze was uncompleted in 1950 when Cox was hired to finish it. A decision was made to complete the historical cycle of America with Leonardo da Vinci greeting the Wright Brothers' flight at Kitty Hawk.[2] Essentially, American history ended with the early twentieth century.

[1]"Streamlined Chambers Await Congress Today," *New York Times,* Jan. 3, 1950, p. 3.
[2]"Frieze in Capitol," *New York Times,* Oct. 26, 1953, p. 16; "President Dedicates," ibid., May 12, 1954, p. 18.

FIG. 1. J. George Stewart.
(Courtesy Office of Architect of the
Capitol.)

FIG. 2. George M. White, FAIA.
(Courtesy Office of Architect of the
Capitol.)

The closure symbolized with the rotunda frieze indicates a larger change occurring within American culture as a whole in the twentieth century. History, from being an abstract concept expounded upon by professional historians, or sought as validation by politicians, or taught as a necessity in elementary and secondary schools, became far more omnipresent in the daily lives of many Americans. This growth of history is in some sense a reaction to the increasing modernization of America, but it also is caused by modernism. Modernism requires the past; it creates or historicizes events, people, and things. Instead of the view predominate for parts of the nineteenth century in which America had no past—the virtual Eden of the *American Adam*—America began to acquire history in the later nineteenth and especially in the twentieth century.[3] History is of course the past, but as David Lowenthal has felicitously described it in *The Past Is a Foreign Country*, history became something almost alien, to be captured, saved, and preserved. In the modernist imagination the past differs markedly from the present: one has entered a new era fundamentally disconnected from earlier periods that were relegated to the status of "historical."[4] The modern imagination requires a past against which to react and to draw upon. Throughout the twentieth century the conception of what constitutes history has progressively expanded. American history crowded up to the front row, but a new type of American history that included far more than the traditional canon of politics, wars, and famous (dead white) males. This progressive enlargement of what was historical occurred as subjects formerly ignored or only of antiquarian interest—clothes, eating, furniture, women, minorities, and culture—began to attract historical attention. One subject in particular, an interest in architecture and old buildings, grew dramatically. The so-called historic preservation movement that had been largely the province of a wealthy elite became more homogenous after World War II.[5] A rise in historical interest came especially during times of tension, the Depression and then the Cold War. For many Americans, safety and respite were sought in history. It is within this context that the U.S. Capitol received a new meaning as a venerable landmark, especially within the architectural and historical community.

For much of its history—until the rise of modernism—the U.S. Capitol was viewed as a contemporary structure. Indicative of the changing perception of the Capitol are a series of polls conducted among practicing American architects of the most admired

[3]With apologies to R. W. B. Lewis, *The American Adam: Innocence, Tragedy, and Tradition in the Nineteenth Century* (Chicago, 1955); see also Warren I. Susman, *Culture as History: The Transformation of the American Society in the Twentieth Century* (New York, 1984); and Michael Kammen, *Mystic Chords of Memory: The Transformation of Tradition in American Culture* (New York, 1991).

[4]David Lowenthal, *The Past Is a Foreign Country* (Cambridge, Mass., 1985); and Jürgen Habermas, *The Philosophical Discourse of Modernity* (Cambridge, Mass., 1990).

[5]Charles B. Hosmer, Jr., *Preservation Comes of Age: From Williamsburg to the National Trust, 1926–1949* (Charlottesville, Va., 1981).

buildings. The first such poll came in 1885 and was conducted by the *American Architect and Building News,* which ranked H. H. Richardson's Trinity Church (1874–77) in first place and four more of his works in the top ten. The U.S. Capitol took second place, R. M. Hunt's W. K. Vanderbilt House (1878–82) occupied number three, and Richard Upjohn's Trinity Church (1841–46) was fourth.[6] Fifteen years later, in 1900, another poll, this time by the *Brochure Series,* listed the Capitol as number one.[7] A 1932 poll by the *Federal Architect* magazine, which in general supported classicism, ranked Henry Bacon's Lincoln Memorial (1911–22) number one; Shreve, Lamb and Low's Empire State Building (1929–31) number two; and the Capitol way at the bottom, somewhere below number twenty.[8] A 1948 poll by the American Institute of Architects, "What Buildings Give You a Thrill?," which ranked Paul Cret's Folger Library (1929–31) number one and the Lincoln Memorial number two, placed the Capitol at number sixteen, just one step above Frank Lloyd Wright's Falling Water (1935–37).[9] A more recent poll of architects conducted by the *AIA Journal* in 1976 placed Thomas Jefferson's University of Virginia (1814–26) at the top, with Rockefeller Center (1929–38) number two, and Dulles Airport (1958–62) and Falling Water tied for third. The Capitol stood at about number twenty-five—surprising given the bicentennial fervor of the mid-1970s.[10] These polls can be interpreted in many ways and reflect many different preoccupations and agendas. What they do reveal is that although classicist taste continued to reign in the United States among professional architects until after World War II, it was a very different type of classicism—a stripped or modernized classicism. From the 1880s to the late 1910s the Capitol served as a model to practicing architects; it stands behind the huge wave of state capitols and courthouses erected in those years.[11] But by the 1920s a new model appeared, symbolized by Bertram Goodhue's Nebraska State Capitol or the work of Cret at the Folger. The type of highly literal classicism based upon knowledge of the details of ancient Greek and Roman architecture passed from current relevance, and the Capitol as a touchstone of contemporary practice disappeared into a limbo, finally becoming a historical artifact.

Certainly some attention to the Capitol's history had existed among antiquarians, but a new interest emerged at the turn of the century among a group of *Beaux-Arts* oriented architects who also acted as historians. Led by Glenn Brown, who produced a monumental book, they were primarily concerned with the Thornton-Latrobe-

[6] "The Ten Best Buildings in the United States," *American Architect and Building News* 17 (1885):282–83.

[7] "The Ten Most Beautiful Buildings in the United States," *Brochure Series* 1 (1900):204.

[8] "What Are the Outstanding Buildings?" *Federal Architect* 2 (1932):7–10.

[9] E. B. Morris, "What Buildings Give You a Thrill?" *Journal of the AIA* 10 (1948):272–77.

[10] "Highlights of American Architecture," *AIA Journal* 65 (1976):91–151.

[11] Henry-Russell Hitchcock and William Seale, *Temples of Democracy: The State Capitols of the U.S.A.* (New York, 1976).

Bulfinch building.[12] Brown and his cohorts, such as Wells Bennett and Fiske Kimball, were looking to their studies as guides for contemporary practice and viewed the system of architecture that had produced the Capitol as containing continuing validity.[13] A shift occurred in the 1930s as architects dropped out of writing about the Capitol and professional historians began to treat it.

The reorientation is important since the building now tends to be treated as an artifact and to disappear from public view. The new history usually appears either in obscure journals or as doctoral dissertations.[14] An exception is Talbot Hamlin's 1955 Pulitzer Prize–winning biography of Latrobe that considers the Capitol as one of many buildings.[15] However, the primary interest of all of these historians lay with the Thornton-Latrobe-Bulfinch Capitol and not the one that existed up on Jenkins Hill. Beginning in the 1970s the Capitol reemerged in architectural scholarship, as will be noted later. Spurred by the bicentennial, interest began to emerge in the total building and also the artwork, though it is fair to say that most concentration lay with the building's pre–Civil War history.

The cause for this shift in interest in the Capitol and its transference into a historical relic has many facets. In a larger or cosmic sense it involves the new, or modern, conceptions of history that emerged in the twentieth century as outlined above. But cosmic changes always involve the specific, and to some degree the new historicized Capitol involves the Office of Architect of the Capitol and its personnel. There also emerged in the twentieth century layers of constituencies involved in the process of making official architecture.

All buildings constructed under federal patronage and especially those erected in the historic core of Washington on the Mall, such as the U.S. Capitol, represent a web of constituencies: politicians, protectors, users, and architects. These constituencies, although frequently overlapping, are stratified or are a hierarchy.[16] First and foremost exists the political constituency, the politicians on the Hill and their power and egos, and their attempt to make a mark, to create memorials to themselves. In the case of the

[12]Glenn Brown, *The History of the United States Capitol,* 2 vols. (Washington, D.C., 1900–1903); U.S. House of Representatives, *Documentary History of the Construction and Development of the United States Capitol Building and Grounds,* 58th Cong., 2d sess., 1904, H. Report 646.

[13]Wells Bennett, "Stephen Hallet and His Designs for the National Capitol, 1791–94," *Journal of the American Institute of Architects* 4 (1916):290–93, 324–30, 376–83, 411–18; Fiske Kimball and Wells Bennett, "William Thornton and the Design of the United States Capitol," *Art Studies* 1 (1923):76–92.

[14]Paul F. Norton, "Latrobe, Jefferson and the National Capitol," Ph.D. diss., Princeton University, 1952; Turpin C. Bannister, "The Genealogy of the Dome of the United States Capitol," *Journal of the Society of Architectural Historians* 7 (1948):1–31; Homer T. Rosenberger, "Thomas Ustick Walter and the Completion of the United States Capitol," *Records of the Columbia Historical Society* 50 (1952):273–322.

[15]Talbot Hamlin, *Benjamin Henry Latrobe* (New York, 1955).

[16]For an earlier treatment of this theme, see my "High Noon on the Mall," in *The Mall in Washington, 1791–1991,* ed. Richard Longstreth (Washington, D.C., 1991), pp. 143–67.

Capitol, the east front extension, or the so-called "Texas Front," and the Rayburn House Office Building are particular examples of the power of Sen. Lyndon B. Johnson and Rep. Sam Rayburn, both Texas Democrats, who served, respectively, as Senate majority leader and Speaker of the House during the 1950s. Nothing gets done without the consent of the power hierarchy in Congress.

The next strata, the protectors—individuals, either official or self-appointed—view it as their mission to safeguard the integrity of a building or landscape. Governmental examples would be the Commission of Fine Arts or the National Capital Planning Commission, but Congress exempted itself from their oversight, although the Commission of Fine Arts did get involved in the west front controversy. Self-appointed examples include independent preservation organizations and interested individuals, such as architecture writers and historians, including Glenn Brown at the turn of the century, and more recently Douglas Haskell of *Architectural Forum* magazine and Ada Louise Huxtable of the *New York Times*.

Lower in the hierarchy comes the user, or the realization that a building such as the Capitol or the various legislative office buildings might actually be used. Buildings are signs and symbols, but they also contain functional activities, which always rank lower in the Washington hierarchy.

Finally, and lowest on the totem pole, exists the constituency of architecture. Professionally, architects are always beholden to their patrons, and although some high-profile architects might challenge the aesthetic preferences of their clients, in the setting of Washington, D.C., they are always last. The architect of the Capitol in the period under consideration was appointed by the president but served at the pleasure of the leaders of Congress. How well the Capitol architect served those leaders was the main criterion for remaining in that position. Politics dominated any aesthetic considerations.

The case of J. George Stewart (1890–1970) illustrates how this hierarchy played out. A tendency exists to treat him as a buffoon, to lampoon him as he was treated by much of the architectural press during his tenure as architect of the Capitol. He had the hide of an elephant to withstand all of the criticism. To many of his critics, Stewart's fatal flaw was that he was not an architect—which they never tired of pointing out—and certainly the issue of professional jealously contributed to their antagonism. But the real issue was that Stewart and his patrons' idea of architecture—principally that of Speaker of the House Rayburn and Senate majority leaders such as Johnson—lay at odds with the aesthetic of the protectors. Stewart saw the Capitol the same way Thomas U. Walter had, as a working building that needed to be brought up to date, not as a historical relic. His idea of contemporary architecture lay back in the 1920s and not in the 1950s and 1960s, when classicism was considered passé, replaced by modernism in all of its varieties.

Stewart's supporters included perhaps the most powerful twentieth-century Speaker of the House, Rayburn, and his successor, John McCormack (D-MA), along with House Armed Forces chairman Carl Vinson (D-GA), House Minority Leader Gerald R. Ford (R-MI), and Senate minority leaders William F. Knowland (R-CA) and Everett McKinley Dirksen (R-IL), and many others. Assiduous in the cultivation of power, Stewart deftly handled and provided for the comfort of the leaders. Reportedly, when John F. Kennedy became president in 1961 he intended to fire Stewart. However, in his first meeting with Kennedy after the inauguration, Rayburn is reputed to have said: "Now, Mr. President, I want you to keep George Stewart. He's a good man, and I want him to stay on the job."[17]

The principal battles of Stewart's reign lay around the east front extension, the proposed west front extension, the construction of two legislative office buildings—the Dirksen Senate Office Building (1955–58) and the Rayburn House Office Building (1955–65), and the planning of the James Madison Building for the Library of Congress. Under Stewart's reign the Office of Architect of the Capitol increased significantly in size to number more than two thousand employees.

Stewart came from Wilmington, Delaware. He studied civil engineering at the University of Delaware and left during his junior year to enter his father's heavy construction company, Stewart and Donohue, one of the largest in the mid-Atlantic region, known for highways, bridges, factories, and residences. He had business and personal ties with the duPont family and had worked for Henry F. duPont at Winterthur, and for Alfred duPont at the gardens at Nemours and at the Hagley Museum site. In 1934 he was elected to the House of Representatives on the Republican ticket (in an election in which the Republicans lost fourteen seats in the House) and served one term. He returned to Washington in 1947 as the chief clerk of the Senate Committee on the District of Columbia and continued as a staff member during the Democratic Eighty-first Congress (1949–51). He was active in the Republican presidential campaigns of 1944, 1948, and 1952 and served as director of the Republican Speaker's Bureau for 1953–54. On August 7, 1954, David Lynn retired after thirty-one years as architect, and a few days later, on August 16, President Dwight D. Eisenhower announced he would appoint the sixty-four-year-old Stewart as architect of the Capitol on October 1, 1954.[18]

The east front extension project went all the way back to Thomas U. Walter's work during the mid-nineteenth century. It had been redesigned at the turn of the century

[17]"J. George Stewart Dies at 79: Controversial Capitol Architect," *New York Times,* May 25, 1970, p. 33. See also D. B. Hardeman and Donald C. Bacon, *Rayburn* (Austin, Tex., 1995).

[18]*New York Times,* Aug. 8, 1954, p. 28; ibid., Aug. 17, 1954, p. 10. On Stewart, see my entry in *Dictionary of American Biography* (New York, 1988), Suppl. 8:629–31.

FIG. 3. East front of Capitol prior to enlargement. *(Courtesy Office of Architect of the Capitol.)*

by Carrere and Hastings, who produced two plans for extending the east front, one twelve feet, the other thirty-two feet; they actually preferred the shorter one.[19] Throughout the 1930s and 1940s the idea of an extension periodically raised its head.[20] The problem involved Walter's dome, which sat uneasily on the central section of the east front, actually overhanging its base by about fifteen feet, nine inches (fig. 3). The original sandstone walls of the Thornton-Latrobe-Bulfinch front had deteriorated, and Stewart wanted to move the center section ahead—to the east—and rebuild it in marble. Initially, Stewart proposed a forty-foot extension that would project the center slightly in front of the flanking Senate and House facades. As the center of the composition and the principal entrance with its grand flight of stairs, this redesign had a classicist lineage. After considerable study, the proposal was modified to move the wall forward thirty-two and one-half feet, nearly in alignment with the Senate and House facades. On the interior, new office space and other facilities—principally a restaurant (lines

[19]Carrere and Hastings, *Supplementary Report on the Extension and Completion of the United States Capitol in Relation to the Dome* (New York, 1904).
[20]Minutes of the Commission of Fine Arts, Apr. 25, 1935, p. 14, Commission of Fine Arts, Washington, D.C.; ibid., Mar. 16, 1949, p. 6. Egerton Swartwout, "The Extension of the East Front of the Capitol," *Octagon* 9 (1937):16–22.

were reported as too long)—would be constructed. Controversy swirled around this extension for years, with the principal opposition concentrating on three factors: the cost, the destruction of the original Thornton-Latrobe-Bulfinch facade, and aesthetics.

Opposition to Stewart's advocation of the extension began to appear in early 1956, when Jane Jacobs, at that time a staff writer for *Architectural Forum,* the most influential and thoughtful architectural magazine of the period, wrote a long article on Washington, D.C., and its future. She bemoaned the state of planning and architecture in the town, focused on preservation issues—a novelty for the architectural press in the 1950s—and then noted the plans for the east front: "One of these days, unless a miracle of public awakening intervenes, the wrecking crews will begin tearing down the finest and most beloved face of the Capitol." She blasted the idea of lining up the center to harmonize with the House and Senate wings by Walter; indeed, to Jacobs, Walter's wings were "much inferior, more textbookish."[21] Jacobs acknowledged the problem of the overhanging dome but argued that the visual flaw was part of its charm —the naive quality—of the Capitol. Jacobs quoted the Washington, D.C., architect Lorimer Rich, who formed the Committee to Preserve the National Capitol, one of the earliest examples of this type of preservation guerrilla warfare: "You may remedy this one feature but the cost in sentiment, history and beauty is too great. The dome now comes all the way down to the ground and this enhances the feeling of grandeur so noticeable when standing in front the Capitol. This is a most happy accident."[22]

The argument of aesthetic naïveté on the Capitol's east front became standard: one viewed the east front from up close, as during presidential inaugurations (until Reagan's in 1981 they took place on the east front), and the dome loomed up overhead creating an extremely impressive backdrop. Extending the east wall and portico forward would lose the drama, or the sublimity of the aesthetic experience of the dome rising up as an almost sheer wall from ground level reaching to the sky.

The next month, Douglas Haskell, the editor of the *Architectural Forum,* wrote an editorial blasting the idea of "correcting" the east front, "a prize piece of architectural boondoggling and folly, tearing down and extending the Capitol for the hell of it."[23] That Haskell, one of the great champions of modern architecture in America, would come out on the side of preservation needs some explanation.[24] Essentially, he argued against the idea of textbookish corrections, or he was anticlassicist; that system Haskell

[21]Jane Jacobs, "Washington," *Architectural Forum* 104 (1956):104.

[22]In addition, Rich wrote a letter that was published: "Letters to the Times," *New York Times,* Feb. 10, 1958, p. 22.

[23]"For *All* Concerned: Leave the Capitol Alone," *Architectural Forum* 104 (1956):166.

[24]Background can be found in Robert Benson, "Douglas Haskell and the Criticism of International Modernism," in *Modern Architecture in America,* ed. Richard Guy Wilson and Sidney K. Robinson (Ames, Iowa, 1991), pp. 164–83.

believed was dead, and the Capitol was now caught in historical circumstance; it was a relic that never should be tampered with. This idea of pastness is of course essential to the idea of modernism and is one of the reasons why historical preservation emerged in these years.

Arguments went back and forth. Stewart, of course, countered with various reasons such as the argument that the old east front's sandstone walls were unsafe. His lead architect, Roscoe P. DeWitt, claimed safety as a reason for the extension and that the overhanging dome was a "joke"; historical inevitability lay with the extension.[25] But arrayed against him were many individuals and groups. The American Institute of Architects (AIA) voted at their national meeting in 1957 to preserve the east front, and Ralph Walker, who was voted "Architect of the Century" at that meeting, wrote an article claiming that the extension would be an "act of artistic ruin reminiscent of the destruction of the Parthenon by the Turks."[26] The Society of Architectural Historians, the Daughters of the American Revolution, and others joined the AIA in condemning the extension.[27] Stewart assembled a group of "advisory architects" who he believed would support his position and announced they "recommended" the extension. However, *Architectural Forum* obtained a copy of the report and discovered that the directive to the advisory architects said: "Whether or not to move out the east front would not be a matter for discussion as this had been decided already by an Act of Congress." Hence, their directive was to determine the "ways that will be *least detrimental* to the beauty of the east front." *Architectural Forum* also learned that Arthur Brown, Jr., a leading West Coast classicist who designed the Interdepartmental Auditorium in the Federal Triangle, and who had been an original member of the advisory group, had told an interviewer he disagreed with the extension. Brown had died before the report was signed, but in an interview he claimed the proposed extension would ruin the dome–east front relationship and said: "It would seem ridiculous, in the face of constant and overwhelming opposition from professional architectural groups to any extension, to proceed."[28]

Stewart counterattacked with his own campaign of articles and letters. Gilmore D. Clarke, a distinguished landscape architect and for years chair of the Commission of Fine Arts and a member of the advisory architects, wrote a long letter to the *New York Times* citing the fact that many architects (all dead) such as Thomas U. Walter, John Russell Pope, Charles Adams Platt, William Mitchell Kendall, and others all supported

[25]Roscoe P. DeWitt, "Extension of the East Front of the Capitol," *Journal of the AIA* 29 (1958):268–77. The quote is on p. 272.

[26]Ralph Walker, "If This Be Sentiment . . . ," *AIA Journal* (1958):278–84. The quote is on p. 279.

[27]"New Group Fights Change in the Capitol," *New York Times,* Jan. 13, 1958, p. 29; "Capitol Plan Fought," ibid., Feb. 1, 1958, p. 8; "D.A.R. Says Nation Should Quit U.N.," ibid., Apr. 18, 1958, p. 10.

[28]"Public Building," *Architectural Forum* 107 (1957):6–7. See also Richard Guy Wilson, "Precursor: Arthur Brown, Jr., California Classicist," *Progressive Architecture* 64 (1983):64–71.

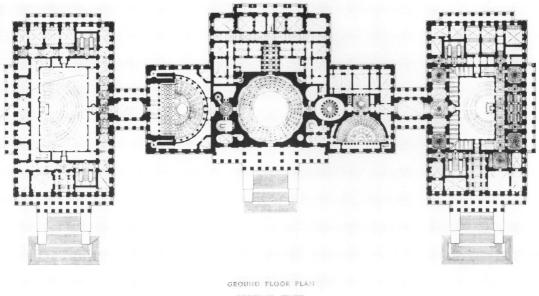

GROUND FLOOR PLAN
PRESENT STATE

FIG. 4. Comparative ground floor plans of Capitol, (a) prior to, and (b) after east front extension. *(Courtesy Office of Architect of the Capitol.)*

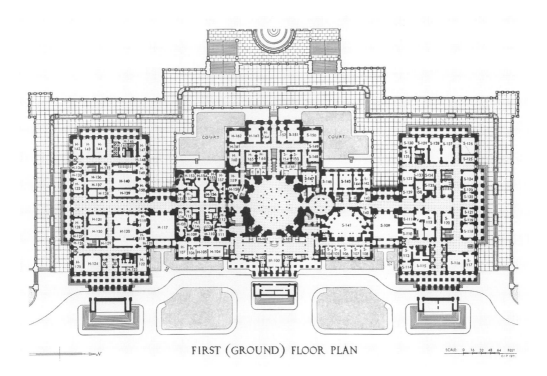

FIRST (GROUND) FLOOR PLAN

SCALE: 0 16 32 48 64 FEET
O.I.P. 1971.

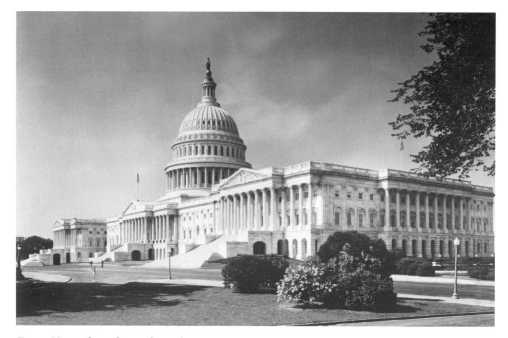

FIG. 5. View of east front after enlargement. *(Courtesy Office of Architect of the Capitol.)*

the idea of the east front extension.[29] Of course the east front extension did go ahead. Speaker Rayburn supported it and between July 1959 and February 1961, at a cost of more than $11 million the east front moved forward thirty-two and one-half feet (fig. 4). The old sandstone walls were preserved inside the new white marble front (fig. 5).

However, the press, both architectural and popular, had found a target, and Stewart continued to face a barrage of hostile criticism. Haskell and *Architectural Forum* published articles with such titles as "The Emperor of Capitol Hill" that caricatured his work at the Rayburn Building.[30] *Life* magazine got into the act; an editorial from 1965 exclaimed, "Get Our Capitol a Real Architect!"[31] And other popular periodicals, such as *Newsweek, Harper's,* and *Fortune,* piled on.[32] The *Atlantic Monthly* joined in with an article caricaturing Stewart along with House Speaker John McCormack and Vice President Hubert Humphrey as devotees of ugliness.[33] Locally, Stewart and his work became a favorite topic of the *Washington Post* and its architectural columnist,

[29]"Capitol Changes Approved," *New York Times,* Mar. 24, 1958, p. 26.
[30]*Architectural Forum* (1958):80–84.
[31]Editorial, "Get Our Capitol a Real Architect!" *Life,* July 9, 1965, p. 4.
[32]"Build He Must," *Newsweek,* July 4, 1968, p. 18; "Stewart's Plot against the Capitol," *Harper's* 66 (1966):40–44; Harold B. Meyers, "A Monument to Power," *Fortune* 71 (1965):122–25, 174–78.
[33] "Capitol Hill's Ugliness Club," *Atlantic Monthly* 219 (1967):60–66.

Wolf von Eckardt.[34] However, the principal opponent who emerged from the debate was the architectural columnist for the *New York Times,* Ada Louise Huxtable.[35]

Not an architect but an architectural historian, Huxtable had done graduate study at the Institute of Fine Arts in New York and then served as assistant curator of architecture under Philip Johnson at the Museum of Modern Art in New York. Her specialty lay with twentieth-century modernism and especially Italian architects such as Pier Luigi Nervi.[36] Through her position as the *Times* architecture critic, she became interested in historic preservation and became one of its leading advocates, though at the same time remaining true to the idea that the twentieth century required a modern architecture free from history. The *New York Times* and Huxtable became Stewart's most formidable antagonist. Between 1958 and 1970, fourteen editorials—some on Sundays for wider exposure—and several magazine articles critical of Stewart appeared in the *New York Times.*[37] Stewart's death in 1970 did not lessen the *Times's* scrutiny of the Capitol's architect, and columns by Huxtable and others maintained a critical watchdog stance.

That the national press, which usually ignored architectural matters, became interested in the aesthetics of the Capitol indicates how much public consciousness concerning historic preservation rose in the 1960s and 1970s. Assisting in the interest were the urban renewal programs of those years and the resultant dismay at the destruction of many neighborhoods and older buildings. In 1966 significant historic preservation legislation mandated certain actions by the states and the federal government, although Congress excused itself. An irony certainly exists in that Lyndon Johnson's Great Society programs included both urban renewal and historic preservation. However, the feeding frenzy of the press over Stewart and his Capitol Hill mentors also indicates

[34]"Vandalism on the Hill," *Washington Post,* Dec. 5, 1965; "A National Outrage," ibid., June 19, 1966; "The Temple Profaned," ibid., June 21, 1966; Wolf von Eckardt, "'Tragic Disfiguration' Seen for Capitol," ibid., June 18, 1966.

[35]Ada Louise Huxtable, "Capitol Remodeling Arouses Criticism," *New York Times,* Feb. 16, 1958, sec. 2, p. 14.

[36]Interview with Ada Louise Huxtable, Apr. 13, 1977; see Huxtable, *Masters of World Architecture: Pier Luigi Nervi* (New York, 1960).

[37]The following list of *New York Times* editorial page citations does not include Huxtable's and other reporters' articles that appeared elsewhere in the *Times:* "Capitol Folly," Feb. 16, 1958, sec. 4, p. 8; "Save the Capitol," Mar. 7, 1958, p. 22; Mar. 13, 1958, p. 28; Arthur Krock, "In the Nation: The Ways and Means of Speaker Rayburn," Mar. 20, 1958, p. 28; "Let Bad Enough Alone," Apr. 12, 1962, p. 34; "Capitol Remodeling," May 11, 1962, p. 30; "Farewell to the Capitol," June 26, 1966, sec. 4, p. 8. For Ada Louise Huxtable, see "Extending the Debate over Extending," *New York Times,* Aug. 1, 1966, p. 26; "Excluding the Capitol," ibid., Aug. 13, 1966, p. 24; "Change the Rules," ibid., Aug. 21, 1966, p. 14; "The Emperor of Capitol Hill," July 19, 1968, p. 34; "Capitol Outrage," ibid., Sept. 14, 1969, sec. 4, p. 12; "Capitol Crime," ibid., Oct. 6, 1969, p. 465; "Affront to the Capitol," ibid., Oct. 21, 1969, p. 46. In addition other important articles are Robert Sherrill, "Architect, Spare Our Capitol,'" *New York Times Magazine,* Apr. 16, 1967, pp. 30–31, 124–33; and "Wanted: Curator for Art in Capitol," *New York Times,* Apr. 21, 1967, p. 41.

FIG. 6. Mario Campioli.
(Courtesy Office of Architect of the Capitol.)

another change, the new and more adversarial relationship of the press toward politicians in these years; the clubby atmosphere that had ruled from earlier in the century disappeared and attack became more the order of the day. Spurring on this change were the astronomical budgets for some of the projects: the Rayburn House Office Building, whose cost was never really stated, started with a $7.5 million appropriation and rose to a reported $86.4 million. The truth however may be closer to $150 million.[38] And finally, the charges of political cronyism, not just among architects but also among contractors who tended to be a small, select group with powerful connections, always provide fodder for the press.

Stewart and his political patrons remained undaunted by the controversy over the east front and immediately returned to the fray with a proposal for extending the west front. In addition to the ever-present issue of needing more interior space for legislative offices and committee rooms, Stewart argued that the old sandstone of the west front was crumbling and unsafe.[39] The Commission of Fine Arts, prohibited unless

[38]Accurate costs and when they were estimated are difficult to obtain; these are based upon Meyers, "A Monument to Power."

[39]Wilfred J. Gregson, "Extending the Capitol's West Front: A Move toward Safety," *Capitol Dome* 4 (1969):2–4.

invited from commenting on Capitol issues, got into the act and commissioned an engineering report that claimed the west front walls could be preserved. The commission intervention caused an uproar, and Congress made the individual commission members pay for the study.[40]

From 1962 until Stewart's death in 1970, the west front extension controversy received much press coverage, most of it negative. Stewart under siege gave one of his classic retorts: "I have no comment on anything—any part of it, I'm only a working stiff here."[41] Stewart could play the public relations game, however, and got an organization known as the Society of American Registered Architects, which had few members, to issue a report backing the extension. Then he persuaded *Science & Mechanics* magazine to report favorably on his position with a front cover showing a wobbly dome and headlines screaming: "Leading Architect Says: 'The Capitol Is Doomed!'"[42]

The local Washington historical society gave Stewart's assistant Mario E. Campioli a forum to press the extension argument (fig. 6). In addition to space as a reason, Campioli claimed that the dome overweighed the whole lower structure both visually/aesthetically and also structurally. Campioli also noted that back in the late 1950s, when the east front extension came under attack, Ralph Walker, who had severely criticized it, argued that the Capitol should be extended to the west, "where there is not a great architectural masterpiece to be preserved." Campioli's respondent counterattacked, invoking the hallowedness of the original building and comparing the proposed extension to the unfortunate addition by Carlo Maderno to Saint Paul's in Rome, which "obscured a full view of Michelangelo's dome."[43]

In addition to work on the Capitol, Stewart remodeled the Longworth House Office Building and constructed the Dirksen Senate Office Building (fig. 7) and the Rayburn House Office Building. Although criticism can be leveled at the two congressional office buildings, underlying the problem was the question of architectural idiom or style and who served as the associate architects. Although Stewart was always listed as architect, the actual design came from nongovernment architects hired for the job. All of the architects who worked under Stewart can be described as beaux-arts oriented; they were trained at either the French Ecole des Beaux-Arts or an American derivative and were exposed to what by the 1950s came to be known as traditional architectural values, not modernism. The architects of the Dirksen Building

[40]Interview with Charles Atherton, secretary of the Commission of Fine Arts, Aug. 22, 1995; Minutes of the Commission of Fine Arts, Jan. 1, 1966, Apr. 18, 1966, Apr. 20, 1966; D. L. Scantlebury, United States General Accounting Office, to William Walton, Chairman, Commission of Fine Arts, July 14, 1967, Commission of Fine Arts.

[41]"Plan to Extend Capitol Scored," *New York Times,* June 24, 1966, p. 22.

[42]*Science and Mechanics,* Apr. 1969, cover.

[43]Mario E. Campioli, "The Proposed Extension of the West Central Front of the Capitol," and Charles McLaughlin, "The Capitol in Peril? The West Front Controversy from Walter to Stewart," *Records of the Columbia Historical Society* 47 (1969–70):212–36, 237–65. The quote is from p. 265.

were Eggers and Higgins, the successors to John Russell Pope—who were well known in Washington for having carried out the National Gallery and the Jefferson Memorial after Pope's death. Much of the design work for the Capitol took place under the banner of the firm of DeWitt, Poor and Shelton. Roscoe P. DeWitt had a large Dallas office and connections to the Texans on Capitol Hill. Alfred Poor was from New York and had his own congressional connections. Jesse M. Shelton came from Atlanta and enjoyed the patronage of Congressman Carl Vinson. At other times, other architects were added to the stew. DeWitt joined with his partner Fred L. Hardison (who also was involved with the east front) to remodel the Cannon House Office Building and design its garage. Poor joined with Albert H. Swanke of New York (who had worked on the east front extension), to remodel the Longworth House Office Building. The Rayburn Building's architects were the Philadelphia firm of Harbeson, Hough, Livingston and Larsen (H2L2), the successors to Paul Cret and one of the darlings of Washington, D.C., classicists. They had acted at various times as consultants on the Capitol extensions. In many ways it was a tight little group, and of course those outside wanted to get in. And all of these individuals also were part of the old guard, or as Huxtable commented, "the last gasp of the early 20th-century academic establishment," committed classicists who were opposed to the new modernist wave dominating American architecture in these years.[44] In truth there was nothing wrong with these architects, they were simply out of touch with the modernist spirit of the times.

Campioli, who joined Stewart's staff in 1969 and pressed many of the arguments for the west front extension, emerged as a key player. Trained as a classicist under the beaux-arts system in place at Columbia University and then in the office of Dwight James Baum, he had been a member of Eggers and Higgins and worked on the National Gallery and the American Red Cross buildings in Washington. He produced the first design for the Dirksen Building in 1947–49. Campioli then had been director of architecture at Colonial Williamsburg, 1949–57; directed the restoration of the Van Cortlandt Manor at Croton, New York; and in 1957–59 acted as the project director for the east front extension under DeWitt, Poor and Shelton. He then moved to Stewart's staff to follow the project through. He remained with the Capitol architect's office working on the proposed west front, and while Stewart was sick during his last year, he was acting architect of the Capitol. Campioli knew classicist-traditionalist architecture, but he was among the last of a dying breed.[45]

[44]Ada Louise Huxtable, "Capitol Architect Comes under Attack over His Plans for New Library," *New York Times,* July 27, 1966, p. 20.
[45]Information from the files of the Office of Architect of the Capitol. See also Mario E. Campioli, "An Historic Review and Current Proposals for the Nation's Capitol," *AIA Journal* 39 (1963):49–53; and idem, "Thomas U. Walter, Edward Clark, and the United States Capitol," *Journal of the Society of Architectural Historians* 23 (1964):210–13.

PLATE 1.
Brumidi's first room in the
Capitol. The room originally
decorated for the House Committee
on Agriculture includes illusionistic
carved stone and gilded frames
that are actually flat. *(Courtesy Office
of Architect of the Capitol.)*

PLATE 2.
Room decorated for the Senate Naval
Affairs Committee in the Pompeiian
style. The floating maidens on the walls
are directly inspired by figures found in
Pompeii. *(Courtesy Office of Architect of the
Capitol.)*

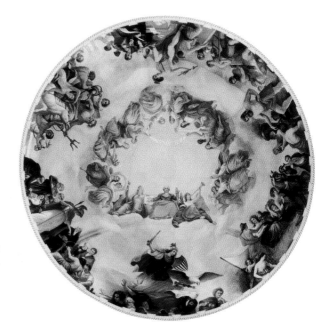

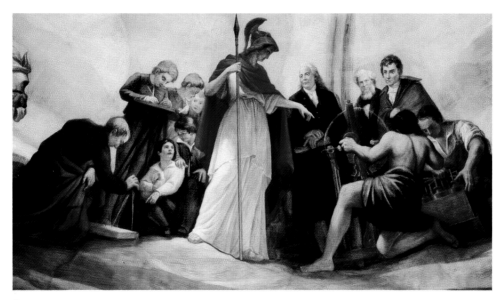

PLATE 5.
"Science." Minerva counsels Benjamin Franklin, Samuel F. B. Morse, and Robert Fulton.
(Courtesy Office of Architect of the Capitol.)

PLATE 6.
"Marine." Neptune with trident in hand rides across the ocean.
(Courtesy Office of Architect of the Capitol.)

PLATE 7.
"Commerce." Brumidi signed and dated his fresco in the scene where Meigs's portrait was removed. *(Courtesy Office of Architect of the Capitol.)*

PLATE 8.
Test windows made by conservator. The painstaking scraping off of layers of overpaint revealed the dramatically different colors and details painted under Brumidi's direction.
(Courtesy Office of Architect of the Capitol.)

PLATE 9.
Overview of the Brumidi corridors
in the Senate wing of the Capitol.
*(Courtesy Office of Architect of the
Capitol.)*

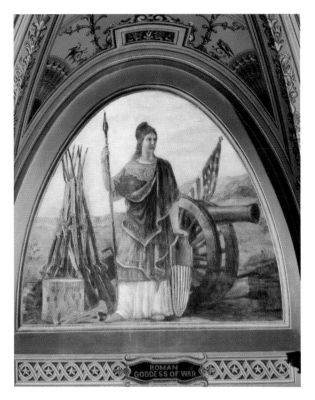

PLATE 10.
Constantino Brumidi, *Bellona,
Roman Goddess of War. (Courtesy
Office of Architect of the Capitol.)*

PLATE 11.
Cross section of a sample from the drapery of *Bellona, Roman Goddess of War.* Note the blue particles, apparently applied *affresco.* Top layers are additions applied *a secco.* SEM/EDS analysis of the blue pigment indicates smalt. *(Courtesy the author.)*

PLATE 12.
Photomicrograph of a sample from the yellow binding of the figure's toga indicates fresco with lime-enforced modeling in yellow. *(Courtesy the author.)*

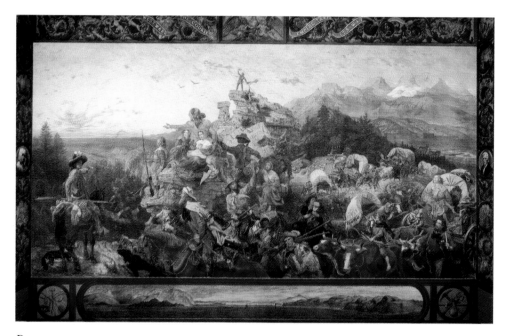

PLATE 13.
Westward the Course of Empire Takes Its Way, mural, 1862, water-glass painting, 20 by 30 feet, House wing, west stairway, U.S. Capitol. *(Courtesy Office of Architect of the Capitol.)*

PLATE 14.
Detail of the African American boy in the 1862 *Westward Ho!* mural.
(Courtesy Office of Architect of the Capitol.)

PLATE 15.
Detail of the American eagle and the allegorical figures of liberty and union
in the upper margin of the ornamental border of *Westward Ho! (Courtesy Office
of Architect of the Capitol.)*

Plate 16.
Albert Bierstadt, *Discovery of the Hudson River,* 1874, oil on canvas, 6 by 10 feet, U.S. Capitol; formerly hung in the chamber of the House of Representatives; presently in the members' dining room. *(Courtesy Office of Architect of the Capitol.)*

Plate 17.
Albert Bierstadt, *Settlement of California, Bay of Monterey, 1770,* 1876, oil on canvas, 6 by 10 feet, U.S. Capitol; formerly hung in the chamber of the House of Representatives; presently in the members' private stairway, west corridor. *(Courtesy Office of Architect of the Capitol.)*

Fig. 7. Dirksen Senate Office Building, west facade, 1947–58, Eggers and Higgins. *(Courtesy Office of Architect of the Capitol.)*

How far removed Capitol Hill aesthetics was from the professional architects can be seen in comparing a 1962 rendering for the Madison Building of the Library of Congress (fig. 8) with the recently completed Air Force Academy Chapel in Colorado Springs (fig. 9).[46] Although the architects substantially redesigned the exterior of the Madison Building (fig. 10), simplifying the colonnade into straight unornamented piers, the new design still found no favor with the critics; Huxtable called it "another mammoth mock-classical cookie from the architect of the Capitol's well-known cookie cutter for gargantuan architectural disasters."[47] The protectors wanted modern architecture on Capitol Hill. Charles Atherton, the secretary of the Commission of Fine Arts, pointed out in testimony to a House of Representatives subcommittee in 1966 that leading modernists such as Marcel Breuer, Kevin Roche, Mies van der Rohe, Gyo Obata, Eero Saarinen, and others had been recently commissioned to design new federal buildings, but the architect of the Capitol seemed stuck with a group of outmoded classicists.[48]

The Rayburn House Office Building became the lasting landmark to Stewart and his mentor's reign of power on the Hill (fig. 11). A mammoth undertaking whose construction took nearly ten years (1955–65) and, as noted, whose cost rose dramatically,

[46]"Capitol Architect Comes under Attack over His Plan for New Library," *New York Times,* July 27, 1966, pp. 1, 20, has the rendering.
[47]Ada Louise Huxtable, "Full Speed Backward," *New York Times,* Sept. 24, 1967, sec. 2, pp. 21, 26.
[48]Statement of Charles H. Atherton to U.S. House of Representatives, Special Subcommittee on Labor of the Committee on Education and Labor, Aug. 4, 1966, p. 159.

FIG. 8. Preliminary design for James Madison Memorial Library, ca. 1962, DeWitt, Poor and Shelton. *(Courtesy Office of Architect of the Capitol.)*

FIG. 9. Chapel, Air Force Academy, Colorado Springs, Colorado, 1955–63, Skidmore, Owings and Merrill. *(Courtesy Richard Longstreth.)*

Fig. 10. James Madison Memorial Library, north entrance facade, as completed 1962–80, DeWitt, Poor and Shelton. *(Courtesy Office of Architect of the Capitol.)*

it has found few defenders. A large building, the Rayburn contains 169 three-room suites for congressmen, nine large hearing rooms, a three-level parking garage for sixteen hundred cars, a gymnasium, a swimming pool, and acres of colossal corridors. Sam Rayburn (who died in 1961) made many of the decisions on the building himself (a statue of him stands at the main entrance). William Livingston of the associated design architectural firm Harbeson, Hough, Livingston and Larsen died a broken man from the experience.[49] Rayburn's personal oversight and taste—more is better—and dictatorial edicts concerning changes led to the vast areas of unrelieved flat marble panels that become the dominant image and features such as monumental staircases that lead nowhere. The sculptural embellishments by C. Paul Jennewein tend toward the massive almost fascist visages and muscular torsos favored by sculptors of the WPA thirty years earlier (fig. 12). A 1993 guidebook called the building "Washington's most maligned public building" and cited it as a "bombastic, architectural expression of raw, arrogant, and uncontrolled power."[50] Earlier critics characterized it as

[49]Interview with Paul Cret Harbeson and Charles Ward of Harbeson, Hough, Livingston and Larsen, Jan. 6, 1984.
[50]Pamela Scott and Antoinette J. Lee, *Buildings of the District of Columbia* (New York, 1993), pp. 136–37.

Fig. 11. Rayburn House Office Building, west front, showing the staircase and garage. *(Courtesy Office of Architect of the Capitol.)*

Fig. 12. Rayburn House Office Building, north entrance with exterior statues by C. Paul Jennewein. *(Courtesy Office of Architect of the Capitol.)*

"Edifice Rex," "King Hottentot's Temple," and its style as "Texas penitentiary" and "Mussolini modern."[51] The Rayburn became the favorite building to hate; it took the place of a similar building from almost a century earlier, the State, War, and Navy Building, 1871–88 (now the Executive Office Building, or EOB), which had been universally despised and came to symbolize the political excesses of the Grant administration and the Gilded Age.[52] Over the years many individuals wanted to either demolish or severely remodel the offending structure that stood on the western side of the White House, but by the 1960s it began to acquire the status of a venerable landmark, recalling the line of a character in the movie *Chinatown:* "Politicians, ugly buildings, and whores are respectable if they last long enough."[53] President John Kennedy ordered the EOB saved, and a process of slow restoration began. The transformation of the Rayburn Building into a loveable landmark and its restoration remains far in the future.

Stewart died while in office May 24, 1970, though he had been sick the last couple of years and Mario Campioli essentially had run the show. Although Campioli's sentiments lay with the classicist camp and with the west front extension that he had designed, still he projected in a 1962 talk that the Capitol might someday become "a ceremonial structure, a museum," and that a "more modern, streamlined Capitol Building" might be built eastward on Capitol Hill.[54] The idea of a new Capitol was fanciful, but Campioli recognized both from a functional point of view and also sentimentally that the days of extending the Capitol were drawing to a close. The building had become an artifact.

The uproar created over Stewart not being an architect led President Richard Nixon to ask Daniel Patrick Moynihan to obtain nominees from the American Institute of Architects. Their leading recommendation was George M. White, a vice president of the AIA. White, born in 1920, a native of Cleveland and the son of an architect, first studied electrical engineering at MIT (both bachelor and masters of science) and then took degrees in business, architecture, and law. He had built up a small commercial practice in Cleveland but specialized in legal and administrative issues related to architecture. A registered Republican, White had campaigned for Nixon in 1960 by putting a sound system on his car and driving around town. He became involved in local architectural politics and got elected to the AIA's national board and then to the vice presidency. Hence he was on the scene in Washington when the call came from the White House. Rumors that lame-duck Rep. William Ayres, Republican of Akron,

[51]"The Emperor of Capitol Hill," *Architectural Forum* 129 (1968):81.

[52]J. Laurie Ossman, "Reconstructing an American Image: The State, War and Navy Building and the Politics of Governmental Design, 1866–88," Ph.D. diss., University of Virginia, 1996.

[53]Robert Towne, *Chinatown* (Paramount Pictures, 1974), cited in Robert A. Nowland and Gwendolyn Wright Nowland, *We'll Always Have Paris: The Definitive Guide to the Movies* (New York, 1995), p. 567.

[54]"Envision New Capitol Building," *Roll Call,* Mar. 14, 1962, pp. 1–2.

Ohio, a president of a heating and insulation company, might become the ninth archi-
tect of the Capitol made White all the more impressive as a candidate. White had po-
litical ties, and in addition to the AIA's nomination, Ohio's Republican senators, Robert
Taft, Jr., and William B. Saxbe, strongly supported him. White brought to the office
the professional architectural experience that many thought Stewart sadly lacked.[55]

White took office with major critical approval in early 1971 and of course inherited
the west front extension controversy.[56] This boiled on until 1983, with a tremendous
amount of ink expended on the proposal. Although White, prior to his appointment,
had been for restoration, after taking office he decided to support the extension—
since the major congressional leaders favored it. Support for the extension in the early
1970s originated with Speaker of the House John McCormack and his successor, Carl
Albert (D-OK), Senate Majority Leader Mike Mansfield (D-MT), House Minority
Leader Ford, Vice President Spiro Agnew, and powerful Rep. Hale Boggs (D-LA)
and Sen. Hugh Scott (R-PA). Later in the 1970s and early 1980s, leaders such as
Speaker of the House Thomas P. "Tip" O'Neill, Jr. (D-MA), also advocated the ex-
tension, viewing the Capitol as a private fiefdom and the addition as indicative of his
powers. The arguments for an extension were similar to those for the east front: the
old sandstone walls were in bad shape, new office and committee space was needed,
and Thomas U. Walter had actually planned an extension. For a congressman, a sure
sign of power and prestige meant having an office within the Capitol itself and not in
one of the Siberian office buildings such as the Dirksen or the Rayburn. At various
times sections of the west front wall actually tumbled down, and to dramatize the sit-
uation, the architect of the Capitol placed wooden shoring to brace the walls and hold
slipping keystones in place (fig. 13).

Once again the architects for the west front extension were DeWitt, Poor and Shel-
ton (and their various incarnations) with Campioli from the architect of the Capitol's
office acting as an adviser and liaison. Over the years several different proposals were
put forth that essentially boiled down to two schemes. Both plans proposed moving
the west front wall substantially over the terrace and constructing new interior spaces.
One of the schemes would have a new central portico with an eighteen-column colon-
nade over a rusticated basement. Visually daunting, this was modified to the favored
scheme that involved a pedimented, or temple-fronted, portico that would mirror, ex-
cept for arcades in place of the steps, the east front (fig. 14). The depth of the extension
varied over the years, from forty-four feet to twenty-two feet, but both would have
meant the substantial destruction of the west front terraces that were the work of
Frederick Law Olmsted.

Criticism of the west front extension replayed many of the themes of opposition to

[55]*New York Times,* Jan. 27, 1971, p. 24; Abbott Combes, "Capitol Architect Seeks No Quarrels," *Washington
Post,* Mar. 5, 1972; see also information supplied by the Office of Architect of the Capitol.
[56]Editorial, " . . . and Capitol Architect," Jan. 29, 1971, p. 71, clipping in files of Architect of the Capitol.

FIG. 13. West front of Capitol with shoring. *(Courtesy Office of Architect of the Capitol.)*

the east front extension, though intensified now because this was the last visible piece of the original building's exterior. Opposition to the extension by the architectural and public press and the preservation movement intensified, a regular drumbeat with seemingly everybody outside of Congress aghast. The press termed the plans: "architecturally atrocious . . . a third rate railroading job . . . a monumental display of arrogance and ignorance."[57] Herblock, the *Washington Post* editorial cartoonist, personified the

[57]Quotation from editorial, "Capitol Crime," *New York Times,* Mar. 13, 1972, p. 34. For other commentary (by no means a complete listing), see the following articles in the *New York Times:* Robert Sherrill, "A Slight Delay for Alterations," Apr. 2, 1972, p. 3; editorial, "Sense and Sensibility," June 27, 1972, p. 72; editorial, "Capitol Crime," Mar. 12, 1973, p. 30; editorial, "An Essential Saving," Apr. 16, 1973, p. 36; Marjorie Hunter, "Capitol Hill Battle Is Renewed over How to Fix West Front," Mar. 17, 1983, p. 13; and from the *Christian Science Monitor:* editorial, "Capitol Cosmetics," May 3, 1973, p. 1; William Marlin, "Face-off over a Facade," Aug. 30, 1977, p. 23; Timothy Appel, "Capitol's Crisis: All's Crumbling on the West Front," Mar. 6, 1981, p. 73; Melvin Maddocks, "A Flawed Wall Is Not a Capitol Crime," May 9, 1983, p. C22. See also "Space Age, Capitol Style," *Los Angeles Times,* May 10, 1983, sec. 2, p. 4; and from the *Washington Post:* editorial, "Obstinate Vandalism on Capitol Hill," Mar. 13, 1972, p. A17; letter from James Biddle (President National Trust for Historic Preservation), Mar. 23, 1972, p. A19; George Will, "Another Mindless Attack on the West Front," June 16, 1977, p. A3; Wolf von Eckardt, "The West Front: 'Capitolizing' on the Politics of Architecture," July 28, 1976, p. B1; editorial, "Back to the Mat on the West Front," June 2, 1977, p. A18; Benjamin Forgey, "West Side Story: A Capitol Crime?" Apr. 17, 1982, p. C1.

FIG. 14. Model of west front of Capitol enlargement proposal. *(Courtesy Office of Architect of the Capitol.)*

extension proponents as Roman voluptuaries (fig. 15).[58] Again, one of the arguments against the extension was the unorthodox nature of the west front's central portico. Classical purists held that visually the columns were too thin for the tremendous weight of the mighty dome overhead and the portico was too narrow. Additionally, the column groupings were "strange," twin pairs of columns at each end with only two thin singles making up the center. But the preservation protectors argued that this "eccentric piece of classicism . . . is more pleasing than troubling," indeed it "has an amiable quality that no other part of the Capitol possesses."[59] Another factor arguing against the destruction of the west front involved the terraces designed by landscape architect Frederick Law Olmsted and constructed between 1874 and 1892. For more than a half-century since his death in 1903, Olmsted remained largely ignored, but beginning in the late 1960s and continuing with greater force in the 1970s and 1980s, his work received renewed public and historical acclaim. He became the father of an American school of landscape architecture, or in the words of one historian: "America's foremost environ-

[58]Herblock cartoon, "Exactly! We Need More Space," *Washington Post,* May 26, 1977, p. A14.

[59]Paul Goldberger, "Capitol's West Front: To Preserve or Extend?" *New York Times,* May 25, 1983, p. 44.

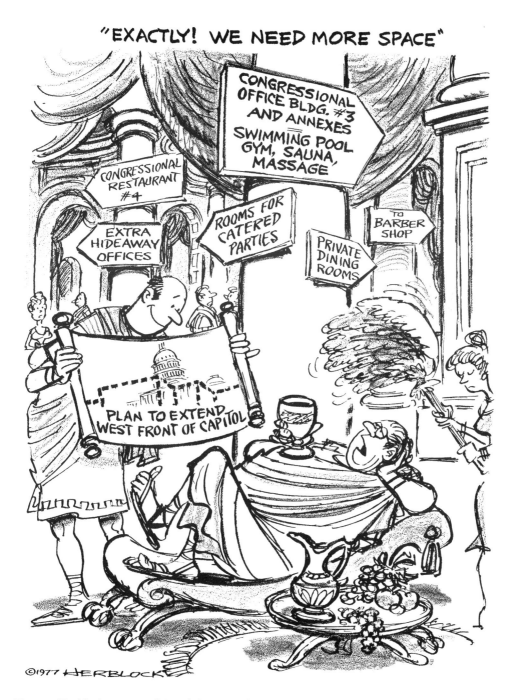

Fig. 15. Herblock cartoon, "Exactly! We need more space," *Washington Post,* May 26, 1977, p. A14. Reprinted from *Herblock on All Fronts* (New American Library, 1980). *(Courtesy Herblock Cartoons,* Washington Post.*)*

mental designer."[60] Although the west front extension did not involve the destruction of any trees planted by Olmsted but rather the terraces, the mere thought of touching his work brought forth the wrath of the protectors.

The outcry against the west front extension bore results within Congress, and a new historical consciousness developed. The leaders in the preservation fight were senators William Proxmire (D-WI), Edward Kennedy (D-MA), and Ernest Hollings (D-SC), and House members Samuel S. Stratton (D-NY), James H. Scheuer (D-NY), and Frank Thompson, Jr. (D-NJ).[61] In spite of the quest by congressional leaders for their immortality through marble, the sustained criticism led to a new study of needs and several different structural reports. Finally, in 1983 the debate came to an end when Congress appropriated $49 million to restore and strengthen the walls of the west central front. White commissioned a revised plan that preserved the west front and Olmsted terraces while providing some new office space. For the next four years until its completion in October 1987—ahead of schedule and $26 million under budget—two construction cranes hung over the Capitol as the Aquia Creek sandstone received reinforcement with stainless steel tie rods and new Indiana limestone was inserted in badly deteriorated sections (fig. 16).[62]

Indicative of the new historical attitude, the Capitol began to be treated as a historical structure containing important art and architectural treasures. For years, statues, paintings, and furniture (some dating back to the Latrobe years) had been moved at will, and rooms dating from Bulfinch or Walter's years were remodeled with no thought for their historical character. Now the Capitol became a preservation project, and positions that the protectors had long advocated were created. In December 1976 the offices of curator and architectural historian of the Capitol were authorized (serving under the architect), and a new era began in the care of the building. Under George White and with Campioli as architect in charge, restoration projects were carried out on the Old Senate and Old Supreme Court chambers, the National Statuary Hall, the frieze and frescoes in the rotunda and the Senate Appropriations Committee Room. Campioli's work, although praised, showed—as in the Old Supreme Court Chamber (fig. 17)—a tendency to overhistoricize, or to make the room too much of the eighteenth century with paneling that resembles his work at Williamsburg.[63] Much more attention began to be paid to developing a history of the Capitol through

[60]Albert Fein, "The American City: The Ideal and the Real," in *The Rise of an American Architecture,* ed. E. J. Kaufman, Jr. (New York, 1970), p. 64. Other critical writings in the Olmsted revival are Albert Fein, ed., *Landscape into Cityscape: Frederick Law Olmsted's Plans for a Greater New York City* (Ithaca, N.Y., 1968); Laura Wood Roper, *F. L. O.: A Biography of Frederick Law Olmsted* (Baltimore, 1973).

[61]"Capitol's Front To Be Extended," *New York Times,* Mar. 9, 1972.

[62]Information from Office of the Curator, Architect of Capitol.

[63]Interview with William Allen, Feb. 1, 1996. See also Mario E. Campioli, "The Capitol's Old Senate, House, and Supreme Court Chambers," *Capitol Dome* 4 (1969):2–4.

FIG. 16. West front of Capitol, distant view with construction cranes. *(Courtesy Office of Architect of the Capitol.)*

displays, models, and other media. The famous "ride" of *Freedom,* or the removal of Thomas Crawford's statue from the top of the dome in 1993, was the literal capstone of these preservation efforts.

White, with his background in both law and architecture, brought a new sense of professionalism to the office. Although the patronage system still operated in some areas, such as elevator operators, White hired competent architects and contract administrators. Under Stewart the office was frequently embroiled in lawsuits over contracts; under White this disappeared. And, White directed the U.S. Capitol Master Plan that set forth guidelines for the future development of the Capitol Hill complex and brought forth rave reviews in the press.[64]

In this context the establishment of the U.S. Capitol Historical Society in 1962, the idea of Fred Schwengel, a Republican congressman from Iowa, is of relevance.[65]

[64]Ada Louise Huxtable, "Keeping up to Date with the Outskirts," *New York Times,* Nov. 23, 1975, p. D25; Wolf von Eckardt, "Capitol Gains," *Washington Post,* Oct. 4, 1980, p. F1; Sarah Booth Conroy, "Plan for Capitol Hill Ready," Sept. 25, 1981, p. A1.

[65]Marjorie Hunter, "History Buff Has Made the Capitol His Pet Project," *New York Times,* Oct. 6, 1977, p. C15. Donald R. Kennon, *The U.S. Capitol Historical Society 1962–1992, A Brief History* (Washington, D.C., 1992); interview with Donald R. Kennon, chief historian, Sept. 7, 1995.

Fig. 17. Restored Supreme Court Chamber. *(Courtesy Office of Architect of the Capitol.)*

Created with the blessings of Speaker Rayburn and chartered by Congress, the Capitol Historical Society, although nominally apolitical and barred from lobbying, owed its existence to political ties. Schwengel ardently supported the east front extension and testified in support of the west front; he saw the mission of the society as supporting the architect of the Capitol.[66] The Capitol Historical Society took as its major mission public education—initially about the functioning of Congress through publications and subsequently symposia. In more recent years it has included architecture and art as a subject for the symposiums. It also raised funds for the hall murals Allyn Cox painted on the House side of the Capitol, an interesting example of the continuation of an older tradition of decorative painting that has almost completely disappeared.

Although the protector community had long argued that the Capitol was historic, in actuality little accurate and scholarly history had appeared since the 1950s. In 1972 the Capitol Historical Society began publishing *Capitol Studies,* which occasionally fo-

[66]Fred Schwengel quoted in Marjorie Hunter, "Capitol Hill Battle Is Renewed over How to Fix West Front," *New York Times,* Mar. 17, 1983, p. A20; and in "60-Second Debate," ibid., Mar. 30, 1983, p. I24.

cused upon the architecture and art of the building. The bicentennial certainly helped spark interest, and in 1976 the American Institute of Architects Octagon Gallery held an exhibition of many of the original competition drawings from 1791.[67] William Allen in the Office of Architect of the Capitol produced several works, and in the scholarly community books by Vivien Green Fryd, Pamela Scott (who also curated an exhibition on the Capitol's architecture at the Library of Congress in 1995), and others helped produce a new picture of the building.[68] Certainly the Capitol was historical, but as the various studies indicated, many different interpretations could be drawn from the evidence.

The view of the Capitol as historical meant that new additions should no longer mimic the past but be of contemporary styles and be by leading modern architects. White inherited from Stewart the Madison Library project already designed, which was completed in 1980. Designed by DeWitt, Poor and Shelton, the Madison was the last of the dinosaurs, very much in official Washington garb of "stripped classicism." Indicating the change was the Philip Hart Senate Office Building by John Carl Warnecke and Associates, which Ada Louise Huxtable actually approved, though she thought the exterior too much a "slipcover" (fig. 18).[69] Wolf von Eckardt of the *Washington Post* called it a "camel, . . . a great deal more desirable than a monster—such as the Sam Rayburn Building."[70] Completed in 1982—with substantial cost overruns— the Hart, although tame by modernist standards on the exterior with a bland grid of openings, which became a sort of federal image, has a lobby filled with an Alexander Calder sculpture (fig. 19). Even more of a change is the Federal Judiciary, or the Thurgood Marshall Building, 1988–92, on Columbus Circle next to Union Station (fig. 20). Here the leading New York architect Edward Larrabee Barnes–John M. Y. Lee and Partners used what in some quarters might be called "postmodern classicism." This emergence of classicism as now an approved language, albeit in postmodernist guise, indicates how much the aesthetic wheel turned in recent years. However, the Marshall Building would never be mistaken for an earlier classicist structure since it has a front of glass and the classical details are simplified.[71]

Back on the Hill the quest for more office space within the Capitol continued. In 1991 Congress agreed, and White commissioned Hugh Newell Jacobsen, a leading Washington, D.C., architect who possessed an equal facility with modernism and postmodernism to fill in two sunken "winter gardens" under the upper terrace on the

[67]Jeanne F. Butler, "Competition 1792: Designing a Nation's Capitol," *Capitol Studies* 4 (1976):10–96.

[68]William Allen, *The Dome of the United States Capitol: An Architectural History* (Washington, D.C., 1992); Vivien Green Fryd, *Art and Empire: The Politics of Ethnicity in the U.S. Capitol, 1815–1860* (New Haven, 1992); Pamela Scott, *Temple of Liberty: Building the Capitol for a New Nation* (New York, 1995).

[69]"How to Slipcover a Building, Washington Style," *New York Times,* June 23, 1974, sec. 2, p.23.

[70]Wolf von Eckardt, "A Camel on Capitol Hill," *Washington Post,* June 22, 1974, p. B1.

[71]Edward Larrabee Barnes, *Edward Larrabee Barnes, Architect* (New York, 1994), pp. 174–81.

FIG. 18. Philip Hart Senate
Office Building, 1973–82,
John Carl Warnecke and
Associates, exterior.
*(Courtesy Office of Architect
of the Capitol.)*

FIG. 19. Philip Hart Senate Office
Building, John Carl Warnecke and
Associates, atrium with Calder
stabile. *(Courtesy Office of Architect of
the Capitol.)*

Fig. 20. Federal Judiciary, or the Thurgood Marshall Building, 1988–92, Edward Larrabee Barnes–John M. Y. Lee and Partners, exterior view. *(Courtesy Office of Architect of the Capitol.)*

central west front, creating corridors and office space. So much had White gained the favor of the press that Jacobsen's work scarcely raised a murmur. Jacobsen's aesthetic though has a certain modernist coolness or spareness that stands apart from the richness of most of the rest of the building.[72]

Although White maintained good relations with the press for the most part and also with the architectural community, his long tenure in the job brought forth some detractors. The architect of the Capitol always had to deal with irritated constituents, whether their concerns involved poor meals in one of the dining rooms (which were under his control), faulty wiring, elevator operators (under the architect's control, but prime jobs for congressional patronage), not getting an office requested, or questions about gender and racial inequality among the staff. Also, the position of the architect of the Capitol contained anomalies such as its life tenure and the method of appointment. On November 21, 1989, Congress enacted new legislation (signed by President Reagan) that limited tenure to six years with the possibility of reappointment and

[72]Hugh Newell Jacobsen, *Hugh Newell Jacobsen, Architect: Recent Work* (Rockport, Mass., 1994), pp. 164–71, 232–33.

altered the method of appointment. Henceforth, instead of the president appointing an individual, as in the past, a congressional commission composed of the Speaker of the House, president pro tempore of the Senate, the majority and minority leaders of both chambers, and the chairmen and ranking minority members of the House Administration (now Oversight) Committee and the Senate Committee on Rules and Administration would "recommend at least three individuals" to the president for appointment.[73] White's term of office expired in November 1995 and he retired. Congress subsequently recommended three names to President Clinton, who nominated the first named candidate, Alan Hantman, on January 7, 1997. Hantman, an architect with a master's degree in urban planning, was vice president for architecture, planning, and construction at the Rockefeller Center Management Corporation at the time of the nomination. The Senate confirmed the nomination on January 30, 1997.

Unde the leadership of an unlikely collaboration of architecture critics, historians, and architects, the U.S. Capitol was transformed into a historic building. In a sense, Congress had lagged behind what was happening nationwide as a new consciousness concerning older buildings developed. Historic preservation, however, results from the modern consciousness; only with modernism can one see the past as history, as providing lessons but not a model for repetition.

Keeping in mind the folly of drawing too many lessons from recent events, still one cannot help but wonder whether this historicization of the Capitol has any implications for the activities that take place inside. Could this shift of perception indicate that some aspects of governance are also anachronistic? Of course this begins to border on political commentary, a slippery precipice, but the shift in the perceptions of the building may foretell other changes that lie ahead.

Much of the activity that took place in the period between 1954 and 1996 is uninspired; few of the structures erected under the auspices of the architect of the Capitol can be viewed as great, or even important, except in a negative sense. In time the Rayburn may acquire a patina of age and semirespectability, but neither it nor the Philip Hart will ever be viewed as uplifting. Certainly passion is evident, but the new buildings were more utilitarian than inspired, and certainly not symbolic. What the preservation community wanted to save was more than just a piece of the original but some elements of the meaning of the original Capitol, a bit of the "Athenian taste" that Thomas Jefferson believed would set "the course of a nation looking far beyond the range of Athenian destinies."[74]

[73]Public Law 101-163, title III, sec. 319, Nov. 21, 1989, 103 Stat. 1068. *United States Code 1988 Edition* (Washington, D.C., 1994), Suppl. V:594.

[74]Thomas Jefferson to Benjamin Henry Latrobe, July 12, 1812, quoted in Saul K. Padover, ed., *Thomas Jefferson and the National Capitol* (Washington, D.C., 1946), p. 471.

Fig. 21. "Freedom's flight," Crawford's statue airborne. *(Courtesy Office of Architect of the Capitol.)*

Well more than 150 years later, the Capitol—not as current politics but as a structure of form, mass, space, architecture, and decoration—can still inspire passion and meaning. This is borne home by a poem inspired by the removal and restoration of Thomas Crawford's grand bronze statue of *Freedom* crowning the Capitol's dome. Rita Dove, poet laureate emeritus of the Library of Congress and a professor at the University of Virginia, composed "Lady Freedom among Us" to read on the occasion of the return of *Freedom* on October 23, 1993 (fig. 21). It indicates that symbolically the building still resonates:

> don't think you can ever forget her
> don't even try
> . . .
> for she is one of many
> and she is each of us.[75]

[75] Rita Dove, *Lady Freedom among Us* (West Burke, Vt., 1994).

II

Decoration

Mid-Nineteenth-Century Art in the Capitol

The Artist of the Capitol

B A R B A R A A. W O L A N I N

Constantino Brumidi, known as "the artist of the Capitol," contributed more than any other single person to the beauty and significance of the interior of the United States Capitol, the nation's major symbol of freedom and democracy.[1] His engaging and lively cherubs, graceful allegorical figures, historical scenes and portraits, and patriotic symbols grace walls and ceilings in many of the most important spaces. He set figures and scenes into a decorative complex of illusionistic carvings, gilded frames, and scrolling vines that place the Capitol in the tradition of the palaces of Europe. Following the Renaissance tradition, he had an uncanny ability to make flat painting look three dimensional and allegorical figures seem alive (fig. 1).

Brumidi immigrated to the United States in 1852, when he was forty-seven years old. He was born in Rome and was thoroughly trained in the classical tradition, with experience painting murals in palaces and chapels. He arrived in Washington at the end of 1854, just as the new extensions to the Capitol had been constructed and were ready for decoration. He worked at the Capitol during a quarter of a century, intensively for the first decade and then sporadically until his death in 1880.

My admiration for Brumidi's achievements has grown during the years of research and writing *Constantino Brumidi: Artist of the Capitol,* prepared under the direction of the architect of the Capitol for Congress as part of the 1993–2000 celebration of the bicentennial of the construction of the Capitol.[2] Work on the book was begun in 1991;

[1]Constantino Brumidi, Petition to the Senate and the House of Representatives, Nov. 17, 1879, Curator's Office, Office of Architect of the Capitol (AOC).

[2]Barbara A. Wolanin, *Constantino Brumidi: Artist of the Capitol* (Washington, D.C., 1998).

FIG. 1. Detail showing one of Brumidi's cherubs. Brumidi's signature appears on the spine of the book on the wall of the President's Room. This detail shows the artist's skill in depicting light and shade and creating figures and objects that appear three dimensional. *(Courtesy Office of Architect of the Capitol.)*

its printing was authorized by Congress in 1994 and accomplished in 1998. Much new information and many new insights about Brumidi's life and career resulted from gathering and analyzing original documents, from searching for his prototypes, and from the process of conserving his murals.

The difference made by conservation is a recurring theme in the book. As Brumidi's murals in the Capitol are cleaned of grime, discolored varnish, and heavy-handed overpaint, and as damaged areas are restored, the full beauty of his work and the scope of his talent are increasingly revealed. Indeed, the conservation work has made appreciation of their high quality possible for the first time in this century. The ongoing mural conservation program carried out for Congress by the architect of the Capitol was begun in the early 1980s by architect George M. White, executive assistant Elliott Carroll, and then curator Anne-Imelda Radice; it has been a major focus since 1985, the year the author was hired as curator for the Office of Architect of the Capitol. The program was based on a 1981 survey and report by Bernard Rabin and Constance Silver. They, as well as the other conservators contracted to work on Brumidi's murals, gained expertise in fresco restoration in Italy.

A proposal for a book on Brumidi and the conservation of his frescoes was first out-lined in 1987 during the restoration of *The Apotheosis of Washington* under the dome. During the project, appreciation for the quality of Brumidi's art was fueled by the enthusiasm of consulting conservators Paolo and Laura Mora from Rome, who had been involved with the restoration of murals by the Renaissance masters, including Michelangelo's Sistine Chapel ceiling.[3] Caroline and Sheldon Keck, pioneers in art conservation education, also provided inspiration and encouragement. Umberto Bal-dini's book on the restoration of Botticelli's *Primavera* provided specific inspiration.[4] In 1991, with the support of Secretary of the Senate Walter J. Stewart, Senate and House historians and curators, and architect White, the book became an official bicentennial project and funding was made available for research assistance.

From the beginning, the goals of the book were to describe Brumidi's contributions to the Capitol, to set his Capitol work in context, and to show the difference made by conservation, through readable text based on thorough scholarly research and high-quality photographs. Illustrations were selected from hundreds of photographs taken by the Architect of the Capitol Photography Branch headed by Wayne Firth.[5] Images of Brumidi's work in Italy were found, many of them lent by other scholars, and com-parative examples were tracked down. The book was designed to be easily portable, so that it can be used as a reference while in the Capitol. Working directly with the de-signer at the Government Printing Office, care was taken to place illustrations near the relevant text. As many color reproductions as possible were included, but, even with more than two hundred images, the book shows only a selection of Brumidi's work.

Another goal was to produce a book that would reach several audiences. The gen-eral reader or visitor to the Capitol can absorb the major points through the images and captions. Serious readers will enjoy delving into the text, while scholars and con-servators will consult the specialized chapters, endnotes, and appendices.

Chapters by outside experts were included to place Brumidi's work in the Capitol in a wider context. Dr. Pellegrino Nazzaro was the first scholar to conduct archival re-search on Brumidi in Rome and to write about the artist's Italian years. His chapter provides previously unknown information about, and images of, Brumidi's work in Rome; his text was updated to include recent findings by Italian art historians. Archi-tectural historian William C. Allen describes the architectural context of the construc-tion of the extensions and new dome of the Capitol, which provided spaces for Brumidi's murals. Dr. Francis V. O'Connor explicates his theories about the icono-

[3]See Paolo Mora, Laura Mora, and Paul Philippo, *Conservation of Wall Paintings* (London, 1984).

[4]Umberto Baldini, *Primavera: The Restoration of Botticelli's Masterpiece* (New York, 1986).

[5]Photographs for the book also were taken by Mark Blair and C. Stephen Payne, with the assistance of Charles Badal.

graphical program in the rotunda as a whole, based on his study of the mural in America. Conservators Bernard Rabin and Constance S. Silver describe the conservation of the frieze and the canopy in the rotunda, while Christiana Cunningham-Adams and George W. Adams discuss the ongoing conservation of the walls in the Brumidi Corridors.

The new book builds on earlier groundwork. Brumidi's art was mentioned in newspaper articles and guidebooks from the time he finished his first room in 1856. George C. Hazelton, author of *The National Capitol,* first published in 1897, suggested that the artist could be called "the Michael Angelo of the Capitol."[6] The first curator of the Capitol, Charles E. Fairman, began to compile information on Brumidi and published brief biographies of him in his 1913 *Works of Art in the United States Capitol Building* and in his 1927 *Art and Artists of the United States Capitol.* Fairman, who retired in 1941, apparently considered Brumidi to be more of a decorative painter than a fine artist, for he did not protest when his murals were "restored" by being painted over.

The first monograph on Brumidi, *Constantino Brumidi: Michelangelo of the United States Capitol,* was published by Myrtle Cheney Murdock in 1950. The wife of an Arizona congressman, she became curious about the artist while giving tours of the Capitol and became dedicated to finding out more about him. Mrs. Murdock gathered documents pertaining to the artist in the records of the architect's office, found paintings in outside collections, and even located and marked Brumidi's grave. She had many of his paintings photographed in color for the first time, not realizing how many of the murals had been overpainted or were in need of cleaning. She did not claim to be a scholar, but she published detailed information about Brumidi's work for the first time, and her book was the only source on Brumidi for half a century.

A number of art historians and researchers have pursued information about Brumidi in recent years, including former Capitol curators David Sellin and Anne-Imelda Radice, and Florian Thayn, former head of art and reference in the architect of the Capitol's office. Art historian Kent Ahrens published an early article on the canopy, and curator Andrew J. Cosentino included Brumidi in the 1983 exhibition *The Capital Image* at the National Museum of American Art.[7] Cornelius Heine and Frank Lancetti have lectured about Brumidi for many years. Henry Hope Reed generously shared information and Italian documentation gathered while writing a book on the Capitol as a classical monument. Many scholars shared information, including Italian art historians who have researched Brumidi in recent years, especially Alberta Campitelli and Marco Fabio Apolloni.

[6]George C. Hazelton, *The National Capitol: Its Architecture, Art, and History* (New York, 1897), p. 192.

[7]Andrew J. Cosentino and Henry H. Glassie, *The Capital Image: Painters in Washington, 1800–1915* (Washington, D.C., 1983), pp. 72–79.

The archival research led to many new discoveries and insights. Research assistants Julie Aronson and Ann Kenny helped search out and organize documentation on Brumidi. We eventually compiled more than seven hundred entries from the records of the architect's office, the National Archives, the Mildred Thompson Papers in the United States Senate Collection, the transcribed shorthand journal of Montgomery C. Meigs, the papers of Thomas U. Walter at The Athenaeum of Philadelphia, archives in Rome, and published references.[8] Numerous documents in Brumidi's hand and payment vouchers have been preserved in the records of the architect of the Capitol. The most valuable new resource for understanding Brumidi was the transcription of the private shorthand journal of supervising engineer Montgomery C. Meigs. His journal includes a detailed description of Brumidi painting the first fresco in the Capitol and details the progress and reception of many rooms on which the engineer set the Italian artist to work. Because none of Brumidi's private papers have been found, Meigs gives us some of the most concrete descriptions we have of the artist and his working methods.

The detailed chronology, which includes many entries from Meigs's journal, was the basis for a more comprehensive understanding of Brumidi's life and work. The summary chronology in the book provides the first comprehensive view of Brumidi's life and career. Once the wealth of material became evident, the simple essay describing Brumidi's work at the Capitol grew into multiple chapters. Even with all of the information about Brumidi included in the book, many questions and gaps still remain; in fact, new works by Brumidi continued to surface even as the book was being printed. Information will continue to be sought and added to the files and the detailed chronology maintained in the curator's office.

The research has led to new insights about and understanding of Brumidi's life and career, his sources of inspiration, and his creative process. There are still many unanswered questions concerning the painter's personal life. Even the question of Brumidi's first name is confusing. "Constantino" is used throughout the book because it appears to be the one used most often after he came to the United States. His Italian name, used for the first two-thirds of his life, was Costantino. He was also sometimes called "Constantine." He most often signed works simply "C. Brumidi." Documents have been located about his parents, marriages, and children, and about his imprisonment

[8]The records of the architect of the Capitol include many letters to and from the artist as well as letterbooks, timebooks, vouchers, architectural drawings, and photographs that document the decoration of the Capitol. The Montgomery C. Meigs Journal, written in Pittman shorthand, is in the Manuscript Division of the Library of Congress (DLC). The entries from 1853 to 1859 were transcribed by William Mohr for the United States Senate Bicentennial Commission under the auspices of the Senate historian, with the final section sponsored by the United States Capitol Historical Society. The Papers of Thomas U. Walter in The Athenaeum of Philadelphia were microfilmed by the Archives of American Art, Smithsonian Institution.

after the republican revolution in Rome was put down. We do not know what became of his second wife or his son Giovanni, both left behind in Italy; only one of Giovanni's three children made a claim to be his heir. His daughter, Maria Elena, corresponded with him and came to visit him in America, and pictures of her were preserved by Brumidi's American wife, Lola Germon Brumidi. We know the outlines of his American son Laurence's career and the sad fact that he ended his life in St. Elizabeth's mental hospital.[9]

One of the most gratifying aspects of preparing the book was learning about Brumidi's career in Italy and seeing how his classical training at the Academy of Saint Luke, his intimate knowledge of ancient Roman wall painting and Renaissance murals, and the projects on which he worked prepared him for the murals he created in the Capitol. Scholars have now documented his major works in Rome, including some of the ones in the Torlonia Palace that have been destroyed and can now be known only through turn-of-the-century photographs. The extensive decoration of the theater of the Villa Torlonia is now thought to have been carried out under his direction.[10] Among his least-known works are marble reliefs in a subterranean chapel in the church of San Marcello al Corso.[11] Brumidi's last work in Rome is the Church of the Madonna dell'Archetto, called the smallest church in Rome. In the center of the dome is Brumidi's fresco of the Madonna of the Immaculate Conception, who is a sister to many of Brumidi's allegorical figures in the Capitol (fig. 2).

New information has also been found concerning Brumidi's American work outside of the Capitol. Brumidi arrived in the United States at a time when the Catholic Church was growing rapidly and building major churches and cathedrals in the New World, providing opportunities for the painter as far away as Mexico City and Havana. He originally came to the United States to paint an altarpiece at St. Stephen's Church in New York. That altarpiece is still visible in the church but is now dwarfed by the monumental mural of the Crucifixion and other murals and altarpieces Brumidi created in the early 1870s after the church was enlarged. Many of Brumidi's religious works are in poor condition, and at least one has been destroyed, but some of them are fortunately now receiving attention from professional conservators. Examples of Brumidi's major church commissions are included in the book, and locations of others are listed in the appendix of known works.

A number of Brumidi's life portraits are identified, but his domestic work for

[9]Laurence S. Brumidi (1861–1920) studied art in Rome and Paris and was director of the Kansas City Art Association and School of Design.

[10]Marco Apolloni, Alberta Campitelli, Antonio Pinelli, and Barbara Steindl, *Villa Torlonia: L'ultima Impresa del Mercantismo Romano* (Rome, 1997).

[11]Brumidi's four reliefs and Crucifixion are in the Weld-Clifford Chapel. See Maria Sofia Lilli, *Aspetti dell'arte neoclassica: Sculture nelle Chiese romane 1780–1846* (Rome, 1991).

Fig. 2. One of Brumidi's frescoes in the Church of the Madonna dell'Archetto in Rome. The figures closely resemble many that the artist later painted in the Capitol. *(Courtesy of Pellegrino Nazzaro.)*

homes and hotels is less well documented or preserved. One example for which a photograph was found is Sen. Justin Morrill's house on Thomas Circle in Washington; although the house has been torn down, Brumidi's ceiling paintings are preserved in Vermont.[12] Documentation for a number of houses thought to have been decorated by Brumidi is yet to be found, and this area is one that is particularly in need of further research.

Written descriptions and photographs, particularly the informal photograph taken

[12]The portraits are at the Justin Smith Morrill Homestead in Strafford, Vermont.

Fig. 3. Informal photographic portrait of Constantino Brumidi taken in 1859. Montgomery Meigs captured a sense of the artist's personality in a photograph he pasted into his journal. Photograph from Charles Fairman, *Art and Artists of the Capitol* (1927). *(Courtesy Office of Architect of the Capitol.)*

by Meigs (fig. 3), reveal that Brumidi was a kind, generous, and lively person, someone who would have been fun to know. He apparently got along well with others and was respected by architect Thomas U. Walter as well as by Walter's rival, Meigs. The few disputes at the Capitol in which he was involved apparently resulted from miscommunications by others.

The payment vouchers and other documents make it very clear that Brumidi did not work alone at the height of activity in the 1850s. At times he had several teams of artists and craftsmen working in a number of rooms at once, and other teams were directed by the painting foreman, Emmerich Carstens. The artists were of many nationalities, most apparently trained in their native countries. In the first years, when the decoration of the Capitol was proceeding rapidly, he was assisted by as many as thirty fresco and decorative painters working in different rooms at one time, dispelling the common misconception that Brumidi painted everything himself. In the first-floor Senate corridors, for example, Brumidi was assisted by English, German, and Italian painters who worked following his basic designs. The book includes an appendix with a list of the painters whose names appear on various payrolls and doc-

uments, with biographical details where known. It is clear that Brumidi truly was considered to be the artist of the Capitol, for he was paid at a much higher rate than anyone else working on the Capitol, even in comparison with the salary of Captain Meigs, the supervising engineer.[13]

Deeper understanding of the creation of each of Brumidi's mural programs in the Capitol has grown out of the documentary and art historical research and through the conservation process. Meigs's journal tells us the exact day that Brumidi began his career at the Capitol at the end of 1854.[14] The captain in the Army Corps of Engineers had been put in charge of the construction of the Capitol when it was placed under the authority of the War Department in 1853. Meigs, trained in art at West Point, took on the commissioning of architectural art as part of his construction responsibilities. He had never been to Europe, but he knew about the frescoes of Raphael and Michelangelo and was determined to have the walls of the Capitol embellished in monumental true fresco. Despite his efforts, he had been unable to find an artist either trained in or willing to learn the fresco technique. Brumidi's appearance must have seemed like an answer to a prayer. The Italian artist described his work in palaces and villas in Rome, but had no example to show. He and Meigs agreed that he would paint a trial fresco in the almost completed room Meigs had just begun using as an office, and that the subject would be Cincinnatus, a Roman hero called from the plow to defend his country (fig. 4). This subject was connected with farming, appropriate for the room intended for use by the Committee on Agriculture, and with the first president, George Washington, who was called the American Cincinnatus. Brumidi may have already painted a lunette with the same subject in Rome, and thus he undoubtedly readily agreed to the idea.[15] George Washington would be an important theme for many of the spaces Brumidi would later decorate in the Capitol.

Meigs recorded the progress of the first fresco, beginning with his approval of the small oil sketch. He recorded his criticism of the large-size cartoons and the positive reactions of people who came to see the fresco, including his superior, Secretary of War Jefferson Davis, who approved placing Brumidi on the payroll to decorate the entire room. Because of its significance, the sections of the journal describing the painting of Brumidi's first room for the House Agriculture Committee are included as an appendix. Strikingly, the conservators' diagram of the *giornate,* the sections of mortar applied each day, corresponds exactly to Meigs's descriptions.

Brumidi's general sources of inspiration have become clearer, although more

[13]Brumidi was first paid eight dollars a day; his salary was increased to ten dollars a day in 1857 and remained at that rate until the end of his life. Other artists were paid four or six dollars a day and Meigs received $150 a month.

[14]Montgomery C. Meigs Journal, Dec. 28, 1854.

[15]Drawing in a private collection, courtesy of Alberta Campitelli.

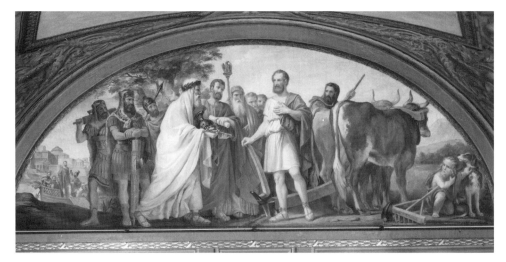

Fig. 4. *Calling of Cincinnatus from the Plow,* 1855. Brumidi's first fresco in the Capitol was considered a success. *(Courtesy Office of Architect of the Capitol.)*

research is yet to be done on specific sources for individual figures and groupings. One discovery in an anonymous print was his source for the scene of Israel Putnam being called from the plow.[16] As in his design for the Agriculture Committee, he conceived of the room as a whole, with the subjects relating to each other across the architectural space and painted illusionistic arched moldings in fresco on the walls below. The concept of creating illusionistic architecture, figures, sculpture, and paintings in fresco, which Brumidi learned in Rome, had its source in seventeenth-century Roman baroque art, a culmination of a tradition that had begun in the Renaissance. After the frescoes were cleaned of grime, one could better appreciate Brumidi's artful skill in painting relief figures and moldings that fool one into believing they are three-dimensional and appear to be illuminated by light from the window (fig. 5; color plate 1).

The classical tradition of mural painting had roots much further back in time, in ancient Rome, and Brumidi credited first-century work as a major inspiration. In the committee room for the Naval Affairs Committee, a notice was posted by 1858 explaining how its decoration was modeled after those in Pompeii and the Baths of Titus (built over the Golden House of Nero) and listing the various classical sea-related deities that are depicted.[17] The ceiling of the Naval Affairs Committee room, with classical gods and goddesses and mythological creatures framed by trellises, resembles ceilings in the Golden House of Nero (fig. 6; color plate 2). In all of its details, this was the most Roman room Brumidi created. It contains only a few figures and details re-

[16]*General Putnam Leaving His Plow for the Defence of His Country,* lithograph in the Yale University Art Gallery.

[17]"The Decoration of the Capitol," *New York Tribune,* May 17, 1858.

FIG. 5. Brumidi's first room in the Capitol. The room originally decorated for the House Committee on Agriculture includes illusionistic carved stone and gilded frames that are actually flat. (See also color plate 1.) *(Courtesy Office of Architect of the Capitol.)*

ferring to America, and it was criticized by some writers and speakers for this very reason.

Another area in the Capitol directly inspired by decoration that Brumidi knew well in Rome, and that Meigs admired in illustrated books, is the Brumidi Corridors (fig. 7; color plate 9). The artist based his designs directly on those by Raphael for a loggia

Fig. 6. Room decorated for the Senate Naval Affairs Committee in the Pompeiian style. The floating maidens on the walls are directly inspired by figures found in Pompeii. (See also color plate 2.) *(Courtesy Office of Architect of the Capitol.)*

in the Vatican, which was in turn modeled after first-century Roman wall painting. A panel in the Vatican loggia with squirrels, mice, and snakes is strikingly similar to four of the panels in the first-floor Senate corridor (fig. 8; color plate 3). Details in the corridor also are closely related to designs seen at the Villa Torlonia in Rome.

Brumidi's classical inspiration was not appreciated by everyone. By 1857, he was working in several rooms at once. When Captain Meigs was pushing to finish the new Hall of the House, he asked Brumidi to paint a fresco in one of the panels only because the plaster was too wet for regular paint. Brumidi completed a scene showing the surrender of Cornwallis in a few weeks, soon after his American citizenship had become final (fig. 9). He proudly noted that fact in his signature: "C. Brumidi Artist Citizen of the U.S."[18]

The artistic quality of the fresco was sharply criticized, while Meigs defended Brumidi for having been given so little time to work. It became clear during the research for the book that the attacks in the 1850s on Brumidi's art, either for its quality or for its use of classical motifs and relative lack of American themes, were not made on purely aesthetic grounds. They resulted in part from the dispute between engineer Meigs and architect Thomas U. Walter over control of the decoration of the Capitol and, in part, from political turmoil. This was the era of the brief ascendancy of the American party, nicknamed the Know-Nothing party, which was anti-immigrant and anti-Catholic. At the same time, American artists were unhappy that they were not given commissions to create art for the Capitol. Meigs defended his hiring of Brumidi and other foreign-born artists, arguing that no Americans were trained in how to paint in true fresco or decorative wall painting.

In 1859 these various forces secured passage of a law creating an art commission and an appropriation for the Capitol that removed Meigs from his position and ordered a moratorium on new art. A year later, the commission submitted a report recommending large expenditures for art.[19] By this time, the American party's political strength had faded, the commission was abolished, and Meigs was reinstated for a brief time. Ultimately, the commission had little effect, for Brumidi continued for the next twenty years to paint murals that Meigs had approved in the 1850s.

Even while the art commission was in existence, Brumidi was able to carry out work already started, including the President's Room (fig. 10). The rich walls with leafy scrolls and cherubs against a gold background were similar to designs he would

[18]*Cornwallis Sues for a Cessation of Hostilities under a Flag of Truce* was covered during the modernization of the House chamber in 1950; in 1961 the section of wall with the fresco was moved to the new House Members' Dining Room (H-117), where it is on display.

[19]The commissioners were sculptor Henry Kirke Brown, portrait painter James R. Lambdin, and landscape painter John F. Kensett. *Report of the United States Art Commission,* Ex. Doc. No. 43, House of Representatives, 35th Cong., 1st sess.

Fig. 7. View of the Brumidi corridors looking east. The fresco of Robert Fulton at the end is by Brumidi; the photograph shows the walls below before conservation. *(Courtesy Office of Architect of the Capitol.)*

Fig. 8. Panel in the Brumidi Corridors. The idea of showing squirrels, mice, and other creatures climbing in the scrolls of leaves came from Raphael. (See also color plate 3.) *(Courtesy Office of Architect of the Capitol.)*

FIG. 9. *Cornwallis Sues for Cessation of Hostilities under the Flag of Truce*, 1857. Brumidi's signature appears on the strap around the dispatch case at the lower right. *(Courtesy Office of Architect of the Capitol.)*

have painted in Rome. This room has direct sources in the Italian High Renaissance. The illusionistic framework of the ceiling is taken from Raphael's Stanza della Segnatura in the Vatican. The allegorical figures in the tondos also pay tribute to the Italian artist. George Washington, shown in a portrait copied from the one by Rembrandt Peale now in the Old Senate Chamber, is the focal point of the room; a note by Meigs on a drawing documents that the portrait was brought to the room so that Brumidi could copy it directly.[20] Portraits of members of Washington's first cabinet grace the walls below. Research into the state seals on the ceiling revealed that the oldest states are grouped toward the center of the ceiling, while those in the lower areas were then territories.[21] During the conservation of the room, Brumidi's sophisticated interplay of a number of different painting techniques became clear.

The Senate Reception Room at the opposite end of the Senate Lobby is complex in both its decor and its history (fig. 11). The ornate decoration consists of frescoed vaults,

[20]Note on drawing for mirrors for the room dated Oct. 28, 1859, Curator's Office, AOC.
[21]Research conducted by Ann Kenny.

FIG. 10. Ceiling of the President's Room. Brumidi based the design of the ceiling on a room by Raphael in the Vatican. His frescoes are surrounded by gilded borders. *(Courtesy Office of Architect of the Capitol.)*

illusionistic sculpture framing scenes that were never painted, and exuberant gilded plasterwork. Unlike the President's Room, which Brumidi completed in a single campaign, documents show that the painting of the Reception Room was a tale of frustration for the artist. He created the first design for the room in late 1855. Three oil sketches of historical scenes approved the next year were never executed. By the end of 1858 he had painted the allegorical paintings in the domed ceiling. He made more designs for the room the next year, giving cost estimates for them in 1862 and again in 1866. At last, he was authorized to paint the frescoes in the groin-vaulted half of the ceiling in 1869. In the next two years he painted the illusionistic statues, and finally, in 1872, executed the only completed historical scene showing Washington with Jefferson and Hamilton. In 1876 he was still unsuccessfully petitioning to be allowed to finish the decoration of the room.[22]

[22]Letters and vouchers in the records of the Curator's Office, AOC.

FIG. 11. The Senate Reception Room. This view of the north part of the room shows Brumidi's murals after conservation. *(Courtesy Office of Architect of the Capitol.)*

Pencil sketches document Brumidi's plan to place portraits of other presidents in the empty spaces.[23] The myth that Brumidi intentionally left some spaces blank for future events is disproved by documents such as this. He also had planned portraits for the oval spaces below; these were finally added in the mid-twentieth century. Removal of a brownish coating and overpaint from the murals and decorative surfaces has made a dramatic change in the appearance of the room.

Brumidi's most important fresco in the Capitol is *The Apotheosis of Washington* in the canopy in the eye of the dome over the rotunda (fig. 12; color plate 4). It was painted in eleven months at the end of the Civil War. As far as the records show, he painted it alone. This fresco is the culmination of the homage Brumidi paid to Washington in other parts of the Capitol. Washington looks down at the center of the nation's Capitol, directly over the spot where he was to have been buried. In the six groups on the earthly level, Brumidi mixed classical deities such as Minerva with historical figures and American inventions, such as the early batteries shown in the foreground (fig. 13; color plate 5). Brumidi took care to make his depictions accurate; Joseph Henry's daughter noted in her diary that Brumidi had asked her father for pictures of electric machines for the dome fresco.[24] Brumidi depicted Neptune, god of the sea, and Venus helping lay the transatlantic cable, which was being tested when he designed the canopy (fig. 14; color plate 6). The boxy iron ship with smokestacks behind the cherub riding a dolphin has yet to be identified. Dr. Francis V. O'Connor's chapter in the book focuses on the development of Brumidi's composition and the iconography in relation to the earlier works of art in the rotunda and the frieze below.

While the canopy was being conserved, it was clear that next to Robert Morris, who is depicted receiving a bag of money from Mercury in the scene of Commerce, the portrait of a head has been removed (fig. 15; color plate 7). Recently, the puzzle was solved by an entry Meigs made in his pocket diary noting that he had demanded that architect Edward Clark make Brumidi remove the portrait of Meigs in a blue uniform from the scene.[25] When Meigs, no longer in charge, came to the Capitol to see Brumidi's masterpiece once the scaffold was taken down, he wrote his critique to the artist, concluding: "I am glad the country at length possesses a Cupola on whose vault is painted a fresco picture after the manner of the great edifices of the old world."[26]

In the fifteen years after the completion of the canopy, Brumidi sporadically worked to fill blank spaces, such as the lunettes over the doorways in the first-floor

[23]*Adams, Jackson, Vanburn* [sic] is in the records of the Architect of the Capitol, while *Washington, Adams, Jefferson* is in the Arthur J. Phelan Collection.

[24]Entry of May 21, 1865, Smithsonian Institution Archives, Record Unit 7001, courtesy of James Goode.

[25]Montgomery C. Meigs Pocket Diary, Sept. 3, 1865, Montgomery C. Meigs Papers, DLC.

[26]Meigs to Brumidi, Jan. 19, 1866, Record Group 48, series 290, National Archives and Records Administration (NARA).

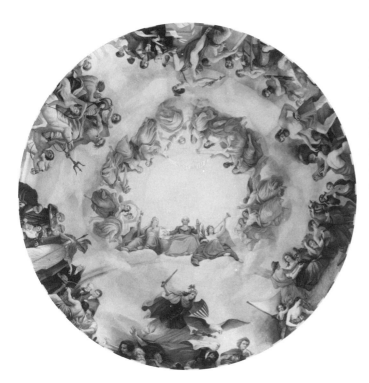

Fig. 12. *The Apotheosis of Washington.* Brumidi's almost 5,000-square-foot fresco under the dome soars 180 feet above the floor. (See also color plate 4.) *(Courtesy Office of Architect of the Capitol.)*

Fig. 13. "Science." Minerva counsels Benjamin Franklin, Samuel F. B. Morse, and Robert Fulton. (See also color plate 5.) *(Courtesy Office of Architect of the Capitol.)*

Fig. 14. "Marine." Neptune with trident in hand rides across the ocean. (See also color plate 6.) *(Courtesy Office of Architect of the Capitol.)*

Senate corridors, as he was able to get work authorized. Brumidi's last work, the rotunda frieze, was his greatest monument to patience. He created the sketch with scenes from American history in 1859, but he was allowed to start painting on the wall only in 1878. He began with Columbus, painted in true fresco on the wet plaster, using browns and whites to simulate sculpture. The painter was in his seventies and his health was not good, but he climbed up many steps and down a long ladder to a little scaffold dangling sixty feet above the rotunda floor. His near fall is well known: his chair leg slipped off the edge, but he managed to hold on to a rung of the ladder until rescued. Two contemporary newspaper accounts were found that show that the story that he never painted again is not true; they describe how he climbed back up the next day and accomplished more on the fresco than he had for a long time.[27] His work on the fresco ended with the figure of William Penn only partially completed (fig. 16). He painted the foot on the left, and the successor he recommended, Fillippo Costaggini, painted the one on the right. When the frieze was conserved in 1986, the pencil inscription where Costaggini noted his starting place could be read.

For the last few months of his life Brumidi stayed in his studio working on his full-size cartoons to enable someone else to complete his design. He was paid for working

[27]"Death of a Great Artist," *Washington Post,* Feb. 20, 1880, and "The Allegorical Work at the Capitol," *Forney's Sunday Chronicle,* Oct. 12, 1879.

Fig. 15. "Commerce." Brumidi signed and dated his fresco in the scene where Meigs's portrait was removed. (See also color plate 7.) *(Courtesy Office of Architect of the Capitol.)*

up until the day before he died. Unfortunately, because of a miscalculation, his design did not fill the full three hundred feet, despite Costaggini's efforts to enlarge the scenes.[28] The entire frieze was finally completed by Allyn Cox in 1953, almost a century after Brumidi had designed it. Cox attempted to clean and restore the rest of the frieze at that time. The fresco was first professionally conserved in 1986.

In addition to describing Brumidi's art and career in historical context, the book emphasizes the difference that professional conservation has made to seeing and understanding Brumidi's murals. Conservation is a relatively young profession, for it was only in 1963 that the American Institute for Conservation first established a code of ethics and standard of practice. The goal of conservation is to preserve and reveal the original work of the artist as much as possible, using scientific analysis as appropriate. Flaking paint is re-adhered rather than scraped off, and missing sections are filled in with reversible pigments, using archival photographs as guides where possible. During the first half of the twentieth century, and in some places still today, it was common practice to paint over murals rather than to clean and conserve them. Effective

[28]Brumidi had been told the frieze was nine feet high and based his calculations on that figure. Because the field was actually less than eight feet high, his scenes ended up proportionately shorter in length as well; this was verified by comparing the notations on his sketch to the dimensions of the frescoed scenes. The last three scenes were added by Allyn Cox.

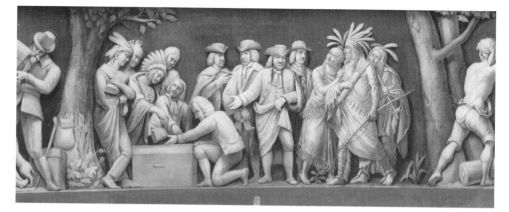

FIG. 16. "William Penn and the Indians." Costaggini completed the right half of the last scene of the frieze painted by Brumidi. *(Courtesy Office of Architect of the Capitol.)*

cleaning techniques were not known, and in any case it is quicker and less costly to simply go over designs with new paint. In the 1920s and 1930s, and even into the 1970s, so-called restorers painted over Brumidi's compositions with oil paints, sometimes adding their own details and often signing and dating their work. In 1959 Allyn Cox repainted *The Apotheosis of Washington* in the rotunda rather than cleaning it; fortunately, unlike the earlier artists, he used paints that could be easily removed and submitted a report on the steps he had carried out and the materials he used. Careful cleaning tests and microscopic examination of samples are needed to help conservators determine how to most safely uncover Brumidi's original layer.

Each year since 1985, more of Brumidi's original work has been uncovered, allowing an appreciation of his radiant colors; his masterful understanding of light and shade to make forms look three dimensional; and the wealth of his subjects, gestures, and expressions, all of which had been obscured by grime and muddy overpaint. The scaffolds used for conservation allow close-up views of Brumidi's work and enhance appreciation for his mastery. Looking at his work from a distance, one can appreciate Brumidi's symphony of rich and subtle colors in his overall decorative scheme and the way the frames and borders surrounding his scenes are part of the total effect.

With each mural that has been conserved, more has been learned about Brumidi's painting methods and techniques as well as his artistic sensibility.[29] Brumidi's mastery of a variety of techniques is shown throughout the book. Brumidi claimed he was the first person to paint in true fresco in America; he probably was the first to paint fres-

[29]Each conservator who has worked on Brumidi's murals has documented his technique through descriptions, diagrams, and photographic details, and as necessary through laboratory analysis of samples. Knowledge of Brumidi's techniques has been increased by Bernard Rabin, Constance Silver, Christiana Cunningham-Adams, and Catherine Myers, whose research was supported by a U.S. Capitol Historical Society Fellowship.

Fig. 17. Test windows made by conservator. The painstaking scraping off of layers of overpaint revealed the dramatically different colors and details painted under Brumidi's direction. (See also color plate 8.) *(Courtesy Office of Architect of the Capitol.)*

coed historical and allegorical scenes. Brumidi painted all of the true frescoes in the Capitol himself. Fresco was used in ancient times and revived in the Italian Renaissance. It is durable because the pigments become part of the wall and demanding because the pigments mixed with water must be quickly applied while the mortar is fresh ("fresco" means "fresh" in Italian); any mistakes or sections that dry too quickly must be chopped out of the wall and redone. The visible joins between the sections of plaster, called *giornate* in Italian, are a distinctive characteristic of true fresco. Documentation about the location of the *giornate* in Brumidi's frescoes has been a benefit of the conservators' attention, and samples of diagrams showing the joins are included in the book.

Brumidi painted some portraits and scenes in oil or an oil emulsion directly on the plaster. Ceilings and borders are now known to have been painted in tempera (then also called distemper), a mixture of pigment and glue. Tempera can be applied quickly and is compatible with the texture of the fresco, but it is fragile. On many ceilings in the Capitol, the tempera decoration has been painted over in oil and in some places

Fɪɢ. 18. Cartoon for a maiden with pearls used for the Senate Naval Affairs Committee Room. Known only through a photograph, this drawing was transferred to the wall by charcoal dusted through pinpricks. *(Courtesy Office of Architect of the Capitol.)*

varnished, destroying the intended matte, velvety effect. The ceiling of the north entry is one area where the original tempera decoration is untouched. Studies conducted by Christiana Cunningham-Adams showed that the walls, always thought to have been painted with oil pigments, were originally executed in lime-wash fresco, a durable decorative technique that could be quickly applied by a team of skilled artists. The walls were first repainted at the turn of the century, and some areas such as the borders have many layers of paint, each one successively darker as the colors were matched to dirty surfaces and discolored varnish. It is now clear that the original colors in the corridors were not the brown, green, and yellowish tan seen today, but

rather creamy white, sapphire blue, and deep red, surrounded by grayish tan stone-colored moldings, similar to the color schemes seen in Rome (fig. 17; color plate 8).

Brumidi's creative process also has become clearer during the research for the book. In some cases, he provided a written description of proposed iconography. In preparing designs for rooms in the Capitol, he made small sketches in pencil, watercolor, or oil on canvas for the approval of Captain Meigs or others in charge; a number of these have been preserved. He would then enlarge the preliminary sketch to half or full size; unfortunately, none of his working cartoons were saved, although one was documented on a glass plate negative (fig. 18). Details presented in the book show various techniques Brumidi used to transfer the outlines of the drawings, visible only at close range.

In 1862 Meigs wrote a letter of recommendation for Brumidi as the only person capable of painting the fresco under the dome, calling him "an artist of great experience and of great ability." He asserted: "The best pictures and decorations of the wall of that building are his design."[30] The book should enable people to understand and appreciate Brumidi's achievement more deeply than ever before, including his originality in bringing together the classical tradition of mural painting with American history and symbols.

[30]Quarter-Master General Montgomery C. Meigs to Secretary of the Interior Caleb B. Smith, June 5, 1862, RG 48, ser. 291, NARA.

A Study of
Constantino Brumidi's
Painting Technique in
the Senate Corridors

Catherine S. Myers

Constantino Brumidi's decorative painting program in the Senate corridors (fig. 1; color plate 9) of the United States Capitol is a tour de force of classical style and technique. Emulating Renaissance models in design and style with their elaborate grotesque scrolls and *rinceaux,* the paintings combine figural fresco lunette murals with decorative paintings in a nineteenth-century version of Raphael's Vatican Logge. In so doing, they demonstrate a range of historic techniques, including one of the earliest examples of fresco in the country, used to achieve the artist's stylistic goals.

This paper considers aspects of Brumidi's painting technique at the Capitol by examining a selection of the Senate corridor murals through the lens of classical methods. It addresses the artist's materials and methods based on in situ, laboratory, and documentary research. This research was sponsored by a six-month fellowship from the United States Capitol Historical Society (1993) and developed from the author's

The author thanks Barbara Wolanin for facilitating this research and the Graduate Program in Historic Preservation, University of Pennsylvania, for the use of the Architectural Conservation Lab.

FIG. 1. Overview of the Brumidi corridors in the Senate wing of the Capitol. (See also color plate 9.) *(Courtesy Office of Architect of the Capitol.)*

commissions to treat three of the lunettes in the Senate corridors[1] and from research on the possible presence of binding media among his frescoes.[2]

This study may be considered preliminary and one of the early technical inquiries into Brumidi's working methods. Since that time recent research on the artist's techniques has contributed new information to the subject.[3]

Brumidi built on historical models for the design, subject, and technique of his paintings at the Capitol. This academic approach developed from his classical training at the Accademia di San Luca and his experience with large decorative programs in Rome, notably at the Villa Torlonia, factors that influenced the atelier working structure he developed and directed at the Capitol. European artists participated at various levels of the painting program from decorative surrounds to scenes and grisaille portraits. Like all architectural commissions, the work yielded to such logistical conditions as the demands of the client and the building, the abilities of his atelier, and the cost and availability of materials.

Methodology

In an effort to understand Brumidi's working techniques, the author reviewed a combination of sources ranging from the paintings themselves to historic treatises. To place the study within its technical context, the author examined historic texts, both preceding and contemporary to Brumidi. Technical references, such as conservation reports, were also reviewed. Archival records were consulted for details of the actual commissions, such as materials, sequence, alterations, and method.

The primary records at the architect of the Capitol's archives described Brumidi's materials. Accounts, contracts, correspondence, and receipts for pigments, brushes, oils, and glues suggested his working methods. Dates for the execution of various paintings, identity of artists working under Brumidi's direction, and extenuating circumstances, such as building schedules and budgets, as well as details of the actual execution of the paintings, indicated process. The correspondence between Brumidi and his patron at the Capitol, Capt. Montgomery C. Meigs, the army engineer in charge of decoration as well as construction, is of particular interest for showing how the com-

[1]The author treated three of Brumidi's mural paintings in the north corridors from 1991 to 1993: *Authority Consults the Written Law; Bellona, Roman Goddess of War;* and *Bartolomé de Las Casas.*

[2]Catherine Sterling Myers, "A Technical Investigation of Binding Medium: The Analysis of Three Wall Paintings by Constantino Brumidi at the United States Capitol, a Case Study," M.A. thesis, University of Pennsylvania, 1992.

[3]Conservators Christiana Cunningham-Adams and Constance S. Silver have conducted conservation treatments and the study of condition and technique since the time of this research. Their findings regarding materials and technique are more current. See Curator's Office, Architect of the Capitol.

missions developed and proceeded. Visual records also illuminated the process and development of the decorative program. Drawings and paintings executed by the artist revealed the planning stages of the paintings.

To establish the technical context in which to consider the artist, the author also consulted relevant historic texts on mural painting from antiquity through the nineteenth century. Since Brumidi's fresco technique demonstrated characteristics of baroque fresco, seventeenth-century sources were especially considered. Of particular interest was Andrea Pozzo's authoritative text, "Breve istruzione per dipingere a fresco." The Italian notebooks of antiquary Richard Symonds also were a valuable resource. They recount his observations on artists' techniques while in Italy from 1649 to 1651, particularly those of painter Giovanni Angelo Canini. Lastly, *Artists' Techniques in Golden Age Spain* also describes mural techniques of the baroque period, notably those of Francisco Pacheco (1649) and Nicolas Poussin.[4]

The author examined the murals themselves. In situ study yielded evidence of drawing technique, sequence of *giornate,* plaster texture, and method of application, such as brushstroke, impasto, etc. This was accomplished through simple examination with plain and raking light recorded on scale drawings, the use of macrophotographs to emphasize texture and technique, and ultraviolet visible illumination to clarify overpainting.

Optical microscopy of point samples served as the primary analytical tool. It allowed the researcher to study both intact samples and separated components from samples, such as pigments. These samples were examined to determine the sequence of paint layer application, the painting technique (i.e., fresco versus *secco*), the presence of surface films, such as overpaint, varnish, etc., and to analyze the pigments.

In order to conduct microscopical study, small samples of paint and substrate layers approximately one-sixteenth to one-quarter inch in diameter were taken at select locations. Usually one-half of the specimen was imbedded and cross-sectioned while the remainder was reserved for other types of analysis. Cross sections were photographed in visible daylight and paired with detail images of the painting.

For organic materials, cross sections were also examined for auto and secondary fluorescence with a fluorescence microscope.[5] Four general classes of materials were considered: lipids (drying oils), proteins (glues and casein), reducing sugars (gums),

[4]Andrea Pozzo, *Prospettiva de' pittori ed architetti,* 2 vols. (Rome, 1692); Mary Beal, *A Study of Richard Symonds: His Italian Notebooks and Their Relevance to Seventeenth-Century Painting Techniques* (New York, 1984). One of Symonds's six notebooks, MS Egerton 1636, an unpublished manuscript located in the British Museum, extensively handles Canini's techniques. *Artists' Techniques in Golden Age Spain,* ed. and trans. Zahira Veliz (Cambridge, 1986) includes six treatises, several on the art of mural painting.

[5]Fluorochromes included FITC and TRITC for proteins, Rhodamine B and DCF for lipids, TTC for gums, and ACP for resins.

and resins. The organic component from a selection of samples was separated and confirmed with FTIR (Fourier transform infrared analysis).

The inorganic components, usually the pigment, were also analyzed. Pigment particles were microscopically removed. One-half of the specimen was mounted for optical analysis and the other half was reserved for microcrystal tests. After these initial tests, inorganics were sometimes confirmed with SEM/EDS (scanning electron microscopy/electron dispersive spectroscopy).

Due to funding limitations, the possibilities for outside analysis were limited. Although confirmation tests and nondestructive examination methods were recommended, they were applied only to an extremely limited extent. For example, infrared photography to detect artistic changes or underdrawing was tested, but infrared reflectography to detect underdrawing and X-ray for defining the wall structure were not used at all.[6] Confirmation testing, which was most needed for the analysis of organic materials, was limited to a few examples with FTIR.[7]

After reviewing the results of scientific analysis and considering each aspect of research and its relation to the techniques, material was compiled and synthesized. The author compared findings from one location to another and related them to documentary records. Context was considered and interpretation made with regard to stylistic and historical precedents.

Conclusions

The most striking aspect of Brumidi's painting technique is the manner in which he combined and manipulated historic styles and methods to achieve his stylistic goals. Mixing historic technique in conventional and unconventional ways, he both continued academic methods and departed from them. This combination of technique shows a range and fluency of historical reference as well as the influence of nineteenth-century painting technology.

In the Senate corridors the artist combined baroque fresco technique with a range of compositional styles: the decorative program is Renaissance, the lunettes are classical or mannered, and the subject is American and is expressed through both classical allegorical and historical subjects. In general, he employed *buon fresco* without serious

[6]Nondestructive analyses using various imaging methods were not possible due to limited access to the paintings and the costs involved.

[7]Fourier transform infrared analysis allows one to characterize broad classes of organic and, to a lesser extent, inorganic materials. Additional analytical methods, such as high pressure liquid chromatography (HPLC) and mass spectroscopy/gas chromatography (MS/GC) are recommended for more specific, conclusive organic material analysis.

deviation, used a traditional fresco palette, and painted in bold brushstrokes utilizing impasto and coarse plaster characteristic of the seventeenth-century baroque. He worked more slowly than his baroque forebears and was less concerned with uniting complex compositions in tone and light. He transferred his design from drawings in traditional methods with a combination of pouncing, incisions, and powder through perforations *(spolvero).*

Like baroque fresco technique of the period illustrated and described by artists such as Annibale Carracci, Martin Knoller, Francisco Pacheco, and Andrea Pozzo, Brumidi exploited the character of coarse plaster to achieve the desired effects. Instead of the classical and Renaissance plastering sequences of coarse preparatory plaster *(arriccio)* followed by finer plaster *(intonaco)* to impart a relatively untextured surface, he worked on the coarse sand intonaco typical of baroque fresco to create texture and lend vibrancy of color to the painting. Documents citing Brumidi's directions to roughen the plaster with a broom recall Pozzo's discussion of *granire,* or removal of the grains of sand from the surface before painting. Furthermore, baroque frescoes were often executed on two layers of relatively coarse plaster. Brumidi apparently worked over only one coarse layer.

This manipulation of plaster to create a coarse surface was influenced in the seventeenth century by oil painting on canvas. The rough plaster surface, like a coarse canvas weave, held more paint and maximized the richness and vibrancy of color and tone of the painting. Brumidi's revival of these methods exploited the desired effects: the texture allowed for greater color saturation and facilitated tonal contrast.

Having painted extensively in oil on canvas and plaster, Brumidi was well aware of the benefits of the oil medium and also used it in the Senate corridors. In the President's Room, where the artist combined traditional fresco and lime painting with oil painting, his proficiency as a painter is best displayed. The oil lunettes in the President's Room contrast sharply with the fresco ceiling paintings and demonstrate his mastery of color, form, and chiaroscuro.

Although his brushwork was bold and painterly at times, suggesting speed and spontaneity typical of baroque style, Brumidi planned his compositions deliberately, reserving time to paint the more demanding passages. The lunette frescoes show a moderate to high number of *giornate* with small *giornate* limited to complicated passages, such as heads, or to problematic compositional passages requiring reworking.[8]

Here Brumidi departed from typical seventeenth-century methods. Baroque fresco painters made use of large giornate to unify the tonally and compositionally complex murals. Although Brumidi attempted a similar level of complexity elsewhere in the

[8]A *giornata* is the area of plaster that may be painted *affresco* (while the plaster is wet) in one day. Generally, *giornate* range in size depending on the difficulty of a passage and the expertise of the artist.

FIG. 2. Constantino Brumidi, *Cession of Louisiana,* from the Senate corridors. *(Courtesy Office of Architect of the Capitol.)*

FIG. 4. Detail from *Cession of Louisiana.* Brumidi used impasto for highlights, as seen on the cuff. *(Courtesy the author.)*

FIG. 3. Brumidi applied brush-strokes on coarse plaster grounds. He applied paint to the surface, creating impasto, as seen in this detail from *Cession of Louisiana.* *(Courtesy the author.)*

Capitol,[9] the paintings in the Senate corridors are more static and closer to classical, rather than baroque, models. Giornate likewise show a slower, less unified working method.

Nonetheless, Brumidi painted boldly and confidently, using brushstrokes rich with paint in a manner associated with baroque mural painting technique (figs. 2, 3). Unlike more delicate fresco methods of the Renaissance, this brushwork was rapid. He often used impasto to create a white highlight opaque enough to achieve the reflectance associated with oil paint (fig. 4).

Brumidi appears to have used pure fresco for the lunettes and a combination of other painting techniques elsewhere.[10] He finished details for the lunettes with enforced fresco/secco, apparently mixing lime with pigment on damp plaster to create layers of fresco and *mezzo fresco*. Such layering of the paint is illustrated in paint cross sections throughout the study area, including the frescoes and decorative paintings. Again, this technique is typical of the baroque period, as explained by Pozzo: "A peculiarity of fresco painting is that the first colors to touch the hardened lime become weak and lose a great deal of their vivacity. Thus it is important to load the brush and paint a second time, and never abandon the part you are working on until it is completely finished, because any retouching a few hours later will stain your work. It is better to wait until the painting is thoroughly dry and then one can retouch it."[11]

Full-scale preparatory schemes to be transferred to the wall were sometimes preceded by smaller scale preliminary drawings or renderings. When transferred, the artist combined classical transfer methods, including spolvero and puntini, which produce dotted lines, and more spontaneous incised lines (fig. 5).

Brumidi employed a classical fresco palette with few deviations. Based on a review of the documentary sources and scientific analysis of point samples, he selected alkaline resistant pigments suitable for fresco. They included ultramarine, ivory black, chrome green, iron oxides, smalt, vermilion, and lime white (fig. 6, color plate 11; fig. 7). Although written sources indicate that Brumidi requested other pigments, such as chrome yellow and Prussian blue, they appear to have been used for his nonfresco paintings. Where nonfresco pigments occur on the frescoes studied, they appear to belong to secco restoration additions.

Generally Brumidi painted the lunettes in buon fresco without adulteration from

[9]Notably in the *Apotheosis of George Washington* in the canopy of the dome.

[10]The extensive overpainting of the decorative paintings has severely marred their appearance, and one is unable to see the artist's original intent. The north entrance corridor is a case in point. Here after conservation treatment, conservator Christiana Cunningham-Adams revealed the original tempera surfaces (1994), which were originally dark but had darkened considerably. Likewise, in small exposures of the decorative painting, the bright, light colors executed apparently in lime painting are strikingly different than the present darker and more saturated colors resulting from repeated campaigns of repainting.

[11]Pozzo, "Breve istruzione per dipingere a fresco," from *Prospettiva de' Pittori e Architetti,* as cited in Paolo Mora, Laura Mora, and Paul Philippot, *Conservation of Wall Paintings* (London, 1984), pp. 392–99.

FIG. 5. Detail from *Cession of Louisiana*. Note the use of *puntini* to transfer the design to the wall. *(Courtesy the author.)*

retouching in organic painting media. He tended to add layers over the first frescoed layers for shadows and highlights with pigments fortified with lime (color plate 12).

Previous research suggested that Brumidi added organic binders to paints to enhance their binding potential. Preliminary analysis of samples by means of fluorescence microscopy and FTIR suggest that proteins are present in samples from both the decorative paintings and the frescoes, notably *Bellona, Roman Goddess of War,* the *Cession of Louisiana,* and elsewhere (figs. 8, 9).[12]

The addition of proteinaceous binding media to fresco technique was common practice among fresco painters, especially during the baroque period. Artists recognized the limitations of fresco for achieving depth and contrast and enforced their paints with

[12]These preliminary findings primarily result from the author's 1990 research. Because of the presence of previous restoration layers, including overpaint and materials used to consolidate, such as casein, as suggested by Constance S. Silver, "The Conservation Treatment of the Fresco *Columbus and the Indian Maiden,*" (1991), p. 3, unpublished report, Curator's Office, Office of Architect of the Capitol, and the possible presence of materials applied as part of building maintenance, it was difficult to identify organic components conclusively within the limits of this research program. More extensive analysis is recommended, notably additional FTIR, GC/MS, and HPLC.

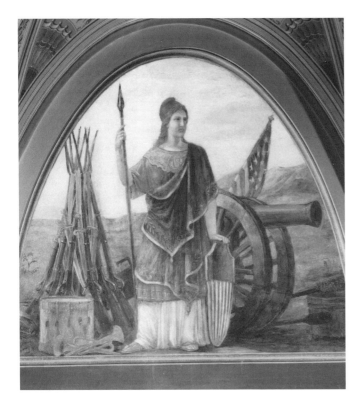

Fig. 6. Constantino Brumidi, *Bellona, Roman Goddess of War.* (See also color plate 10.) *(Courtesy Office of Architect of the Capitol.)*

Fig. 7. Detail of *Bellona, Roman Goddess of War. (Courtesy the author.)*

FIG. 8. Detail from
*Bellona, Roman Goddess of
War* showing one of the
locations where protein-
based materials were
found. *(Courtesy the author.)*

binding medium to achieve their goals. They added all types of organic binders in-
cluding casein, egg, and glue, painting over the already dried or drying surface.[13]

While Brumidi evidently intended to paint the lunettes in fresco and to combine
fresco and secco methods for the decorative paintings, he also resorted to other methods.
An example among the lunettes is the oil painting, *Bartolomé de Las Casas,* painted in

[13]Recent research by Leonetto Tintori, Paolo Bensi, and others documents examples of the use of organic
binders in historic fresco technique. See Guido Botticelli and Giuseppe Centauro, eds., *Il legante organico nell'af-
fresco, espressione e vitalità da salvaguardare: Ricerche, campionature, testimonianze* (Florence, 1992); and Paolo
Bensi, "La pellicola pittorica nella pittura murale in Italia: Material e tecniche esecutive dall'alto medioevo at
XIX secolo," in *Le Pitture murali: Tecniche, problemi, conservazione,* ed. Cristina Danti, Mauro Matteini, and
Archangelo Moles (Florence, 1990), pp. 72–102.

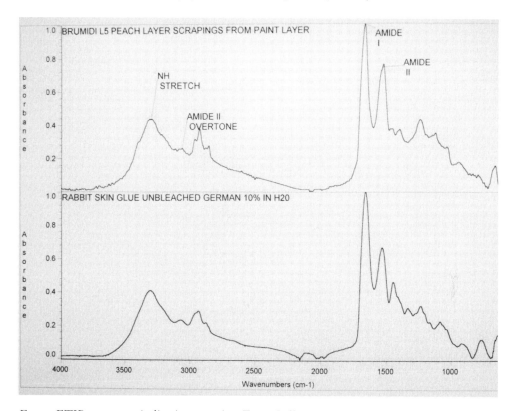

1876, twenty years after the decoration of the walls. He painted it over a monochromatic fresco field color apparently executed at the same time as the surrounding decorative paintings and lunettes. When the composition was later commissioned, instead of reapplying fresh plaster, he worked over it in oil paints (fig. 10).

Like all worthwhile research, this inquiry warrants additional study. The foundation laid by assembled documents, analyzed samples, and digested historical texts has cultivated rather than quenched the real substantive questions.

Among the substantive issues still to be resolved are questions of Brumidi's technique in relation to his contemporaries. In particular, how did Brumidi's mural technique differ from that of his contemporaries in America; and did his technique depart from his methods before he emigrated to America; or did it diverge from contemporary Italian techniques? Also interesting are questions of alteration of his technique while he worked at the Capitol. Did it change during the twenty-five years he worked at the Capitol? There also remain questions of combination of technique, both Brumidi's and his predecessors'. Since his decorative program at the Capitol clearly derived from

FIG. 10. Unlike the fresco lunettes elsewhere in the Senate corridors, *Bartolomé de Las Casas* was painted with oils over a tinted or frescoed plaster layer. Cross sections from all locations illustrate that oil paint layers were applied over a frescoed plaster ground. *(Courtesy Office of Architect of the Capitol.)*

classical and Renaissance programs, such as Raphael's Logge, to what extent were the methods consistent with those techniques? And finally, like some of the fresco masters, especially baroque masters, did Brumidi complete passages of the frescoes with binding media, especially with organic binding media?

That being said, observations here contribute to an understanding of how the artist worked: he modeled his design, and his techniques, on classical precedents, combining for the fresco compositions and decorative paintings a mixture of technique. His fresco methods were predominantly baroque, as seen in the coarse plaster surface, bold brushwork, and impasto reinforced with lime. And, in style and sequence of painting, notably size of *giornate,* he followed Renaissance instead of the more demanding baroque models. For the lunettes, the artist painted in a baroque version of fresco with lime enriched paints. It is also possible that he added organic media as retouching, although these preliminary conclusions require additional study. Brumidi designed an interior based on the Vatican Logge. For its execution, he directed an atelier of artists who worked in a variety of techniques and materials under his direction.

Brumidi appears to have relaxed his technical standards for the Senate corridors' lunettes, a result either of declining technical rigor after years away from European peers and commissions, or old age, or both. Here, he resorted to more static compositions, less dramatic and less expert than his earlier work in the building. Even when using oil paint in the Senate corridors for *Bartolomé de Las Casas,* he did not achieve the technical potential seen in the President's Room.

It is the whole of the decorative design that emerges as his achievement. There, in the convergence of palette, form, and detail with the architecture, he reigns as a master of design and the descendant of historic technique.

Brumidi and the Case of
the Mutant Mantel Clock

National Iconography in Decorative Projects for
the House of Representatives Extension, 1855–1858

DAVID SELLIN

CCOMPLISHED AND DEDICATED SCULPTORS SUCH AS GIUSEPPE CERACCHI
were attracted from Europe to Philadelphia by the vision of liberty in a
New World republic. A revolution it helped to inspire soon brought an
influx of French refugee artists such as Denis Volozan. These European artists all contributed significantly to the character of the arts in the new nation. Yet, both Thomas
Jefferson and Benjamin Henry Latrobe found this nation "entirely destitute of artists"
capable of doing the kind of decorative sculpture needed for the new Capitol in Washington.[1] Sculptors were recruited from Italy to create suitably republican (classical)
allegories of America, Liberty, Justice, and History—simplified for ready comprehension by the unsophisticated. In a simultaneous quest for an identifiable national
iconography, Latrobe invented an architectural order with shaft and capital derived
from native maize for the east foyer. From Charles Willson Peale he sought accurate
drawings of the American eagle to serve his Italian carvers. American elements—bald
eagle, rattlesnake, tobacco, corn, and cotton—became favored ornamental motifs
within accepted classical canons of decoration.

Dedicated to the memory of Robert C. Smith.

[1]Benjamin Henry Latrobe to Philip Mazzei, Mar. 6, 1805, quoted in Charles E. Fairman, *Art and Artists of the Capitol of the United States of America* (Washington, D.C., 1927), p. 3.

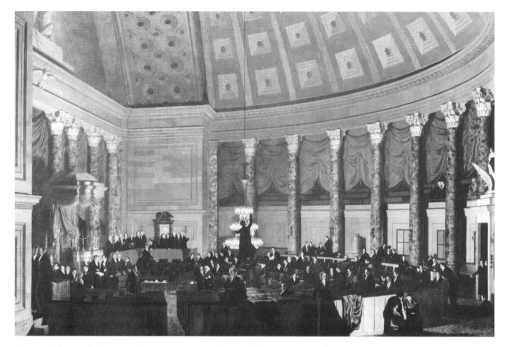

Fig. 1. *The U.S. House of Representatives.* Samuel F. B. Morse, oil on canvas, 1822. *(Courtesy Corcoran Gallery of Art, Washington, D.C.)*

Clocks are essential congressional furniture, timing deliberations, limiting debates, and useful tools of parliamentarians, and they can become reminders to legislators of the indelible passage of their actions into history. Samuel F. B. Morse's painting documenting Latrobe's House of Representatives in 1822 (fig. 1) depicts, directly opposite the Speaker's rostrum, Carlo Franzoni's marble *Car of History,* from which the muse of History records the acts of Congress from a chariot propelled by a clock. A similar allegorical timepiece proposed in 1824 for the Senate chamber was modeled by Enrico Causici from iconography provided by Charles Bulfinch. That project was dropped as an unessential extravagance; and, like the companion painting of the Senate chamber planned by Morse, it was never executed.

Between completion of the original Capitol in 1825 and the massive additions after 1850, a single generation saw dramatic change in American sculpture. Americans could send plaster models to Munich for casting and to Italy for cutting in marble; but now American foundries in Bladensburg, Maryland, and Chicopee, Massachusetts, also were capable of large casting. On the Capitol grounds in Washington, plaster models sent home from Italy by Thomas Crawford were cut in American marble by resident Italian and German immigrants, and a foundry was established for casting small bronzes.

Just when the most ambitious monumental building campaign in America was projected in Washington at midcentury, new political upheavals throughout Europe sent a fresh wave of experienced artists and craftsmen to our shores in search of refuge and opportunity. Among these expatriates were Constantino Brumidi, Joseph Alexis Bailly, and probably Edmond Baudin, although the reasons for the departure of the latter from France are still obscure. The remainder of this essay focuses on decorative projects for the House of Representatives Extension in which these and other artists were involved: a fireplace for the Speaker's Lobby, its metamorphosis into a monumental clock, and the new House and Senate staircases. Finished working drawings for these were produced by the office of the architect of the Capitol Extension, Thomas U. Walter, worked up from conceptual designs of Brumidi, under the direct authority and supervision of Capt. Montgomery C. Meigs, who controlled the purse strings for utilitarian elements not specifically designated as art nor structurally clearly architecture.

In 1855 Walt Whitman pulled *Leaves of Grass* from his press, adding an American presence to that of Cooper and Poe in international literature; James A. McNeill Whistler left a bureaucratic job in Washington for *la vie de la Bohème* in Paris; Richard Morris Hunt returned from Paris and Beaux-Arts to work briefly on Walter's projected Capitol dome before establishing the vogue for Second Empire French Renaissance style in American architecture; his brother, William Hunt, returned to promote a taste for Barbizon tonalist landscape painting that would dominate Boston for most of the century; and George Inness returned from Italy. In Philadelphia, the Pennsylvania Academy of Fine Arts was resurrected after a hiatus. At the U.S. Capitol, Meigs took an ever-increasing role in directing artistic embellishment of the Capitol Extension. Without authority over artwork to hang on the walls or to install in niches or on pedestals provided, Meigs, as supervising engineer, did have direct responsibility and allocations for portals and staircases, official furnishings, details for heat and ventilation, plaster, paint, and skilled labor for properly finishing walls. His field office shifted as work progressed, and in 1855 it was in the room planned for the House Committee on Agriculture (HB-144), its walls finished in brown coat and awaiting plaster when Constantino Brumidi came seeking employment.

Expelled from Rome for his republican sympathies, Brumidi was highly accomplished in the art of painting in fresco—directly applying color to the freshly applied coat of finish plaster. While he could certainly produce portable examples of his art, which he had practiced in New York, he could only demonstrate his command of that craft and offered a demonstration in the Capitol at no charge. Assigned a lunette in Meigs's office and a subject appropriate to agriculture in the new republic, he accomplished his task with such knowledge and dispatch that he was engaged to complete

the first integrated pictorial fresco decoration in the United States. Had he been paid by the square yard of artwork, other congressional oversight and funding would have been required, but who could contest the need to finish and paint the walls? He remained on the job until his death in 1880, paid by the day. He had no real competition in America as a fresco artist. Because he stood alone for two decades, his finest accomplishments—the Raphaelesque House Agriculture Committee Room, the President's Room in the Senate wing, the Renaissance and Pompeiian Senate Military and Naval Committee Rooms, and the vast canopy over the rotunda, to cite only the most remarkable—are too frequently ignored by scholars of the American Renaissance. An American citizen, and proud of it, Brumidi cannot be dismissed from American art as too Italian without throwing out most of our best artists as too English, Italian, German, or French. Thoroughly versed in architectural embellishment, Brumidi would be consulted by Meigs on virtually all aspects of interior decoration and furnishing of the Capitol Extension, but not without conflict with its architect.

Feverish activity was undertaken in 1857 to finish the interiors of the House and Senate Extension for occupancy before the year ended (fig. 2). Stairs providing members private access to the chambers needed appropriate railings, and on March 27 Meigs asked Brumidi to "look at the private stairs of the Senate and House just built and sketch me a design for a bronze railing for them," a task apparently not to be left to the architect who designed the stairs.[2] The first stairs to receive railings would be those leading from near Meigs's temporary office up to the Speaker's Lobby. This ample corridor behind the House chamber is behind the rostrum and parallel to a formal Retiring Room to the south. This last location was to be graced by an ornamental mantelpiece. Fireplace, railings, and clock for the new House of Representatives have an interlocking history.

The Mantelpiece Clock

Simple preliminary drawings for the Retiring Room date from 1854, but those submitted in July 1856 by Walter for Meigs's signature now contain an ornate fireplace (fig. 3). The arched opening, with ideal mask as keystone, is flanked by classical caryatids, and a heraldic eagle surmounts the tall overmantel mirror above. Captain Meigs discussed the mantelpiece project with the Philadelphia firm of Archer, Warner, and Misky, with detailed specifications (a drawing, no. 1069, executed August 20, 1856, is now unlocated): "The parts drawn in red are to be made of bronze. . . . Make me a

[2]Montgomery C. Meigs to Constantino Brumidi, Mar. 27, 1857, Art and Reference Division Archives, Office of Architect of the Capitol, Washington, D.C. (hereafter AOC).

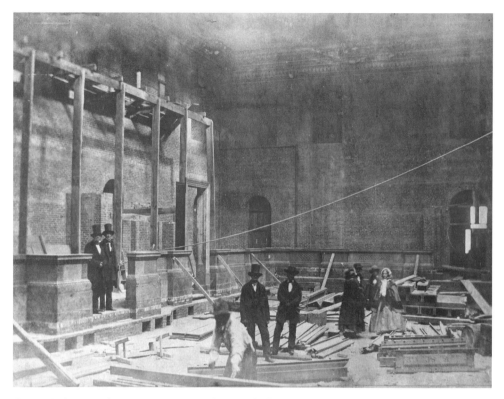

Fig. 2. U.S. Capitol Extension, House chamber before 1857, work in progress. *(Courtesy Office of Architect of the Capitol.)*

written proposal for casting the bronze portions of the work stating time and price at which they can be delivered. I should prefer some variations in the modeling of the figures—desiring only to have upon the mantel the best statuettes that I can obtain."[3] Whether or not the firm offered the services of foreign bronze casters is unclear, but their estimate far exceeded that of Meigs, who wrote again: "The estimated cost of $2,500 is too great for such an object. I should not be willing to expend that sum upon the mantel as a specimen of bronze work merely—And as a work of high art I should prefer that the designer be an American artist of established reputation or of high ability. For double the sum I could procure a portrait statue larger than life of Italian marble delicately finished."[4]

Meigs found his American sculptor in William H. Rinehart, back in Baltimore from study in Florence (where Hiram Powers was at work on ambitious Capitol commissions, now under the influence of Bartolini's modern *Gusto Purista*). On March 19, 1857, Rinehart agreed to "model in the best manner possible for me to do and deliver

[3]Meigs to Archer, Warner, and Misky, n.d., 1856, AOC.
[4]Meigs to Archer, Warner, and Misky, Feb. 4, 1857, AOC.

Fɪɢ. 3. Members' Retiring Room, detail drawing no. 1073, Thomas U. Walter, countersigned by M. C. Meigs, July 19, 1856. Notes read: "The eagle and heraldry to be omitted, and the mouldings to run straight across the doors and the looking glass frames, the mantel to be made in Washington," "mantel to be made of marble with applied bronze ornament." *(Courtesy Office of Architect of the Capitol.)*

Figs. 4 *(left),* 5 *(below). Indian* and *Woodsman [Hunter?].* William H. Rinehart, plaster, August 1857. Both models were photographed at the Capitol in September 1857 with supporting elements added on the glass plate for printing. *(Courtesy Office of Architect of the Capitol.)*

to you in plaster by the first of November 1857 two figures three feet three inches high for a mantel to be placed in the House retiring room for members, of the same design and character as the sketch shown to you and now in my possession."[5] Two days later, Meigs acknowledged the contract for "two caryatids . . . to fit the mantel as designed and represented on the drawing to be furnished by you under my signature. The models to be executed in plaster and delivered here or in Philadelphia, as I may prefer . . . [at] five hundred for the pair as proposed by you orally. The subjects to be the *Hunter* and the *Indian* as sketched and exhibited to me by you."[6]

Brumidi favored the native and transplanted races in combination as personifications of America in his first Agriculture Committee Room frescoes, and with or without him, Meigs conceived Indian motifs for drinking fountains for the Capitol, as well as the Post Office Extension, which he also supervised, giving Rinehart a Post Office commission at the same time as the fireplace caryatids. Brumidi was asked to provide conceptual designs for the bronze railings the same week.

Rinehart held to schedule, reporting in August, "The two figures for the mantel of the House reception room will be ready for shipment on Saturday the 30th inst."[7] Meigs advised him to "send the figures to this office carefully packed."[8] Arriving safely, they were photographed, and prints were sent to the artist (figs. 4, 5). On September 8, Meigs wrote identical letters to the Ames Foundry in Chicopee, Massachusetts, and Cornelius and Baker of Philadelphia: "I enclose you photographs of two figures, . . . which I desire to be cast in antique bronze, chased and finished in the highest style, for caryatids of mantel in members retiring room. Please inform me at what price you will undertake the work, and at what time you will engage to deliver them. . . . The figure stands alone. The rocks are only in the picture."[9]

To Cornelius and Baker, a major supplier of fine bronze casting in chandeliers and garniture for the Capitol, Meigs wrote on September 17: "I have estimates from other parties for caryatids. Be good enough to let me have yours in $ & cts."[10] A week later he acknowledged their composition for antique bronze to be correct but objected to estimates based on an edition for the general market: "As to the models, we cannot duplicate them. They are the original and only models and ought to be preserved entire."[11] A subsequent estimate for $150 each won them the contract, and the casting was completed by late December; the figures were sent from Philadelphia with the

[5]William H. Rinehart to Meigs, Mar. 19, 1857, AOC.
[6]Meigs to Rinehart, Mar. 21, 1857, AOC.
[7]Rinehart to Meigs, Aug. 25, 1857, AOC.
[8]Meigs to Rinehart, n.d., AOC.
[9]Meigs to Ames Foundry, Sept. 8, 1857, AOC; Meigs to Cornelius and Baker, Sept. 8, 1857, AOC.
[10]Meigs to Cornelius and Baker, Sept. 17, 1857, AOC.
[11]Meigs to Cornelius and Baker, [1857], AOC.

comment: "They have elicited much admiration from all who have seen them in this city and we think you will be pleased with them."[12] But Meigs found the patina wanting, a fault he attributed to inferior metal, to which the firm indignantly replied that it was the exact formula approved and the same used in the arms for the seats in the House Gallery that it had provided to Meigs's satisfaction. Nevertheless, the *Indian* and *Hunter* were sent back to Philadelphia to be rebronzed at the foundry's expense.

Cornelius and Baker had already retained the plasters longer than seemed necessary to Rinehart, who requested their return to him in February 1858 before he departed for Italy. Shortly after the bronzes were returned to the Capitol in August 1858, Cornelius and Baker had a pirate edition on sale in Philadelphia. The authorized pair is signed by the sculptor, but the Vermont Capitol in Montpelier acquired a pair in 1859 bearing only the foundry's stamp for seventy-five dollars apiece (at that price they must have been mass produced, but so far I have found no others).[13] Perhaps the efforts of influential Baltimore art patron and friend of the sculptor, William T. Walters, had effect. He wrote Meigs indignantly: "These gentlemen have not only duplicated the figures and exposed them for sale, contrary to what I was informed was the understanding with them, but parties in their place of business representing them have denied the true authenticity of the works and claim them as having originated in their establishment—thus inflicting a double injury upon a meritorious and excellent man, now laboring in a foreign land to acquire a name in his profession."[14]

Whether the pirate edition was cast from the original plasters or from surmoulages from the bronzes when they were returned could be determined by comparing exact measurements. Whether the firm acted to subsidize a low bid or to recoup what it deemed unjustified criticism for "change in color," it was an underhanded bit of work. But already changes in Washington might well have made the original color incompatible to a new use.

With pressures mounting in the fall of 1857 to have the House chamber ready, Meigs wrote to Brumidi to push the Speaker's retiring room to completion. Brumidi was then executing major frescoes and providing details for ironwork and drawings for furniture. In December the House convened in its new chamber, six days before Cornelius and Baker first shipped the bronzes. Eight months later, having just been rebronzed, they were still not in place. In fact, the whole original fireplace concept was scrapped. But nothing was abandoned—just rearranged. Undated Walter drawings incorporating Rinehart's photographs had dropped the eagle to the position originally held by the mask (figs. 6, 7). Eagle, *Hunter,* and *Indian* now all go the way of the mask,

[12]Cornelius and Baker to Meigs, Dec. 1857, AOC.
[13]Winslow Ames, "The Vermont Statehouse and Its Furniture," *Antiques* 88 (1965):202.
[14]William T. Walters to Meigs, [1859], AOC.

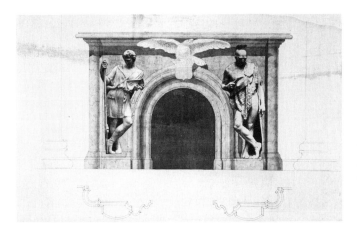

Fig. 6. Proposed Mantel for Members' Retiring Room, Thomas U. Walter, 1857, incorporating photographs of Rinehart's *Indian* and *Woodsman [Hunter?]*. *(Courtesy Office of Architect of the Capitol.)*

Fig. 7. Detail drawing no. 1043 for Members' Retiring Room, Thomas U. Walter, 1856. *(Courtesy Office of Architect of the Capitol.)*

all to reassemble in a new decorative scheme in the chamber itself, in which Brumidi probably played a decisive role.

The ideal mask, the first element discarded in the fireplace ensemble, was actually the first to take its place in the chamber itself (fig. 8). The arched portals onto the floor of the House chamber from the cloakrooms to the north, opposite the Retiring Room and Lobby, were always designed to receive masks in keystone position (fig. 9). Thomas Crawford agreed to provide plasters for fifty dollars apiece, but death claimed him before he could supply more than one sample, which was cast in the Capitol's own modest bronze foundry and put in place in 1857, directly opposite the Speaker's rostrum. Meigs wrote Rinehart, in exploring the possibility that he might complete the series: "You have seen one mask for the House of Representatives in bronze. It looks much better now that it is place than when it was not mounted. Indeed, it is very beautiful, as a calm, pure, female face."[15]

The Clock

A clock had been contemplated for some time for the spot directly above the Crawford ideal mask opposite the rostrum. Franzoni's old House clock could have been moved into the new chamber when the old one was abandoned. It had a justified celebrity and an undeniable historical identity. Its neoclassical purity would seem appropriate to the style of Walter, but not to the taste of Meigs. Considering the decor envisioned for the new chamber, it would have been out of place. Moreover, the old clock did not keep accurate time, and a modern Congress required reliable modern clockworks.

In the 1859 Pennsylvania Academy of the Fine Arts Annual Exhibition, the entry of Joseph Alexis Bailly was a *Clock Case for the Capitol*.[16] Like Brumidi, Bailly was a refugee from the revolutions of 1848. The son of a Paris cabinetmaker, he followed that profession; but when pressed into military service, he fled France—apparently after shooting a commanding officer—to London, then to New Orleans and New York, settling by 1850 in Philadelphia, where he married the daughter of a Dock Street tavern keeper named Louis David.[17] In 1852 he exhibited a *Bouquet Carved out of One Piece of American Oak* at the Pennsylvania Academy, and by 1855 he had formed a partnership with a master carpenter as Bailly and Buschor, located at 47

[15]Meigs to Rinehart, n.d., AOC.

[16]Anna W. Rutledge, ed., *Cumulative Record of Exhibition Catalogues: The Pennsylvania Academy of the Fine Arts . . . 1807–1870* (Philadelphia, 1955).

[17]Information provided by James Dallet, archivist of the University of Pennsylvania and the French Benevolent Society, Philadelphia.

Fig. 8. *Ideal Head.* Thomas Crawford, bronze, cast 1857, present location Office of Architect of the Capitol. *(Courtesy Office of Architect of the Capitol.)*

Fig. 9. House chamber under construction, August 28, 1857. Note spaces reserved in cast-iron door frames for keystone ornaments. *(Courtesy Office of Architect of the Capitol.)*

South Eighth Street, receiving major commissions for furniture, sculpture, and decoration for such prominent Philadelphia edifices as Napoleon Lebrun's new Academy of Music and the Masonic Temple (fig. 10). In 1858 Meigs addressed him as "Sculptor in wood," at 144 North Eighth Street above Cherry (a short distance from the factory of Cornelius and Baker), but he worked in marble and bronze as well, and was professor of sculpture at the Pennsylvania Academy.[18] Bailly wrote Meigs at the beginning of 1858: "I am at present engaged in modeling the design for the clock instead of making the drawing (as I first intended) as it will give a much more correct idea. It will be finished in a few days then I will bring it to Washington myself."[19] To which Meigs replied: "There is much time lost in making models, and they cost the artist so much that I am not in the habit of asking for them. I said to you that if you would present a sketch for a clock I would take it into consideration. This was so long since that I have now sketches by others, and had given up all idea of hearing from you on the subject. I have approved the design of another party, and expect to have it executed."[20]

Indeed, a drawing signed A. Kimbel (of the New York firm Bembe and Kimbel that was already producing furniture after designs by Brumidi) bears the note: "Mr. Walter. How do you like this and what alterations do you suggest? What wood for the north (back) of the case."[21] Walter sent his alterations to Meigs on the same day the latter informed Bailly of the adoption of the design of another.

Bailly's agitation is palpable in his response: "As this was my first piece of work for Washington I thought it would be better to make a model to display my workmanship. It is now nearly completed and I shall be at Washington with it on Thursday." His reception there, and offer of regular work at low pay, left him embittered:

> I only wish to have some work directly from you in the arts of figures or ornaments. I asked Mr. Thomas five dollars per day and I do not think it is too much for a man like me who has been used to getting in New York from 25 to 28 dollars per week for common work . . . but sir I am an artist and if you have confidence enough in my knowledge will you give me a figure to do which if it does not please you I will not ask you for any remuneration. P.S. If you have no use for the clock will you please send it on as soon as is convenient.[22]

Early in March, Bailly sent a note by the hand of a friend requesting the return of the clock, noting "my means are so limited I cannot afford to come for it now having

[18]H. H. Hawley, "Joseph A. Bailly," M.A. thesis, University of Delaware, 1960.
[19]Joseph A. Bailly to Meigs, 1858, AOC.
[20]Meigs to Bailly, [Jan. 11], 1858, AOC.
[21]Drawing, A. Kimbel, n.d., AOC.
[22]Bailly to Meigs, 1858, AOC.

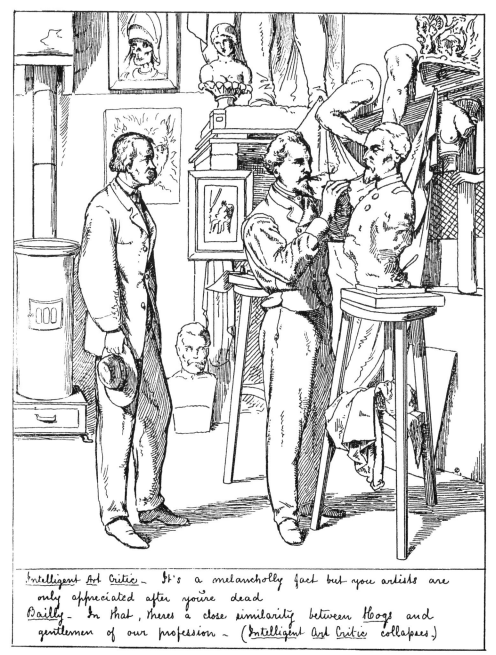

FIG. 10. *Immortality.* William Cresson, pen drawing in sketchbook, showing studio of Joseph A. Bailly in Philadelphia. *(Courtesy Robert Schwarz, Philadelphia.)*

nothing to do nor any prospect of anything."[23] Meigs returned the clock by express the same day, with a testy remark observing that he had told Bailly he had approved another design before he submitted his model. On its return, the clock model went on exhibition at the Academy, and perhaps today it graces one of Bailly and Buschor's Philadelphia commissions. Having just returned the Rinehart plasters, Cornelius and Baker learned only in March that a clock would incorporate their own castings. William Baker asked Meigs for a photograph of the design (with no prospect of a commission, they probably wanted it for promotion of the pirate edition bronzes).

The Eagle

After consultation with Sperry and Company, the firm providing the clockwork, Bembe and Kimbel sent Meigs the design for the back of the case, informing him it would take two months at a cost of $450 to complete: "The front . . . will be like your approved design and the whole case will be executed in oak wood." A month later they requested a "copy of the eagle's claws—standing on top of the clock case."[24]

The disposition of Rinehart's personifications of America around a garland of bountiful harvest in the final revised design (fig. 11) presupposes a major contribution from Brumidi and relates directly to frescoes in the Agriculture Committee Room (fig. 12). Eagles hovering over national allegory, however, are generally more palatable to American taste than naked putti. In their position in the final design for the clock that would constantly confront its representatives, the heraldic eagle rejoins the original ensemble (fig. 13).

The eagle itself was done in plaster at the Capitol by Italian modeler and marble cutter Guido Butti. Butti executed Crawford's models for the Senate pediment in marble and translated designs of Brumidi for decorative plaster in the formal Senate reception rooms into three dimensions. But this eagle was the result of yet another collaboration, cast in Philadelphia by a firm that had lost the original mantel commission. The day following Kimbel's request for the claws, Archer, Warner, and Misky wrote Meigs: "Your two favors of the 3rd inst., one covering a drawing of the clock of House of Representatives is received. *Our Mr. Baudin* has not yet arrived. P.S. Your letter of the 4th inst. is just received and the plaster cast of the eagle's feet will be sent to Messrs. Bembe and Kimbel."[25] The eighty-pound bronze eagle was cast on the eighteenth of the month, sent to the chaser, and on the same day an impression of the claws was sent

[23]Bailly to Meigs, Mar. 1858, AOC.
[24]Bembe and Kimbel to Meigs, 1858, AOC.
[25]Archer, Warner, and Misky to Meigs, [Mar.] 1858, AOC.

FIG. 11. Sketch proposal for House of Representatives clock, A. Kimbel, based on Rinehart photos provided by Meigs. *(Courtesy Office of Architect of the Capitol.)*

FIG. 12. *Washington* (detail of House Agriculture Committee Room [HB-144]). Constantino Brumidi, oil, 1855–56. *(Courtesy Office of Architect of the Capitol.)*

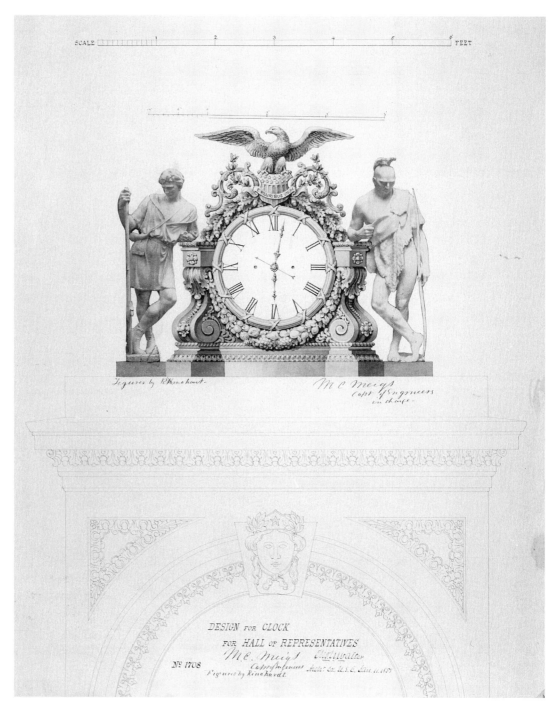

Fig. 13. Design for clock for Hall of Representatives, Thomas U. Walter, January 11, 1858, incorporating Rinehart photos in relation to Crawford's *Ideal Head*. *(Courtesy Office of Architect of the Capitol.)*

in a lump of plaster to ensure proper fit on the oak case. Meigs was informed that "*Mr. Baudin* will have it in Washington for you to look at during the next two weeks," and it was finished and delivered on April 22, 1858.[26]

Edmond Baudin first appeared in Capitol records in late 1856, when he wrote from his own bronze and brass foundry at 95 Mercer Street, New York, to introduce himself to Meigs, having missed the captain of engineers on a trip to Washington for that purpose:

> I have the most unequalled facilities for executing all styles of bronze work and artistic chasing. I can offer my establishment as being equal to any for the manufacture of artistic bronzes. I have already executed in New York works of remark, such as a Bas reliefs [*sic*], and two statues of large dimensions, and I would at this time remark that the works executed at my establishment are on the average scale of prices as the houses of Paris, and that I can undertake works of any style, dimension or of difficulty to execute. I will if you would desire it send to you specimens at any early moment.[27]

A later letter from Crawford's widow to Meigs indicated that Baudin would not shrink from monumental size: "A few days ago, while in Bordentown, I was waited upon by Mr. Baudin of the Philadelphia foundry, who seemed most sanguine of his ultimate success in casting it and inspiring me with much confidence in the satisfactory completion of the work confided to him."[28] Meigs's response to Baudin's original introductory inquiry, however, indicates that the Frenchman was at the time unknown:

> The importance of the works in Bronze which shall be executed for the Capitol Extension is such that without some knowledge of the ability of the artist who may offer for them I could not decide upon his employment. I have *here* artists who say they are equal to any else I may have. The Chicopee foundry of Ames is desirous of casting important works. I cannot therefore answer you without evidence of your skill (and) the production of your establishment and some information as to the size and character of your works—and the facilities you have for producing works of large size.[29]

Baudin responded by coming to Washington early in January 1857 with samples of his work, leading Meigs to tender him the position of director of the Capitol bronze foundry. Assuring Meigs that he had complete confidence in the craftsmanship of the Capitol bronze workers, most of whom he said were Frenchmen who had worked for

[26]Ibid.
[27]Edmond Baudin to Meigs, Dec. 13, 1856, AOC.
[28]Mrs. Louisa Ward Crawford to Meigs, Apr. 23, 1859, AOC.
[29]Meigs to Baudin, Dec. 23, 1856, AOC.

him in New York, Baudin declared the more ample facilities in Philadelphia of Archer, Warner, and Misky to be more suitable to his needs. In February, Meigs rejected Archer, Warner, and Misky's bid for the caryatids, expressing preference for an American sculptor.

Baudin's familiarity with architectural embellishment may have been a critical factor in Meigs's request in March that Brumidi provide drawings for four important ornamental stair railings (figs. 14, 15). In July, Baudin suggested that if the Philadelphia firm were given the work, he could come to Washington as frequently as necessary for consultation—also that he eagerly awaited drawings of the projected railings, in order that they might proceed on a timetable that would permit the care merited by their importance. These drawings were worked up on July 1 by Walter's office from Brumidi's sketch. Later that month Meigs sent two detail drawings to Archer, Warner, and Misky, writing: "I showed one of these to Mons. Boudin [sic] when last here."[30] The next day Baudin was in Washington with full authority to make a contract. Soon afterward a correspondent to the New York Times reported:

> The Manufacture of bronzes . . . has assumed, in Philadelphia, more imposing proportions, and higher artistic character, than it possesses anywhere else in this country. Everybody who has been compelled, for his sins, to furnish a house, knows, of course, that the chandeliers, argands, and general gas fittings of Cornelius and Baker and Archer and Warner are the only American articles of the kind which can sustain a comparison with the goods imported from Paris. But in the latter of these establishments I have just seen the moulds, and the models, and some of the completed portions of a magnificent bronze balustrade designed for one of the grand stairways of the new Capitol building at Washington . . . altogether, more elaborately elegant than anything of the kind which is to be seen in Europe. . . . The designs, furnished by Brumidi, of Washington, are singularly bold and graceful. They represent alternate groups of infants, eagles and serpents, pursuing and pursued through wreaths of foliage and flowers, and they consequently comprise almost all of those curvilinear forms and intricate traceries which lay the heaviest tax upon the skill of the draftsman and founder.[31]

Baudin and his assistants in the modeling department worked in wax from life. Before the establishment of the present Zoological Garden, a public menagerie was located at Logan Square near the Academy of Science. In February, Meigs had word at the Capitol of the Philadelphians' faithful pursuit of truth to nature—that they had bought an eagle in order to have a good model and had obtained permission from the

[30]Meigs to Archer, Warner, and Misky, July 24, 1857, AOC.
[31]New York Times, 1857, quoted in E. T. Freeley, Philadelphia and Its Manufactures . . . in 1857 (Philadelphia, 1859), pp. 438.

Figs. 14 and 15. Railing for House of Representatives staircase, preliminary drawings, Constantino Brumidi, April 1857. Note caryatid newel post. *(Courtesy Office of Architect of the Capitol.)*

city authorities to take a buck from the public square, box him up, and carry him into the fourth story of the workshop, where they kept him for three weeks, "having a hard fight with him in order to get him up and down."[32] For the serpents, they obtained a snake from the Academy of Sciences. It is not hard to imagine the smells on the fourth floor, in a Philadelphia summer, of animals and hot wax, or the cacophony of an essentially French atelier at work among buzzing rattlers, screaming eagles, and squealing babies (models for the putti). Progress was followed with interest by the press.[33]

When specimens of the House railing were put on exhibition in Brumidi's Agriculture Committee Room, never had American eyes been exposed to so many putti—nor in such a splendid combination of the very finest decorative architectural bronze and fresco (figs. 16, 17). In combination of motif and design the railing has an extravagant Roman flair, combined with the attention to natural detail of a true French *animalier*. In choice of fauna it satisfies the American passion for national identity. Within the ornate Renaissance *rinceaux,* corn and other native plants appear in repeats, with variations, in the major elements of the four stairways. The *Baltimore Sun* caused such intense consternation by reporting it as the work of Cornelius and Baker that, at Baudin's insistence, a correction was issued, the commission having been sought, he said, more for prestige than profit. Rivalry being so intense between the firms, Archer, Warner, and Misky suggested that their man, Baudin, be permitted to recast Rinehart's *Hunter* and *Indian* to show how it might be done properly to make them really a work of art: "We can only say that any price you may name for the work will be accepted. Although we have done quite enough for glory in the railing, it cost us much more than we shall receive for it, yet we cannot omit the opportunity of placing our work side by side with other manufactures, that it may [be] properly judged."[34]

Brumidi's original sketch for the railings included a caryatid in the newel post (fig. 14), which Walter simplified, changing the material to stone (fig. 18), to the dissatisfaction of Archer, Warner, and Misky. In September 1857, the firm sent new designs restoring bronze and suggesting figural candelabra: "The figure of 'Aurora' standing on it, is drawn from one we are just finishing for our sales. It would of course come at a much lower price than one modeled on purpose, so we send you a sketch of it."[35] Again, promotion through prestigious association with the Capitol Extension seems to be a strong motivating factor. The suggestion appealed to Meigs, who asked for an

[32]Baudin to Meigs, Feb. 21, 1857, AOC.
[33]Freeley, *Philadelphia and Its Manufactures,* pp. 438.
[34]*Baltimore Sun,* Nov. 13, 1857; Archer, Warner, and Misky to Meigs, Dec. 7, 1858; ibid., Dec. 20, 1858, AOC.
[35]Archer, Warner, and Misky to Meigs, Sept. 21, 1857, AOC.

Fig. 16. Detail of House of Representatives staircase with rattlesnake, cast by Edmond Baudin, bronze, 1857. *(Courtesy Office of Architect of the Capitol.)*

Fig. 17. Detail of House of Representatives staircase with eagle, cast by Edmond Baudin, bronze, 1857. *(Courtesy Office of Architect of the Capitol.)*

estimate, which came to $900 each, or $2,400 for four. After a conference with Baudin in Washington early in October, the candelabra were abandoned, but another of his sketches for the newel post was adopted, along with a more substantial handrail for the remaining three stairways, otherwise to be identical. To the first of the four stair-cases, ornamental braces were added for strength (fig. 19). Now under the name of Warner, Misky, and Merril, the firm wrote Meigs in March 1859: "We have now one flight of the railing finished, and wish to take it down that we may put another up (having room but for one at a time)."[36]

What impact could all of this sculptural activity have had in Philadelphia, where some of the most skilled wax modeling and French casting and chasing was going on, and at any given time one of the four great stairways was mocked up in the studio while in production, available to anyone in the city interested in sculpture? Thomas Eakins was enrolled at Central High School, where his professor of mechanical draw-ing corresponded with Meigs at the Capitol, requesting photocopies of drawings from the Office of Architect as demonstrations for his students, and Eakins's drawings for this course would have made him a welcome addition to Walter's drafting room. Meigs also used the old Pennsylvania Academy as a showcase for his efforts, and in 1854 deposited plaster executed by Guido Butti that still holds a conspicuous place in the present building.

There is a dynastic succession in Philadelphia sculpture from Ceracchi, who re-turned home, to Rush, who never left home (a friend of Latrobe at the time, who noted the absence in America of any sculptor capable of architectural work), to Bailly, less for his very competent work than for his affiliation with the academy, where he was an instructor of the generation of Howard Roberts, Thomas Eakins, and Mary Cassatt. From there the blossom opens from the stem, for from Eakins emerge the Calders, Charles Grafly, Samuel Murray, J. J. Boyle, and others. In the brief period that Bailly and Buschor and Baudin flourished in Philadelphia, that city was the American cen-ter for decorative sculpture in the finest French tradition. Immediately following the completion of the stairs, a generation of Philadelphia students went abroad to study— not to Dusseldorf, Florence, or Rome, but to Paris. It is hard to imagine that the young Robert Wylie, then foreman of ivory carving in the handle department of an umbrella factory and resident curator of the Pennsylvania Academy, could have been unaware and not inspired to a higher goal. And could young Eakins, always fascinated by anatomy in motion, have looked on as Baudin caught the live action of animals in wax? Bailly, friend of Baudin and also active in the French colony in Philadelphia, was Eakins's teacher at the Pennsylvania Academy after 1862, but by then Baudin was gone.

[36]Warner, Misky, and Merril to Meigs, Mar. 17, 1859, AOC.

Fig. 18. Members' private staircase, detail, Thomas U. Walter, July 1, 1857, introduces marble newel post. *(Courtesy Office of Architect of the Capitol.)*

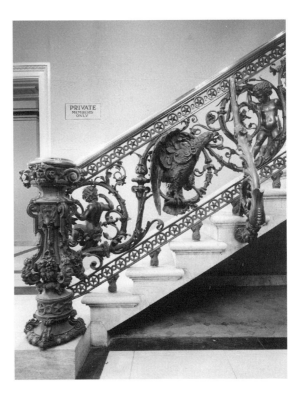

Fig. 19. Members' private staircase. *(Courtesy Office of Architect of the Capitol.)*

Philadelphia directories listed Baudin from 1859 through 1862 as an artist, residing in 1861 with Clementine Baudin, milliner, at 721 Spruce Street. The Civil War closes the record of Baudin's activity at the Capitol. Lincoln's call for volunteers brought him once again to Washington at age thirty-four, when he enlisted with a company composed of Philadelphia's French colony. The *Washington Star* reported:

> Fifty of a company of the French Zouaves will leave immediately for Washington to tender their services to the President . . . men all occupying respectable positions; Captain Baudin, who built the great stairway at the new Capitol extension, leaves a situation yielding him $60 a week as foreman of Messrs. Misky, Archer, and Warner; an artist with Messrs. J. Struthers and one who has just completed an excellent plaster bust of President Lincoln and three proprietors of the Hotel de France also go with this company. Captain Baudin has just declared his determination to take the uniforms from such other members as cannot, or may not wish to go.[37]

Company D was assigned garrison duty in Maryland and was mustered out in Philadelphia after its three-month tour of duty. This must have been beneath dignity. Baudin did not reenlist and vanished from city directories after 1862, at the age of thirty-five.

The Works

The handsome carved oak case for the mantel clock had been completed and delivered to Sperry and Company in New York on April 18, 1858. Two weeks later the works were installed; soon afterward the clock arrived at the Capitol and was put in its destined location, directly over Crawford's ideal mask (fig. 20). Finally all of the decorative elements of the original scheme for the ornamental mantelpiece for the Speaker's Retiring Room were reunited. Its migration in space was not far from the original fireplace: it faces the Speaker's rostrum, behind which is the Speaker's Lobby and Retiring Room, from which to the west Baudin's first stairway descends to an open corridor giving access to the Agriculture Committee Room in which all of this began. But, the continuing saga of the clockwork bears mention.

Whether by defect in manufacture, accident in transit, or sabotage on arrival (all of which were claimed), the new House clock did not function. Within a month of its installation a Sperry employee was sent "to make such arrangements as will keep the clock going until the end of the session." At which time, Sperry wrote, "I hope the key

[37]*Washington Star,* Apr. 18, 1862.

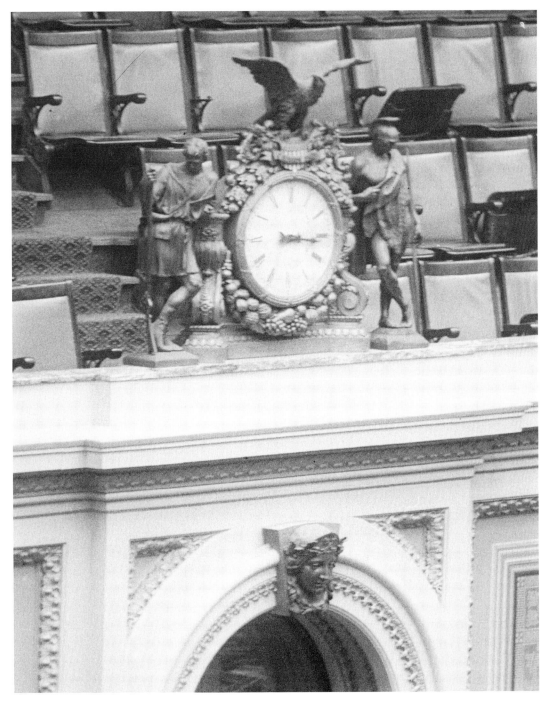

FIG. 20. *House of Representatives Clock. Indian* and *Hunter [Woodsman?]* figures by Rinehart and cast by Cornelius and Baker, eagle by Guido Butti and cast by Baudin, case by Bembe and Kimbel, works by Sperry and Company (1858) and Howard and Company (1859), shown in place in the House of Representatives chamber. *(Courtesy Office of Architect of the Capitol.)*

and the charge of the same may be placed in such hands as will insure its good performance and redeem my injured reputation." He was convinced that his works had been sabotaged by Charles Haydon, Capitol clock maker, who was also the agent for the rival firm, Howard and Company of Boston. "Take that key from this man," Sperry wrote, "and give the sole charge to Messrs. Galt of your city. . . . The profit on this clock is nothing compared to the reputation it will establish, and I am perfectly willing to stake my reputation on it. . . . A doorkeeper of the House informed me that Mr. Haydon had openly expressed his hostility both to me and the clock as soon as it arrived there."[38] The key was not turned over, and without it Galt refused to have anything to do with it. Then a Capitol employee wound it and a weight fell.

On examining the clockwork in June, Sperry's man found it "very much abused," rusty and broken. Confronted with Sperry's accusations by Speaker James L. Orr (D-SC), Haydon repeated what he claimed to have said when helping Sperry's man install the clock: "I then said it would not suit the place it was intended for, I say so now. There is sufficient room and depth enough for a properly constructed clock to run two weeks if necessary."[39] Haydon continued to promote Howard and Company's superior virtues and surrendered the key, but he was called in December for emergency repairs to keep it going to adjournment. Sperry, to save his reputation when faced with detailed description of the faults of the works, agreed to replace them, attributing the problems to the misconceptions in the carved case—which would not be at all surprising given that it began as a fireplace.

There is a fine symmetry in Sperry's efforts to prepare a sketch for a new Senate clock, which went the way of the Bulfinch/Causici project. In this case, it was not Senate reticence to justify the expenditure, but Sperry's efforts to press a personal timepiece on Meigs's representative, a Mr. Briggs, which so smacked of bribery that it had the opposite of the desired effect. Within a fortnight, William H. Willson of Howard and Company wrote Meigs: "While in Washington a few days since, I learned that you was not pleased with the performance of the clock in the Gallery of the House of Representatives and was permitted by Mr. Briggs to examine the space now occupied by the movement." He went on to offer, "I should be glad of the opportunity to furnish a weight clock of our manufacture for the same place. . . . The work could probably be executed at Washington, thus saving cost and risk of transportation and might be sculptured by your own artists. . . . Our object in trying to obtain the work is more for the reputation we may gain by it than the amount of profit." This time he would begin the clock with a clock, trusting others to suitably surround it to specifications. But all this continuing altruism seems a little forced when he continued on to offer to submit

[38]Sperry and Company to Meigs, 1858, AOC.
[39]Charles Haydon to Meigs, 1858, AOC.

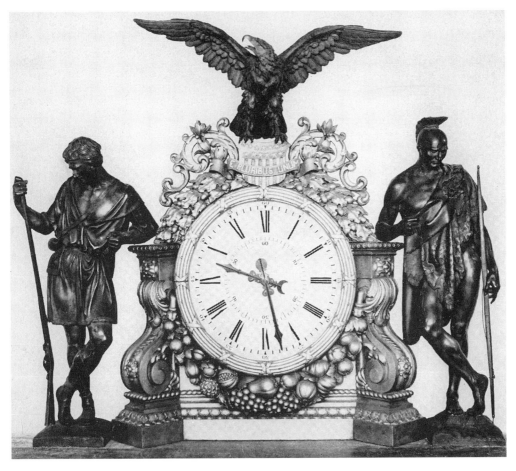

FIG. 21. The mutant mantel clock. *(Courtesy Office of Architect of the Capitol.)*

a design of his own for a Senate clock, "the figures and rocky base to be sculptured from White Marble, the parts tinted green proposed to be of bronze, with bronze figures."[40] All presumably more for reputation than profit.

Sperry did not get to eradicate his chagrin. On June 25, Meigs received the following: "You will much oblige the executor of the late Mr. Sperry by having the clock carefully packed and sent back to New York. This is the first instance in which our clocks have failed to give satisfaction, but we have the consolation in this case of knowing that it is no fault of the clock."[41] In November 1859 at a cost of $375, new works were fitted in the House clock by Howard and Company.

The mutant mantel clock timed House sessions for seventy years before being

[40]William H. Willson to Meigs, 1858, AOC.
[41]Sperry and Company to Meigs, June 25, [1858], AOC.

replaced by a modern timepiece and relegated to storage, where it survived World War II scrap drives and resurfaced in 1948 for an exhibition in Baltimore (fig. 21).[42] The House chamber was then facing drastic remodeling, and the clock was returned to deep storage, which saved it from the fate of hundreds of bronze ornaments origi- nating in the Capitol's own foundry that were stripped from the chamber to vanish with few traces. Removed about 1967 to an oubliette in the subterranean labyrinth of the House, the clock defied my efforts to find it when I was curator in the Office of Ar- chitect of the Capitol, but the initiative produced the desired results. On April 7, 1982, Architect of the Capitol George White wrote me: "It is my intention to recommend to the Speaker that the Clock be reinstalled in the House chamber in the near future."[43] It is presently on view in the crypt under the rotunda, awaiting the right time.

[42]M. C. Ross and A. W. Rutledge, *William Henry Rinehart* (Baltimore, 1948), p. 56.
[43]George M. White to David Sellin, Apr. 2, 1982, copy in author's possession.

Emanuel Leutze's *Westward the Course of Empire Takes Its Way*

Imagining Manifest Destiny, the "Stars and Stripes," and the Civil War

DANIEL CLAYTON LEWIS

IN THE LATE NINETEENTH CENTURY, WALT WHITMAN DECLARED THAT "THE REAL war will never get in the books."[1] Perhaps he was right about books, but recently scholars have been finding the real war in a diverse range of visual images produced during the Civil War. At first glance, some of these representations appear to have little to do with the national crisis. Under closer examination, paintings by Frederick Church, Emanuel Leutze, and other artists reveal the pervasiveness of the Civil War even in subjects seemingly unrelated to the sectional conflict.[2]

In 1861 and 1862 Emanuel Leutze, one of the premier history painters of nineteenth-century America, completed three versions of the composition *Westward the Course of Empire Takes Its Way:* two oil studies in the first quarter of 1861 and a large mural in late 1862 on the third floor wall of the west stairwell of the House of Representatives wing of the U.S. Capitol. All three versions of *Westward Ho!* (short title) mythologize what historian Frederick Jackson Turner identified as "the great historic movement

[1]Walt Whitman, "Specimen Days" (1882), in *Leaves of Grass and Selected Prose,* ed. Lawrence Buell (New York, 1981), p. 629.

[2]See, e.g., Joni L. Kinsey, "History in Natural Sequence: The Civil War Polyptychs of Frederick Edwin Church," in *Redefining American History Painting,* ed. Patricia Burnham and Lucretia Giese (Cambridge, 1995), pp. 158–73.

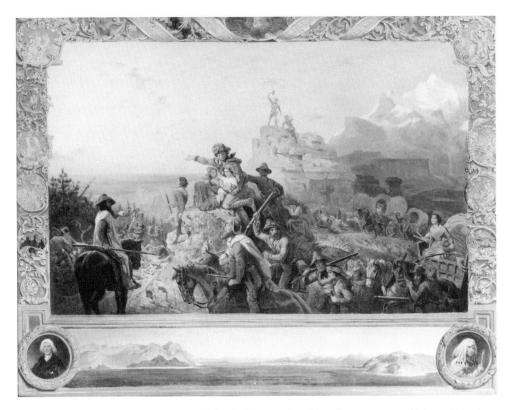

FIG. 1. *Westward the Course of Empire Takes Its Way,* study, 1861, oil on canvas, 33¼ by 43⅜ inches. *(Courtesy National Museum of American Art, Smithsonian Institution, Washington, D.C., bequest of Sara Carr Upton.)*

of America": pioneers traveling west to the land of paradise—captured by Leutze in this tantalizing representation of Manifest Destiny (figs. 1–2; color plate 13).[3]

In the main panel of *Westward Ho!* Leutze depicts a wagon train winding through the Rocky Mountains to the West. The pioneers have reached a point in their journey where they are able to see their final destination, the Golden Gate, located at the entrance of San Francisco Bay, shown beneath in the predella. In the left area of the com-

[3]Leutze's title, *Westward the Course of Empire Takes Its Way,* is based upon a line in George Berkeley's poem "America or the Muse's Refuge: A Prophesy" (1752). Berkeley was the bishop of Cloyne and an Irish philosopher. The poem is reprinted in *The Works of George Berkeley,* 9 vols., ed. A. A. Luce and T. E. Jessop (London, 1948–57), 7:369–73. Patricia Hills observes that the phrase was popular from the 1840s to the 1870s; see her "Picturing Progress in the Era of Westward Expansion," in *The West as America: Reinterpreting Images of the Frontier, 1820–1920,* ed. William H. Truettner (Washington, D.C., 1991), pp. 100–102. The two oil studies are owned by the National Museum of American Art, Washington, D.C., and the Gilcrease Institute of American Art, Tulsa, Oklahoma. It is not possible to determine the exact completion dates for the oils. The first was finished at the end of March 1861, and the second prior to mid-April. For a discussion of the dating of the studies, see Raymond Stehle, *The Life and Work of Emanuel Leutze* (Washington, D.C., 1972), p. 79. The origins of the short title also are unknown. For the Turner thesis quotation, see Frederick Jackson Turner, *The Significance of the Frontier in American History* (1893; reprint ed., New York, 1963), p. 27.

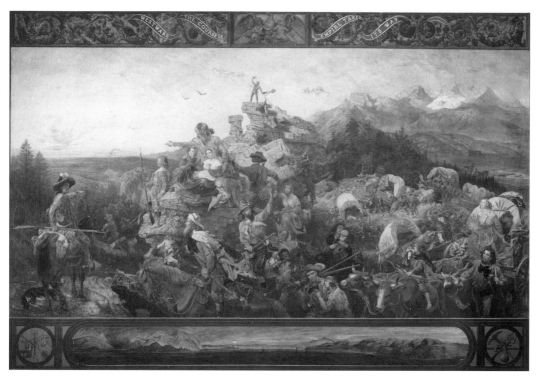

FIG. 2. *Westward the Course of Empire Takes Its Way,* mural, 1862, water-glass painting, 20 by 30 feet, House wing, west stairway, U.S. Capitol. (See also color plate 13.) *(Courtesy Office of Architect of the Capitol.)*

position, three figures—the man on horseback (bottom left), the trapper with the coonskin hat (center), and the figure on the prominent outcropping (in the upper center) —direct our attention to the west and the glorious sunset. In the two oils, the right medallion presents explorer William Clark and the portrait on the left is of Daniel Boone.

An ornamental border frames *Westward Ho!* on the left, right, and top margins. An American eagle is at the center of the upper decorative border. In the mural, the Boone medallion is situated approximately in the middle of the right margin and the Clark portrait is in the same position on the left border. Although the predella, the three borders, and medallions are important features in the overall composition, these elements —with the exception of the American eagle—are not central to my discussion of the main panel.

There are significant differences between the oil studies and the mural. Unlike the oil studies, the mural is cluttered with human figures, wagons, and horses. The images of the pioneers are significantly more distinct and separate in the oil studies than in the mural. The Capitol composition features five wagons, compared to only two in each

of the other versions. In the mural—despite a more expansive landscape—the pioneers, wagons, and horses are forced into a smaller space. Why are the studies so different from the mural? What happened to Leutze to change his mind about the composition of *Westward Ho!* between 1861 and 1862?

In 1846 William Gilpin, the mouthpiece of expansionism, articulated the divine mission of Manifest Destiny: "The untransacted destiny of the American people is to subdue the continent—to rush over this vast field to the Pacific."[4] The pioneers Leutze depicted in the 1862 version of *Westward Ho!* represented the "untransacted destiny" of the nation at a time when the very existence of the United States was in question. In his composition he embodied the root cause of the Civil War—the heated debate between Northerners and Southerners over the question of permitting slavery in the western territories. Leutze also revealed the fatal consequence of the sectional crisis—civil war. He attempted to abate the violence and suffering of the war by insulating the pioneers in *Westward Ho!* from the carnage. Through these images, Leutze celebrated the "untransacted destiny" of the United States and the preservation of the Union.

Leutze's allegiance to the United States had its origins in the revolutions of 1848. A German by birth, he participated in the radical movement to unify the German states in 1848 and 1849. Leutze and other Forty-eighters wanted to overthrow "autocratic authority and feudal privilege" so that democratic and egalitarian institutions could be established.[5] Despite some early successes, the revolutions failed to change the status quo. When the Civil War broke out in the United States in 1861, Leutze and other Forty-eighters looked to the uprising as an opportunity to reaffirm their idealistic agenda. As historian of German immigration Carl Wittke observed, "Forty-eighters who . . . had fought for liberty in the German fatherland, rallied in 1861 to battle for the principles of freedom, popular sovereignty and national unity which inspired their efforts in 1848 and 1849."[6] Leutze did not fight for the Union as Carl Schurz and other famous Forty-eighters did; instead, he picked up his brush and painted a picture of America that celebrated the Union cause.[7]

While the majority of newspaper correspondents who reviewed *Westward Ho!*

[4]This statement is contained in a report William Gilpin submitted to Congress regarding Oregon, reprinted in *Mission of the North American People: Geographical, Social, and Political* (1860; New York, 1873), p. 124. John L. O'Sullivan coined the phrase "Manifest Destiny" in *Democratic Review* (July 1845):5.

[5]Carl Wittke, *Refugees of Revolution: The German Forty-Eighters in America* (Philadelphia, 1952), p. 18. A discussion of the specific activities in which Leutze was involved exceeds the parameters of the present analysis. See Barbara S. Groseclose, *Emanuel Leutze, 1816–1868: Freedom Is the Only King* (Washington, D.C., 1975), pp. 30–32. None of the other studies of Leutze to date have considered how his experiences as a Forty-eighter may have influenced his art during the Civil War.

[6]Wittke, *Refugees of Revolution,* p. 221.

[7]Immigration historians have failed to consider Leutze's status as a Forty-eighter in America. Wittke discusses Carl Schurz and other notable German Forty-eighters but ignores Leutze (ibid.). Even the most recent studies overlook the artist, including Charlotte L. Brancaforte, ed., *The German Forty-Eighters in the United States* (New York, 1989).

noted its patriotic theme, a number of artists found the composition unsettling. Walt Whitman regarded *Westward Ho!* as a "nightmare dream," a puzzling observation given his spirited advocacy of westward expansion and the Union cause. Nathaniel Hawthorne, an outspoken critic of the war, feared that the country and the German artist's depiction of Manifest Destiny would be devastated by the sectional crisis. The wide range of comments elicited by the mural suggests that Leutze himself was struggling to understand what direction the "course of empire" was heading at a time when the nation was divided against itself in a bloody civil war.

Leutze incorporated elements of the Civil War into his mural, resulting in an amalgam of Manifest Destiny and the national crisis. He altered his final composition in four significant ways: he omitted a scene from the two oil studies depicting human figures surrounding a grave of an individual who had died on the journey; he included an African-American boy traveling with the other settlers to the West; he added icons representing union and liberty; and finally, he inserted two American flags. With the country literally "splitting at its seams" with the Civil War, Manifest Destiny and the West took on different meanings than they had before, and Leutze embodied these changes in his mural.[8]

A few days after the United States surrendered Fort Sumter to Confederate forces in mid-April 1861, Leutze submitted one of his oil studies to Capt. Montgomery Meigs, supervising engineer in charge of the U.S. Capitol Extension, after negotiating with the federal government for almost a decade about painting a mural outside the House of Representatives chamber.[9] On July 9, a legal agreement between Leutze and the federal government was formalized whereby for twenty thousand dollars he would paint a mural, based upon the oil study, to be located on the west staircase of the House wing. The federal government made the decoration and construction work on the Capitol a priority, despite the enormous expenditures needed to support the war effort.[10]

Before beginning the mural in July 1861, Leutze was variously involved in observing the war from the vantage point of the Union's central command in Washington, D.C. In May he sketched soldiers quartered at the Capitol on the floor of the House of Representatives chamber. Leutze also designed a certificate of service for the Union army. Furthermore, he made a number of visits to Camp Cameron, located on Meridian Hill in Northwest Washington. One observer reported that Leutze "has been a good deal

[8]Although Patricia Hills provides useful commentary concerning how Leutze's *Westward Ho!* was representative of expansionist ideology, she does not consider Manifest Destiny in the historical context of the Civil War. See Hills, *The West as America,* pp. 118–19.

[9]The oil study submitted to Meigs is the one now held by the National Museum of American Art, Washington, D.C. Meigs, on assignment when Leutze presented the painting, delegated his authority to Capt. J. N. McComb, see Stehle, *Life and Work of Leutze,* pp. 79–80.

[10]There was a flurry of artistic activity at the Capitol during the Civil War, see Charles E. Fairman, *Art and Artists of the Capitol of the United States of America* (Washington, D.C., 1927), pp. 199–217.

about the camp making memoranda. He will find great use for the materials he collects here, in his military subjects."[11]

The capital, indeed, was filled with a multitude of "military subjects." Noah Brooks, a newspaper correspondent, claimed that the city exhibited a "martial spirit": "Washington was . . . a military camp, a city of barracks and hospitals. . . . Long lines of army wagons and artillery were continually rumbling through the streets; at all hours of the day and night the air was troubled by the clatter of galloping squads of cavalry; and the clank of sabers, and the measured beat of marching infantry, were ever present to the ear."[12] Throughout the war Leutze expressed a keen interest in military subjects. He painted portraits of generals Ambrose Burnside, John Sutter, and Ulysses S. Grant, and of other Union officers. Furthermore, he painted a depiction of the Union bombardment of Fort Sumter.[13]

While Leutze was in the process of working on *Westward Ho!* intermittently from July 1861 to December 1862, Confederate spies roamed the city of Washington, hospitals overflowed with the wounded, and newspapers documented a war that was extinguishing life on a massive scale. On September 17, 1862, at Antietam, more than twenty thousand Union and Confederate soldiers were killed or wounded—the bloodiest single day of the war.[14]

In the midst of this chaotic and bloody period of American history, Leutze diligently worked on the Capitol mural. One newspaper correspondent admired the federal government's commitment to the decoration of the nation's Capitol at a time when the future of the United States was in jeopardy: "Nothing more clearly indicates the vigorous power of this young and growing nation than this, that, while a civil war of unequaled magnitude is raging in her midst, she calmly puts forth her energies in all the peaceful arts, and provides for the future of a united nation as if the war were but a momentary impediment."[15]

Nathaniel Hawthorne also was intrigued that Leutze was painting *Westward Ho!* at

[11]Raymond Stehle postulates that this sketch likely depicted soldiers of Col. Elmer E. Ellsworth's company, stationed at the House of Representatives in this time period in close proximity to the future location of the *Westward Ho!* mural, see Stehle, "Five Sketchbooks of Emanuel Leutze," *Quarterly Journal of the Library of Congress* 21 (1964):91–92.

[12]Noah Brooks, *Washington, D.C., in Lincoln's Time,* ed. Herbert Mitgang (Chicago, 1958), pp. 15–16. Brooks was a reporter for the *Sacramento Union* and lived in Washington during most of the Civil War.

[13]On the military portraits, see Groseclose, *Leutze,* pp. 119–20. For an informative account of the Union assault on Fort Sumter, see E. Milby Burton, *The Siege of Charleston, 1861–1865* (Columbia, 1970), pp. 183–209. I wish to thank Daniel Visnich of the Historic State Capitol Commission, Sacramento, California, for bringing this unknown Leutze painting, *Fort Sumter after the Bombardment,* to my attention. According to Norton P. Chipman, the original owner of the painting and a Union officer during the Civil War, Leutze witnessed the bombardment in person and made a sketch of the incident. He used this drawing as the basis for the painting (Court Memoranda, Apr. 7, 1921, District Court of Appeal, Third Appellate District, Sacramento, California, N. P. Chipman, Presiding Justice).

[14]James H. Whyte, "Divided Loyalties in Washington during the Civil War," *Records of the Columbia Historical Society of Washington, D.C.* (1960–62):103–22; Margaret Leech, *Reveille in Washington, 1860–1865* (New York, 1941), pp. 204–33.

[15]*Daily National Intelligencer* (Washington, D.C.), June 17, 1862.

a time when the war threatened to extinguish the Union: "It was delightful to see him so calmly elaborating his design, while other men doubted and feared, or hoped treacherously, and whispered to one another that the nation would exist only a little longer."[16] Hawthorne admired Leutze's artistic endeavor all the more because his own muse had been crippled by the war. Hawthorne made his comments about Leutze in "Chiefly about War Matters," a severe critique of the war that literary scholar Nina Baym proposes was "an attempt to belittle the war, to treat it as lightly, so to speak, as it had treated him." Indeed, Hawthorne was literally consumed by the war; he died in 1864, but not before Leutze completed a portrait of the aging author.[17]

Leutze worked on *Westward Ho!* at a time when the momentum of the Union cause—established in a number of military victories in the West during the first four months of 1862—had been thwarted by Confederate successes in Virginia. Stonewall Jackson's brilliant Shenandoah Valley Campaign in the early spring and summer and Robert E. Lee's victory at Second Manassas (Second Bull Run) on August 28–30 demoralized Union sympathizers. Confederate advances in Virginia were particularly unsettling to residents in Washington, immediately adjacent to Virginia. Northerners also were alarmed that Lee was planning to invade Maryland in the fall.[18]

In the foreboding environment following the bloody stalemate at Antietam, Leutze completed the mural, measuring twenty by thirty feet, at the end of November 1862. None of the newspapers announced the official unveiling of *Westward Ho!* in early December. Perhaps correspondents were preoccupied with reporting General Burnside's troop movements in Virginia.[19] Shortly thereafter, however, dozens of reviews of Leutze's mural appeared in the Washington, New York, and Boston newspapers. The general public was enthusiastic about the mural. Journalists observed large crowds viewing *Westward Ho!* in the Capitol. One correspondent indicated that "Mr. Leutze, the artist, has received many warm congratulations today from crowds who have gazed with delight at his grand work of art."[20]

[16]Nathaniel Hawthorne, "Chiefly about War Matters," *Atlantic Monthly* 10 (1862), reprinted in *Tales, Sketches, and Other Papers* (Boston, 1890), p. 307.

[17]Hawthorne indicated to his longtime publisher and friend, William T. Ticknor, that "the excitement [of the Civil War] had an invigorating effect on me for a time, but it begins to lose its influence. But it is rather unreasonable to wish my countrymen to kill one another for the sake of refreshing my palled spirits; so I shall pray for peace" (quoted in James R. Mellow, *Nathaniel Hawthorne in His Times* [Boston, 1980], p. 542). Most literary scholars acknowledge that Hawthorne's literary powers declined during the Civil War period. Nina Baym challenges this interpretation; she argues for the literary merit in Hawthorne's *Our Old Home* (1863), but admits that he himself blamed the Civil War for disrupting his "muse." See Baym, *The Shape of Hawthorne's Career* (Ithaca, N.Y., 1976), chap. 8, "The Last Phase, 1860–1864," pp. 251–78. Hawthorne sat for his portrait in April 1862 during a visit to Washington. See Mellow, *Hawthorne in His Times,* p. 555.

[18]Union forces scored significant victories at Fort Henry and Fort Donelson (Tennessee), Pea Ridge (Arkansas), and Shiloh (Tennessee). See James M. McPherson, *Battle Cry of Freedom: The Civil War Era* (Oxford, 1988), pp. 392–422, 453–60, 526–33. For an informative discussion tracking Northern morale in 1861 and 1862, see J. Matthew Gallman, *The North Fights the Civil War: The Home Front* (Chicago, 1994), pp. 37–55.

[19]See Stehle, *Life and Works of Emanuel Leutze,* p. 95.

[20]Ibid.

The audiences of *Westward Ho!* praised the artist for creating a picture that celebrated Manifest Destiny. Hawthorne observed that the mural "looked full of energy, hope, progress, irrepressible movement onward."[21] Another reviewer also used expansionist rhetoric to applaud Leutze's composition: "The design displays great diversity, energy, and characteristic action, representing with marked fidelity the peaceful settlement of the far West." This observer echoed Gilpin's program that it was imperative that the American people "emblazon history with the conquest of peace."[22] Even Leutze had stated in his program notes, which were released to the newspapers, that *Westward Ho!* represented "the grand peaceful conquest of the great west."[23]

But James Jackson Jarves, the preeminent art critic of the time, criticized *Westward Ho!* He offered a remarkable counterstatement to the prevailing public opinion: "Of all his frantic compositions, the fresco of Westward Ho! . . . is the maddest. . . . Confusion reigns paramount, as if an earthquake had made chaos of his reckless design, hot, glaring coloring, and but ill comprehended theme."[24] Although Jarves published these observations in 1869, the words he chose to criticize the mural—"the maddest," "confusion reigns paramount," "earthquake," "chaos"—are reminiscent of wartime rhetoric. Inadvertently, Jarves's caustic description of the mural aptly *describes* the nation in the midst of the rebellion. It is plausible that *Westward Ho!* was popular among contemporaries because the composition—despite its overt Western subject matter—embodied the uncertain, troubling mood of a nation in the throes of civil war. It is probably not coincidental that Leutze's two oil studies—painted before the war became a bloody and lengthy affair—are significantly less chaotic and cluttered than the mural.

Walt Whitman also found *Westward Ho!* unsettling. On one of his frequent visits to the Capitol he viewed the mural, scribbling in one of his notebooks a puzzling observation: "The hodge-podge of pictures in the great panel (a *masquerade* or *nightmare dream,* of an overland emigrant train crossing the Rocky mountains)—the blue bay of the San Francisco frescoed underneath—the whole grandeur and beautiful proportions and color and enduring [?] material of this staircase and its area altogether, (I

[21]Hawthorne's comments were made before the mural was completed. See "Chiefly about War Matters," p. 306.

[22]*Daily Morning Chronicle* (Washington, D.C.), Nov. 28, 1862; Gilpin, *Mission of the North American People,* p. 124.

[23]Quoted in Justin G. Turner, "Emanuel Leutze's Mural, *Westward the Course of Empire Takes Its Way,*" *Manuscripts* 18 (1966):15.

[24]James Jackson Jarves, *Art Thoughts* (New York, 1869), p. 298. Jarves's criticism also is representative of the art world's growing opposition to history painting in the decades following the Civil War. See Mark Thistlethwaite, "A Fall from Grace: The Critical Reception of History Painting, 1875–1925," in *Picturing History: American Painting, 1770–1930,* ed. William Ayres (New York, 1993), pp. 177–219.

think it the best thing I have seen in Washington)."[25] It is surprising that one of the most enthusiastic advocates of westward expansion in nineteenth-century America chose "masquerade" and "nightmare dream" to describe a composition that appeared to celebrate Manifest Destiny. Although Whitman's praise of *Westward Ho!*—"the best thing I have seen in Washington"—may represent his attempt to diffuse these observations, it fails to explain why he viewed *Westward Ho!* in such haunting terms.[26]

Spending his days attending to the wounded and dying soldiers in Washington hospitals, Whitman may have found Leutze's mural at odds with the force driving his own life. In a letter to his brother Thomas, Whitman expressed his disappointment that the interior decorations at the Capitol were "without grandeur, and without simplicity," and then made an abrupt transition: "These days, the state our country is in, and especially filled . . . from top to toe, of late with scenes and thoughts of *the hospitals* . . . the interior Capitol . . . seem[s] to me out of place beyond any thing I could tell."[27] Perhaps Whitman viewed Leutze's mural as a "masquerade" because it was "out of place" with the unsettling realities of war. It may have been difficult for him to forget the "scenes and thoughts of the hospitals" as he viewed Leutze's mural.

The "nightmare dream" Whitman saw in Leutze's mural was possibly the war itself. As Wyn Thomas observes, Whitman conflated the course of empire and the war in his own art. In "Pioneers! O Pioneers," a poem first appearing in Whitman's volume of wartime poetry, *Drum-Taps* (1865), the persona beckons "my tan-faced children" to march westward and encourages them to acknowledge the war dead who follow at the rear of the procession:

> See, my children, resolute children
> By those swarms upon our rear, we must never yield or falter,
> Ages back in ghostly millions, frowning there behind us urging,
> Pioneers, O pioneers![28]

In the midst of the Civil War, Whitman associated Manifest Destiny with a bloody

[25]Walt Whitman, *Notebooks and Unpublished Prose Manuscripts: Washington,* 6 vols., ed. Edward F. Grier (New York, 1984), 2:563; emphasis mine.

[26]Henry Nash Smith, *Virgin Land: The American West as Symbol and Myth* (Cambridge, Mass., 1950), pp. 44–48. It is surprising that there is no secondary literature on Whitman's observations, especially given the popularity of this image among art historians. As far as I can determine, I am the first to identify Whitman's description of Leutze's *Westward Ho!* Scholars have become increasingly interested in the relationship between Whitman and the visual arts; see Geoffrey M. Sill and Roberta K. Tarbell, eds., *Walt Whitman and the Visual Arts* (New Brunswick, N.J., 1992).

[27]Walt Whitman, *The Correspondence, 1842–1867,* ed. Edwin Haviland Miller, 6 vols. (New York, 1961–77), 2:75; emphasis in original.

[28]Walt Whitman, *Leaves of Grass: A Textual Variorum,* ed. Sculley Bradley et al., 3 vols. (New York, 1980), 2:476.

legacy. "Swarms" of "ghostly millions" sacrifice their lives to ensure that the course of empire would continue to exist. During the Civil War, the "untransacted destiny" of the United States "to subdue the continent" came at a tremendous human cost. Whitman situates this haunting vision of Manifest Destiny in "all the mystic nights with dreams," a "nightmare dream" he sees in *Westward Ho!* Indeed, the nightmare dream of the Civil War haunted the poet for the rest of his life.[29]

One reviewer treated *Westward Ho!* as a prophecy for a postwar America. He claimed that the mural "is a great historical picture, an epical view of the future of America. It is no allegory, no borrowed fantasy, but a real, living, actual breathing fact."[30] Leutze's mural becomes a tragic omen that America would survive the Civil War and exist in a glorious future, consecrated by the deaths of hundreds of thousands of Union soldiers. Lincoln immortalized this future "fact" when he declared at Gettysburg in 1863 that "these dead shall not have died in vain; that this nation, under God, shall have a new birth of freedom; and that government of the people, by the people, for the people, shall not perish from the earth."[31] In a sense, Leutze painted the future Lincoln was imagining for America.

Leutze dissociated the pioneers depicted in *Westward Ho!* from the war dead. He did not invite Whitman's "ghostly" soldiers to join his wagon train of pioneers. Leutze's program notes for the mural indicate that the artist was distancing the subject of the composition—Manifest Destiny and the West—from the harsh realities of war. Within the formal features of the mural itself, he divides the physical space between what he identifies as the "promised land," the view of the West (on the left), and the "valley of darkness," the vista to the east (on the right). One correspondent viewed the "valley of darkness" in the mural as the place from which the pioneers departed: "Behind the travelers lie all the busy cities of the East, the tilled farms, the smoke of factories, the freighted rivers."[32] Also behind the pioneers is the war, generating its own peculiar kind of pollution—the corpses of soldiers. The "valley of darkness" represents war and death, while the "promised land" connotes peace and life.

The "promised land" during the Civil War was a place far removed from the car-

[29]A discussion of the contradictory relationship between Native Americans and the ideology of nineteenth-century expansionism lies outside the scope of this essay. Leutze included three Indian figures in the ornamental border. For an informative discussion of this issue, see Vivien Green Fryd, *Art and Empire: The Politics of Ethnicity in the U.S. Capitol, 1815–1860* (New Haven, 1992), pp. 209–13. M. Wyn Thomas contends that "the reference to the 'ghostly millions' from 'ages back' is an anguished awareness of those victims of the recent past, the dead of the Civil War . . . [who] now come swarming upon the rear, frowningly urging America to live up to their sacrifice." Thomas also argues that "the American dream becomes the only escape from this newly acquired American nightmare" (Thomas, *The Lunar Light of Whitman's Poetry* [Cambridge, Mass., 1987], pp. 271–72). Thomas unknowingly captures what Whitman wrote after viewing Leutze's *Westward Ho!* His interpretation would have been more convincing had he been aware of Whitman's notebook entry.

[30]*National Daily Intelligencer,* June 27, 1862.

[31]See Garry Wills, *Lincoln at Gettysburg: The Words that Remade America* (New York, 1992), p. 263.

[32]Turner, "Leutze's Mural," p. 12; *Daily National Intelligencer,* June 27, 1862.

FIG. 3. Detail of the grave scene from the 1861 oil study. *(Courtesy National Museum of American Art, Smithsonian Institution, Washington, D.C., bequest of Sara Carr Upton.)*

nage of war. Although Union and Confederate armies fought one another as far west as the New Mexico Territory the year Leutze painted the mural, the war's epicenter was the eastern theater. The West was particularly attractive for deserters who could hide there from military authorities. After passage of the Homestead Act in 1862, twenty-five thousand settlers moved west to stake their claims before the Civil War ended in 1865.[33]

Leutze distanced *Westward Ho!* from the bloody conflict by removing the death scene of human figures surrounding a grave, a motif that appeared in both oil studies for the mural (fig. 3). He may have been alarmed by the images of death saturating the Northern press. Mathew Brady, Alexander Gardner, and other photographers armed with cameras feverishly searched for corpses on battlefields throughout the war. Perhaps Leutze did not want to subject viewers of his mural to more death. Even on the home front in Washington, death was omnipresent. On a daily basis, army hearses carried dead soldiers through the streets of the city. At the Capitol, itself, there were ominous signs of war that Leutze could not have ignored. Between September and November 1862—while he worked on the mural—the Capitol was used as a hospital for wounded Union soldiers.[34]

Leutze's extended exposure to death manifested itself in *Angel Hovering above a*

[33]McPherson, *Battle Cry of Freedom,* pp. 450–51.

[34]By 1866, Alexander Gardner and George Bernard in their respective photographic albums, *Gardner's Photographic Sketch Book of the War* (1866) and *Photographic Views of Sherman's Campaign* (1866), included very few photographs of dead soldiers; the general public had grown weary of these disturbing images. For an illuminating discussion of this issue, see Alan Trachtenberg, *Reading American Photographs: Images as History, Mathew Brady to Walker Evans* (New York, 1989), pp. 93–111. On military hospitals in the capital during the war, see John Wells Buckley, "The War Hospitals," in *Washington during War Time,* ed. Marcus Benjamin (Washington, D.C., n.d.), p. 140.

Battle Scene (1864), a painting in which he chose not to marginalize the war. Although Leutze apparently was depicting a Civil War "battle scene," the soldiers wear uniforms identified with the Revolutionary War era.[35] Almost all the men are dead; their bodies lie clustered together in a scene reminiscent of Civil War battlefield photographs.

At the same time that Leutze insulated the pioneers depicted in *Westward Ho!* from the carnage of war represented in *Angel Hovering above a Battle Scene,* he also included a human figure in the mural that threatened to push the wagon train back into the "valley of darkness." Unlike the two oil studies, the mural contains a figure of an African American boy (fig. 4; color plate 14). Leutze stated in his program notes: "A mother [is] kissing her babe with tears of joy, mounted on a mule led by a Negro boy who caresses the beast for the work done." He also identified the "Negro boy" as a freedman.[36] Even though Leutze presents the African American in a position of subservience—his responsibility is to lead the mule—he does not cast him as a slave. But in viewing the African American boy as a freedman, Leutze implies that this individual had previously been a slave. In the context of the Civil War, the artist's freedman was an ideologically charged image because slavery in the Southern states had ultimately led to the crisis of the Union. For Leutze, this figure of emancipation resonated with a distinctive meaning in the nation's capital.[37]

During the time Leutze was painting *Westward Ho!* Washington was a beacon of liberty for thousands of African Americans fleeing slavery. Between 1861 and 1862, slaves migrated to Washington because the Union military in a number of campaigns in Virginia and Maryland had confiscated the farms and plantations on which slaves resided.[38] On April 15, 1862, the federal government emancipated all slaves in the District of Columbia. Federal, local, and military officials scrambled to establish refugee camps in Washington in order to handle the flood of fugitive slaves arriving in the city. Between March and July, many were centrally housed at Duff Green's Row, a building located a block from the U.S. Capitol. Leutze probably saw former slaves in the vicinity of the Capitol and on the streets of Washington.[39] On September 22, President Lincoln announced his preliminary Emancipation Proclamation, effective on January

[35]Groseclose, *Leutze,* p. 99.

[36]Turner, "Leutze's Mural," p. 15. Leutze confirmed that the African American boy was a freedman in an interview with art critic Anne Brewster. See *Lippincott's Magazine* 2 (1868):526.

[37]Eric Foner contends that slavery was "the fundamental cause" of the Civil War. See "Slavery, the Civil War, and Reconstruction," in *The New American History,* ed. Eric Foner (Philadelphia, 1991), pp. 73–92.

[38]For an exhaustive discussion of this pattern of migration, see Allen Johnston, *Surviving Freedom: The Black Community of Washington, D.C., 1860–1880* (New York, 1993), pp. 101–53.

[39]For a concise account of African Americans living in the District of Columbia during the Civil War, see Ira Berlin et al., eds., *Freedom: A Documentary History of Emancipation, 1861–1867,* 4 vols. to date (Cambridge, 1982), 2:243–63.

FIG. 4. Detail of the African American boy in the 1862 *Westward Ho!* mural. (See also color plate 14.) *(Courtesy Office of Architect of the Capitol.)*

1, 1863. This measure—while unenforceable—freed all slaves residing in states that had seceded from the Union.[40] It is possible that Leutze's figure of the freedman in *Westward Ho!* was inspired by the emancipation of slaves in the District of Columbia and Lincoln's actions to liberate slaves in the Southern states.[41]

Leutze's figure of emancipation in *Westward Ho!* eluded the notice of the general public in the war years. Newspaper correspondents typically referred to the African American in the language of Leutze's program notes. The "Negro boy" was not identified specifically as a freed slave. Some reporters failed to mention his presence in the composition. Perhaps Leutze placed the black figure in a cluttered space to partially obscure him from view.[42]

Leutze's depiction of the African American as a *boy* instead of a *man* in *Westward Ho!* takes on added meaning as the federal government moved cautiously toward allowing African Americans to serve as soldiers in the Union army. While he worked on his mural in the summer of 1862, military officials began recruiting African Americans.[43] Leutze may have distanced the black figure from the war by depicting him as too young to fight. Perhaps the artist did not want the war to threaten the serenity of the "promised land" in *Westward Ho!*

Leutze added two more youths to the mural—the allegorical figures of union and liberty, situated in the upper margin of the ornamental border on top of the composition

[40]Ibid., 2:42.

[41]In 1868, the year Leutze died, he completed a cartoon featuring the emancipation of slaves. See Groseclose, *Leutze,* p. 62.

[42]See, e.g., *New York Evening Post,* Dec. 17, 1862.

[43]The Union commander on the South Carolina coastal islands was given the order to recruit 5,000 freedmen as soldiers on August 25, 1862. See McPherson, *Battle Cry of Freedom,* p. 564.

FIG. 5. Detail of the American eagle and the allegorical figures of liberty and union in the upper margin of the ornamental border of *Westward Ho!* (See also color plate 15.) *(Courtesy Office of Architect of the Capitol.)*

(fig. 5; color plate 15). Undoubtedly, the presence of these icons indicates that Leutze was engaged with the war. He remarked in his program notes that "the standard bird shields union and liberty under his wings—influences of superior intelligence." In Leutze's mural, the American eagle—one of the central symbols of the republic—protected union and liberty from harm's way. Usually the national bird "clutched arrows in one claw . . . and an olive branch in the other."[44] Instead, Leutze situated the American eagle in the historical context of the Civil War. In the antebellum era, this national icon represented the unity of America.[45] However, during the national crisis, it was impossible for the eagle to represent the union of all states. It is possible that Leutze coupled the image of liberty in the ornamental border with the figure of emancipation. At a minimum, he captured the crisis of the Union in the image of the American eagle shielding union and liberty.

The presence of the American flag in *Westward the Course of Empire Takes Its Way* indicates that Leutze's final composition incorporated his understanding of the impact the war was having on the country's future. He included two banners, one situated on an outcropping above the pioneers and the other located on one of the wagons (figs. 6, 7). It is especially compelling in this context that Leutze's two studies for *Westward Ho!* do not contain the central symbol of the Union cause, the American flag.[46] In the final version, the Stars and Stripes is featured prominently—indeed, it is the most triumphant feature of the composition.

[44]Turner, "Leutze's Mural," p. 15; Joshua Taylor, *America as Art* (Washington, D.C., 1976), p. 10.
[45]Taylor, *America as Art,* p. 10.
[46]See Scot M. Guenter, *The American Flag, 1777–1924* (Cranbury, N.J., 1990), pp. 66–87.

FIGS. 6 *(above)* and 7 *(below)*. Detail of the American flags depicted in *Westward Ho! (Courtesy Office of Architect of the Capitol.)*

Reviews of *Westward Ho!* suggest that viewers recognized the national significance of the American flag in the mural. One reporter commented that "the 'stars and stripes' [were] emblematic of the national sovereignty of the Union, one and indivisible."[47] Another correspondent emphasized the same theme: "Two of the party are emulous to plant the Stars and Stripes upon the topmost peak, and, in these dark days of trial, we felt the beauty of the whole marvelous production, almost as a prophetic conviction that the idea of our 'manifest destiny' could not perish."[48]

Hawthorne's observations about the flag offered a sharp contrast to those who viewed the Union symbol in triumphant terms. He imagined that the Capitol would collapse upon itself, obliterating *Westward Ho!* if the Union were dissolved: "The free-stone walls of the central edifice are pervaded with great cracks, and threaten to come thundering down, under the immense weight of the iron dome—an appropriate catastrophe enough, if it should occur on the day when we drop the Southern stars out of our flag."[49] The removal of the Southern stars from the flag would signal the end of Manifest Destiny and the Union. Hawthorne's dark vision about the demise of the Union shares a certain affinity with Whitman's "nightmare dream." Each artist had difficulty reconciling Leutze's *Westward Ho!* with the realities of civil war.

The American flag also took on a distinctive meaning in the nation's capital in the first two years of the war. With Washington in close proximity to Virginia, areas of which were under Confederate control, and Maryland, a border state, the American flag was used to designate the city as a federal stronghold. Before the areas of Virginia bordering on Washington were secured by Union forces, residents in the city could see Confederate flags "waving from the Virginia heights across the Potomac."[50]

Leutze also had made significant use of the American flag in *Washington Crossing the Delaware* (1851), a tremendously popular painting in the nineteenth century. His depiction of George Washington leading his men in the attack on the Hessians, mercenaries for the British, is not unlike the historical context surrounding *Westward Ho!* In fact, Leutze proposed to the federal government during the negotiations for the commissioning of his Capitol mural that the work be part of a series celebrating key events in American history, including, not coincidentally, depictions of the Revolutionary War. His addition of the national banner to his mural seems designed to emphasize the work's symbolism in this political context. Other artists had used the flag to similar effect, most notably Frederick Church in *Our Banner in the Sky,* which was produced in chromolithographic reproductions to benefit the Union fund in the opening weeks of the war.

[47]*Daily Morning Chronicle,* Nov. 28, 1862.
[48]*Daily National Intelligencer,* Nov. 27, 1862.
[49]Hawthorne, "Chiefly about War Matters," p. 307.
[50]Brooks, *Washington in Lincoln's Time,* p. 22.

As some historians have argued, the Civil War was the second American Revolution, a concept Leutze recognized in associating the figure of emancipation with the Union cause.[51] By inserting the freedman into the wagon train of pioneers, he proposed that the element that made the Civil War a revolution was the emancipation of slaves. As a Forty-eighter who had fought for freedom in his native country, Leutze could appreciate the Union's efforts to liberate African Americans.[52]

Westward Ho! was finally a testament to Leutze's faith in the Union cause. As one of his friends observed, he was a "Union man of 'The Strictest Sect.'"[53] Those who viewed his mural also appreciated his patriotism. *Westward Ho!* boosted Union morale at a time when defeats in the spring and summer of 1862 had disheartened many.[54] In the aftermath of additional losses at Fredericksburg and Chancellorsville in mid-December and early May 1863—which threatened to dissolve the Union permanently—Leutze's depiction of Manifest Destiny represented a beacon of hope that the United States would survive the "dark days of trial" and emerge victorious, "one nation, indivisible."

Emanuel Leutze's *Westward the Course of Empire Takes Its Way* was about more than Manifest Destiny and the American West; it was about the Manifest Destiny of the American Union. The African American boy, the allegorical figures of union and liberty, and the American flags Leutze included in his mural demonstrate his efforts to incorporate elements of the Civil War context into his composition. The omission of the burial scene from the mural reflects his attempt to soften the destructive force of war. Taken together, the changes Leutze made in his mural show that he was confident that the United States would have a future beyond the Civil War, when pioneers could continue to move west in search of the promised land.

[51]James M. McPherson, *Abraham Lincoln and the Second American Revolution* (New York, 1990).

[52]Leutze also was keenly aware of the historical significance of the Revolution in an international context. Barbara Groseclose argues that Leutze's *Washington Crossing the Delaware,* completed in the aftermath of the failed uprising of the German states, represented his hope that Germans would look to the American Revolution for inspiration. See Groseclose, *Leutze,* pp. 36–40.

[53]Lucille Griffith, ed., "The Old Capitol Journal of George Henry Clay Rowe," *Virginia Magazine of History and Biography* 62 (1964):427.

[54]William F. Strobridge makes the argument that Leutze's mural "revived the morale" of Washington residents without situating the positive reception of the composition in a specific historical context. See Strobridge, "A Western Mural for Morale," *Pacific Historian* 23 (1979):24–27.

Albert Bierstadt

History Painter for the U.S. Capitol

KIMBERLY A. JONES

ALBERT BIERSTADT IS BEST REMEMBERED TODAY AS A CHRONICLER OF THE American West. But in addition to his large-scale and frequently theatrical depictions of the western landscape, Bierstadt also executed a small number of paintings inspired by history that form an important though little-known component of the artist's oeuvre. From the early work, *Gosnold at Cuttyhunk* (1858), through the very late painting of the *Landing of Columbus* (1892–93), Bierstadt returned to the historical landscape at critical points in his artistic development.

Certainly the most important experiment of this genre was the pair of pendant paintings that Bierstadt executed for the United States Capitol, the *Discovery of the Hudson River* (1874) (fig. 1; color plate 16)[1] and the *Settlement of California, Bay of Monterey, 1770* (1876) (fig. 2; color plate 17).[2] Bierstadt, an ambitious artist desirous of the recognition and prestige that would accompany a major commission for the Capi-

[1]*Discovery of the Hudson River,* oil on canvas, six feet by ten feet, purchased by the Joint Committee on the Library on March 3, 1875, for ten thousand dollars; it originally hung in the new House chamber (currently hanging in the members' dining room). See Glenn Brown, *History of the United States Capitol,* 2 vols. (Washington, D.C., 1900–1903), 2:188. The second and final installment of seven thousand dollars for this painting was approved by Timothy Howe, chairman of the Joint Committee on the Library on July 1, 1875. The payment was made on July 21, 1875 (National Archives, Record Group 217, No. 199.326, voucher no. 3).

[2]*Settlement of California, Bay of Monterey, 1770,* oil on canvas, six feet by ten feet, purchased by the Joint Committee on the Library in 1878 for ten thousand dollars; it originally hung in the new House chamber (currently hanging in the members' private stairway, west corridor). This painting was hung provisionally in the House of Representatives in 1875 under the title *California Landscape.* See Brown, *History of the Capitol,* 2:188.

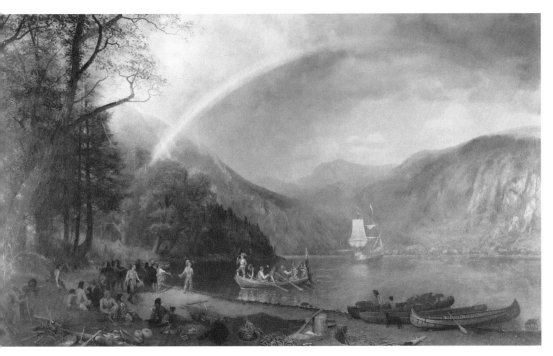

Fig. 1. Albert Bierstadt, *Discovery of the Hudson River,* 1874, oil on canvas, 6 by 10 feet, U.S. Capitol; formerly hung in the chamber of the House of Representatives; presently in the members' dining room. (See also color plate 16.) *(Courtesy Office of Architect of the Capitol.)*

tol, pursued this goal for more than a decade. But instead of depicting pure landscape, Bierstadt chose to treat two relatively obscure pages from American history, which he used to construct an edifying, symbolic narrative of American progress appropriate to this monument to American democracy.

This pair of paintings is the focus of this study, which examines four key factors in order to illuminate the evolution and meaning of these two works: the history of the commissions themselves, their relationship to the tradition of history painting in the Capitol, their setting and spatial structure, and their subject matter. It is only by examining these paintings within the context in which they were produced that their significance in the oeuvre of Albert Bierstadt and their role in the decoration of the Capitol may be appreciated.

The history behind these paintings is a complex one.[3] Bierstadt first sought a commission for the Capitol in 1866. At that time he was at the peak of his popularity and financial success, having just sold his monumental canvas *The Rocky Mountains, Lander's*

[3]This history has been masterfully traced by Linda S. Ferber in "Albert Bierstadt: The History of a Reputation," in *Albert Bierstadt: Art and Enterprise* (Brooklyn, San Francisco, and Washington, D.C., 1991–92), pp. 40–45, 49–53.

FIG. 2. Albert Bierstadt, *Settlement of California, Bay of Monterey, 1770,* 1876, oil on canvas, 6 by 10 feet, U.S. Capitol; formerly hung in the chamber of the House of Representatives; presently in the members' private stairway, west corridor. (See also color plate 17.) *(Courtesy Office of Architect of the Capitol.)*

Peak (fig. 3) the previous year for the impressive sum of twenty-five thousand dollars.[4] In a letter of December 1866, Bierstadt announced his interest in a commission for the House of Representatives chamber of the U.S. Capitol. He proposed a subject depicting the Rocky Mountains or Yosemite, though he also suggested two possible programs of decoration for the House chamber. The first—and the artist's preferred —program would depict two western landscapes: "One might represent scenery of the Rocky Mts showing in the foreground something of Indian life . . . [and] the other comprising the . . . leading features of the wonderful Yo Semite Valley. Both these subjects it seems to me would be strictly American, and would have the advantage of being in strong contrast to each other."[5]

For the second program, however, Bierstadt suggested subjects of a historical nature: "Some more appropriate subject might be found where figures would come to il-

[4]The painting was sold to James McHenry; ibid., p. 42.
[5]Bierstadt to Captain Adams, Dec. 17, 1866, Miscellaneous Papers, Manuscript Division, New York Public Library, cited in Ferber, "History of a Reputation," p. 43.

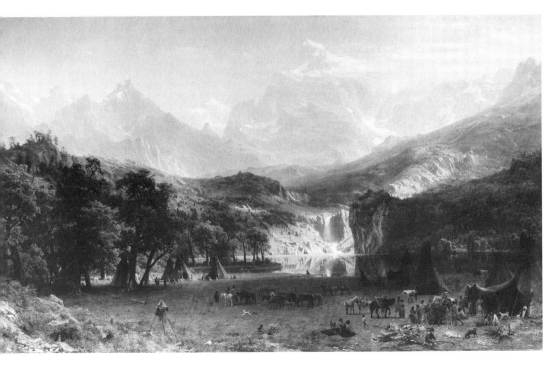

FIG. 3. Albert Bierstadt, *The Rocky Mountains, Lander's Peak*, 1863, oil on canvas, 73 ½ by 120 inches. *(Courtesy Metropolitan Museum of Art, New York.)*

lustrate some event in the history of our country—the discovery, for instance, of the Hudson River which I have in progress."[6]

Initial response to Bierstadt's proposition for a pair of paintings to adorn the walls of the Capitol was very positive, and on January 21, 1867, the House of Representatives submitted a resolution authorizing the artist to execute a pair of paintings to fill two unoccupied panels in the House chamber. The resolution was approved by the Joint Committee on the Library the following month, with the stipulation that Bierstadt submit plans for the two paintings as well as his fee.[7] However, when Bierstadt's proposition and his required price were read at a meeting of the Joint Committee on the Library on March 13, 1867, Congress was taken aback. The artist had requested the astronomical amount of forty thousand dollars for each of his two proposed paintings, citing the current market value of his works, most notably *The Rocky Mountains, Lander's Peak*. Congress responded immediately, voting: "That the Librarian be instructed to inform Mr. Bierstadt that no appropriation having been made to carry out

[6]Ibid.
[7]Charles E. Fairman, *Art and Artists of the Capitol of the United States of America* (Washington, D.C., 1927), p. 270.

the purpose of the House resolution respecting the panels in the Hall the Committee deemed it inexpedient in the present state of our finances to recommend an appropriation for the object in question."[8]

If this first attempt to obtain a commission for the Capitol had failed, Bierstadt had not yet abandoned all hope. In August 1874 he once again broached the subject. Writing to Edward Clark, then architect of the Capitol, he requested permission to exhibit two paintings there in an obvious attempt to reopen negotiations with Congress. Even though Bierstadt had failed to request permission from the Joint Committee on the Library, the body that oversaw the acquisition of works of art, his unorthodox tactics worked. By December of the same year, two of his paintings were hung in the House chamber.

One of the two paintings displayed was the *Discovery of the Hudson River,* the painting that Bierstadt ostensibly had already commenced in 1866, though it was not completed until October 1874.[9] Initially, he chose a scene of the American West, the *Kings River Canyon* (now known as *Autumn in the Sierras*) (fig. 4), to act as the companion piece to this historical subject.[10] As has been suggested, this decision as well as Bierstadt's renewed interest in the Capitol commission may have been influenced by Thomas Moran's recent success in obtaining the purchase of his paintings *The Grand Canyon of the Yellowstone* (1872) and the *Chasm of the Colorado* (1873–74) for the Senate chamber of the Capitol.[11] Bierstadt had already begun to feel the competition from the younger artist, whose career so closely paralleled his own. This was particularly apparent when Moran was chosen to accompany Ferdinand Hayden on the geological survey to Yellowstone in 1871, just as he himself had accompanied Frederick Lander's survey party to the Rocky Mountains in 1859.[12] Moran's rise to fame, culminating in his Capitol

[8]Ibid.

[9]Bierstadt to George Bancroft, Oct. 17, 1874, Bancroft Papers, Massachusetts Historical Society, Boston, cited in Ferber, "History of a Reputation," p. 50.

[10]Nancy Anderson has found an unidentified clipping in a scrapbook kept by Bierstadt's first wife, Rosalie, that describes these two paintings in situ. It presents a different description of the events surrounding the artist's first campaign for the commission for the Capitol, a description no doubt provided by the artist: "Congress many years ago directed the Library Committee to order or contract with Mr. Bierstadt for two paintings upon national subjects. He declined to sell them in advance, preferring, in a very popular spirit, to do his work first and submit it to the judgment of his countrymen. If it should merit a place in the Capitol, he felt sure of its appreciation and acceptance; but if it proved unworthy, he could not afford to let it be purchased by the nation" ("Two Paintings" [1875], photocopy in the Curatorial Records, Office of Architect of the Capitol, Washington, D.C.).

[11]Ferber, "History of a Reputation," pp. 51–52. Both of Moran's paintings for the Senate chamber, *The Grand Canyon of the Yellowstone* (1872) and *Chasm of the Colorado* (1873–74), are currently in the National Museum of American Art, Smithsonian Institution, Washington, D.C.

[12]On the participation of Bierstadt and Moran in the western surveys, see Howard E. Bendix, "Discovered! Early Bierstadt Photographs, Part One: The Lander Expedition," *Photographica* 6 (1974):4–5; Ralph A. Britsch, *Bierstadt and Ludlow: Painter and Writer in the West* (Provo, Utah, 1980); Carol Clark, *Thomas Moran: Watercolors of the American West* (Austin, Tex., 1980); Joni Kinsey, *Thomas Moran and the Surveying of the American West* (Washington, D.C., 1992); Debora Ann Rindge, "The Painted Desert: Images of the American West from the Geological and Geographical Surveys of the Western Territories, 1867–1879," Ph.D. diss., University of Maryland at College Park, 1993.

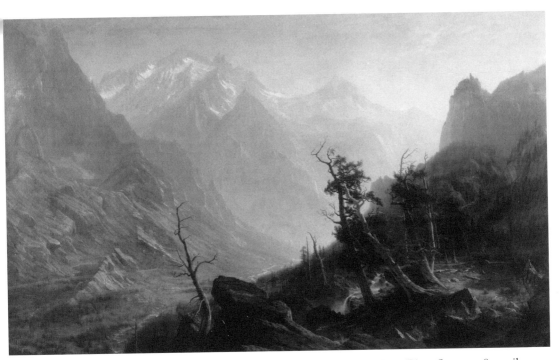

F<small>IG</small>. 4. Albert Bierstadt, *Autumn in the Sierras,* formerly known as *Kings River Canyon,* 1873, oil on canvas, 72 by 120 inches. *(Courtesy City of Plainfield, New Jersey.)*

commissions, was all the incentive that Bierstadt, now a middle-aged artist, would have needed to renew his pursuit of his own project for the Capitol.

These two paintings by Bierstadt, however, cannot be viewed as true pendants, but rather as an attempt by the artist to hedge his bets by proposing two very different subjects and themes in a final attempt to win the commission that he had coveted for so many years. When only one of the two, the *Discovery of the Hudson River,* was at last accepted by Congress in 1875, Bierstadt's next line of action became apparent. He abandoned pure landscape in favor of history in the hopes of executing a companion piece for the House chamber. The painting that he produced was the *Settlement of California, Bay of Monterey, 1770,* which would not be acquired until nearly four years later, in 1878. The exact date of this acquisition remains unclear. On January 25, 1878, the Joint Committee on the Library submitted to the House that the appropriation bill incorporate further funding in order to purchase a work of art for the decoration of the House chamber.[13] The next official reference to the acquisition of works of art for the Capitol came in June 1878. In the records of the U.S. Statutes at Large of the Forty-fifth Congress is found the following entry: "June 20, 1878: chap. 359—An act making appropriations for sundry civil expenses of the government for the fiscal year ending June thirteenth, eighteen hundred and seventy-nine, and for other purposes. . . .

[13]Fairman, *Art and Artists of the Capitol,* p. 271.

Congressional library: To enable the Joint Committee on the Library to purchase works of art for the Capitol building, fifteen thousand dollars.... Approved, June 20, 1878.[14]

Apparently this did not resolve the issue. In a letter to Ainsworth Spofford, the librarian of Congress, dated July 9, 1878, Bierstadt indicated that he had received no confirmation on the matter:

> When I was in Washington I saw General Hooker about an hour after the meeting of the committee and I intended to tell you this in my last letter. He expressed himself in favor of the purchase of the picture and if you have not already heard from him I would gladly bear the expense of sending him a telegraph. I have tried to find out where he is but thus far I have failed to do so.
>
> You can readily understand my wish to have this matter disposed of as I sail for Europe next week.
>
> Any means you may employ to facilitate this matter will be appreciated by Yours.[15]

It would appear that the issue was settled prior to Bierstadt's departure for Europe on July 20, since there is no further correspondence from the artist on this matter. Bierstadt had at last succeeded in having his paintings acquired by the Joint Committee on the Library, but it seems that at least some of his tactics had met with the stern disapproval of Congress. In their meeting of May 22, 1878, the Joint Committee approved the following motion: "On motion of Mr. Edmunds [Sen. George F. Edmunds, R-VT] it was VOTED;—That after the present session of Congress, no works of art, not the property of the United States, shall be exhibited in any part of the Capitol."[16] Given the timing of this motion and the events leading up to the acquisition of Bierstadt's painting, there seems little doubt that the motion was provoked by his unusual, though highly successful, methods.[17]

In light of Bierstadt's efforts to gain his coveted Capitol acquisition, his decision to abandon pure landscape in favor of historical narrative was one guided by the same spirit of pragmatism. In its commissions and acquisitions, Congress had long exhib-

[14]U.S., *Statutes at Large,* vol. 20, p. 239. In spite of the appropriation, there is no record of any payment voucher in the National Archives.

[15]In the postscript Bierstadt goes on to say: "I saw M. [Samuel S.] Cox a few days since and he said that there would be no delay that the matter had been fully decided and only wanted Senator Howe's signature" (Bierstadt to Spofford, July 9, 1878, Library of Congress Archives).

[16]"Extracts from the Minutes of the Joint Committee on the Library," 45th Cong., 2d sess., May 22, 1878, p. 121 (typescript copy, Library of Congress, General Records, 1872–1897, and undated, A.2).

[17]Bierstadt was not the only one who attempted such a ploy. Thomas Moran tried a similar tactic in 1878. On January 18, 1878, he requested permission of Congress to hang his painting *Ponce de León in Florida, 1512* in the empty panel in the chamber of the House of Representatives. The request was denied, see Thurman Wilkins, *Thomas Moran, Artist of the Mountains* (Norman, Okla., 1966), pp. 111–12. Moran's painting is currently in the Gilcrease Institute of American History and Art, Tulsa, Oklahoma.

ited a preference for historical subject matter for the decoration of the Capitol. Even as late as 1875, one author addressed this state of affairs, commenting: "In America there is also little government patronage of art, save the rare purchase by Congress of historical pictures or statues."[18]

There were, of course, numerous precedents for historical paintings, particularly those that illustrated scenes of discovery and settlement.[19] The most obvious were the paintings that had been executed for the rotunda of the U.S. Capitol between the years 1817 and 1855.[20] Of those eight paintings, three related to the themes of discovery and settlement: the *Embarkation of the Pilgrims at Delft Haven, Holland* by Robert W. Weir,[21] the *Landing of Columbus at the Island of Guanahani* by John Vanderlyn,[22] and the *Discovery of the Mississippi by De Soto* by William H. Powell.[23]

Another important influence was the work of Emanuel Leutze, one of the most celebrated history painters active in America at the time. Bierstadt had met Leutze while a student in Dusseldorf, where he may have even studied under the older artist.[24] Although Bierstadt had concentrated upon landscape during his studies, Dusseldorf was well known as a center of history painting, and Bierstadt inevitably came into contact with a number of practitioners of this genre, including Karl Friedrich Lessing. When Leutze received a commission for the Capitol, the fresco painting *Westward the Course*

[18]Philip Quilibet, "Art and the Centenary," *Galaxy* 19 (1875):697. This lack of government patronage was often viewed as a want of patriotism, as another author pointed out that year: "Again, paintings are ordered in this country neither by churches nor the state, mural art is unknown, and the only commands for decoration in fresco go to humble workmen of Italian or German origin when a new theater is to be hurried up" (*The Nation*, Apr. 15, 1875, p. 264). Frequently, the problems of patronage issued from within Congress. Such was the case with a proposed statue of Abraham Lincoln by Vinnie Ream. In a speech against this commission, Sen. Charles Sumner cited her relative inexperience and questionable ability to bring the project to fruition: "Suffice it to say that art throughout the whole country must suffer if Congress crowns with its patronage anything which is not truly artistic. By such patronage, you will discourage where you ought to encourage" (*Art in the United States Capitol: Speech of Hon. Charles Sumner in the Senate of the United States, July 17, 1866* [Boston, 1866], pp. 5–6).

[19]See William Truettner, "The Art of History: American Exploration and Discovery Scenes, 1840–1860," *American Art Journal* 14 (1982):4–31. On the more general issue of history painting in America, see Gilbert Tapley Vincent, "American Artists and Their Changing Perceptions of American History, 1770–1940," Ph.D. diss., University of Delaware, 1982; and William H. Gerdts and Mark Thistlewaite, *Grand Illusions: History Painting in America* (Fort Worth, Tex., 1988).

[20]See *Art in the United States Capitol* (Washington, D.C., 1976); *Compilation of Works of Art and Other Objects in the United States Capitol* (Washington, D.C., 1965).

[21]The full title reads: *Embarkation of the Pilgrims at Delft Haven, Holland, July 22nd, 1620*. Executed between 1837 and 1847, it was purchased for ten thousand dollars. See *Art in the Capitol*, p. 136; *Compilation of Works of Art*, p. 116.

[22]The full title reads: *Landing of Columbus at the Island of Guanahani, West Indies, October 12, 1492*. It was executed between 1837 and 1847 and was acquired for ten thousand dollars. See *Art in the Capitol*, p. 140; *Compilation of Works of Art*, p. 116.

[23]The full title reads: *Discovery of the Mississippi by De Soto A.D. 1541*. The painting was executed between 1847 and 1855 and was acquired for twelve thousand dollars. See *Art in the Capitol*, p. 134; *Compilation of Works of Art*, p. 116.

[24]Bierstadt was in Dusseldorf from 1853 until 1856. Tuckerman wrote that Bierstadt "enjoyed either the direct instruction or personal sympathy of Lessing, Achenbach, Leutze and Whittredge" (Henry Tuckerman, *Book of the Artists* [1867; reprint ed., New York, 1967], p. 387).

of Empire Takes Its Way in 1861, Bierstadt may have first conceived of the idea of pursuing his own commission for the Capitol.[25] The similarities of their German heritages, not to mention the impressive sum of twenty thousand dollars that Leutze was to receive for his mural, no doubt provided further incentive for the ambitious young artist. Leutze's subject of western expansion also would have struck a chord with Bierstadt.[26] But Leutze's allegorical treatment of the theme with its evocation of the New World Eden and its acquisition by the bold American settlers may have had an even greater influence upon Bierstadt's own works for the Capitol than previously has been thought.[27]

Another important factor in understanding the meaning of these paintings is their setting. Both works were designed with a particular site in mind, namely the two empty panels in the House of Representatives chamber. As early as November 1866, a month before his formal proposition was read to Congress, newspapers had begun reporting that Bierstadt had been awarded the commission to decorate the two empty panels in the House chamber.[28] Bierstadt may already have had firsthand knowledge of this room. In the spring of 1865 his celebrated painting, *Rocky Mountains, Lander's Peak* was exhibited in Washington, D.C., and it is possible that the artist at some point came to the capital to see it.[29]

The original installation of these two paintings can be seen in a photograph of the House chamber (fig. 5) predating the renovation of the room in 1901 and the subsequent rehanging of the paintings in the members' private stairwells in the House wing at the beginning of this century.[30] Initially, Bierstadt's two canvases were hung at each end of the room, flanking a pair of full-length portraits already in situ: a portrait of General Lafayette by the French artist Ary Scheffer and a portrait of George Washington by John Vanderlyn after the well-known portrait by Gilbert Stuart, which

[25]Stereochromed fresco, twenty feet by thirty feet, U.S. Capitol, House wing, west stairway. Leutze was awarded this commission in July 1861. There are two preparatory studies for this painting, one in the Gilcrease Institute of American History and Art, Tulsa, Oklahoma, and a second, more finished version, in the National Museum of American Art, Washington, D.C. See Barbara S. Groseclose, *Emanuel Leutze, 1816–1868: Freedom Is the Only King* (Washington, D.C., 1975), pp. 60–61, 95–96; and the essay by Daniel Clayton Lewis in this volume. See also Fairman, *Art and Artists of the Capitol,* pp. 202, 204.

[26]Ferber, "History of a Reputation," pp. 41–42.

[27]For a discussion of Leutze's painting as an allegory of the New Eden, see Groseclose, *Leutze,* p. 61.

[28]The New Bedford *Daily Mercury,* Nov. 13, 1866, announced "that the great American landscape painter, Bierstadt, will be commissioned this winter to paint pictures for two of the panels in the Representatives Hall, in the Capitol" (quoted in Ferber, "History of a Reputation," p. 40).

[29]*The Rocky Mountains, Lander's Peak* arrived in Washington on April 14, 1865, and remained on display there into the month of May before going to the Northwestern Sanitary Fair, which opened in Chicago on May 30. See Nancy K. Anderson, "Chronology and Colorplates," in *Albert Bierstadt, Art and Enterprise,* p. 181.

[30]The *Settlement of California* remains in the west stairwell, though its companion *Discovery of the Hudson River* is now housed in the members' dining room. The paintings were moved from the House chamber to the lobby corridor in 1901. See *Report of the Superintendent of the U.S. Capitol, 1902–1906* (1901 annual report), p. 22.

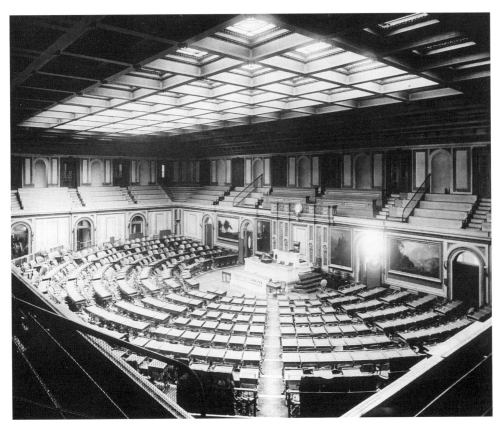

FIG. 5. View of the chamber of the House of Representatives prior to the 1901 renovation. *(Courtesy Office of Architect of the Capitol.)*

hang to either side of the podium of the Speaker of the House.[31] Given this context, Bierstadt's paintings may be viewed as part of a site-specific narrative in which the artist creates a symbolic representation of the United States, with the heart of its nation as its government, symbolized by the Speaker, flanked by two great men who helped to forge and defend the nation. Lastly, framing the rest, is the body of the nation itself, viewed from east to west and bounded by coastal land.

If the first painting, the *Discovery of the Hudson River* was executed as an individual work, such was not the case of the second. The *Settlement of California* was designed from the start to function as the perfect companion to the first. It has identical dimensions, six by ten feet. Compositionally, the two paintings are reflections of one another, each depicting a scene that places the viewer deeply within the landscape looking out

[31]The portrait of General Lafayette had been given as a gift to the American government from the painter Ary Scheffer in 1824. The John Vanderlyn portrait of George Washington was commissioned by the government in 1832. See Fairman, *Art and Artists of the Capitol,* pp. 85, 129.

toward the water. Although the coast is not clearly visible in the *Discovery of the Hudson River,* the organization of the canvas implies the sense that the viewer is at the river's end looking backward through the course of the river that will ultimately empty into the Atlantic Ocean. The result is the depiction of two safe havens, of regions strongly linked to the coasts yet at the same time protected and self-contained, as in the inland river of the *Discovery of the Hudson River* and the harbor of Monterey in the *Settlement of California.*

A comparable structure had been previously implemented by Bierstadt in his first historical painting, *Gosnold at Cuttyhunk* (fig. 6) executed in 1858.[32] Though a youthful work, the approach to the treatment of space is relatively sophisticated, creating a heightened sense of penetration backward into the canvas. Already in this early work, Bierstadt has employed many of the elements that he would continue to exploit in his later historical subjects: the sense of the viewer's vantage from within the landscape, the careful compositional manipulation that forces the viewer's gaze into the extreme lower left-hand corner then upward, and hence outward, and the aggressive diagonal that would become standard in his later discovery images, which is introduced though not yet fully formed at this early stage in his development. This formal construction is crucial for the understanding of these works, for just as one reads a canvas from left to right, so too, one reads a map of the United States from left to right, from the west to the east. In the *Discovery of the Hudson River,* Bierstadt forces the viewer's eyes to the bottom of the canvas, where he encounters the Indians and their possessions spread out upon the ground, while the natives, who step forward to greet the explorers, serve to link the two groups, native and European. The Indian who stands on the extreme edge of the shore, in particular, is aligned with the landing skiff with the explorer Henry Hudson at its prow, the direction of which leads the eye to Hudson's ship, the *Halfmoon,* anchored in the river, the last marker of the diagonal gaze. The *Settlement of California,* by contrast to the *Gosnold at Cuttyhunk* and the *Discovery of the Hudson River,* reverses the thrust of the diagonal, moving from the lower right toward the upper left, starting with the Indians, whose gaze draws the viewer along to the Europeans holding mass beneath the tree. Beyond, framed by the forms of the two groups of trees, can be seen first their skiff and then the ship that brought them to the New World. The arrangement of forms in this painting is not unique in Bierstadt's oeuvre; rather, this configuration is strikingly similar to Bierstadt's treatment of a number of

[32]There is some apparent confusion as to the patron of this painting. In his doctoral dissertation, Richard Schafer Trump claims that the work had been commissioned by the Hathaway family. See Trump, "Life and Works of Albert Bierstadt," Ph.D. diss., Ohio State University, 1963, p. 56. However, an article that appeared in the *New Bedford Standard,* Jan. 1, 1859, states that it was painted for Thomas Nye, Jr., a sea captain who owned the property (cited in Anderson, "Chronology and Colorplates," p. 137).

F<small>IG</small>. 6. Albert Bierstadt, *Gosnold at Cuttyhunk, 1602,* 1858, oil on canvas, 30 by 50 ½ inches. *(Courtesy Old Dartmouth Historical Society–New Bedford Whaling Museum, New Bedford, Massachusetts.)*

scenes depicting the American westward movement, such as *Emigrants Crossing the Plains* of 1867[33] and *The Oregon Trail* of 1869.[34]

All of these considerations eventually lead to the question of the meaning of these paintings. It is generally believed that the artist had already begun work on the first subject, the *Discovery of the Hudson River* in 1866, apparently independent of a Capitol commission. Nevertheless, the artist's initial intentions remain unclear. Did Bierstadt begin this canvas as an artistic exercise and later recognize its potential as a subject appropriate to the Capitol, or did the artist regard it as an offering for the Capitol even from its inception, working on the assumption that his reputation would guarantee its eventual purchase, even without an established commission? Regardless of the motivation, the fact does remain that Bierstadt did not complete this painting until 1874, when the artist had reopened negotiations with the Joint Committee on the Library, which suggests that this painting was intimately linked to the Capitol in his own mind.

Ultimately, it is the second painting, the *Settlement of California,* that warrants the term *pendant,* for it is this canvas that actually defines the relationship of the two

[33]This painting is currently located in the National Cowboy Hall of Fame and Western Heritage Center, Oklahoma City, Oklahoma.
[34]This painting is currently located in the Butler Institute of American Art, Youngstown, Ohio.

works that found their way into the House chamber. However, the *Settlement of California* is a particularly problematic work, not merely because of the convoluted history preceding its creation, but also because of confusion surrounding its actual subject. This was apparent even early on. In an article that appeared in the *Boston Evening Transcript* in September 1876, we learn that: "There is now on Alfred Bierstadt's easel a large canvas upon which a picture is well outlined—a passage from the history of California, when the western coast was taken possession of by the Spanish. The spot chosen is south of San Francisco, a view full of picturesque beauty."[35]

There can be no doubt that the painting in question is the one designated for the Capitol. But when it was provisionally hung in the House of Representatives in 1875, the painting bore merely the descriptive title *California Landscape*.[36] However, that title did not remain. When Bierstadt exhibited this painting in the Philadelphia Centennial Exhibition of 1876, he gave it the more specific title *The Landing of the Spaniards in California in 1770*.[37] This raises another question, namely whether Bierstadt informed the Joint Committee on the Library of this new title when it was purchased for the Capitol. Unfortunately, there is little extant documentation associated with the acquisition in 1878 to confirm this, but the later history surrounding the painting's title suggests that Bierstadt had never provided a title for his painting, and hence had never made an attempt to establish the painting's definitive subject.[38]

In later years a number of titles and subjects have been attributed to the work, adding to the confusion about the specific subject of this painting. Already in 1880, just two years after the painting was acquired for the Capitol, the travel guide *Roose's Companion and Guide to Washington* called it the *Discovery of California*, which is a fairly vague title.[39] In his 1903 publication *History of the United States Capitol*, Glenn Brown returned to the earlier title, *California Landscape*.[40] George Hazelton in his 1914 book on the Capitol proposed two possible subjects corresponding to the theme

[35]"Art and Artists," *Boston Evening Transcript,* Sept. 7, 1876, p. 6.

[36]Brown, *History of the Capitol,* 2:188.

[37]Gerald Carr, *American Paradise: The World of the Hudson River School* (New York, 1987), p. 297 n. 10. As Carr also discovered, the subject depicted by Bierstadt was clearly identified in a review, "Art Notes," that appeared in the *New York Evening Express,* Apr. 5, 1876, p. 1.

[38]There is a pragmatic reason that may have inspired Bierstadt to change the title of this painting once again. John W. Weir, the director of the Yale School of Fine Arts, one of the appointed judges for the fine arts section of the Centennial Exhibition, also wrote the official report concerning the work shown there. His comments concerning Bierstadt were far from flattering. He contrasted Bierstadt's early work, which he said exhibited a "vigorous" style, with the pictures by the artist that found their way to Philadelphia, by remarking that there was a notable "lapse into the sensational and meretricious effects and a loss of true artistic aim" (quoted in Trump, "Life and Works," p. 185). Given the negative tenor of this report, Bierstadt may have wished to disassociate his painting *Settlement at California,* the work he intended for the Capitol, from these criticisms.

[39]*Roose's Companion and Guide to Washington and the Vicinity* (Washington, D.C., 1880), p. 55.

[40]Brown, *History of the Capitol,* 2:188. It was called *An Early California Scene* in Abby G. Baker, "The Art Treasures of the United States Capitol," *Munsey's Magazine* 38 (1908):584.

of the discovery of California: *Landing of Viscaino* and *Father Junípero Serra*.[41] Charles Fairman in his own 1927 volume on the art of the Capitol preferred the more general title *Entrance into Monterey*.[42]

Another contributing factor to this confusion is the similarity of two major historical events that both took place at Monterey. The first event was the landing of Viscaino. Sebastiano Viscaino was a Spanish mariner, who, in 1599, under orders from the Spanish crown, sailed to the western coast of the North American continent. There he explored the coast from San Diego to Cape Blanco de San Sebastiano, and on December 16, 1601, discovered the natural harbor that he called Porto de Monterey after the Conde de Monterey, the viceroy of New Spain. The day following the landfall he ordered that preparations be made for a mass of thanksgiving.[43]

The second event took place two centuries later. In 1769 four parties were sent to California from Spain under the leadership of Capt. Gaspar de Portola and Father Junípero Serra. On June 3, 1770, Portola took possession of the harbor in the name of the king of Spain and began to found the presidio of San Carlo while Serra began construction of the mission of the same name. Until the completion of the mission church two weeks later, Serra held his services outside, under a large tree where they had planted a cross.[44] While the actual date on which Bierstadt commenced work on the *Settlement of California* is not known, it certainly postdates his visit to San Francisco in 1871, when he may have become acquainted with the local history of the region, which inevitably would have included both histories.

In the painting itself there is little visual evidence that confirms either of the two subjects first proposed by Hazelton eighty years ago. The only discerning element is the presence of the cattle and sheep in the lower right-hand corner of the canvas. Their inclusion does tend to suggest the more permanent nature of settlement, hence supporting the title *Settlement of California*. However, the lack of permanent dwellings could equally affirm the discovery theme of the *Landing of Viscaino*. This confusion and the multiplicity of viable titles may have been deliberate on the part of the artist. The manner in which he incorporated temporally nonspecific, and at times contradictory iconography lends strength to the argument that what concerned Bierstadt was not the depiction of specific historical events, but the creation of an allegorical representation of the more general theme of American progress in the New World Eden.

In both works Bierstadt celebrates the origins of the nation and a more innocent

[41]George C. Hazelton, Jr., *The National Capitol: Its Architecture, Art and History* (New York, 1914), p. 203.

[42]Fairman, *Art and Artists of the Capitol,* p. 177. See also Hon. Burt L. Talcott, "Abridged History of Bierstadt's Paintings in the Speaker's Lobby," *Congressional Record,* Sept. 10, 1970, p. E8104.

[43]Hazelton, *National Capitol,* p. 203.

[44]For the history of the mission of Portola and Serra, see Herbert Eugene Bolton, ed., *Historical Memories of New California by Fray Francisco Palou, D.F.M.,* 4 vols. (1926; reprint ed., New York, 1966), 2:268–304.

era. This element is reinforced by the landscape itself. Although Bierstadt has been criticized for his somewhat generic landscape in these paintings, that is in keeping with their allegorical nature. These paintings should not be read as factual documents, but rather as symbolic evocations of the birth of what would become America, historical fictions tinged with nostalgia. As Nancy Anderson has noted, Bierstadt's first history painting, *Gosnold at Cuttyhunk,* was a nostalgic re-creation not only of the event, but of the site itself; by 1858, when the artist undertook this work, there was not a single tree remaining on the island. Bierstadt's willingness to reconstruct and romanticize the historical event even early on simply supports a symbolic over a literal, historical reading.[45]

In both paintings Bierstadt produced for the Capitol, he suggests two different though interlinked forms of existence: the agrarian and the pastoral. In the *Discovery of the Hudson River,* the ground is littered with a variety of agricultural products, while the *Settlement of California* shows cattle and sheep in the lower right corner of the composition. In both cases these attributes of two idyllic forms of lifestyle are placed in the foreground, linking their presence with that of the Indians. Here the Indians perform an almost emblematic function, reinforcing the paradisiacal quality that was certainly in keeping with the longstanding tradition of America as the new Eden, destined to be discovered, appropriated, and then cultivated by the new American people. Contemporary texts such as C. W. Dana's *The Great West, or the Garden of the World* (1856) extolled the pristine virtues of the New World and its sacred destiny: "*The Land of Promise* and the *Canaan* of our time is the region which, commencing on the slope of the Alleghenies, broadens grandly over the vast prairies and mighty rivers, over queenly lakes and lofty mountains, until the ebb and flow of the Pacific tide kisses the golden shore of the El Dorado."[46]

In the *Settlement of California* the Indians are witness to the beginning of this process of appropriation, while in the *Discovery of the Hudson River,* the Indians come forward to greet the European visitors, their bounty displayed and offered—at least visually—to these new arrivals. Bierstadt himself advocated this belief in the inevitability of Anglo-Saxon progress at the expense of the Indian. In a pamphlet accompanying the 1864 exhibition of his painting *The Rocky Mountains, Lander's Peak,* the author reflected upon the role of the Indian, "that race which before the advance of civilization, fades away like the mists of the morning before the rays of the rising sun. Their customs and habits . . . will be preserved when, perhaps, the scene which it depicts, will no longer echo to the ring of their war-cry, or mark their stealthy step following in the chase. Upon that very plain where an Indian village stands, a city, populated by

[45]Nancy Kay Anderson, "Albert Bierstadt: The Path to California, 1830–1874," Ph.D. diss., University of Delaware, 1985, p. 119.

[46]C. W. Dana, *The Great West; or, The Garden of the World, Its History, Its Wealth, Its National Advantages and Its Future* (Boston, 1856), p. 13.

our descendants, may rise and in its art galleries this picture may eventually find a resting place."[47]

Bierstadt's painting makes no allusion to the violence and bloodshed engendered by this process, but instead creates a narrative of benevolent acquisition that would have been comforting in an era of rising Indian warfare and broken treaties.[48] Even in this earlier painting Bierstadt includes the Indian as a symbol of primitive culture, innocent and in harmony with nature, but ultimately fragile and doomed.

Bierstadt's paintings for the Capitol should not be judged as truly historical works, but as mythic narratives, moving beyond their depiction of past events toward the broader theme of progress. In both works an older, primitive culture is in the process of being supplanted by a newer and more aggressive cultural agenda—that of the American nation and the encroachment of civilization—that Bierstadt himself prophesied. In these works the artist celebrates the inevitability and righteousness of the progress of the white man in the New World. In this regard, Bierstadt's paintings for the Capitol have much in common with Leutze's earlier work, *Westward the Course of Empire Takes Its Way*. Leutze's painting is less a depiction than an evocation of emigration and the glorious western expansion. Its character is overtly allegorical, its imagery consciously universal, even timeless, in spite of the appearance of contemporary dress. The biblical references that the artist incorporated both within the composition and in the vignettes in the border further raised the image out of the mundane realm of historical experience into the more abstract realm of the ideal and the allegorical.[49]

Bierstadt would return again to this myth of American progress in another historical painting that he produced for the Columbian Exposition of 1893,[50] the *Landing of Columbus* (1893) (fig. 7).[51] Once again the artist commemorates the glorious acquisition of America by the intrepid explorer and the triumph of European-based civilization,

[47]Quoted in Trump, "Life and Work," p. 130.

[48]For a general history of attitudes toward the Indian, see Roy Harvey Pearce, *Savagism and Civilization: A Study of the Indian and the American Mind* (Baltimore, 1971); Francis Paul Prucha, *American Indian Policy in Crisis: Christian Reformers and the Indian, 1865–1900* (Norman, Okla., 1976); Brian Dippie, *The Vanishing American: White Attitudes and U.S. Indian Policy* (Middleton, Conn., 1982).

[49]On the biblical implications of *Westward the Course of Empire Takes Its Way*, see Groseclose, *Leutze*, pp. 61–62. In his paintings for the Capitol, Bierstadt may also have been making subtle biblical allusions. The story used in both works is the mass of thanksgiving of Noah following the Flood (Gen. 8:20–22, 9:1–17). The prominent place given to the animals in *The Settlement of California* seems to recall the passage: "And Noah built an altar unto the LORD; and took of every clean beast and of every clean fowl, and offered burnt offerings on the altar" (Gen. 8:20), while the rainbow in *The Discovery of the Hudson* recalls the covenant of God following the cleansing of the world (Gen. 9:16–17).

[50]Ultimately, Bierstadt did not exhibit this painting. A number of artists, including Bierstadt, withdrew their submissions at the last moment as a protest against the jury, which they considered biased against older artists. See Anderson, "Chronology and Colorplates," p. 247.

[51]There are in fact three versions of this subject, all of which date to 1892–93 and which are more or less identical in composition. The largest of the three was formerly at the American Museum of Natural History (destroyed). The other versions are in the Newark Museum, Newark, New Jersey, and the Plainfield Public Library Art Collection and Gallery, Plainfield, New Jersey.

FIG. 7. Albert Bierstadt, *The Landing of Columbus,* 1892, oil on canvas, 80 by 120 inches. *(Courtesy City of Plainfield, New Jersey.)*

here embodied in the person of Christopher Columbus. Bierstadt even went as far as to utilize the same composition he had earlier used for the *Discovery of the Hudson River,* down to the inclusion of the arching foliage as a device to link both sides of the composition in a manner comparable to the rainbow in the earlier canvas.

The *Landing of Columbus* is generally viewed as a *retardataire* work, lacking the force of Bierstadt's pure landscape subjects. The same view has also been applied to the *Discovery of the Hudson River* and the *Settlement of California* with a certain degree of validity. But if these paintings are not cutting edge, we must remember that they were never intended to be. The Capitol, while a prestigious venue for the American artist, was also a bastion of artistic conservatism.[52] Over the course of negotiations with Congress, Bierstadt, like so many other artists, had learned that lesson well. In his decision to embrace the historical idiom, Bierstadt made a conscious effort to adapt to the tastes and needs of Congress and the American public. Consequently, it is only by viewing these paintings in light of the context in which they were produced that

[52]See Lillian B. Miller, *Patrons and Patriotism: The Encouragement of the Fine Arts in the United States, 1790–1860* (Chicago, 1966), for the most complete discussion of this atmosphere of artistic conservatism.

their value as artistic experiments can be appreciated. In his pendant paintings, Bierstadt did not merely create a pair of companion canvases; he attempted to construct a dialogue between the two works, both in composition and subject. In the *Discovery of the Hudson River* and the *Settlement of California* the artist looked to his nation's past from which he forged an edifying narrative of American progress, worthy of this monument to democracy.

"Worthy of National Commemoration"

National Statuary Hall and the Heroic Ideal, 1864–1997

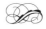

Teresa B. Lachin

And the President is hereby authorized to invite each and all the States to provide and furnish statues, in marble or bronze, not exceeding two in number for each State, of deceased persons who have been citizens thereof, and illustrious for their historic renown or for distinguished civic or military services such as each State may deem to be worthy of this national commemoration; and when so furnished the same shall be placed in the Old Hall of the House of Representatives, in the Capitol of the United States, which is set apart, or so much thereof as may be necessary, as a national statuary hall for the purpose herein indicated.

—Sec. 1814 of the Revised Statutes, July 2, 1864

NATIONAL STATUARY HALL IS ONE PART OF A COLLECTION OF PAINTINGS, sculpture, and other works of art that have been commissioned by, donated to, or purchased for the United States Capitol since the late eighteenth century. Authorized by the Thirty-eighth Congress in 1864, Statuary Hall contains ninety-six portrait statues of "illustrious citizens [deemed] worthy of national commemoration" by the fifty states for their political, military, or civic achievements in public life. Over the past 130 years, the states have commissioned works for Statuary Hall in well-

State and federal legislation, dedication program brochures, and correspondence cited in the footnotes are all located in the files of the curator of the architect of the Capitol.

defined regional patterns that, in retrospect, reiterate the historical patterns of exploration, conquest, settlement, and statehood across the North American continent. More specifically, these patterns reflect the westward advance of urbanization, industrialization, and subsequent development of fine arts institutions necessary for the production of public and commemorative art.[1] Criticized in recent times as ethnocentric and lacking in cultural diversity, Statuary Hall is one of the oldest collections of public sculpture in America and a database of information on the history of American commemorative art.[2]

Congressional lawmakers of the 1860s instituted Statuary Hall as both a practical necessity and a symbolic overture to federal reconstruction of the Union, granting each state the unprecedented opportunity to designate and artistically represent aspects of its history in the U.S. Capitol, one of the nation's most visible and sacred spaces. Since the 1860s, the process of designating honorees for Statuary Hall has been appropriated, more or less consistently, by influential political or social groups whose beliefs and ideologies have shaped the scope, content, and commemorative character of the collection. State designations have perpetuated traditional popular beliefs in the American past while addressing, both directly and indirectly, issues, events, or concerns that were contemporaneous with the historical and geocultural environments from which they emerged. Furthermore, these designations have expressed changing national standards of heroism, success, and achievement in public life consistent with those popularized in success manuals, published biographies, magazines, and other media.[3]

This essay surveys the general history of Statuary Hall and analyzes the regional patterns of state designations, correlating those patterns with the social, political, and cultural institutions that were most influential in the designation and commissioning

[1] This essay does not include a discussion or analysis of aesthetic characteristics. The collection contains the work of fifty-seven American and European sculptors, twenty-two of whom were commissioned to sculpt more than one statue and thirteen of whom were American women sculptors. For a discussion of some of the works contained in Statuary Hall, see Wayne Craven, *Sculpture in America,* rev. ed. (Newark, Del., 1984); and Charlotte Streifer Rubinstein, *American Women Sculptors: A History of Women Working in Three Dimensions* (Boston, 1990).

[2] Kevin Merida, "Why Doesn't Capitol Art Collection Look More Like America?" *Washington Post,* Aug. 16, 1993, p. A15.

[3] Research on standards for success and heroism in American culture is based on biographical profiles published during the late nineteenth and early twentieth centuries. These include Howard Carroll, *Twelve Americans: Their Lives and Times* (1883; reprint ed., Freeport, N.Y., 1971); Noah Brooks, *Men of Achievement: Statesmen* (New York, 1898); Helen Mehard Davidson, *Founders and Builders of Our Nation* (Chicago, 1920); Roy Floyd Dribble, *Strenuous Americans* (New York, 1923); William E. Dodd, *Statesmen of the Old South; or, From Radicalism to Revolt* (New York, 1929). Scholarly studies on the self-made man, public heroism, and the success ethic include Dixon Wecter, *The Hero in America: A Chronicle of Hero-Worship* (New York, 1940); John G. Cawelti, *The Apostles of the Self-Made Man* (Chicago, 1965); Theodore P. Greene, *America's Heroes: The Changing Models of Success in American Magazines* (New York, 1970); Wilbur Zelinsky, *Nation into State: The Shifting Symbolic Foundations of American Nationalism* (Chapel Hill, N.C., 1988), pp. 20–68; Michael Kammen, *Mystic Chords of Memory: The Transformation of Tradition in American Culture* (New York, 1991).

Fig. 1. Eastman Johnson, *Justin S. Morrill,* 1884, oil on canvas, 25 by 21 inches, U.S. Capitol, Senate wing, second floor, main corridor. *(Courtesy Office of Architect of the Capitol.)*

process used by the states to contribute works to the collection. Regional patterns are also examined within the broader context of prevailing cultural standards of heroism and achievement in public life. Designation bills, dedication speeches, and other commissioning records housed in the U.S. Capitol Curator's Office provide the basis of this analysis.

Early History and Overview

The 1864 legislation for a national hall of statuary marked a new era in the history of the Capitol arts program, which, as Vivien Green Fryd has documented, was developed and closely supervised by federal authorities throughout the early to mid-nineteenth century. For the first time in the Capitol's history, the states were given the opportunity to contribute to a national collection of art for the U.S. Capitol without federal control over subject matter or its artistic interpretation.[4] Each state was invited to ded-

[4]Vivien Green Fryd, *Art and Empire: The Politics of Ethnicity in the United States Capitol, 1815–1860* (New Haven, 1992). Fryd's insightful analysis examines the content and aesthetic format of works commissioned for the Capitol between 1815 and 1860 and documents the ways in which federal authorities and Capitol arts officials shaped the iconography and political meaning of the collection during the first half of the nineteenth century.

icate two portrait statues, in marble or bronze, of "deceased persons" selected for their historic renown or "distinguished civic or military services." An initial draft of the Statuary Hall bill specified "distinguished men" but was amended in committee to "persons," indicating that federal lawmakers of the 1860s anticipated the designation of both men and women honorees.[5]

Enactment of the Statuary Hall bill was prompted by political concerns and practical considerations, among them the scarcity of federal funds available during the Civil War for architectural improvements and artistic decoration of the Capitol. Much of the funding available for decorative arts projects had been diverted to military spending or allocated for a handful of major projects, notably the completion of the Capitol dome and installation of Thomas Crawford's *Statue of Freedom*.[6] Justin Morrill of Vermont (fig. 1), principal sponsor of the Statuary Hall legislation, promoted the bill as a "simple and inexpensive" means of eliciting new works of art for the Capitol, noting that states, rather than the federal government, were to assume the commissioning costs of the new collection.[7]

Furthermore, the bill specified that the collection was to be housed in the Old Hall of the House of Representatives, one of the oldest and most historic spaces in the Capitol (fig. 2). Various proposals for a collection of paintings or sculpture had been discussed since the 1840s but were not seriously considered until the 1850s, when construction on the new House wing was nearing completion. The semicircular colonnaded Old Hall, designed by B. Henry Latrobe and immortalized by painter Samuel F. B. Morse, was ideally suited for portrait sculpture. Prior to 1864, however, little was done to develop this plan. Vacated in 1857, when members moved to a new House chamber, the Old Hall became a gathering place for vagrants and street vendors and a temporary storage area "draped in cobwebs [and] carpeted with dust." Morrill described the area as a "conspicuous nuisance" and exhorted his colleagues to "protect it from desecration."[8]

On a more symbolic note, Morrill expressed the hope that a national hall of sculpture honoring distinguished Americans—"the best representative men"—would help "cement together the great sisterhood of States" in the aftermath of the Civil War.[9]

[5]*Legislation Creating the National Statuary Hall in the Capitol with the Proceedings in Congress Relating to the Statues Placed in the National Statuary Hall by the States,* comp. H. A. Vale (Washington, D.C., 1916); Charles E. Fairman, *Art and Artists of the Capitol of the United States of America* (Washington, D.C., 1927), pp. 222–24.

[6]Fryd, *Art and Empire,* pp. 1, 190–200.

[7]Justin Morrill quoted in *Congressional Globe,* Apr. 19, 1864, pp. 1736–37. Morrill helped organize the Republican party in the 1850s. He served in the House (1854–67) and Senate (1867–98) and is best known for tariff legislation and the Land Grant College Act of 1862.

[8]*Congressional Globe,* Apr. 19, 1864, p. 1736.

[9]*Congressional Globe,* Jan. 20, 1870, p. 595. Congress passed the Statuary Hall bill in July 1864, the same month it enacted the Wade-Davis bill, a Radical Republican alternative to Lincoln's moderate plan for Reconstruction. See Eric Foner and Olivia Mahoney, *America's Reconstruction: People and Politics after the Civil War* (New York, 1995), pp. 21–23. In January 1865 Morrill asked Lincoln to notify the states of the Statuary Hall bill. F. W. Seward, writing on Lincoln's behalf, notified all thirty-six states on February 3, 1865. See Fairman, *Art and Artists of the Capitol,* pp. 228–32.

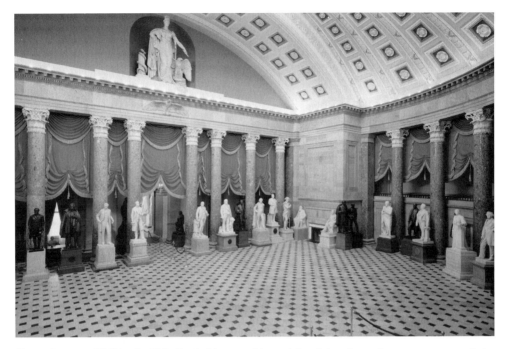

FIG. 2. Statuary Hall in the U.S. Capitol houses thirty-eight of the ninety-five statues currently in the National Statuary Hall collection. This chamber originally served as the Hall of the House of Representatives until 1857. (*Courtesy Office of Architect of the Capitol.*)

Indeed, Morrill, a moderate Republican who served on the Joint Committee on Reconstruction, spoke at the 1870 dedication of Rhode Island's statue of Gen. Nathanael Greene, the first work dedicated in Statuary Hall (fig. 3). On this occasion Morrill suggested that the states consider reuniting old political foes such as Hamilton and Madison, Jackson and Clay, Lincoln and Douglas, in Statuary Hall and thereby reconcile, through art, the animosities of the Federal, Jacksonian, and antebellum eras.[10]

Since 1870 the states have dedicated ninety-six statues; four states—Nevada, New Mexico, North Dakota, and Wyoming—have made only one presentation to Statuary Hall thus far but are currently considering designation initiatives.[11] Statuary Hall commemorates nearly five hundred years of American history from the early colonial era (*John Winthrop,* Massachusetts, 1876) to the space age of the late twentieth century (*John L. "Jack" Swigert,* Colorado, 1997).[12] The majority of works honor political

[10]*Congressional Globe,* Jan. 20, 1870, p. 595; ibid., June 10, 1876, pp. 3738–40.

[11]Most states have held formal dedication or unveiling and/or congressional acceptance ceremonies. Some states have simply placed or installed works in Statuary Hall, including *Uriah M. Rose* (1917) and *James P. Clarke* (1921), Arkansas; and *George Clinton* (1873) and *Robert R. Livingston* (1875), New York. Like other collections in the Capitol, Statuary Hall falls under the jurisdiction of the Joint Committee on the Library.

[12]The statue of NASA astronaut Jack Swigert was dedicated in 1997 and is Statuary Hall's most recent acquisition.

Fig. 3. Henry Kirke Brown, *Nathanael Greene* (Rhode Island), 1869, marble, 6'4", the first statue to be placed in Statuary Hall, 1870. *(Courtesy Office of Architect of the Capitol.)*

leaders (*Daniel Webster,* New Hampshire, 1894) and military heroes (*General Lew Wallace,* Indiana, 1910), including former presidents and vice presidents.[13] Despite the overwhelming preference for political and military history, there are a number of state tributes to religious leaders (*Brigham Young,* Utah, 1950), scientists and inventors (*Robert Fulton,* Pennsylvania, 1889), and folk heroes (*Will Rogers,* Oklahoma, 1939), and six works honoring women, all of whom were designated for their contributions to equal rights and humanitarian efforts on behalf of women and the oppressed (*Jeannette Rankin,* Montana, 1985; *Mother Joseph,* Washington, 1980).[14]

The states have commissioned works in clearly defined and sometimes overlapping regional patterns. The northern states designated colonial leaders and patriots of the American Revolution, dedicating a majority of their statues between 1870 and 1919. States of the Midwest, which selected politicians and statehood leaders, completed their quota between 1886 and 1920. The South, which commemorated heroes of both the Old and New South, dedicated works between 1910 and 1939. And the western states, which honored the pioneers and empire builders of the Golden West, commissioned most of their statues after World War II. Alaska and Hawaii, admitted to the union in 1959, contributed works between 1969 and 1977.[15]

Some honorees such as Sam Adams (Massachusetts, 1876) (fig. 4) or Henry Clay (Kentucky, 1929) are still well known on the state and national level; others (William Borah, the "Lone Lion" of Idaho, 1947; "Honest John" Burke of North Dakota, 1963) are today relatively obscure political figures.[16] Recent controversy over the Whitewater Affair focused national attention on the Rose Law Firm of Little Rock, Arkansas, whose founder, Uriah Rose, was designated in 1915 by the Arkansas state legislature (fig. 5). For the first time in many decades, Rose's name surfaced in national media coverage of Special Prosecutor Kenneth Starr's investigation of the Clinton presidency.

[13]U.S. presidents include George Washington (Virginia), Andrew Jackson (Tennessee), and James Garfield (Ohio). Vice presidents include George Clinton (New York), John C. Calhoun (South Carolina), and Hannibal Hamlin (Maine). Edward Douglass White (Louisiana) served as chief justice of the Supreme Court of the United States. See *Art in the United States Capitol* (Washington, D.C., 1978).

[14]Women honorees include suffragist and temperance crusader Frances E. Willard (Illinois, 1905), educator and women's rights advocate Maria L. Sanford (Minnesota, 1958), medical researcher Dr. Florence R. Sabin (Colorado, 1959), suffragist Esther H. Morris (Wyoming, 1960), missionary Mother Joseph (Washington, 1980), and congresswoman and pacifist Jeannette R. Rankin (Montana, 1985).

[15]Alaska honored Sen. Edward Lewis "Bob" Bartlett (the "Architect of Alaska Statehood") in 1971 and Sen. Ernest Gruening, a former governor and "Father of Alaska Statehood" in 1977. Hawaii's statues of Belgian missionary Joseph Damien (the "Leper-Priest of Molokai") and King Kamehameha I, the island-nation's first monarch, were unveiled in 1969.

[16]Massachusetts lawmakers jointly designated Puritan leader John Winthrop and patriot Sam Adams in 1872. Henry Clay was designated by the Kentucky legislature in 1926. William E. Borah, a six-term U.S. senator from Idaho and chairman of the Senate Foreign Relations Committee, was designated by the Idaho legislature in 1945. John Burke, "North Dakota's Lincoln," a state governor and chief justice of the North Dakota Supreme Court, also served as U.S. treasurer under Woodrow Wilson.

FIG. 4. Anne Whitney, *Samuel Adams* (Massachusetts), 1876, marble, 7'8". *(Courtesy Office of Architect of the Capitol.)*

Fɪɢ. 5. Frederic W. Ruckstuhl, *Uriah M. Rose* (Arkansas), 1917, marble, 7'6".
(Courtesy Office of Architect of the Capitol.)

Undoubtedly, when this controversy subsides, Uriah Rose will once again fade into the arcana of American political and legal history.[17]

Works contributed to Statuary Hall are, by federal mandate, the gift of states rather than individuals or groups; therefore, the state is the active party in the designation, commissioning, and funding process. Typically, this process involves three steps:

1. Enactment of state legislation naming an individual (or individuals if a joint designation is made)[18]

2. The appointment of a Statuary Hall commission whose responsibilities include selecting a sculptor, selecting and approving a design, and arranging for installation and dedication ceremonies

3. The determination of funding method(s)

Once a designation bill has been enacted, this process takes, on average, about six years to complete. There have been, however, a number of historically significant delays. Wisconsin's designation in 1887 of Jesuit explorer Jacques Marquette (fig. 6) provoked a series of anonymous bomb threats and aroused anti-Catholic opposition from the American Protective Association, delaying the dedication of Marquette's statue until 1896.[19] Virginia's tribute to Robert E. Lee (fig. 7) and George Washington, whose statues were sent to the Capitol in 1909, generated objections by Union veterans groups to the commemoration of Confederate history in the U.S. Capitol. The statues of Lee and Washington were placed in Statuary Hall and not formally dedicated

[17]Uriah M. Rose, a charter member and president of the American Bar Association and the U.S. delegate to the 1907 Peace Congress at The Hague, was designated by the state of Arkansas in 1915. In 1865 Rose founded the Rose Law Firm, which in the early 1990s was investigated in connection with the Whitewater Affair. See Susan Schmidt, "Rose Law Firm Probes Billings by Hubbell," *Washington Post,* Mar. 2, 1994, pp. A1, A7; Michael Isikoff, "Hubbell Resigns at Justice in Rose Law Firm Dispute," *Washington Post,* Mar. 15, 1994, pp. A1, A6; Michael Isikoff and Susan Schmidt, "Rose Law Firm Has Hard Landing after Auspicious National Take-off," *Washington Post,* Dec. 25, 1994, pp. A1, A22.

[18]A joint designation, the naming of two individuals in one legislative bill, was commonplace during the late nineteenth century, principally in the North.

[19]Marquette, a French Jesuit, was designated in 1887 by the Wisconsin legislature as "the faithful missionary whose work among the Indians and explorations within the borders of the state in the early days are recognized all over the civilized world" (*Laws of Wisconsin,* May 2, 1887, chap. 544, no. 10-S). See also E. David Cronon, "Father Marquette Goes to Washington: The Marquette Statue Controversy," *Wisconsin Magazine of History* 56 (1973):266–83; Donald L. Kinzer, *An Episode in Anti-Catholicism: The American Protective Association* (Seattle, 1964), pp. 3–32, 210; "APA Crank Arrested—Made Boisterous Threats in the Corridor of the Capitol; Marquette Statue Excitement," *Washington Post,* Mar. 1, 1896. Opponents of Marquette's statue, who conveniently ignored previous Statuary Hall tributes to John Winthrop, Roger Williams, and other religious figures, argued that the Jesuit missionary had not been a citizen of the United States or Wisconsin and therefore was ineligible for Statuary Hall under the regulations specified in the 1864 bill. In 1893 Congress adopted a special resolution granting the state of Wisconsin the right to place a statue of a non-U.S. citizen in the Capitol. See Fairman, *Art and Artists of the Capitol,* p. 415.

Fig. 6. Gaetano Trentanove, *Pere Jacques Marquette* (Wisconsin), 1895, marble, 7'7".
(Courtesy Office of Architect of the Capitol.)

Fig. 7. Edward V. Valentine, *Robert E. Lee* (Virginia), 1909, bronze, 6'6". *(Courtesy Office of Architect of the Capitol.)*

until the 1930s, a decade more sympathetic to mainstream ideals of sectional recon-
ciliation.[20]

State designations have been influenced by a variety of factors. In many instances,
the death of a prominent individual (Will Rogers, Huey Long, Jeannette Rankin)
aroused the political and popular support necessary to initiate and enact legislation.
The 1881 assassination of James Garfield prompted the Ohio legislature to commis-
sion a statue of the slain president for Statuary Hall, thus marking the Midwest's first
contribution to the new collection.[21] Temperance crusader Frances Willard died in
1898, and, at the urging of her devoted followers in the World's Woman's Christian
Temperance Union, was designated by Illinois lawmakers the following year.[22] In
fact, Willard was the first and only woman honored in Statuary Hall until the late
1950s, when Minnesota selected educator and suffragist Maria Sanford (1958) and
Colorado designated medical researcher Dr. Florence R. Sabin (1959).[23]

Since the late nineteenth century, social institutions, such as patriotic-hereditary
groups, business and professional organizations, and heritage associations, have lob-
bied successfully for state designations, served on Statuary Hall commissions, and, in
many instances, helped raise funds through private donations and membership drives.
Overall, there has been a steady decrease in the number of projects initiated and ad-
ministered solely by public officials and funded through state appropriation bills. At

[20]In 1909 Michigan veterans of the Military Order of the Loyal Legion of the United States issued a procla-
mation condemning the placement of Lee's statue in the Capitol as "treason." The group urged its "sister Com-
mandery" in other former Union states to "take similar action [in protesting] the consummation of this wrong"
(Military Order of the Loyal Legion of the United States, State of Michigan, Resolution Adopted October 7,
1909). In a 1910 letter to the superintendent of the Capitol, an Iowa veterans group questioned Congress's au-
thority to accept the statue (Capt. E. D. Hadley to Elliott Woods, Nov. 7, 1910). Opinions about the statue were
mixed even within the Virginia legislature. In 1910 the *Washington Post* reported that when legislators had voted
on the Lee designation in 1903, some opposed the bill, fearing that a tribute to Lee would arouse old hostilities
against the South in former Union states. The *Post* also stated that Virginia Governor Montague allowed the
designation bill to become law without his signature, claiming that the designation of Lee was "unwise, unnec-
essary, and inexpedient" ("Virginia's Two Bronzes for Statuary Hall Completed," *Washington Post,* July 18,
1909).
[21]See House J. R. 3, 65th Ohio General Assembly, 1st sess., adopted Jan. 25, 1882; House Bill No. 436, Ohio
General Assembly, passed Apr. 11, 1882; "The Statue of Garfield—Unveiled and Accepted for the Nation," *New
York Times,* May 13, 1887, pp. 1, 4.
[22]According to Mary Earhart, Anna Gordon, Willard's secretary from 1877 to 1898, "devoted herself to the
task of winning popular acclaim" for the temperance crusader after her death. Earhart notes that, among other
tributes, Gordon secured the 1899 Statuary Hall designation and the nine-thousand-dollar state appropriation to
fund the project. Gordon was appointed a member of the state commission. See Mary Earhart, *Frances Willard:
From Prayer to Politics* (Chicago, 1944), pp. 1–4. Willard's statue was dedicated in February 1905. See *Statue of
Miss Frances E. Willard, . . . Proceedings . . . on the Occasion of the Reception and Acceptance of the Statue . . . Febru-
ary 17, 1905* (Washington, D.C., 1905); *Congressional Record,* Feb. 17, 1905, pp. 2801–9.
[23]Maria Sanford, one of the first women professors in the United States, was designated by the state of Min-
nesota in 1943, a bill that was endorsed by the Minnesota Federation of Women's Clubs. See S.B. No. 1161, chap.
448, *Session Laws of Minnesota,* approved Apr. 14, 1943. Dr. Florence R. Sabin, a pioneering medical researcher
who helped draft the Sabin Health Laws of Colorado, was designated by Colorado legislators in 1957. See
H.J.R. No. 15 and S.B. No. 153, 41st General Assembly of the State of Colorado, approved Mar. 12, 1957. The
Colorado Division of the American Association of University Women raised $17,500 to fund this project.

the same time, there has been an increase in projects initiated by social groups whose members shared administrative responsibilities with public officials and raised all or part of the necessary funding through private contributions. In effect, the designation process has become increasingly democratized, with a corresponding shift in financial responsibility toward the private sector. Escalating costs have undoubtedly made this public-private collaboration a virtual necessity. The first works dedicated in Statuary Hall cost the states, on average, about $7,000, compared with more recent projects such as Utah's tribute to Philo T. Farnsworth, which was completed in 1990 for $250,000 in private donations.[24]

Northern States

The twelve northern and New England states (the North) were the first to commission works for Statuary Hall, contributing a total of twenty-four statues, twenty-one (88 percent) of which were dedicated between 1870 and 1910.[25] The majority of northern statues were of colonial leaders (*John Winthrop,* Massachusetts, 1876) and patriots of the American Revolution (*Roger Sherman,* Connecticut, 1872). In most instances, state commissions were composed of politicians and public officials and were chaired by state governors or their appointed representatives. Typically, commission members compiled a slate of prospective honorees, appointed sculptors, and approved final designs of statues. All northern states appropriated public funds for Statuary Hall projects.

Rhode Island, Massachusetts, Connecticut, and New York were the first states to dedicate works in Statuary Hall. Indeed, by the 1870s the region had long since established itself as the artistic center of the nation and had the necessary artistic and institutional resources to bring these projects to completion.[26] Henry Kirke Brown (*Nathanael Greene,* Rhode Island, 1870) and Erastus Dow Palmer (*Robert R. Livingston,*

[24]Architect of the Capitol David Lynn outlined the escalating costs of labor and materials for Statuary Hall projects in 1944 (David Lynn to Henry C. Dworshak, Dec. 18, 1944). For information on the costs of the 1990 Farnsworth statue, see "Philo T. Farnsworth Commemorative Statue: A Special Heritage in Humanistic and Scientific Achievement" (n.p., n.d.); Rick Atkinson, "In Utah, Grade-School Lobbyists Experience Power and Politics," *Washington Post,* Apr. 1, 1990, p. A3; Lee Davidson, "Farnsworth May Finally Win PR War," *Deseret News,* Apr. 24–25, 1990, p. B3. In January 1997 the *Denver Post* reported that Swigert's seven-foot bronze statue (designed by Colorado sculptors George and Mark Lundeen) cost an estimated $210,000, of which only $138,000 had been raised. A $25,000 donation from Lockheed Martin enabled project sponsors to complete the statue in time for the scheduled dedication. See Michelle Dally Johnston, "Swigert Pals Went to the Ends of the Earth for Statue," *Denver Post,* Jan. 5, 1997, pp. B1, B4.

[25]The twelve northern states include Connecticut, Delaware, Maine, Maryland, Massachusetts, New Hampshire, New Jersey, New York, Pennsylvania, Rhode Island, Vermont, and West Virginia.

[26]Neil Harris, *The Artist in American Society: The Formative Years, 1790–1860* (Chicago, 1966); Michele Bogart, *Public Sculpture and the Civic Ideal in New York City, 1890–1930* (Chicago, 1989); Craven, *Sculpture in America;* Lillian B. Miller, *Patrons and Patriotism: The Encouragement of the Fine Arts in the United States, 1790–1860* (Chicago, 1966).

New York, 1875), important sculptors of the mid-nineteenth century, were among the first artists awarded Statuary Hall commissions.[27]

The North's preference for colonial and Revolutionary history was based on long-standing traditions of regional heritage and commemoration.[28] Designations of colonial leaders and Revolutionary patriots were readily approved by state legislatures and, as one Connecticut congressman stated in 1872, the principal difficulty lay in the embarrassment of choices that early American history afforded the northern states.[29]

Throughout Reconstruction northern politicians frequently invoked regional heritage to underscore the North's role in establishing the principles of republican government during the Revolution and defending those principles during the Civil War. Not surprisingly, Statuary Hall dedication speeches were peppered with pointed references to the Civil War, the "disloyalty of the South," or "recent rebellion" of Confederate states. At the 1870 dedication of Nathanael Greene's statue, Charles Sumner alluded to Greene's command of colonial troops in the Carolinas during the Revolution. Sumner, a staunch abolitionist and Radical Republican, praised Greene as the "Savior of the South," noting that the Civil War had made the promises of the Declaration of Independence ("Liberty, Independence, and Equal Rights for all") a "reality."[30] Connecticut state legislator J. Pomeroy initially advocated the designation of abolitionist John Brown, a Connecticut native, but voted with the majority in 1865 for colonial statesmen Roger Sherman and Jonathan Trumbull. Later, Pomeroy facetiously suggested that John Brown's tribute was reserved for Virginia or South Carolina, states which undoubtedly would want to honor him as the "benefactor of the South."[31] Morrill's hopes for "sectional reconciliation," artistic and otherwise, would prove to be a long-term goal.

Dedication speeches from the 1870s and 1880s characterized northern honorees as Christian statesmen whose public careers and private lives had been guided by religious piety, moral courage, and filial devotion to their fellow man—virtues and stan-

[27]Works in Statuary Hall by Henry Kirke Brown include *General Nathanael Greene* of Rhode Island, 1870; *George Clinton* of New York, 1873; and *General Philip Kearny* of New Jersey, 1888. Erastus Dow Palmer sculpted New York's tribute to Robert Livingston (1875). For a discussion of naturalistic sculpture in nineteenth-century American art, see Craven, *Sculpture in America.*

[28]Michael Kammen, *Mystic Chords of Memory,* analyzes various historical and regional commemorative themes.

[29] "Statues of Trumbull and Sherman," *Congressional Globe,* Mar. 8, 1872, p. 1526.

[30]Charles Sumner's speech honoring Gen. Nathanael Greene in *Congressional Globe,* Jan. 20, 1872, p. 594.

[31]Pomeroy's comments were paraphrased from the *Connecticut Courant.* See George Adams to J. George Stewart, May 1, 1963. Roger Sherman and Jonathan Trumbull were designated by the Connecticut legislature in 1865. See Resolution No. 72, General Assembly of the State of Connecticut, May Session, 1865, approved July 7, 1865. Roger Sherman, a former Connecticut state legislator, U.S. representative and senator, was the only member of the Continental Congress to sign the Declaration of 1774, the Articles of Confederation, the Declaration of Independence, and the Federal Constitution. Jonathan Trumbull was Connecticut's chief justice in colonial times and governor for fifteen years. Trumbull was also the father of artist John Trumbull. See *Art in the Capitol,* pp. 263, 267.

dards associated with the Revolution and early republic. Jonathan Trumbull, a colonial statesman and Connecticut governor, was acclaimed for his prudent leadership and depicted by sculptor Chauncey B. Ives in the manner of George Washington delivering a farewell address after fifty years of distinguished public service. During the 1870s and 1880s the term *pantheon* was frequently used as a synonym for Statuary Hall, invoking the cult of rulership and the traditional concept of the Capitol as a temple of democracy honoring the Olympian statesmen of a virtuous historical past. These heroic ideals, popularized during the Revolution and Federal period, by the 1880s were largely anachronistic and soon to be displaced by standards more compatible with the industrial temperament of the Gilded Age.[32]

The Midwest States

The fourteen states of the American Midwest, the second region of the country to contribute works to Statuary Hall, dedicated the majority of their twenty-seven statues (nineteen, or 70 percent) between 1886 and 1920.[33] In most respects, state commissions were similar to those appointed in the North; however, some commission appointees were prominent businessmen or civic leaders with important contacts in eastern and burgeoning midwestern arts communities. Detroit banker Philo Parsons chaired the commission for Michigan's statue of Gen. Lewis Cass (1889) and personally interviewed sculptors in Boston and New York, finally selecting Daniel Chester French for the ten-thousand-dollar state-funded project (fig. 8).[34] Between 1886 and 1925 costs were funded through state appropriation; those commissioned between 1933 and 1959 were, for the most part, financed through private-sector contributions.

The Midwest selected a diverse range of individuals whose public careers reflected the dynamic crosscurrents of bipartisan politics, economic prosperity, and middle-class ideologies of the American heartland. The majority of honorees were political figures and former statehood leaders, self-made men who epitomized the regional ethos of material and moral prosperity characteristic of the mid-1800s. Many of these individuals typified the midwestern success story of entrepreneurs and businessmen

[32]Cawelti, *Apostles of the Self-Made Man;* Greene, *America's Heroes.*

[33]The fourteen states of the Midwest and Plains region include Illinois, Indiana, Iowa, Kansas, Michigan, Minnesota, Missouri, Nebraska, North Dakota, Ohio, Oklahoma, South Dakota, Texas, and Wisconsin.

[34]Lewis Cass had a long and varied career as a territorial governor, secretary of war, U.S. senator, and secretary of state. General Cass, as he was popularly remembered, had also served in the War of 1812. See *Art in the Capitol,* p. 235. Cass was designated by the Michigan legislature in 1885. See J.R. No. 26, 33d Legislature, Senate and the House of Representatives of the State of Michigan, approved June 17, 1885. Detroit banker Philo Parsons led the Michigan Commission for Cass's statue. See Philo Parsons to Gov. R. A. Alger, Dec. 27, 1886; Michael Richman, "Daniel Chester French: His Statue of Lewis Cass in the United States Capitol," *Records of the Columbia Historical Society* 48 (1973):548–69; *Congressional Record,* Feb. 18, 1889, pp. 2001–10.

FIG. 8. Daniel Chester French, *Lewis Cass* (Michigan), 1888, marble, 7'8". *(Courtesy Office of Architect of the Capitol.)*

who rose through the ranks of party politics to become influential leaders in state or national government (*Zachariah Chandler,* Michigan, 1913; *Henry Mower Rice,* Minnesota, 1916).[35] Throughout the Gilded Age, honorees were celebrated for their "iron-willed determination," "fierce competitive instincts," or "Napoleonic" ambition—traits considered essential for success in a new industrial and social order. By the 1890s, *Valhalla,* a term connoting Teutonic militarism, emerged as a synonym for Statuary Hall and was used periodically in dedication speeches until the 1930s.[36]

After 1900, however, midwestern states designated social crusaders (*Frances Willard,* Illinois, 1905) and progressive reformers (*Robert M. LaFollette,* Wisconsin, 1929), individuals who had challenged the abuses of capitalism or championed the rights of the common man (*William Jennings Bryan,* Nebraska, 1937). Oklahoma's tributes to Cherokee leader Sequoyah (1917) and humorist Will Rogers (1939) framed the commemoration of ethnic heritage within the broader context of racial stereotypes and social hierarchies. Sequoyah, depicted by Vinnie Ream as philosopher-statesman, "the American Cadmus," was described as "the ablest intelligence produced among the American Indians." Will Rogers, well known for his Cherokee ancestry and Indian cowboy stage persona, was celebrated in 1939 as "the archetype of the American people —the plain and kindly spokesman of the inarticulate."[37]

By the 1930s Statuary Hall was more or less permanently dubbed a *hall of fame,* a term popularized by the Hall of Fame for Great Americans established in 1899 at New York University. Ironically, the New York collection had been instituted, in part, as a more prestigious and regulated alternative to Statuary Hall, which university

[35]Andrew R. L. Cayton and Peter S. Onuf, *The Midwest and the Nation: Re-Thinking the History of an American Region* (Bloomington, Ind., 1990). Zachariah Chandler, an abolitionist and U.S. senator, was a founder of the Republican party and served as secretary of the Interior Department under Grant. See *Art in the Capitol,* p. 235. Chandler was designated by the Michigan legislature in 1911. See S.B. 27, No. 136, 46th Michigan Legislature, approved Apr. 25, 1911; "Tribute to 'Old Zach,'" *Washington Herald,* June 30, 1913. Henry Mower Rice was a key figure in the Minnesota statehood movement and a U.S. senator from 1853 to 1863. See *Art in the Capitol,* p. 258. Rice was designated in 1913. See Chap. 583, H.F. No. 1246, General Laws of Minnesota for 1913, sec. 15, approved Apr. 28, 1913.

[36]The term *Valhalla* was used periodically in designation bills, speeches, correspondence, news reports, and other media from the late 1890s to 1935. See "Acceptance of the Statue of Frances E. Willard," *Congressional Record,* Feb. 17, 1905, pp. 2801–9; "Statue of Lewis Cass," *Congressional Record,* Feb. 18, 1889, pp. 2001–10; E. A. U. Valentine, "Maryland in Statuary Hall," *Baltimore News,* Dec. 9, 1902; J. Thomas Scharf letter to the editor, *Evening News* (Baltimore), July 19, 1897, reprinted in *John Hanson, President of the United States in Congress Assembled, 1781–1782* (Baltimore, n.d.); *The Speech of Honorable Don P. Halsey on the Bill to Provide a Statue of Robert Edward Lee . . . February 6, 1903* (Richmond, 1904); *Acceptance of the Statues of George Washington and Robert E. Lee,* H. Doc. 410 (Washington, D.C., 1934).

[37]*Statue of Sequoyah: Proceedings in Statuary Hall of the United States Capitol* (Washington, D.C., 1924), p. 11. Sequoyah, whose anglicized name was George Guess, invented the eighty-six-character alphabet for the Cherokee language. He was sent to Washington as a delegate from the Cherokee nation in 1828. "Rogers Statue Is Unveiled at Capitol Rites," *New York Times-Herald,* June 6, 1939; "1800 Dedicate Rogers Statue in Capitol," *Washington Post,* June 7, 1939.

organizers castigated as artistically mediocre and subject to partisan political senti-ment.[38] On a popular level, hall of fame has become Statuary Hall's most enduring appellation.

The South

The South, which commissioned few works prior to World War I, emerged in the 1920s and 1930s as the nation's principal contributor to Statuary Hall.[39] The eleven southern states dedicated the majority of their twenty-two statues (nineteen, or 86 per-cent) between 1910 and 1939. Predictably, many southern states honored leading figures of the Old South, including antebellum statesmen (*Andrew Jackson,* Tennessee, 1928; *Henry Clay,* Kentucky, 1929; *John C. Calhoun,* South Carolina, 1910) and heroes of the Confederacy (*Robert E. Lee,* Virginia, 1934; *Jefferson Davis,* Mississippi, 1931). Patriotic-hereditary groups such as the Daughters of the American Revolution, United Daughters of the Confederacy, and Sons of Confederate Veterans, which sponsored monument crusades throughout the South, lobbied for Statuary Hall desig-nations and raised money through membership contributions and fund-raising drives. Approximately one-half of these projects were financed through state appropriation; the others were funded through matching appropriation bills and private contributions.[40]

Statuary Hall provided one of the few opportunities outside the South for com-memorating southern heritage, specifically the Lost Cause, a memory narrative that emerged in the 1870s and subsequently shaped the white South's interpretation of the

[38]Robert Underwood Johnson, *Your Hall of Fame* (New York, 1935), pp. 11–13; *The Hall of Fame for Great Americans at New York University,* rev. ed. by Theodore Morello (New York, 1967). In 1915, sculptor Frederick W. Ruckstull, who created three works for Statuary Hall between 1910 and 1929, proposed a separate facility for the Statuary Hall collection, which he called a "Hall of Fame." Ruckstull's proposal, designed to relieve over-crowding in Statuary Hall, featured a central domed space and a separate room for each of the states. See Fair-man, *Art and Artists of the Capitol,* pp. 493–96.

[39]The eleven southern states include Alabama, Arkansas, Florida, Georgia, Kentucky, Louisiana, Missis-sippi, North Carolina, South Carolina, Tennessee, and Virginia.

[40]State chapters of the D.A.R. initiated designations of Andrew Jackson (1928) and John Sevier (1931) in Tennessee and lobbied for South Carolina's 1910 tribute to John C. Calhoun. Representatives of the Sons of Con-federate Veterans served on the Statuary Hall commission for Florida's 1917 tribute to Confederate Gen. William Kirby Smith. For a history of southern monument crusades, see Foster, *Ghosts of the Confederacy;* Thomas Connelley, *The Marble Man: Robert E. Lee and His Image in American Society* (New York, 1977). South-ern states used a variety of funding methods. Twelve statues were funded through state appropriation bills: *Jef-ferson Davis* and *James Z. George* (Mississippi); *John Gorrie* and *W. K. Smith* (Florida); *Huey Long* and *Edward D. White* (Louisiana); *Zebulon B. Vance* and *Charles B. Aycock* (North Carolina); *Robert E. Lee* and *George Washing-ton* (Virginia); *Andrew Jackson* (Tennessee); and *John C. Calhoun* (South Carolina). Tennessee *(John Sevier)* and South Carolina *(Wade Hampton)* authorized appropriations to be matched by private contributions. In Ken-tucky *(Henry Clay, Ephraim McDowell)* and Georgia *(Crawford W. Long, Alexander H. Stephens),* statues were funded entirely through private contributions. And in Alabama *(J. L. M. Curry, James Wheeler)* and Arkansas *(James Clarke, Uriah M. Rose),* the families of Statuary Hall honorees paid the costs of statues.

Civil War.[41] American victories in the Spanish-American War and World War I en-
hanced respect for military heroism and provided the context for a symbolic repatria-
tion of Confederate heroes in Statuary Hall, some of whom (Jabez L. M. Curry and
Gen. Joseph Wheeler) had served with distinction in the Spanish-American War and
U.S. missions abroad.[42]

Public opposition to the commemoration of Confederate history was infrequent after
World War I but surfaced briefly in the 1920s. In 1926 the Washington, D.C., chapter
of the National Association for the Advancement of Colored People protested the
dedication of a statue honoring Confederate Vice President Alexander H. Stephens in
the Capitol's hall of fame (fig. 9). Buttressed by popular white sentiment, southern apol-
ogists trivialized such objections, insisting that Georgia's tribute to Stephens marked
the long-awaited era of sectional reconciliation.[43] At the 1931 dedication of Jefferson
Davis's statue, Mississippi Sen. Pat Harrison vindicated the former Confederate pres-
ident, declaring that "the tolerant spirit of a reunited people [had finally conceded] to
the people of both sections a conscientious discharge of duty as they saw it under the
Constitution and principles of government."[44]

Southern states also honored their native-born scientists (*Crawford W. Long,* Geor-
gia, 1926; *John Gorrie,* Florida, 1914), jurists (*Edward Douglass White,* Louisiana, 1955),
and politicians (*Charles B. Aycock,* the "Educational Governor" of North Carolina,
1932), designations initiated by business groups, civic organizations, and philanthropists
of the New South eager to promote the economic and political interests of the region
in the 1920s and 1930s.[45] Progressive heroes of the New South (*Huey P. Long,* Louisiana,

[41]Foster, *Ghosts of the Confederacy;* G. Kurt Piehler, "The Divided Legacy of the Civil War," in *Remembering
War the American Way* (Washington, D.C., 1995), pp. 47–91; Kammen, *Mystic Chords of Memory;* Kirk Savage,
Standing Soldiers, Kneeling Slaves: Race, War, and Monument in America (Princeton, 1997).

[42]In 1903 the Alabama legislature designated Jabez Lamar Monroe Curry, a former Confederate soldier,
member of the U.S. House of Representatives and Confederate Congress, and U.S. minister to Spain. Curry was
also a college professor and advocate of public education. See *Art in the Capitol,* p. 239; S.J. Res. No. 233, *General
Laws and Joint Resolutions of the Legislature of Alabama,* 1903 sess., filed Sept. 29, 1903. In 1923 Alabama legisla-
tors designated Gen. Joseph Wheeler, a West Point graduate who served in the Confederate Army. Wheeler was
promoted to brigadier general in the Spanish-American War and served in the U.S. House of Representatives.
See *Art in the Capitol,* p. 270; S.J. Res. No. 93, *General Laws and Joint Resolutions of the Legislature of Alabama,*
1923 sess., approved July 29, 1923; "Statue of General Joseph Wheeler," *Congressional Record,* Mar. 16, 1925, pp.
281–87.

[43]Neval H. Thomas to Architect of the Capitol [1926?].

[44]Sen. Pat Harrison quoted in "Excerpts from the Exercises at the Unveiling of the Statues of Jefferson Davis
and James Z. George, Presented by the State of Mississippi for National Statuary Hall in the U.S. Capitol, June
2, 1931," dedication brochure, p. 36; H.B. No. 133, chap. 324, *General Laws of the State of Mississippi,* 91st sess.,
passed Apr. 5, 1924. Alexander H. Stephens, a U.S. representative and vice president of the Confederate States
of America, was designated by the state of Georgia in 1922. See H. Res. No. 152, 106th [Georgia] Legislature,
1922 sess., chap.-pt. 4, *Resolutions,* July 12, 1922; *Art in the Capitol,* p. 266.

[45]John Gorrie, M.D., was designated in 1911 by the state of Florida for his invention of a mechanical refrig-
eration system to alleviate the suffering of his patients. Gorrie's invention led to the development of air condi-
tioning and mechanical ice making. See Chap. 6144, No. 25, *Laws of Florida 1911,* approved June 5, 1911; *Art in
the Capitol,* p. 242. In 1922 Georgia designated Dr. Crawford W. Long, the first surgeon to use sulfuric ether

294 TERESA B. LACHIN

1941) were celebrated for their "humble origins" and "unselfish devotion to the Common Man."[46]

The West

The eleven states of the Far West and Rocky Mountain region (the West) dedicated the majority of their nineteen statues between 1930 and 1997; fifteen (79 percent) of these were commissioned after World War II.[47] Between 1950 and 1960, nine states dedicated ten statues in the Capitol.

Throughout the West, designations were initiated by regional heritage groups, business and professional organizations, and citizens' coalitions whose members were, in many instances, invited to serve with public officials on Statuary Hall commissions.[48] Throughout the West most projects were financed by private contributions and statewide fund-raising campaigns. Colorado's tribute to medical researcher Dr. Florence R. Sabin (dedicated 1959) was launched in 1957 by the Colorado Division of the American Association of University Women, whose members raised seventeen thousand dollars in funding costs. The 1980 statue of Catholic missionary educator Mother Joseph of Washington (fig. 10) was the result of an eleven-year crusade by a

(1842) as an anesthesia for surgical patients. See H.R. No. 152, *Laws of Georgia 1922*, 106th Legislature, 1922 sess., chap.-pt. 4, *Resolutions*, July 12, 1922. Dr. Ephraim McDowell, designated by the Kentucky General Assembly in 1928, was the first surgeon to successfully perform an Ovariotomy (1809). See Chap. 599, *Acts of the General Assembly of the Commonwealth of Kentucky 1928*, Jan. 3 to Mar. 16, 1928, approved Mar. 21, 1928. Edward Douglass White, who served in the Confederate army at the age of sixteen, was a U.S. senator, associate justice of the Louisiana Supreme Court, and chief justice of U.S. Supreme Court. White was designated for Statuary Hall in 1952. See Act No. 455 (S.B. No. 236), *Laws of Louisiana 1952*, approved July 10, 1952. Charles B. Aycock, the "Educational Governor of North Carolina," was designated in 1929. See Chap. 293, *Public Laws of North Carolina 1929*, approved Mar. 19, 1929; "Statue To Be Ready at Capitol Friday—North Carolina to Dedicate Piece to Great Educator, Charles B. Aycock," *Washington Post*, May 15, 1932.

[46]Huey P. Long, the "Kingfish" of Louisiana politics, was assassinated in 1935. His designation for Statuary Hall was controversial; when his statue was unveiled in 1941, five anti-Long members of the Louisiana delegation abruptly left the House chamber as one of his supporters rose to eulogize him as "the champion of the poor . . . who gave the entirety of his life to his country, that others may live in more abundance" ("Remarks of the Hon. Newt V. Mills of Louisiana in the House of Representatives, Friday, April 25, 1941," *Congressional Record*, Mar. 17 to May 20, 1941, p. A1910; "Veil Is Lifted from Statue of Huey Long," *Washington Post*, Apr. 26, 1941, p. 13).

[47]The eleven states of the West and Rocky Mountain region include Arizona, California, Colorado, Idaho, Montana, New Mexico, Nevada, Oregon, Utah, Washington, and Wyoming.

[48]In California the Sons and Daughters of the Golden West conducted a vigorous lobbying effort to obtain the designations of Junípero Serra and Thomas S. King (1927). The Oregon Pioneers Association and Oregon State Historical Society were instrumental in the designation of John McLoughlin and Jason Lee (1921, 1945). The Kino Memorial Statue Association, an affiliate of the Arizona Pioneers Historical Society, raised forty thousand dollars for the statue of Eusebio Kino. The Washington State Business and Professional Women's Clubs helped obtain the 1949 designation of Marcus Whitman and directed a thirty-thousand-dollar fund-raising campaign to sponsor the project.

FIG. 9. Gutzon Borglum, *Alexander Hamilton Stephens* (Georgia), 1926–27, marble, 5'8". *(Courtesy Office of Architect of the Capitol.)*

Fig. 10. Felix W. de Weldon, *Mother Joseph* (Washington), 1980, bronze, 4'8". *(Courtesy Office of Architect of the Capitol.)*

Fig. 11. Mahonri Young, *Brigham Young* (Utah), 1947, marble, 5'11". *(Courtesy Office of Architect of the Capitol.)*

grassroots citizens' coalition that collected eighty-five thousand dollars to fund the project.[49]

The western states selected the most diverse group of individuals in Statuary Hall, including "Cowboy Artist" Charles M. Russell (Montana, 1959), Catholic missionaries Junípero Serra (California, 1931) and Eusebio F. Kino (Arizona, 1965), and territorial colonizers Brigham Young (Utah, 1950) (fig. 11) and Dr. John McLoughlin (Oregon, 1953).

Designation bills and dedication speeches glorified the exploits of western pioneers and empire builders, individuals who had "brought the gospel of civilization [to a] primitive and savage land."[50] In 1953 Marcus Whitman, medical missionary of the Oregon Territory, was honored by the state of Washington as a symbol of "Christian faith, spiritual purpose, and unfaltering courage" on the American frontier.[51] Commemorative rhetoric romanticized the paternalism of white settlers and either ignored or minimized the territorial conflicts with Native Americans who were described as the beneficiaries of humane or just treatment. Arizona's 1961 designation of Jesuit Eusebio Kino stated that the seventeenth-century missionary and explorer had "regarded the poor natives as his personal wards [and] recorded every indication of their intelligence."[52]

The celebration of pioneer heritage and rugged individualism also signaled deep-seated anxiety among westerners about demographic changes and unregulated economic growth within the region, particularly after World War II.[53] Nostalgia for the Old West prompted Montana's designation of artist Charles M. Russell (fig. 12), who

[49]Of the seventeen statues contributed by western states between 1930 and 1990, ten were funded through private contributions, including tributes to Esther Morris (Wyoming, $35,000), Philo T. Farnsworth (Utah, $250,000), Mother Joseph (Washington, $85,000), Marcus Whitman (Washington, $30,000), Florence Sabin (Colorado, $17,000), and Eusebio Kino (Arizona, $40,000).

[50]*Acceptance and Unveiling of the Statues of Junípero Serra and Thomas Starr King* (Washington, D.C., 1932), pp. 25–26, 34–39, 50–53. Statues honoring Dr. John McLoughlin, head of the Hudson Bay Company and the "Father of Oregon," and Rev. Jason Lee, the "first missionary of the Oregon Territory," were unveiled in 1953. At the 1953 dedication of McLoughlin's statue, Rep. Sam Coon of Oregon praised his "mild and paternalistic rule [over the Oregon Territory] that grew from a wilderness of savages to a settled country." Lee was cited as an example of the "self-sacrificing men and women who laid the foundations of greatness and prosperity" on the American frontier (Myrtle Cheney Murdock, *National Statuary Hall in the Nation's Capitol* [Washington, D.C., 1955], p. 67; Burt Brown Barker, *Oregon: Prize of Discovery, Exploration, Settlement* [Salem, Ore., 1952]).

[51]Washington Gov. Arthur B. Langlie quoted in *Marcus Whitman's Statue: Program for the Unveiling Ceremony,* p. 5.

[52]H.J. Memorial No. 5, Arizona House of Representatives, 25th Legislature, 1st sess., approved Mar. 9, 1961. Jesuit missionary and explorer Eusebio Kino, a native of Italy, was designated by Arizona legislators in 1961. See *Art in the Capitol,* p. 250. Mormon leader Brigham Young, "Utah's great and beneficent pioneer and colonizer," was selected by the state of Utah in 1943. See Utah H.C.R. No. 4, passed Mar. 11, 1943.

[53]Charles B. Hosmer, *Preservation Comes of Age: From Williamsburg to the National Trust, 1926–1942,* 2 vols. (Charlottesville, 1981), vol. 1, pt. 2, "Local and State Preservation Efforts," pp. 231–465; James Gilbert, *Another Chance: Postwar America, 1945–1968* (New York, 1981).

FIG. 12. John B. Weaver, *Charles Marion Russell* (Montana), 1957–58, bronze, 7'1". *(Courtesy Office of Architect of the Capitol.)*

was honored in 1959 for his well-known artistic interpretations of frontier life. Paradoxically, Russell symbolized both the "search for freedom and opportunity" in the American West of the nineteenth century and the "encroachments of civilization" in the twentieth.[54]

Regional folklore was adapted to a variety of commemorative themes, from women's history to the technological advances of the information and space age. In all, four women were designated by western states, areas of the country where suffrage had gained an early but tenuous foothold. Suffragist Esther Hobart Morris (fig. 13) of Wyoming, the "Equality State," and Montana Congresswoman Jeannette Rankin (fig. 14) were characterized as trailblazers and rugged pioneers, epithets that tempered suffrage militancy and reshaped commemoration of women's history within the canons of male-dominated regional folklore.[55] In the 1990s Utah and Colorado commemorated the pioneering spirit of the frontiers of technology and space exploration with statues honoring Philo T. Farnsworth, the "Father of Television," and Apollo 13 astronaut Jack Swigert. The dedication of Swigert's statue was part of a broader movement to commemorate, if not redeem, the legacy of manned space flight following the 1986 Challenger disaster.[56]

[54]*Remarks Made by Representative Sumner Gerard of Ennis, Montana at the Dedication of Statue of C. M. Russell . . . March 19, 1959.* Charles M. Russell was designated twice by Montana legislators. A 1929 designation (H.J. Memorial No. 3, *Laws of Montana,* approved Mar. 1, 1929) was not implemented by the state commission due to disputes over the proposed design of Russell's statue. See Archie L. Clark to J. George Stewart, Sept. 25, 1956. The second designation was made in 1947. See H.B. No. 211, sec. 19–120, *Revised Codes of Montana 1947.*

[55]Jeannette Rankin, a leader of the suffrage movement in Montana and the first woman elected to the U.S. House of Representatives, was cited in 1985 dedication speeches for her feminist beliefs and dedication to international peace and cooperation. Rankin was also characterized as epitomizing the rugged individualism and feisty determination of the American frontier and was hailed as "one of the great trailblazers of our time." *Dedication of the Statue of Jeannette Rankin, Rotunda, United States Capitol, Wednesday, May 1, 1985,* S. Doc. 99-32 (Washington, D.C., 1985). Mother Joseph (Esther Pariseau), a Catholic nun and founder of numerous orphanages, Indian schools, and homes for the elderly in Washington State, was characterized as a "pioneer builder" in publicity statements. Esther H. Morris, an early proponent of women's suffrage and the first woman elected to public office in the United States, was designated in 1955 by Wyoming, the first state to grant universal suffrage. Morris was cited for her efforts on behalf of the abolition of slavery and women's rights. The inscription on her statue lists Morris's achievements and describes her as a "stalwart pioneer" who became the nation's first woman justice of the peace. See *Art in the Capitol,* p. 256. At the 1960 dedication of the statue, former Wyoming Gov. Nellie Tayloe Ross listed Morris's pioneering achievements and "strong qualities of heart and mind." Ross also described Morris as a "lady in the best sense of the word . . . fastidious in dress . . . [with] iron in her blood aplenty" (*Acceptance of the Statue of Esther Morris . . . April 6, 1960,* S. Doc. 69 [Washington, D.C., 1961] pp. 28–34). Ross, the first woman elected governor in U.S. history, had guided the Morris designation through the Wyoming legislature. When the bill stalled in the state senate, women throughout the state sent an avalanche of telegrams protesting the recalcitrance of their representatives and demanding that it be approved. See "To Women's Rights, Statue Adds Stature," *Washington Post,* Apr. 3, 1960, p. F8.

[56]Utah's 1990 tribute to Philo T. Farnsworth was launched in the mid-1980s by Dr. Bruce Barnson, an elementary school principal in Sandy City. As a result of an informal survey, Barnson and his students determined that Farnsworth was a popular candidate for Statuary Hall. See Rick Atkinson, "In Utah, Grade-School Lobbyists Experience Politics and Power," *Washington Post,* Apr. 1, 1990, p. A3; Sheridan R. Hansen, "Destination: Statuary Hall," *Deseret News,* Apr. 24, 1990. For Colorado's 1997 statue of Jack Swigert, see note 24.

FIG. 13. Avard Fairbanks, *Esther Hobart Morris* (Wyoming), 1958, bronze, 8'. *(Courtesy Office of Architect of the Capitol.)*

Fig. 14. Mary Theresa Mimnaugh, *Jeannette Rankin*
(Montana), 1985, bronze, 6'10". *(Courtesy Office of Architect of
the Capitol.)*

Conclusions

National Statuary Hall, which was instituted to unite—if not reconstruct—a bitterly divided country, has long since outgrown its allotted space in the Old Hall. Derided as a "Chamber of Horrors" in the early 1900s, due, in part, to the overcrowding of statues, the collection was reorganized in 1933 and again in 1976 and today is dispersed in public viewing areas throughout the Capitol. Most states are represented by one statue in Statuary Hall; the remaining number are distributed in the rotunda, House and Senate connecting corridors, Hall of Columns, east front lobby, and adjacent areas.[57]

From the perspective of the multicultural 1990s, Statuary Hall embodies a somewhat outmoded, ethnocentric, and paternalistic interpretation of distinguished service in public life.[58] Like other established collections of public art, Statuary Hall tends to marginalize or stereotype women, exclude or denigrate ethnic minorities, glorify American imperialism, and foster an anachronistic commemorative idiom that is difficult to reconcile with postmodern historical consciousness.

However, recent initiatives in New Mexico and North Dakota (two of the four states with one statue) have identified women and ethnic leaders as prospective honorees. If approved, these designations will help diversify the collection and promote a more balanced and pluralistic interpretation of American history.[59] Still other initiatives reiterate the 1990s shift toward neotraditionalism. In 1993 Florida lawmakers authorized a recall of the statue of Confederate soldier William Kirby Smith (1917) and the commissioning of a new work honoring Gen. James A. Van Fleet, a World War II hero and former University of Florida football coach. In response, Architect of the Capitol George M. White notified state officials that all works of art contributed by the states were federal property and, unless or until Congress amended the 1864 Statuary Hall legislation, could not be deaccessioned by state mandate.[60]

[57]For criticisms of Statuary Hall, see "Statues at Random," *New York Times,* Feb. 6, 1902, p. 8; Thomas Nelson Page, "What Ails Art in America?" *New York Times,* Jan. 15, 1911, p. 6; Labert St. Clair, "The Nation's Mirth-Provoking Pantheon," *Collier's Magazine* 51 (1913):14. By the 1930s Statuary Hall held sixty-five statues which, in some instances, were placed three deep. Concerns about the appearance of the collection and weight of sculpture on the chamber floor resulted in a 1933 reorganization plan. See House C.R. 47, Feb. 24, 1933. The collection was again reorganized in 1976. See "The National Statuary Hall Collection," a memorandum prepared by the Office of the Curator, January 1992.

[58]There are currently no state tributes to African Americans. Women and ethnic groups also are underrepresented.

[59]The state of New Mexico has designated Pope, a Native American who led the Taos uprising against Spanish colonists in the sixteenth century. A bust of Martin Luther King, Jr., was commissioned by Congress in 1982 and dedicated in the rotunda in 1986. One of the few honorific images of African Americans in the U.S. Capitol, this bust is on permanent display in the rotunda. Adelaide Johnson's 1921 "Portrait Monument" to suffrage leaders Lucretia Mott, Elizabeth Cady Stanton, and Susan B. Anthony (a gift of the National Woman's Party) was relocated to the rotunda in 1997. Neither of these works is part of Statuary Hall.

[60]Architect of the Capitol George M. White to Lori Tinney, Mar. 16, 1993; Bill Rufty, "House Favors Van Fleet Statue," *Lakeland Ledger,* Mar. 17, 1993.

Initiatives such as these might become more commonplace. Pressured by public demand to recall obscure or unpopular honorees and designate new ones, Congress might conceivably amend the 1864 legislation to allow voluntary deaccessioning or increase the number of statues allotted to each state.[61]

In the final analysis, the history of Statuary Hall has not been as simple or as inexpensive as Justin Morrill and his colleagues imagined it in the 1860s. As a pantheon of republican virtue, Statuary Hall voiced the lofty ideals of political reunion while harboring the smoldering resentments of longstanding sectional animosities. As a Valhalla of warrior-statesmen, Statuary Hall celebrated the energy and raw ambition of a highly competitive industrial and social order. And in ways that are both progressive and regressive, Statuary Hall as a hall of fame extended and diversified the frontiers of public commemoration. Shaped by powerful political and social forces, Statuary Hall has also been highly responsive to and representative of popular commemorative standards. Ultimately, it represents what Alexis de Tocqueville called "the great and imposing image of the people."[62]

[61]The Florida legislation was unprecedented, but there have been other tentative deaccessioning initiatives. In 1963 Oklahoma lawmakers considered a resolution to replace the state's 1917 statue of Sequoyah with one honoring Robert Kerr, a U.S. senator who had recently died. This proposal generated a storm of opposition both in Congress and throughout the state. Kerr was castigated as a pork-barrel politician unworthy to replace the well-liked Sequoyah. See John Maffre, "Oklahoma Bid to Oust Favored Indian for Kerr Sets Off War Drums," *Washington Post,* May 3, 1963, p. A4; Walker Stone, "Has Oklahoma Lost Its Sanity in Statuary Row?" *Washington Daily News,* May 6, 1963, p. 25; Jim G. Lucas, "A Political Storm Rips over Oklahoma Prairie," *Washington Daily News,* May 2, 1963, p. 27; Stephen C. Rogers, "Oklahoma's Entry in Statuary Hall Invented Language for Indian Tribe," *Washington Post,* May 15, 1963. In 1979, a proposal to deport Kansas's 1914 statue of George W. Glick (a Civil War veteran and Free Soil governor) and replace it with one honoring Dwight Eisenhower was discussed but not acted upon. See Phil Sanfield, "Gov. Glick May Be Traded for President Eisenhower," *Roll Call,* July 26, 1979, p. 7.

[62]Alexis de Tocqueville, *Democracy in America,* 2 vols. (1835).

Contributors

William C. Allen is the architectural historian for the Office of Architect of the Capitol. He is the author of *The Dome of the United States Capitol: An Architectural History* (1992) and a book on the Capitol's four cornerstones. He currently is at work on a comprehensive architectural history of the Capitol.

William B. Bushong is the historian for the White House Historical Association. He is the author of *Uncle Sam's Architects: Builders of the Capitol* (1994) and a history of the Washington chapter of the American Institute of Architects. His edited and annotated version of Glenn Brown's *History of the United States Capitol* is forthcoming. In progress is an illustrated history of the Office of Architect of the Capitol.

Jeffrey A. Cohen is lecturer in the Department of Growth and Structure of Cities at Bryn Mawr College. He is co-author of *Drawing Toward Building* (1986), *Frank Furness: The Complete Works* (1991), and *The Architectural Drawings of Benjamin Henry Latrobe* (1994).

James M. Goode is a consultant in architectural history. He is the author of three books published by the Smithsonian Institution Press: *The Outdoor Sculpture of Washington, D.C.* (1974), *Capital Losses: The Cultural History of Washington's Destroyed Buildings* (1979), and *Best Addresses: A Century of Washington's Distinguished Apartment Houses* (1988).

Kimberly A. Jones is assistant curator of French paintings at the National Gallery of Art, Washington, D.C. A former museum fellow at the Musée National du Château de Pau and Musée d'Orsay in Paris, she has published a number of articles on various aspects of eighteenth- and nineteenth-century art. She was a curator of the *Degas at the Races* exhibition at the National Gallery in 1998. She co-authored the catalog for the exhibition *Jean-Paul Laurens, 1838–1921, Peintre d'histoire,* at the Musée d'Orsay, and she is currently writing a book-length study of Laurens and history painting in late-nineteenth-century France.

Teresa B. Lachin is a cultural historian who specializes in material culture and American commemorative art. She teaches American studies and interdisciplinary humanities courses at various universities in the Washington-Baltimore area. Her research on National Statuary Hall was supported by a fellowship from the U.S. Capitol Historical Society. Dr. Lachin is currently working on a history of Adelaide Johnson's 1921 "Portrait Monument" and works by other women artists included in the Capitol arts collection.

DANIEL CLAYTON LEWIS is a cultural historian of the Civil War period. He is currently completing his dissertation, "The Contest over Union, Emancipation, and American History in Emanuel Leutze's Art of the Civil War Era." In 1995 and 1996 he received fellowships from the U.S. Capitol Historical Society to research Leutze's mural at the Capitol and his other works pertaining to the sectional crisis.

CATHERINE S. MYERS is a conservator of mural paintings and architectural materials in private practice in Washington, D.C. She is a research associate at the Graduate School of Fine Arts, University of Pennsylvania.

DAVID SELLIN is an independent scholar in Washington, D.C. He has taught art history at Colgate, Tulane, and Wesleyan University and was curator in the Office of Architect of the Capitol from 1976 to 1980. He is the author of *The First Pose* (1976), *Americans in Brittany and Normandy, 1860–1900* (1982), and numerous articles.

PAMELA SCOTT is an independent architectural historian whose specialty is Washington, D.C., architecture. Her book *Temple of Liberty: Building the Capitol for a New Nation* (1995) accompanied an exhibit at the Library of Congress. She was co-author of *Buildings of the District of Columbia* (1993). Currently she is working on a biographical dictionary of American architects.

RICHARD GUY WILSON is Commonwealth Professor of Architectural History at the University of Virginia and has written and contributed to many books along with curating exhibitions on many aspects of architecture and decorative arts of the eighteenth to the twentieth centuries.

BARBARA A. WOLANIN is the curator for the Office of Architect of the Capitol. She previously taught art history at James Madison University and Trinity College in Washington, D.C. She has published a number of exhibition catalogs, articles, and reviews in the field of American art and is the primary author of *Constantino Brumidi: Artist of the Capitol,* published in 1998.

Index